TRANSMEDIAL LANDSCAPES AND MODERN CHINESE PAINTING

Harvard East Asian Monographs 446

TRANSMEDIAL LANDSCAPES AND MODERN CHINESE PAINTING

Juliane Noth

Published by the Harvard University Asia Center
Distributed by Harvard University Press
Cambridge (Massachusetts) and London 2022

The Harvard University Asia Center publishes a monograph series and, in coordination with the Fairbank Center for Chinese Studies, the Korea Institute, the Reischauer Institute of Japanese Studies, and other facilities and institutes, administers research projects designed to further scholarly understanding of China, Japan, Vietnam, Korea, and other Asian countries. The Center also sponsors projects addressing multidisciplinary and regional issues in Asia.

This book was published with funding from the Deutsche Forschungsgemeinschaft (DFG, German Research Foundation), project nos. NO 968/1-1 and NO 968/1-2.

Cataloging-in-Publication Data is on file at the Library of Congress.

ISBN 9780674267947 (cloth) | ISBN 9780674267954 (paperback)

Index by Anne Holmes of EdIndex
⊗ Printed on acid-free paper
Last figure below indicates year of this printing
28 27 26 25 24 23 22

To my parents,
Evi and Jochen Noth

CONTENTS

MAPS AND FIGURES

Maps

Figures

ACKNOWLEDGMENTS

This book is the outcome of the research project "Landscape, Canon, and Intermediality in Chinese Painting of the 1930s and 1940s," funded by the Deutsche Forschungsgemeinschaft (DFG, German Research Foundation) from 2012 to 2017. I am deeply grateful to the DFG, and especially to Dr. Claudia Althaus and Stefanie Röper, for their continuing generous support, which has included granting publication funds for this book. An earlier version of the manuscript was accepted as an Habilitationsschrift by the Department of History and Cultural Studies at the Freie Universität (FU) Berlin, my intellectual home for the duration of the project.

The lively discussions I enjoyed with colleagues at the Institute for Art History at FU Berlin, and with the research group FOR 1703, Transcultural Negotiations in the Ambits of Art: Comparative Perspectives on Historical Contexts and Current Constellations, made my work on this project an exciting and pleasurable experience. Jeong-hee Lee-Kalisch has been my mentor and friend for many years. I am also very grateful to Karin Gludovatz for her continuous support and advice on many matters. My special thanks go to my friends and former colleagues Kerstin Pinther, Joachim Rees, Wibke Schrape, and Matthias Weiß for countless lunches and coffees over which we discussed our work and various other important and less important matters in life.

Many people offered invaluable help by granting me access to the collections, archives, and libraries of their institutions. I am deeply indebted to Xu Jiang and Gao Shiming for inviting me to the China Academy of Art, which has become my second home in China. Yu Hui of the Palace Museum always offered assistance, advice, and contact information for various other museums. Wu Hongliang of the Beijing Painting Academy helped me to make contact with artists' relatives.

I also owe my sincere gratitude to Xu Hongliu and Luo Jianqun of the Zhejiang Provincial Museum; Shi Dawei, the former director of the Shanghai Institute of Chinese Painting, and his staff; Li Weikun of the Shanghai Museum; Sha Wenting and the staff at the Gushan branch of the Zhejiang Provincial Library; the staff at the Shanghai Library; Lian Zhaoxi of the Nanjing University of Arts Library; and Yang Fanshu, who dug through the libraries at the Guangdong Museum of Art and the Guangzhou Academy of Art with me. In Taiwan, Ba Dong shared his insights on the paintings of Zhang Daqian and Fang-mei Chou gave me access to the Long Chin-San Archive at National Central University. I also wish to thank Yu-jen Liu at the National Palace Museum and Gao Pin-pin at the National Museum of History.

This book has profited immensely from the insights, suggestions, and support offered by many friends and colleagues during conferences, workshops, and private conversations that have provided some of the most delightful moments of my academic life. In particular, I would like to say thank you to Cai Tao, Pedith Chan, Sarah Fraser, Yi Gu, Christine I. Ho, Paola Iovene, Monica Juneja, Kong Lingwei, Tian S. Liang, Yukio Lippit, Yu-jen Liu, Adhira Mangalagiri, Julia Orell, Claire Roberts, Catherine Stuer, Melanie Trede, Cheng-hua Wang, and Eugene Wang. With this book, I hope to give something back in return.

I am deeply grateful to my editors Robert Graham and Deborah Del Gais for their wonderful support, for overcoming the obstacles of communication and logistics in pandemic times, and for helping me maneuver between German and North American academic and administrative conventions. Peter Holm created the beautiful cover and layout, and Walker Scott designed the two maps based on Republican-period materials—thank you both for making this book so readable and beautiful. Julie Hagen made my English a lot more elegant with her thoughtful edits. Christine I. Ho and Paola Iovene read chapters of my manuscript and made valuable suggestions for how to clarify my line of argument, as did the two anonymous reviewers; I am grateful for their very helpful comments. My student assistants Astrid Klein, Liu Fan, and Yang Piaopiao supported me in various bibliographical and editorial matters. I am particularly grateful to Yang Piaopiao, who checked every translation from Chinese texts and saved me from several errors. Her help in working through some of Huang Binhong's more obscure writings was essential. All remaining mistakes are, of course, my own.

The family members of the artists whose creations are the subject of this book generously granted me permission to reproduce their works: I am very much obliged to He Guonian, Yu Mengling and Tony Lee, Eve Long, Sing Chang,

Yien-Koo King, Yu Gang, and Shen Guangwei. Zhang Zhenzhen from the China Institute for Visual Studies at the China Academy of Art helped with acquiring image permissions from libraries in China. I wish to extend my special thanks to Hubert Graml, the photographer at the Institute for Art History at FU Berlin, for editing and rendering publishable the numerous photographs from Yu Jianhua's albums and Republican-period publications that I took myself.

Parts of chapter 1 were previously published in "Reproducing Chinese Painting: Histories, Illustration Strategies, and the Self-Positioning of *Guohua* Painters in the 1930s," *Ars Orientalis* 48 (2018), and in "Comparing the Histories of Chinese and Western Landscape Painting in 1935: Historiography, Artistic Practice, and a Special Issue of *Guohua Yuekan*," in the volume *Art/Histories in Transcultural Dynamics: Narratives, Concepts, and Practices at Work, 20th and 21st Centuries*, edited by Pauline Bachmann, Melanie Klein, Tomoko Mamine, and Georg Vasold (Fink, 2019). Parts of chapter 3 were published in "Landscape Photography, Infrastructure, and Armed Conflict in a Chinese Travel Anthology from 1935: The Case of *Dongnan lansheng*," *TransAsia Photography Review* 8, no. 2 (2018). Unless otherwise noted, all translations are mine.

I could not have written this book without the love and support of my husband, Liu Anping, and my children, Eva and David, who bore with my many travels and counterbalanced the world of academic life with art, school, politics, criminal law, and the pure happiness of family life. Many women in my family have served as models and inspiration for my work, especially my grandmother Ursula Noth and my aunts Karin Schiele and Monika Härdle. Most of all I am grateful to my parents. My father, Jochen Noth, was the first reader of every chapter as I finished it and, with his expertise on China, was of invaluable help. The unwavering support of my mother, Evi Noth, who passed away when this project was still at an early stage, carried me all the way. I dedicate this book to them.

Introduction

When a group of friends, colleagues, and students of Huang Binhong (1865–1955) produced a woodblock-print album of his travel paintings in 1933–34 on the occasion of his seventieth birthday, they emphasized the fundamental difference between Huang's experience and that of their own generation. In the preface, they gave their reason for making an album on the subject of travel:

> What the master enjoys most is painting and traveling. We were born in modern times and we do not have the fulfilment of self-attainment. How could we achieve longevity? When we read the master's travel poetry, our mind wanders for a long time. Therefore, we should ask the master to recall his former travels and paint a small album to carve in wood, so that his joy may spread endlessly.[1]

The authors expressed their inability to participate in the practices of traveling, painting, and composing poetry, practices that were available to Huang Binhong, who received his formative education several decades before the end of the Qing dynasty (1644–1911). For those born in "modern times" (those who came of age after the turn of the century), the formats of classical painting and poetry, and the associated coded responses to landscape, did not form the basic tenets of elite culture but were merely among several options for artistic practice. The epochal gap that Huang Binhong's students perceived between themselves and their master, a caesura that is most clearly marked by the disintegration of the Chinese empire around 1911 and the New Culture

Movement around 1919, was one that had to be bridged by anyone engaging with traditional art forms during the Republican period, even someone of Huang Binhong's generation.

By the 1930s, painting in ink and writing classical poetry were still the most commonly employed formats, especially among artists who had not studied abroad. Choosing those formats, however, meant making a conscious decision to discard other artistic forms introduced from Europe and America, often via Japan. That choice, moreover, had to be justified, and its relevance argued, since literati culture and its practices had been thoroughly questioned and criticized during the first decades of the twentieth century. In other words, pursuing ink landscape painting and writing landscape poetry in classical verse required a reappraisal of their formal means, their semantic conventions, their histories, and their theoretical foundations. *Shanshuihua* 山水畫, or landscape painting in ink, was no longer regarded as an unquestioned artistic expression of the educated elite; rather, it was understood as characteristic of one culture (the Chinese) among many competing national cultures. Thus it was redefined, not as representative of a pervasive, if elite, culture, but as a particular, national form of art. This particularization and nationalization of ink painting was most clearly expressed in a new term for ink painting that came into use in the early twentieth century: *guohua* 國畫, or "national painting." The term subsumed all paintings executed in a particular medium, ink applied with a soft brush on paper or silk, under the category of national identity, regardless of their style and motif.[2]

The process of redefining and reappraising landscape painting in ink as "national" required a definition of "Chinese painting" as well as a "Chinese land-scape." Discussions about these issues were prolonged and intense, and the solutions proposed in art journals as well as in paintings and photographs were diverse. The theoretical discussions and pictorial and literary experiments, as well as political and economic developments that shaped the reconfiguration of ink landscape painting, will form the heart of this study. Indeed, these complex discussions, intense negotiations, and multiple explorations are still ongoing.

The search undertaken by artists in the Republican period for what defined a Chinese landscape implied a constant engagement with the past and with processes of modernization, such as the influx of Western technologies, products, thought, and modes of representation. The issue of how to define modernity with regard to the works of twentieth-century Chinese artists has also formed the prevalent framework for art-historical research on the period. Several scholars have discussed the critique of literati painting brought forth by such influen-

tial reformers as Kang Youwei (1858–1927) and Chen Duxiu (1879–1942), who in the late 1910s called for the adoption of realist modes of representation in Chinese painting in order to overcome its perceived inferiority to post-Renaissance European painting and regain the presumed global superiority of Tang and Song painting.[3] The establishment in 1902 of schools with modern curricula based on Japanese and Euro-American models, including drawing classes, had an even more sustained impact on the way ink painting was perceived and practiced. From its inception, art education in primary, secondary, and art schools mainly consisted of training in drawing, watercolors, and oil painting.[4] As a consequence, Chinese painting and its theories and techniques were increasingly measured against "Western" painting and artistic concepts.

Those artists who argued that indigenous practices were still relevant frequently claimed that historical ideas and techniques had a timeless validity and were intimately linked to cultural identity. However, the conceptual restrengthening of ink painting over the course of the 1920s and 1930s also resulted from transnational exchanges and involvement with European modernism as well as Japanese *nihonga* and *bunjinga*.[5] Last but not least, representations of China's landscape in the medium of photography fundamentally changed the pictorial conventions of landscape painting.[6] This study looks at how the techniques, practices, and ideas regarded as "Chinese" were reinterpreted through discursive engagement and repeated comparisons with European art and photographic visuality, and how they were translated into conceptual frameworks and pictorial idioms that were characterized, in turn, by transnational discourses and transmedial practices.

Landscape Painting, Modern Travel, and Nation Building

The transnational character of the Republican discourses on *guohua* is most explicitly stated in a special issue of *National Painting Monthly* (*Guohua yuekan*), a journal that was published by the Chinese Painting Association (Zhongguo huahui) between November 1934 and August 1935.[7] One aim of the "Special Issue on the Ideas of Landscape Painting in China and the West," was to secure the future of ink painting in a modern global context. The chief editor, Xie Haiyan (1910–2001), called for a "New Chinese Painter" who would be able to express the spirit of the times as well as national characteristics. It seems that the editors of *National Painting Monthly* saw themselves as those New Chinese Painters: in

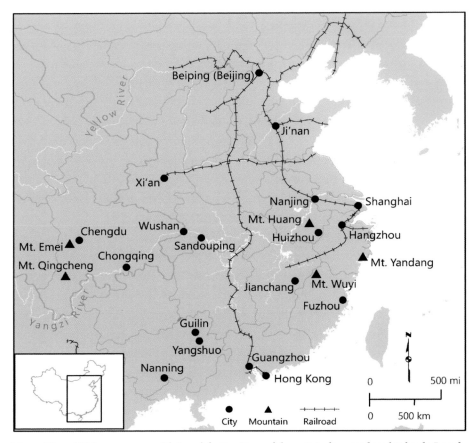

Map 1. Map of China, ca. 1934, with travel destinations of the artists discussed in this book. Based on "The Map of China," in Wu Liande, ed., *China As She Is: A Comprehensive Album* (*Zhonghua jingxiang: Quanguo sheying zongji*) (Shanghai, 1934). Map courtesy of Scott Walker, Harvard Map Collection, Harvard College Library.

their texts, and even more so in their paintings, they proposed solutions for the critical situation in which they saw their artistic medium embroiled.

It is no accident that the editors of *National Painting Monthly* chose landscape painting as the subject of their special issue. Certainly one reason they did so was because landscape had been the core genre in Chinese painting (especially literati painting) since the Song dynasty (960–1279). In the logic of competitive comparison that underpinned the special issue, this was perceived as an advantage for China because landscape painting in Europe was not seen as the most prestigious genre and its history in Europe was not comparable to its history in China. Moreover, the influential figures on the journal's editorial board were landscape painters themselves. More importantly, landscape

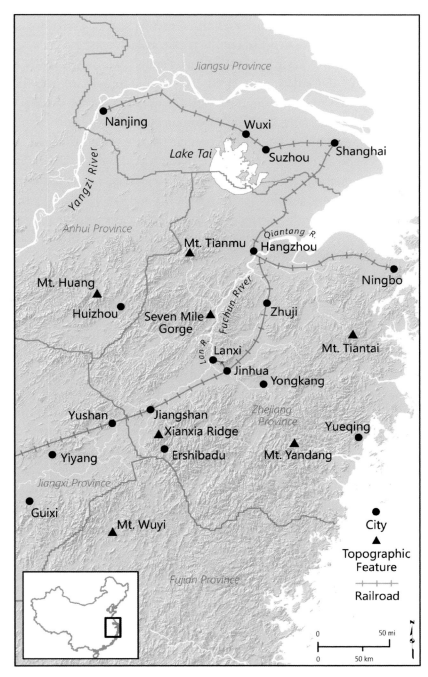

Map 2. Map of Southeast China, ca. 1935, with scenic sites and travel destinations of the artists discussed in this book. Map courtesy of Scott Walker, Harvard Map Collection, Harvard College Library.

painting formed the basis for the redefinition of ink painting as national, especially since it could serve to represent the nation's land.

As a consequence of the influx of Western ideas and painting methods, drawing from nature and outdoor sketching had become important activities for many ink painters (maps 1 and 2). It helped artists to base *shanshuihua*, both factually and conceptually, on "real mountains and real waters" (*zhen shan zhen shui*). Famous mountains and particular places became frequent motifs, which proponents of outdoor sketching claimed had also been the case for the earliest practitioners of landscape painting in the Tang and Song dynasties. Interestingly, the large numbers of travel-related and topographical paintings Chinese artists had produced since the early Ming period are never a major reference point.[8] Perhaps the disparaging discourse on the lack of realism in Ming and Qing painting was too powerful to make those artists the models for *xiesheng* 寫生, or "sketching from nature." By conceptually basing the very beginnings of landscape painting on *xiesheng*, all forms of *shanshuihua* became more closely attached to the actual landscape of China.

During the Republican period, *guohua* was not isolated from other forms of artistic practice, such as photography or modernist oil painting, nor from political developments. This book studies how landscape painters actively promoted the Nationalist Party (*Guomindang*, hereafter *GMD*) government's efforts at nation building through road construction and touristic development, and how they engaged in the physical transformation of the country. Artists' involvement with these nation-building efforts is manifested most clearly in a book titled *In Search of the Southeast* (*Dongnan lansheng*), which was published in March 1935.[9] Produced under the auspices of the Construction Bureau of Zhejiang Province, *In Search of the Southeast* can be described as a high-end propaganda tool for what was called the Southeastern Infrastructure Tour, a publicity tour that accompanied an infrastructure campaign launched by the Nationalist government in 1934. Writers, photographers, and painters were invited to travel the tour routes, at the government's expense, to produce texts and images that would visually and poetically draw urban travelers' attention to formerly remote places that were now connected to the urban centers of southern China. The project testifies to the heavy involvement of the Shanghai art and literary worlds with government agencies and the budding tourism sector and exemplifies their collaboration on infrastructure projects, touristic development, and relief aid.[10]

Guohua artists in the 1930s were deeply involved with the social and political world around them: They were constantly interacting with each other, and with

politicians and businessmen, at countless social events, such as exhibitions and banquets. The continual reports in the widely read Shanghai newspaper *Shenbao* covering small and large events, both private and public, reveal that these activities were followed with interest.[11] The involvement of ink painters in the political sphere and other social circles was important not only with regard to their formation as a social group and their economic success; it also had profound implications for their artistic practice. Private excursions to draw landscapes from nature were complemented by the travels artists undertook at the government's invitation in preparation for *In Search of the Southeast*, or to teach in other cities (Huang Binhong, for example, was invited twice to Guangxi Province to teach summer courses, in 1928 and 1935).[12] The artists' heightened engagement with various landscapes during these extended journeys through China led to an increased production of travel-related paintings and sketches.

In their intimate connection to the modernization efforts of the Nationalist government, these travel-related images can be regarded as expressions of political power; claims to power are clearly expressed in some passages of *In Search of the Southeast*. In premodern China, the landscape was preeminently a cultural site that was made into an object of aesthetic appreciation through the accumulation of texts and images, which were in many cases carved onto the sites themselves and thus embodied in the landscapes.[13] As Elizabeth Kindall has remarked, an "unmediated experience of the natural Chinese landscape was not only impossible, but also culturally undesirable" for viewers. "Visits to specific sites allowed sightseers to commune with the individuals and ideas associated with those sites throughout history."[14] In his study of travel writing, Richard E. Strassberg even goes so far as to state that the experience of an "inscribed landscape" not only had an aesthetic function but also "often accompanied social, political, military, and economic development. It was one way a place became significant and was mapped onto an itinerary for other travelers. By applying the patterns of the classical language, writers symbolically claimed unknown or marginal places, transforming their 'otherness' and bringing them within the Chinese world order."[15] Landscape in pre-twentieth-century China, therefore, does not "[naturalize] a cultural and social construction, representing an artificial world as if it were simply given and inevitable," as W. T. J. Mitchell has suggested the European landscape tradition did.[16] Rather, its goal was to make this construct visible and readable.[17] As I will show in the following chapters, the artists and writers participating in the Southeastern Infrastructure Tour took part in the project of inscribing the modern nation-state onto the mountains,

rivers, and lakes of China's southeastern provinces, and of bringing into the modern Chinese world order, so to speak, formerly unexplored regions that had become newly accessible to travelers on a weekend outing.

The power of landscape imagery to naturalize a new political, social, and economic use of the land is inherent in the landscape paintings, sketches, photographs, and texts studied in this book. This naturalization was realized through the efforts, and sometimes the struggles, to reconcile new spatial and social practices, such as modern travel by car and train on newly built roads, as well as new imaging techniques such as photography, with the inherited pictorial and textual conventions in landscape representations. The images and texts convey the inner expansion of territory through the opening of roads as well as the increased speed of travel, the velocity of motorized transport, and the walking speed of a sedan chair carried by hired locals. Established "famous sites" (*mingsheng*), on the other hand, served as anchors that marked cultural continuity and as destinations for touristic outings, distracting the viewer from the strategic and economic goals behind the state's infrastructure campaign. In analyzing these images, I trace the symbolic reinterpretation of mountains, rivers, temples, and other places as representing national culture.

Transmedial Practice

The reconfigurations of both natural landscape and landscape imagery are most clearly visible in the intermedial and interpictorial references deployed by numerous artists involved with the Southeastern Infrastructure Tour. Ink painters' drawing of pencil sketches and interpictorial engagement with landscape photography, and photographers' invention of a "Chinese" landscape photography that cites ink painting, each required a new configuration of the landscape.[18] The representational techniques, framings, and pictorial conventions of specific media convey landscapes differently, foregrounding some aspects and obscuring others. By conditioning the perception of landscape, different media inscribe different meanings onto it; one might even argue that they produce different landscapes. Places and environments, however, are not passive objects of mediation. As W. T. J. Mitchell and Rachael Ziady DeLue have remarked, they may be ascribed their own agency in shaping how they are represented.[19] They may invite, solicit, or obstruct a specific form of representation, for example, through their size, steepness, deepness, dullness, wilderness and danger,

invisibility, and human-made barriers. The images presented in this book bear witness to artists' experiments and creative solutions in visualizing the modern Chinese landscape as they engaged with the topographical conditions of a given place, the technical properties and qualities of their chosen media, and pictorial conventions.

Many pictures made during both officially organized and private journeys were published shortly after their production. They appeared in *In Search of the Southeast* and related books, and more often in one of the numerous pictorials and journals published in Republican Shanghai; *Liangyou* (*The Young Companion*) and *Arts & Life* (*Meishu shenghuo*) were the most important of these, but they were by no means the sole publishing venues.[20] Place-related ink paintings were published alongside landscape photographs in journals devoted to travel and to art photography. These printed encounters and visual interactions had a fundamental impact on the way landscapes were visualized and conceptualized as Chinese in ink painting as well as in photography, especially since artists engaged, often competitively, with landscape imagery produced in other media.

Given the importance of this intense engagement with various media for the formation of modern Chinese art, a major focus of this study is transmedial practice. While the hanging scroll, handscroll, and album formats, as well as the use of brush and ink, still formed the core of what was understood as *guohua*, an exploration of the paradigmatic shifts taking place in this field of painting during the Republican period must consider the broadened range of media involved. Painters who experimented with different techniques and formats, such as Huang Binhong and Yu Jianhua (1895–1979), still positioned themselves firmly within the field of *guohua*. They defined their practice with reference to historical Chinese painting method and theory. Besides ink, however, they also employed various other pictorial media to reflect their experiences—photography, pencil drawing, watercolors, and woodblock printing—and thus widened the formal and medial possibilities of *shanshuihua*. And conversely, they also referenced the visual effects achieved in those media when using traditional formats. This practice can be described as translation on a formal and visual level. It is closely linked to modern practices such as sketching from nature and photography and is comparable to the use of neologisms such as *xiesheng* (sketching from nature) and *sheying* (photography), which were coined to name these techniques.[21] It can also be linked to the adoption of the modern concepts of creativity, progress, realism, and so on, which were used alongside terms and

concepts taken from classical Chinese texts on painting in the theoretical writings of the Republican period.

These processes of visual and verbal translation were not unidirectional transfers from source to target idiom, but rather were multivocal and multidirectional. Following the translational turn, translation has been increasingly understood as offering a space where new meanings, relations, and situations can be created.[22] In her seminal study of modern Chinese literature, Lydia Liu has described "translingual practice" as occurring in "the process by which new words, meanings, discourses, and modes of representation arise, circulate, and acquire legitimacy within the host language due to, or in spite of, the latter's contact/collision with the guest language." This conceptual approach emphasizes the invention of meaning and takes translation as the site "where the irreducible differences between [host and guest language] are fought out, authorities invoked or challenged, ambiguities dissolved or created, and so forth, until new words and meanings emerge in the host language itself."[23]

In citing Liu's concept of translingual practice in my use of the term "transmedial practice," I am combining the analytical potential of translation theory with the notion of transmediality. The concept of transmediality is largely based on theories of intermediality that were developed by scholars of literature and media studies. Based on the term "intertextuality" as coined by Julia Kristeva, "intermediality" is mostly employed to describe interactions between distinct artistic media, such as literature and music, or literature and visual arts.[24] Irina O. Rajewksy has defined three distinct phenomena of intermediality: the combination of different media, the change of medium, and intermedial references.[25] While medium change or transposition is described as superseding the source medium, intermedial references are conceptualized as translations or "transformations."[26] Urs Meyer, Robert Simanowski, and Christoph Zeller distinguish between inter- and transmediality by stating that the latter refers to the simultaneous presence of the media involved.[27] They also stress the transfer process and the crossing of boundaries between distinct media that is implied in the prefix "trans-."[28] This understanding of transmediality also resonates with the concept of remediation, which Jay David Bolter and Richard Grusin define as "the representation of one medium in another."[29] They argue that "our culture conceives of each medium or constellation of media as it responds to, redeploys, competes with, and reforms other media."[30] The same can be said of the culture of Republican China, with its unprecedented variety of art forms available to artists. Moreover, the emphasis on the specific medial and material qualities

implied in a focus on transmediality highlights the explorative nature of painting practice in the Republican period.

As I will demonstrate in chapter 1, some of the essays published in *National Painting Monthly*'s "Special Issue on the Ideas of Landscape Painting in China and the West" offer textbook examples of translingual practice as defined by Lydia Liu. Simultaneously, very similar processes can be observed on a visual level in the multiple references and translations among different pictorial media—painting in ink and oil, drawing with pencils and ink brush, photography, and woodblock-printed and photomechanical reproductions. It is here that the negotiations of meaning, the interventions, inconsistencies, and creative misunderstandings become particularly visible. The "intermedial gap" created by differences in medium specificity brings into view the processes of translation, including the ruptures and inconsistencies that they generate.[31] Birgit Mersmann has emphasized the strong interconnection between translation and what she cites Nicholas Mirzoeff as calling "visual transculture." "More pronouncedly in visual translation processes than in verbal ones," she remarks, "the media(l) aspect plays an important transmissive and transformative role[,] so that with these processes, transmediation and transculturation are linked very tightly."[32]

The term "transculturation" as used by Mersmann can also be applied to some of the artistic phenomena described in the following chapters. It is, however, not unproblematic. Coined in 1940 by the Cuban sociologist Fernando Ortiz, it was reintroduced into literary studies by Ángel Rama and Mary Louise Pratt.[33] According to Pratt, transculturation describes "how subordinated or marginal groups select and invent from materials transmitted to them by a dominant or metropolitan culture. While subjugated peoples cannot readily control what the dominant culture visits upon them, they do determine to varying extents what they absorb into their own, how they use it, and what they make it mean."[34] Transculturation in this sense can be regarded as a form of cultural translation. The notion of transculturation has been successfully used to dissolve essentializing notions of distinct and pure cultures, and to highlight the constant evolution of cultures through moments of contact and processes of transmission and translation. Moreover, as Pauline Bachmann, Melanie Klein, Tomoko Mamine, and Georg Vasold remark in a summary on conceptions of the transcultural, it is used to disclose power asymmetries; as they note, an acknowledgment of transcultural dynamics "has to be combined with a questioning of the contexts and

power constellations in which such interactions took place."[35] Paying attention to colonial hierarchies and power constellations, however, also risks reinscribing and reinforcing those same constellations and asymmetries.

An examination of translingual and transmedial practice, on the other hand, emphasizes the multifaceted nature and reciprocal directionality of the processes of translation. It also avoids the traps of essentializing notions attached to the term "culture" that are still contained in the concept of the transcultural, without ignoring the asymmetric power relations that underpinned the dissemination of Euro-American systems of knowledge throughout other world regions since the nineteenth century. By studying translingual and transmedial practice from the perspective of the host language, the agency of the non-Western authors comes into focus; instead of regarding them as mere recipients of modern concepts of Euro-American origin, they can be understood as interlocutors who engage with these words and concepts by adopting them and creating new meanings. Translingual and transmedial practices also include moments of resistance and the scripting of counternarratives.

My aim is to draw attention to the self-confident attitude that many Chinese painters assumed, whether they were proponents of a translated modernism or took a revisionist position and regarded the Chinese painting tradition as endangered but ultimately superior. They all engaged in a virtual conversation with Chinese, European, and Japanese sources in a manner comparable to the strategies that Partha Mitter has described as "virtual cosmopolitanism."[36]

A perspective that focuses on transmedial practice offers a particularly strong opportunity to highlight the agency of artists working on the colonial periphery. Analyzing how artists used different media, how they referenced others, and how they reflected on these practices is helpful in de-essentializing and de-nationalizing a seemingly "national" medium such as *guohua*, as well as "imported" or "Western" media such as oil painting, pencil drawing, and photography. It shows how modern "Chinese" painting and visual culture were created as invented traditions in the sense described by Eric Hobsbawm. Hobsbawm observed that new traditions are likely to be invented "when a rapid transformation of society weakens or destroys the social patterns for which 'old' traditions had been designed, producing new ones to which they were not applicable, or when such old traditions and their institutional carriers and promulgators no longer prove sufficiently adaptable and flexible, or are otherwise eliminated."[37] This assessment fits the historical situation encountered by the artists of Republican China. In my study of modern ink painting, I therefore also wish to shed light on its situated-

ness and the contingencies affecting its reinvention as *guohua* in the specific historical moment of the Nanjing decade.

The Scope of the Book and the Main Protagonists

The earliest painting I discuss in the main chapters of this book dates from 1928 and the latest is from 1936. This relatively short span of time represents a period of intense artistic, literary, and publishing activity, and the focus on this narrow time frame also throws into relief how important the artistic output of these few years was for later conceptions of "Chinese painting" and even "Chinese land-scape."[38] The period covered coincides with the so-called Nanjing decade (1927–37), when the GMD under Jiang Jieshi (Chiang Kai-shek, 1887–1975) established a central national government in Nanjing after the Nationalist army's Northern Expedition of 1926–28, thereby ending years of unstable governments controlled by regional warlords. China experienced a period of relative political stability and unification in these years, during which the government worked toward economic modernization, international cooperation, and cultural nation-building projects. As William Kirby has phrased it, "Nanjing was the capital of a 'New China' whose aim was as much the physical as the cultural remaking of the nation."[39] The city of Nanjing itself was remade into a national capital, with broad streets and modern government buildings.[40] The infrastructure campaign launched by the Nanjing government that eventually led to the publication of *In Search of the Southeast* was part of these efforts. In fact, it can be linked to Sun Zhongshan (Sun Yat-sen, 1866–1925) and his *The International Development of China* of 1921, in which he named the construction of roads and railways as key elements in China's industrial modernization.[41]

The New Life Movement, launched by Jiang Jieshi in February 1934, also played an important part in the cultural remaking of the nation. It combined elements of fascist ideology with Confucian morality and Christianity; recent scholarship has highlighted both the complexity of the movement and its role in nation building.[42] In its first year, the New Life Movement concentrated on furthering the values of cleanliness and orderliness, but by its second year it was promoting the so-called three transformations: militarization, productiv-ization, and aestheticization (*yishuhua*). Travel was seen as a means of identi-fying with the nation's countryside and cultural heritage.[43] The Southeastern Infrastructure Tour and its related publications, although not part of the New

Life Movement, were also part of the cultural nation-building effort. The various events around the tour testify to the common goals and joint efforts of GMD leaders, state institutions, private enterprises, the Shanghai mediasphere, and the art world in shaping perceptions of the national landscape. Owing to the large number of actors involved, the tour incorporated a multitude of literary voices and visual experiments.

One catalyst for the New Life Movement was the fall of the Jiangxi Soviet in 1934. People who had for several years lived under a communist administration needed to be reeducated and persuaded of the legitimacy of Nationalist rule.[44] Another was the general militarization of society in preparation for war.[45] The GMD government's control over the territory it claimed was tenuous throughout the Nanjing decade, and contested in various regions. The Japanese invasion of Manchuria in 1931, the establishment of the puppet regime of Manchukuo in the following year, and the attacks on Shanghai in the January 28 Incident of 1932 posed constant threats to national sovereignty and finally ushered in the Second Sino-Japanese War (1937–45). The communist Jiangxi Soviet (1931–34), the Fujian Rebellion of 1933, and conflicts with regional warlords further destabilized the country.[46] As Colin Mackerras has observed, only the provinces around Nanjing, especially Jiangsu and Zhejiang, were under Jiang Jieshi's firm control; he was confronted with military and political opposition from many sides throughout the decade.[47] It was therefore not accidental that the infrastructure campaign that eventually led to the publication of *In Search of the Southeast* concentrated on the five southeastern provinces of Jiangsu, Zhejiang, Fujian, Anhui, and Jiangxi. Moreover, it was motivated not only by plans for economic development, but also by military concerns driven by the diverse threats confronting the Nationalist government.

Although the Nanjing decade provides the broader time frame for this study, the majority of the material I discuss was produced within the span of two years—1934 and 1935. Those two years saw an enormous amount of creative output in painting, writing, and photography, spurred in part by the infrastructure campaign.[48] Focusing on this short period of time allows for a detailed and dense analysis of the activities of a small but highly representative group of artists working in Shanghai during the 1930s and collaborating on various occasions. In addition, it enables me to trace their relationships and collaborations as well as their interactions with the political and the media spheres. Studying paintings, photographs, and texts, as well as the artists' involvement in various publication projects, allows me to assess what these painters thought about their

own work, how they positioned their medium in relation to other art forms, and how that affected the ways they perceived and represented landscape.

This book explores how artists defined and described their practice in the texts and images that they published between 1928 and 1936; therefore, many paintings are reproduced here from contemporary publications. One reason for using their published form is that the works' present whereabouts are, in most cases, unknown. Studying these collotype and halftone reproductions of varying quality also sheds light on the editorial selections and discursive strategies at work in the art world of Republican Shanghai. Following up on studies by Yu-jen Liu and Cheng-hua Wang on the role of reproductions in the modern conception of "art" as well as cultural heritage, my study contributes to, in Geraldine A. Johnson's words, a "visual historiography" of art history through the study of reproductions of art objects.[49]

In particular, I dedicate separate chapters to three painters who were prolific as both painters and writers, and who collaborated closely and published in the same venues: Huang Binhong, He Tianjian (1891–1977), and Yu Jianhua. As I will elaborate in more detail, they had very different backgrounds, produced very different works, and had very different later careers. A comparative study of their work thus also serves to highlight the diversity of ink painting practices in this period, despite the artists' participation in a common discourse. Through a close reading of paintings by these three artists and their colleagues, I trace how that discourse was reflected in their artwork and how they engaged with historical painting, realism, and photography. In addition to discussing their artworks, I provide an in-depth analysis of their contributions to *National Painting Monthly* and *In Search of the Southeast*. The two publications were both produced in 1934–1935, and Huang Binhong, He Tianjian, and Yu Jianhua were involved in both. Their work can thus be contextualized visually, intellectually, socially, and politically.

Since He Tianjian, Yu Jianhua, and Huang Binhong will receive special attention in the following chapters, they require a more detailed introduction.

He Tianjian was born in Wuxi, Jiangsu Province, in 1891. He started to learn painting by copying illustrations in the *Mustard Seed Garden Painting Manual, Journey to the West,* and the *Dianshizhai Pictorial.*[50] Although he began studying with a local portrait painter named Sun Yunquan at the age of nine, he later presented himself as self-taught in his autobiography. His most formative learning experience, by his own account, was copying paintings by famous masters such as Shen Zhou (1427–1509) and Wen Zhengming (1470–1559), which he borrowed

from his neighbors.[51] His higher education appears to have been episodic; after settling in Shanghai in 1916, he swiftly moved on to establish himself as a professional and financially successful painter who took pride in being able to paint in any style. Like many of his colleagues during the period (including Huang Binhong and Yu Jianhua), He Tianjian held various part-time teaching positions at several art schools, including the Shanghai Art School (Shanghai meishu zhuanke xuexiao) and the Changming Art School (Changming yishu zhuanke xuexiao). More important, he became a member of several painting societies, and eventually cofounded the Bee Society (Mifeng huashe) and its successor, the Chinese Painting Association. Closely linked to his role as an administrator in these societies, he also worked as an editor for several art journals, including the *Bee Pictorial* (*Mifeng huabao*), *Painting Studies Monthly* (*Huaxue yuekan*), and *National Painting Monthly*.

He Tianjian's paintings from the period testify to his stylistic breadth. He engaged eclectically with the modes of numerous painters, from the Five Dynasties to the Qing period, blending them into an individual style that self-consciously exhibits its foundations in ancient painting and thus in most cases appears rather conservative. His motifs range from "true mountains and true waters" to ideal landscapes that can appear fantastic and dreamlike. He neither fit the narratives of modernization and reform in Chinese painting nor had the seniority and the credentials to become one of the "great masters" of twentieth-century *guohua*. Moreover, he managed to keep a low political profile after 1949 and continued to paint topographical landscapes, though in a slightly more realistic and less style-conscious mode, dressing his figures in socialist garb. He therefore does not figure in studies of post-1949 art in China, which tend to focus on the impact of politics on art. Although his importance in the prewar Shanghai art world has been recently reassessed by Yi Gu and Pedith Chan with regard to his role in the art societies, his work as an editor, and his writings for *National Painting Monthly* and *In Search of the Southeast*, his engagement with the canonical modes of historical painters, and his revision of that canon by measuring it against "true" landscapes and modern artistic concepts, has not been studied.[52] Nevertheless, He's translation of the classical canon into a modern framework is representative of the invention of "Chinese" painting during the Republican period. Investigating this process is therefore important for forming a more nuanced understanding of modern ink painting.

Yu Jianhua, like He Tianjian, has only recently received scholarly attention for his role in the Shanghai art world of the 1920s and 1930s as a promoter of *guohua*

xiesheng, or Chinese-style outdoor sketching.[53] Today he is mainly known as one of the founding fathers of modern art history in China, and as the editor of such widely used handbooks as *Ancient Painting Theories According to Genre* (*Zhongguo gudai hualun leibian*, 1959, reprinted in 1998) and *Comprehensive Dictionary of Chinese Painters' Names* (*Zhongguo huajia renming da cidian*, 1934, reprinted in 1981 under the title *Zhongguo meishujia renming cidian*).[54] Yu and He worked on related publication projects and moved in the same circles, but they had very different educational backgrounds, and their paintings differ accordingly. Yu, a native of Ji'nan in Shandong Province, studied from 1915 to 1918 in the three-year "crafts and painting" (*shougong tuhua*) program at Beijing Advanced Normal School (Beijing gaodeng shifan xuexiao), which included classes in ink as well as Western-style painting, technical drawing (*yongqihua*), and design (*tu'an*). After graduating, his first teaching positions were in drawing and watercolors, technical drawing, and design. He privately studied ink painting with Chen Shizeng (1876–1923), who had been one of his professors at the Beijing Advanced Normal School, until Chen's premature death in 1923.[55]

Beginning in 1919, Yu Jianhua went on multiple sketching tours and published related travelogues in newspapers and journals. It seems that his early landscape sketches, painted from nature, were executed with pencil and watercolor, not with a Chinese brush and ink. After moving to Shanghai in 1927, he began to socialize in the circles of *guohua* painters and established himself in that field. His watercolors are not published in the catalogues dedicated to him, and he seems to have successfully evaded that earlier profile. Many of his ink paintings, however, contain elements that betray his training in "Western-style" painting: he used strong shading, linear perspective, and rich and subtle coloration. They are not particularly varied in terms of style, and their uniformity may explain why he is better known as an art historian than as a painter.

In his preface to the *Collected Paintings of Yu Jianhua*, Xie Haiyan describes Yu as a tireless and extremely prolific worker.[56] This observation is verified by the material studied in this book, which confirms that Yu attempted an exhaustive visual and verbal documentation of almost every place he encountered. His paintings and writings from the 1930s serve as an important case study in the context of this inquiry, first, because we can see in his works the tensions between modes of visual representation derived from the European and the Chinese pictorial traditions, and second, because he generously and eloquently shared his observations and the problems he encountered with his readers and viewers.

Unlike He Tianjian and Yu Jianhua, Huang Binhong has always been within

focus of art-historical research. He is firmly canonized as one of the "masters" of twentieth-century ink painting and is appraised in almost every publication dealing with modern Chinese art. Huang has received scholarly attention to an extent that is unprecedented for any twentieth-century Chinese painter except perhaps Zhang Daqian (1899–1983). Besides countless Chinese-language essays, books, and catalogues, the Anglophone scholarship on his work includes three dissertations, two monographs, and numerous articles.[57] At least two factors contribute to the crucial role that Huang plays in the historiography of twentieth-century Chinese art. First, his paintings are technically and theoretically grounded in classical painting while they also show strong abstract qualities that resonate with modernism; his late works, in particular, are therefore appealing to both conservative and modernist viewers alike. Second, Huang Binhong was not only a painter but also a journalist, editor, art historian, educator, art dealer, and collector who moved in various interconnected social and intellectual circles; he had a long and multifaceted career that has yet to be fully explored.

Huang Binhong was born in 1865 in Jinhua, Zhejiang Province, where his father was a merchant. However, he strongly identified with his family's ancestral home in the village of Tandu in Shexian (She County), Anhui Province, in the vicinity of Mount Huang, a mountain famous for its scenic beauty. He adopted the name Binhong as a reference to the Binhongting (the Pavilion of the Rainbow at the Water's Edge) in Tandu, and he referred to Mount Huang in several of his painting signatures and seals. Little is known about the first decades of his life, when he seems to have been mainly occupied with his family's business. In 1909 he relocated to Shanghai, where he soon started his career as an editor at some of the most influential publishing enterprises of early twentieth-century China, beginning with publications linked to the National Essence Movement, the *Journal of National Essence Studies* (*Guocui xuebao*) and the series *National Glories of Cathay* (*Shenzhou guoguang ji*).[58] He worked as an editor or contributor for numerous other journals and served on the editorial boards of both *National Painting Monthly* and *In Search of the Southeast*. He was also a member of several artist societies, including, of course, the Bee Society and the Chinese Painting Association. For his role in Shanghai's cultural circles, his pedigree as a scholar was as important as his work as a painter. Another notable factor that distinguished him was his seniority: Huang Binhong was about thirty years older than the other artists at the center of the Shanghai art world in the 1930s.

These three painters, He Tianjian, a versatile and commercially successful artist who attempted to translate modes of classical painting into a modern

idiom; Yu Jianhua, an artist trained in "Western-style" drawing and painting who shifted to ink painting; and Huang Binhong, a scholar-cum-painter who created a modern version of literati painting, are exemplars of the variety of stylistic and ideological approaches taken by artists working in the medium of *guohua*. Both *National Painting Monthly* and *In Search of the Southeast* were important catalysts for the theoretical and visual formation of modern ink painting, and He Tianjian, Yu Jianhua, and Huang Binhong played decisive roles in that process.

Outline of the Book

Chapter 1 discusses how *guohua* painters in the 1930s positioned themselves and their medium at large. I examine not only how authors from different artistic backgrounds wrote about Chinese ink painting but also how they revised the narratives of European art history to fit their own discursive demands. The majority of the chapter focuses on the most influential art publication of the period, *National Painting Monthly*, looking at how the editors defined Chinese painting and the role they envisioned for contemporary *guohua* in what they perceived as the struggle for the survival of Chinese culture. In analyzing selected contributions to the journal's "Special Issue on the Ideas of Landscape Painting in China and the West" as translingual practice, I foreground the situatedness of twentieth-century *guohua* in the varied field of transnational modernities. I also discuss the rhetorical strategies underlying the choice of illustrations for those texts; as I propose, the unevenness of translation becomes apparent the moment an image is remediated through reproduction. Reproduction is also a central concern in the second line of inquiry in this chapter. Following a discussion of the illustrations of contemporary painters' works (artists who were, in fact, the journal's contributors) in the final issue of *National Painting Monthly*, I offer a study of three catalogues of Republican paintings that were published as members' catalogues for the Chinese Painting Association and its predecessor, the Bee Society. In analyzing the paintings as well as the structure of the books, I read them as forming a discourse that parallels and complements the artists' writings, allowing for a more differentiated picture of ink painting and ink painters' organizations than can be gleaned from the texts alone.

He Tianjian was one of the most prolific and ideologically outspoken contributors to *National Painting Monthly*, and for its final numbers he was its sole chief editor. Chapter 2 is dedicated to his works from the late 1920s to the mid-1930s.

I discuss He's paintings against the background of his writings, working on the assumption that he made his artworks based on his own published advice to his readers, and that they perhaps even served as guiding principles for his advice. He proposed that artists should be trained according to the following guidelines: they should first copy from the old masters to learn the techniques of Chinese painting, then make excursions to famous mountains and rivers to ground those artistic techniques in observation and sketching from nature; as a final step, they should combine both approaches to find their own style and create individual paintings. I take these rules as a point of departure from which to discuss He's own painting practice, analyzing how he adapted the topography of places to the conventionalized modes of brushwork, and how those were, in turn, reinterpreted for the representation of a specific place.

For He, it was the natural landscape that served to verify the painting conventions. In other words, he did not measure the successful use of painting techniques against the topography of a given site, but the other way around. He used the names of various texture strokes as technical terms to describe the physical makeup of given formations in the landscape, an approach that effectively dehistoricized and also disassociated them from specific painting genealogies. They thus represented the plurality of what made up "Chinese painting" and were perceived as representing a timeless stylistic reservoir from which the Chinese painter could freely pick and choose. The framework of "Chineseness" therefore outweighed any stylistic, genealogical, or social differentiation.

One journey was of crucial importance for He's (transmedial) painting practice and his theoretical reflections: the journey he made in the context of the Southeastern Infrastructure Tour, which he documented in an essay, numerous poems, and in one painting that he contributed to the volume *In Search of the Southeast*, the subject of chapter 3. *In Search of the Southeast* presented its readers with a visual and narrative journey through the landscape of the southeast that would prove to be groundbreaking and highly influential in the visual arts. As mentioned, the book was published in March 1935 in conjunction with the Southeastern Infrastructure Tour. More than one hundred writers, photographers, and painters were invited to travel along designated routes and record their impressions. An exhibition was organized that solicited submissions in the categories of *guohua*, Western painting (oils and watercolors), photography, and literature, some of which were included in the book. With texts and images produced in this context, *In Search of the Southeast* is a combination of transportation survey, travel guide, poetry anthology, and art book, and in its pages

the negotiations of spatial concepts and transmedial practice surface in a highly condensed way. The poems, travelogues, and images are arranged in a sequence that suggests forward movement experienced through multiple voices and viewpoints. The major portion of chapter 3 focuses on a section in the volume dedicated to the then newly opened Zhejiang-Jiangxi Railway (Zhe-Gan tielu). I explore the visual and textual strategies photographers, writers, and editors employed to bring the scenic sites of the heretofore remote border regions between Zhejiang and Jiangxi to the attention of potential travelers. However, as I show in analyzing a travelogue by the modernist writer Yu Dafu (1896–1945) and a related photograph, editorial strategies in the volume also worked to erase the presence of military conflict and the role of the railway in its suppression, a function that was crucial to its construction in the first place.

In Search of the Southeast became the model for a series of manuscript and illustrated travelogues that Yu Jianhua produced in 1935 and 1936, and these are discussed in chapter 4. Yu's goal was, I argue, to show that *guohua* was better suited than photography to comprehensively documenting the landscapes of China and their national characteristics. As noted, Yu Jianhua was a prolific writer of travelogues and a proponent of outdoor sketching. Trained in both Western-style watercolors and ink painting, he reflected on the advantages and disadvantages of both techniques for sketching from nature; in his writings and paintings, translingual and transmedial practice can be seen in the making. Yu had strong sensibilities concerning publication formats and layout. For his travelogues of 1935 and 1936, he not only followed the routes of the Southeastern Infrastructure Tour but also adapted some of *In Search of the Southeast*'s editorial strategies and entered into a competitive dialogue with its (photographic) illustrations. Yu's direct references to a photographic visuality in ink paintings, both critical and affirmative, effectively changed how landscape was imagined and represented. In this regard, Yu Jianhua's works are exemplary of many contemporary landscape paintings.

How images of the Chinese landscape were reshaped through the medium of photography can be most clearly observed in the changing representations of Mount Huang, the topic of chapter 5. Mount Huang had long been a destination for travelers seeking to experience an aesthetic appreciation of landscape in imperial China, with visitor numbers peaking in the seventeenth century. Despite its prominence, the premodern infrastructure that facilitated visitors' access to the mountain had fallen into neglect by the early 1930s. The development of modern tourism on Mount Huang began in 1934 with the Southeastern

Infrastructure Tour, but the ensuing development and publicity campaign quickly outgrew the scope of the tour and the publication *In Search of the Southeast*. The destination's popularity initiated the publication of a separate book and a large traveling exhibition that received ample media coverage.

Visual and textual evidence reveal that by the mid-1930s, photography had become the medium that defined the discourses and practices of Huangshan imagery. As photographers strove to conform to what they perceived as "Chinese" pictorial aesthetics, they also came to redefine the qualities and characteristics of those aesthetics according to the properties and possibilities of their medium. Over the course of a few years, Mount Huang not only became the "standard mountain" of China, as it was termed in *In Search of the Southeast*, but also the standard Chinese landscape for painters as well as photographers. One important key to its popularity as a pictorial motif was that it allowed artists to bridge the differences in representational possibilities between the two media. *Guohua* artists responded to the visual models provided by travel photography in different ways, but their responses had fundamental implications for a wider understanding of "Chinese" pictorial aesthetics. Even conservative painters, such as Huang Binhong, occasionally adopted modes of vision or composition linked to photography.

Until recently Huang Binhong's paintings have been discussed mainly with regard to his brushwork and use of ink, and his references to earlier masters. Beyond their stylistic and theoretical references, Huang's works have only rarely been analyzed for the sources of their formal and iconographic solutions. Moreover, while his paintings from the 1940s and 1950s are well studied and much published, very little research has been undertaken on his earlier paintings. While it is true that Huang's theoretical writings of the 1930s address brush and ink methods and issues of canon formation first and foremost, a significant portion of his work from this period relates to the places he visited during his extensive travels between Shanghai, Hangzhou and the Mount Huang region, Sichuan, and Guangxi. In chapter 6, I undertake the first in-depth investigation of the travel- and place-related paintings and sketches that Huang Binhong produced between 1928 and 1936. My purpose in this chapter is twofold. The first is to study Huang's use of different media to produce and frame pictures (ink, pencil, colored pencil, woodblock printing, collotype, and photolithographic printing), as well as the different sources on which his images are based. Although most of his sketches are catalogued as *xieshenggao*, or sketches from nature, not all of his toponymic drawings were actually drawn in situ, and some

even depict places that Huang never actually visited. Moreover, the locations described in painting inscriptions cannot always be easily identified in the paintings themselves. Therefore, I examine the textual and visual sources that Huang referenced in his paintings, the relations between texts and images, and how pictures in different formats and media relate to one another.

My second aim is to address the discrepancy between Huang Binhong's intense engagement with places and the fact that he does not address such issues in his theoretical writings, which are concerned with the formal means of ink painting. A similar conundrum is posed by the fact that his stylistic references to earlier artists in his paintings cannot be identified as readily as one might infer from the inscriptions on the same works. As in the case of his toponymic paintings, many of which appear to be topographically unspecific, artistic models referenced in Huang's inscriptions are not necessarily cited in the brushwork. Rather, in his writings and paintings Huang adopted an idiosyncratic reinterpretation of brushwork and ink methods, especially in works he created after 1940. I trace the origins of this reinterpretation to two sources in his work from the 1930s: his place-related paintings and the different media and materials that they encompassed, and his theoretical writings, which I again analyze as translingual practice.

The Second Sino-Japanese War ended the period of intense artistic, literary, and publication activity as well as the nation building covered in these chapters. As institutions were disbanded, relocated, and reorganized across the fragmented territory of war-torn China, artists had to adapt to the dramatically altered situation, often in different places and circumstances. However, their engagement with the natural landscapes of China and the canon of historical Chinese painting, as well as with translated sources and their transmedial experiments, continued to inform their artistic work. This was true even after the establishment of the People's Republic in 1949, when nation building was redefined as the building of socialism and, instead of worrying about the survival of Chinese painting in the global competition among national cultures, artists struggled to make their medium "serve the people." Paintings of "true mountains and true waters" and the transmedial practices that drove artistic innovation during the Nanjing decade now helped landscape painters respond to the new exigencies of the state: in portraying the socialist motherland, their genre was given a new raison d'être.

國畫月刊 葉恭綽

山水畫思想專號

中國畫會月刊社出版　　第四期　　一卷

Fig. 1.1. Cover of *National Painting Monthly* (*Guohua yuekan*) 1, no. 4 (1935); title calligraphy by Ye Gongchuo. Harvard-Yenching Library of the Harvard College Library, Harvard University. Photo: Harvard Imaging Services.

Positioning Chinese Painting in
National Painting Monthly

National Painting Monthly was founded in 1934 as the journal of the Chinese Painting Association (fig. 1.1). The journal ran for a total of twelve issues, from its first issue in November 1934 until its discontinuation in August 1935, owing to a lack of funding and organizational backing.[1] It was briefly revived in 1936 under the title *National Painting (Guohua)*, and another six issues were published. Despite the precarious situation that led to its early discontinuation, *National Painting Monthly* was a highly ambitious project that involved some of the leading artists of the Shanghai art world. The editors' stated aim was to promote norms for painting in the hope of improving work styles. To reach that goal, they believed it was necessary to first recognize the problems in current practices; the journal would therefore strive to reproduce ancient and modern paintings that could serve as models, together with texts that expounded on the "spirit of norms."[2]

The journal's ideological mission was closely linked to that of its mother organization, the Chinese Painting Association. The association was initiated by the politician, calligrapher, and collector Ye Gongchuo (1881–1968) and was founded in 1932 by several prominent *guohua* artists working in Shanghai.[3] It was the immediate successor of the Bee Society, founded in 1929, but unlike that earlier organization, it was registered with the government as a professional association and was thus more political in its outlook and work.[4] The new association published its mission statement in the last issue of the Bee Society's journal, the *Bee Pictorial*. Drafted by the art critic Lu Danlin (1896–1972) and titled "*Guohua* Artists Must Unite," the statement addressed several issues that would become recurrent themes in *National Painting Monthly*.[5]

Beginning with the declaration that "In the current situation of comparison between the cultures of the world, there is nothing that fails to give us a feeling of indignation and shame," Lu expressed his deep sense of national weakness and disadvantage in comparison with countries in Europe and America, and with Japan, which, he wrote, "presents itself to the world as the patriarch of Oriental art." Governmental institutions were unable to sufficiently promote the nation's art because of China's political unrest and constant wars, while in society, he complained, "material power surpasses everything else." It was therefore the responsibility of artists themselves to save Chinese culture from its state of decline. To serve that purpose, the Chinese Painting Association had three main goals: "(1) to develop the age-old art of our nation; (2) to publicize it abroad and raise our international artistic stature; (3) with a spirit of mutual assistance on the part of the artists, to plan for a [financially] secure system."[6]

The publication of *National Painting Monthly* addressed the first two goals. It featured contributions on painting history, theory, and art education. The texts were for the most part written by members of the Chinese Painting Association, who were active as painters themselves. This was especially true for the journal's editorial board, which consisted of some of the most renowned and theoretically minded painters of the time, including Huang Binhong, He Tianjian, Yu Jianhua, and Zheng Wuchang (1894–1952). Several members of the board also took on administrative positions within the association: Huang served on the advisory committee, and He and Zheng on the executive committee. In addition, He Tianjian was one of three members of the standing committee.[7] From the journal's third issue, He and Xie Haiyan were identified as editors in chief; after Xie announced his resignation in issue number 7, He remained alone in the position.[8] Not only was He Tianjian the most prolific contributor to the journal, together with Zheng Wuchang and Xie Haiyan, he was also very outspoken in promoting its political goals, often in a passionate and polemical tone.

In this chapter, I discuss how the editors defined the role of Chinese painting in the pages of *National Painting Monthly* and analyze the role they envisioned for contemporary *guohua*, and for the Chinese Painting Association, in what they perceived as a struggle for the survival of Chinese culture. They subscribed to social Darwinist thinking, or at least rhetoric, while at the same time adhering to the inherited practices and theories of Chinese painting as timeless truths. This paradox underlies many of the articles published in *National Painting Monthly*; it is particularly prominent in the "Special Issue on the Ideas of Landscape Painting in China and the West." In my discussion I

focus on how authors from different artistic backgrounds reimagined Chinese and European painting histories in order to legitimize the former as equivalent or even superior to the latter; I also examine the visual strategies of the illustrations in the special issue. While the editors set out to define painting "on China's own terms" (*Zhongguo benwei*), their endeavor involved a multifaceted translation of European terms and a repositioning of Chinese painting in the modern, interconnected world, as well as in an artistic practice that was much less conservative than it claimed to be.

The Responsibilities of the Artist

In a long article in the first issue of *National Painting Monthly*, He Tianjian outlined the tasks of the Chinese Painting Association.[9] He began with the pessimistic statement, repeated in several other articles, that modern Chinese painting did not reach the technical and theoretical level achieved by the painters of the Song and Yuan (1279–1368) dynasties, nor even of the Qianlong (1736–95) and Jiaqing periods (1796–1820) of the Qing. Some painters were comfortably settled and did not feel the need to contribute to the advancement of art; others were busy making a living, catering to popular tastes, and thus compromising the quality of their art. This, according to He, was what made the social mission of the Chinese Painting Association relevant. Since He saw social security as the necessary precondition of good art, he envisioned the association providing an infrastructure for artists that would include communal housing with integrated exhibition space, loan agencies and bank accounts, libraries, shared studios, art academies for the younger generations, and public exhibition halls.[10] Similar to Lu Danlin, in the mission statement he wrote three years earlier, He refers to the government's inability to promote national culture because of its military, political, and economic problems. He stated that it was therefore the responsibility of the artists themselves to bring about a renaissance of Chinese culture, and that the Chinese Painting Association was the only organization that was able to take on that responsibility.

Of particular interest here is the fact that, in the remainder of the article, He argues in an evolutionist vein. Countering a purported accusation that the Chinese Painting Association was trying to take control of artistic creation, he wrote that although most of humanity's abilities were acquired "a posteriori (through education)" (*houtian* [*jiaoyu*] 後天 [教育]), the portion gained "a priori (through inheritance and talent)" (*xiantian* [*yichuan ji tianfu*] 先天 [遺傳

及天賦]) was not to be underestimated; thus the association could not possibly have the power to exert such control. Nevertheless, He Tianjian envisioned the association's role as crucial for the improvement of Chinese painting and the advancement of national culture. According to He, every movement is a product of its own time and society and is influenced by the competition of nations. This point is his key argument for the importance of art, and thus for the association's role in Chinese culture: none of the civilized nations were eliminated in the course of evolution, he states, because the expressions of their national spirit remained undestroyed. Since national survival depended more on the preservation of cultural heritage, as He proposes, than on military force, the salvation of Chinese painting became a question of utmost national urgency.

When writing about the importance of theory for the practice of painting, He Tianjian employs a biological metaphor to describe their relationship: while theory is like the germ within the seed, practice resembles the state after the sprout has come out of the hull. How might one imagine, therefore, the fruition of painting practice without the potentiality of theory? The terms that he uses for his metaphor—"potentiality" (*chuneng* 儲能) and "fruition" (*xiaoshi* 效實)—are directly derived from the 1895 translation by Yan Fu (1854–1921) of Thomas Huxley's *On Evolution and Ethics* into classical Chinese under the title *Tianyan lun (On evolution)*.[11]

The rhetoric of evolutionism and survival, if not of the fittest then of the most civilized, had been part of the underlying political and cultural discourse in China since the late nineteenth century.[12] By the mid-1930s, the Nanjing government was trying to establish cultural and educational institutions on a national level and thus it provided a master narrative for a cultural revival. At the same time, the Japanese invasion of Manchuria, the Nationalists' ongoing warfare with communists and warlords, and an economic crisis gave the issue of national survival a renewed urgency. He Tianjian's ambitious plans for the Chinese Painting Association's sociopolitical activities and his thinking about Chinese painting in comparative, if not competitive, terms in relation to the art of other countries are characteristic of this predicament.

In seeming contrast to the notion of evolution and progress, painting of the Song and Yuan dynasties is repeatedly referred to as the ultimate standard for Chinese painting, one that had to be regained. The most outspoken case for Song and Yuan painting as the solution to the perceived deficiencies of modern ink painting is posited in a short text published under the pseudonym "Correct Practice" (Zhengfeng), titled "The Demons of Today's Painting Practice." It

identifies the demons as artificiality, vulgarity, superficiality, slackness, rudeness, stiffness, weakness, meanness, shallowness, and turbidity; the only way to overcome them, according to Correct Practice, is to promote the methods of the Song and Yuan masters.[13]

The call for a return to the models of Song painting, much like evolutionist rhetoric, had been virulent in discourses on Chinese painting since the 1910s and was at that time equally informed by the notion of competition among nations. Comparing Chinese painting with European painting, and with works by the Italian Renaissance painter Raphael in particular, Kang Youwei stated in 1917 that Chinese painting during the Tang and Song dynasties was the best in the world, but it had gradually fallen into decline since the Yuan period.[14] The next year, his protégé Xu Beihong (1895–1953), in two lectures given to the Peking University Painting Research Association, similarly asserted that "the high point of Chinese painting development had been reached during the Song dynasty."[15] Also in 1918, Chen Duxiu, in an often-cited statement in an article titled "Revolution in Art," called on artists to discard the art of Wang Hui (1632–1717), which was representative of the orthodox style of seventeenth-century literati painting, and return to the "realism" of Song painting.[16] Moreover, as I discuss in more detail in chapter 4, by the early 1920s *guohua* painters such as Hu Peiheng (1892–1962) were claiming that landscape painting of the Tang and Song periods had actually been based on *xiesheng*, or sketching from nature.[17]

This invention of an indigenous history of realism and sketching from nature was an attempt to find a Chinese source for what was at that time regarded as the hallmark of modern painting and a potent remedy for the main deficiency identified in literati painting: the absence of a foundation in visual observation. Cheng-hua Wang has pointed out that the early twentieth-century discourse that claimed Song dynasty painting as the paragon of Chinese painting and the Yuan dynasty as a transformative period that ultimately led to decline was derived from the Song-Yuan dichotomy that was first conceptualized in the late Ming dynasty (1368–1644). In this dichotomy, Song painting stood for *xieshi* 寫實, "depicting the substance," while Yuan painting was associated with *xieyi* 寫意, or "expressing the idea." In the early twentieth century, *xieshi* became synonymous with "realist," while *xieyi* was identified by reformers such as Kang Youwei, Xu Beihong, and Chen Duxiu as the source of literati painting's flaws.[18]

The search for progress in Chinese painting of the distant past thus already had an established history of almost two decades when the first issue of *National*

Painting Monthly appeared in November 1934. But unlike Kang Youwei, Xu Beihong, or Chen Duxiu, who discerned in Song painting a way to reform Chinese painting by making it compatible with European-style realism, the editors of *National Painting Monthly* addressed a readership that identified more unequivocally with the tradition of Chinese ink painting, and they repeatedly criticized the adoption of "Western" techniques in *guohua*. For example, in an article titled "The Responsibility of Modern Chinese Painters," Zheng Wuchang lamented the selling out of China's artistic heritage to Japan, and the fact that art students preferred to specialize in Western painting instead of *guohua*. Zheng called on his fellow painters to take responsibility and strive for the preservation of China's heritage for future generations. Apparently, this implied not only studying historical artworks (Zheng himself was the author of two art-historical books) but also painting in a more purely Chinese manner.[19]

This perspective was also expressed in repeated invocations of Song *and* Yuan painting as remedies for current artistic shortcomings. What Cheng-hua Wang has termed the Song-Yuan dichotomy in the art discourses of the 1910s became a Song-Yuan binarism in *National Painting Monthly*, with deeper implications for how the editors envisioned an improved practice of *guohua*. The grouping of Song and Yuan painting as a conceptual unit possibly originated in Japanese art-historical writing, for instance by Ōmura Seigai (1868–1927), that was based on an understanding of "Song and Yuan influences . . . as the main source for Japanese ink painting."[20]

The objectives and implications of the Chinese artists' use of the Song-Yuan binarism were quite different, however. Another essay by He Tianjian, "Why Landscape Painting Is the Primary Painting Genre in China," exemplifies the argumentation.[21] The text is replete with quotations from a broad range of historical treatises on painting dating from the fifth to the seventeenth centuries, with some cited in their full length.[22] While He Tianjian inserted text-critical comments at several points, he in fact treated the cited texts in an ahistorical manner, taking their main concepts as given. He used them as evidence for his case—namely, that landscape had been the most prestigious genre in Chinese painting ever since it became an independent subject, and that it continued as such in his own time.

His discussion of landscape's importance takes the reader through various key concepts in Chinese painting theory. He Tianjian begins by arguing that, for Chinese painters, inner cultivation was more important than mimetic representation. Positing that external form is only the result of the movement of inner

life (*neizai shengming* 內在生命), which he equates with inner cultivation (*neixiu* 內修), he proposes that the painter's character is visible within the One Brushstroke (*yihua* 一畫). This in turn, according to He, is the origin of the concept of *qiyun* 氣韻, or "spirit resonance." He links the One Brushstroke, the main concept in the treatise *Discourses on Painting by the Monk Bittermelon* (*Kugua heshang huayulu*) by Shitao (1642–1707), with the first and most authoritative of the Six Laws of Painting laid down by Xie He in the fifth century: *qiyun shengdong*, "spirit resonance, which means vitality."[23] And in linking *qiyun* to inner cultivation as opposed to mimetic representation, He Tianjian implies the former's primacy over the latter. Paraphrasing the *Book of Changes*, or *Yijing*, He states that "the doctrine of what is above form is called the Dao; the doctrine of what is within form is called the tool," and concludes that the Dao is more important than technique (*jifa* 技法).[24] This rather circular argumentation resulted in the equation of inner life/inner cultivation, *qiyun*, and the Dao, as opposed to outer form, technique, and the tools. Finally, He added another concept from literati painting theory to the equation, that of *yi* 意, commonly translated as "idea" or "concept." He defined *yi* as "what in psychology is called 'imagination' [*jiaxiang* 假象]," and stressed again that expressing *yi* necessitated a high degree of inner cultivation.[25]

To sum up, what He Tianjian proposes is the classical literati argument, famously phrased by Su Shi (1037–1101), that the expression of a painter's cultivation in a brushstroke is more important for a painting's quality than formal resemblance or representational techniques.[26] What he leaves unmentioned in his equation is what might be the opposite term to *yi*. As noted, the opposite of *xieyi* in early twentieth-century discourse would be *xieshi*—in other words, realism. It is this void, created by the omission of realism, that lies at the center of He's argument. In the second part of his essay, he introduces realism under the guise of "form-likeness" (*xingsi* 形似) in a quotation from Zhang Yanyuan's *Notes on Famous Paintings from All Dynasties* (*Lidai minghua ji*) from 847, which states that painting may disregard form-likeness but not *qiyun*.[27] Thus, He concludes, painting is not about the representation of "landscape (the natural object)" (*shanshui* [*ziran duixiang*] 山水 [自然對象]), but about its transformation (*bian* 變) through brushwork.[28]

Throughout He Tianjian's article, he equates the core terms of premodern Chinese painting theory with modern concepts, thereby translating them into a new conceptual framework. This modern framework, however, is simultaneously explained in terms of classical Chinese painting texts. It is therefore

impossible to determine which of these conceptual frameworks supersedes the other. The text oscillates between both and effectively blends them, for example when He annotates "landscape" as "natural object." He once again employs the evolutionist terms "potentiality" (*chuneng*) and "fruition" (*xiaoshi*), which he had used in his article on the Chinese Painting Association to describe the relation of theory and practice.[29] In short, He Tianjian interprets Chinese painting practice and its large body of theory using modern artistic concepts introduced from Europe, such as "imagination" (*jiaxiang*), "genius" (*tiancai* 天才), and "art" (*yishu* 藝術), and vice versa. However, he does not include realism or *xieshi* as a tool to solve perceived problems in contemporary painting practice; on the contrary, He stops short of an outright rejection of form-likeness and mimetic realism and instead affirms the superiority of the abstract categories of inner cultivation, spirit resonance, the Dao, *xieyi*, and imagination.

He's essay is thus an exercise in translingual practice. Using this rhetorical strategy, He Tianjian inserts Chinese art, both historical and modern, into a global discursive field that was dominated by Euro-American concepts, with the goal of putting *guohua* discourse on an equal footing with other artistic forms, and with realism. But in many cases the modern vocabulary appears to have been emptied of its original meaning in the process of translation. For example, although He was apparently very fond of the terms "potentiality" and "fruition" and their metaphoric possibilities, his text is far from a progressive narrative on the evolution of Chinese painting. Instead, *shanshuihua* and its theoretical foundations emerge as timeless truths. This contemporaneity of the tradition also implies that the canon of the past is not detached from the present but can be reinterpreted and remodeled.

The "Special Issue on the Ideas of Landscape Painting in China and the West"

With the special issue, in which He's essay appeared, the editors of *National Painting Monthly* set out to position modern *guohua* in the global arena, on "China's own terms" (*Zhongguo benwei*), and thereby contribute to the "renaissance of the art of our nation."[30] Although the editorials in *National Painting Monthly* generally had a decidedly ideological ring and were marked by a rhetoric of cultural survival and the related quest for an uncompromised "Chinese"

way of painting, the special issue is actually quite pluralistic and diverse. The authors included *guohua* painters as well as modernist artists and critics; many who wrote for the special issue were members of the Chinese Painting Association and frequent contributors to *National Painting Monthly*. The issue included articles by the editors and *guohua* painters He Tianjian, Xie Haiyan, Zheng Wuchang, Yu Jianhua, and Huang Binhong. Other authors were trained in oil painting; Ni Yide (1901–70) was a leading member of the modernist art group Storm Society (Juelan she), with which critic Li Baoquan was loosely associated. Chen Baoyi (1893–1945), who like Ni Yide had spent some years studying in Japan, was one of the founders of the Shanghai Art School and was also active in modernist art circles. The French-trained essayist Sun Fuxi (1898–1962), a professor at the National Hangzhou Art School, and critic Chen Yingmei (d. 1982) also specialized in "Western painting."

These differences among the authors in their chosen artistic medium and training clearly influenced the approaches taken in their respective contributions. As Li Weiming has remarked, the *guohua* artists who were the editors responsible for the journal commonly held a rather pessimistic and defensive view of the future of Chinese painting while nonetheless claiming a superior position for this tradition. The painters and critics with modernist inclinations, on the other hand, were less troubled by such issues of legitimization.[31] Their accounts, for the most part, followed an established narrative of European art history from Leonardo da Vinci (1452–1519) through to the post-impressionists and the fauves. However, although distinct differences do exist among the authors' attitudes toward Chinese and European painting, they should not be assigned to opposing camps. Therefore I will outline a more complex picture of the proclaimed traditionalism of the *guohua* painters and their interactions with more modernist-oriented colleagues.

The title "Special Issue on the Ideas of Landscape Painting in China and the West" points to a conspicuous imbalance in the journal's comparison of the art of a single country versus an entire cultural hemisphere. Japanese art, in contrast, is mentioned only in passing, in terms of the impact of Japanese and Chinese art on European painting in the nineteenth century.[32] Japanese expertise on Chinese painting plays a more decisive role; one of the contributions by Xie Haiyan is in fact based on a text by the Japanese scholar Matsushima Shūe (1871–1935).[33] More important, many of the illustrations were actually reproduced from Japanese publications, and most of those paintings were in Japanese collections. Moreover, the Japanese invasion of Manchuria in 1931 and the attack on

Shanghai in 1932 underpinned the pervasive feeling of national crisis that gave birth to the *National Painting Monthly* special issue. Japanese art, scholarship, publications, and, most of all, imperialism therefore formed a muted presence behind the essays.

The special issue was announced in the monthly's third number, by editor in chief Xie Haiyan, as part of a planned series of special issues on various topics (the series was never realized).[34] The choice of topic for this double issue sprang from the feeling of crisis that also permeated the articles I have discussed. Xie declared that despite landscape painting's long history in China, it had fallen into decay. In his view, painters either copied old masters without transforming them, without reflecting the current Zeitgeist or creating anything new, or they strove for novelty, painting either bizarre pictures with no foundation in reality or paintings that were completely Westernized and oblivious to the national spirit of art. What was needed, according to Xie, was a "new Chinese painter" (*xin Zhongguo huajia*) who could express the spirit of the times as well as national characteristics. The future of China's cultural renaissance depended on it. The main objectives of the special issue were therefore twofold, wrote Xie:

> (1) to introduce knowledge of Western painting and broaden [the reader's] intellectual horizons, in order to recognize oneself, and to recognize the other, to analyze the respective advantages and shortcomings, and to realize which aspects should be preserved and which should be discarded; (2) to compare the quality of Chinese and Western art, clarify the reasons for their respective rise and decline, to take [those reasons] as a warning, and to strive diligently for the renaissance of the art of our nation.[35]

Zheng Wuchang followed up on this perspective in his introduction to the special issue.[36] Referring to a document titled "Manifesto for the Construction of a Culture on China's Own Terms," published in January 1935 by ten professors around the historian He Bingsong (1890–1946), Zheng wrote that their text expressed the common goal of all Chinese people, namely, to create the culture of a new China.[37] The manifesto expressed a sense of deep cultural crisis in the signers' diagnosis: "[in] the field of culture, China has disappeared. . . . Because in today's world there is no China, there are seemingly no more Chinese on Chinese soil."[38] As a remedy against the disappearance of a vital Chinese culture that was part of the modern world, the authors proposed "not to hold on to the

old, not to blindly follow [foreign models], and according to China's own position, critically and scientifically examine the past, grasp the present, and create the future."[39]

Zheng Wuchang introduced the special issue as part of this endeavor to build a modern Chinese culture and, more specifically, art. He phrased it more poetically, calling on his colleagues to be not only like spiders spinning their webs in a given place, but also like bees that fly toward the gardens of both Chinese and Western culture, ancient and modern art, to drink their best nectar and turn it into the outstanding honey of a new era.[40] With this metaphor, he referred back to the Chinese Painting Association's forerunner, the Bee Society, of which he had formed the backbone.[41] That earlier art society had given the following explanation for its name: "Bees are tiny insects. They like to work collectively and systematically. They collect nectar to serve human beings; get tired but never give up; work hard but do not claim credit; have enormous righteousness. We gather our tiny effort to research art and pick the best essence for the public."[42]

The tension between the impulses of cultural defense and cosmopolitanism that characterized Zheng's programmatic combination of "art on China's own terms" and the metaphor of a bee flying around the world's artistic gardens to collect the best essence once again testifies to the enormous influence of evolutionism and social Darwinism on Chinese intellectuals in the early twentieth century. This influence is clearest when Zheng writes: "In the process of historical evolution, each period has its own art, and in each period every nation has its characteristic art, which reflects its environmental and historical conditions."[43] The collective activities of the bees, like Xie Haiyan's more straightforward call to "analyze the respective advantages and shortcomings, and to realize which aspects should be preserved and which should be discarded," are necessary for national survival in a moment of political, economic, and cultural crisis.

Comparing Landscape Painting in China and the West

Contributions to the special issue that addressed Xie Haiyan's call "to compare the quality of Chinese and Western art and clarify the reasons for their respective rise and decline" were marked by frictions brought about by the need to find adequate terms of comparison. Typical in this regard is a contribution by the art critic Li Baoquan, titled "Classicism and Naturalism in Chinese and Western Landscape Painting," in which he takes a comparative approach.[44]

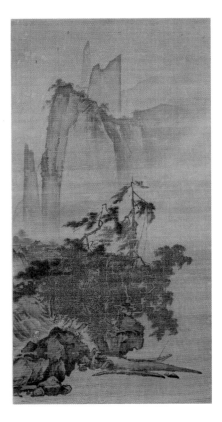

Fig. 1.2. Ma Yuan, attr., *Landscape in Wind and Rain*, 13th century. Hanging scroll, ink and colors on silk, 111.2 × 56.1 cm. Seikado Bunko Art Museum, Tokyo. Photo: Seikado Bunko Art Museum Image Archive / DNPartcom. This painting was reproduced in *National Painting Monthly* 1, no. 4 (1935): 85.

Li starts out with the assumption that classicism (*gudianzhuyi* 古典主義) and naturalism (*ziranzhuyi* 自然主義) exist in Chinese as well as in Western European landscape painting. With these two neologisms, he establishes a European framework for his discussion. This framework, however, is mediated by his use of the term *shanshuihua*—generally reserved for Chinese-style landscapes, whereas European-type landscapes are commonly referred to as *fengjinghua* 風景畫—for both types of works, following the usage in the title of the special issue.[45] Turning to the early history of Chinese painting, he situates the beginning of landscape painting in the Tang dynasty (618–906) and links it to the decline of figure painting, and then goes on to describe the foundational moment: "At that time, painters divided into the Southern and Northern Schools. The Southern School was [founded by] Wang Wei [701–61], and he also was the originator of naturalist painting. The Northern School was [founded by] Li Sixun [fl. ca. 705–20], and he was the founder of classicist painting."[46] What Li Baoquan recounts here is very similar to the standard version of the theory of the Northern and Southern Schools, established by the late-Ming painter,

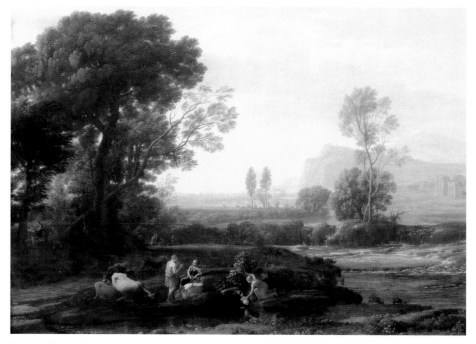

Fig. 1.3. Claude Lorrain, *Landscape with the Rest on the Flight into Egypt*, 1647. Oil on canvas, 102.5 × 135 cm. Staatliche Kunstsammlungen Dresden, Gemäldegalerie Alte Meister. Photo: bpk / Staatliche Kunstsammlungen Dresden.
This painting was reproduced in *National Painting Monthly* 1, no. 4 (1935): 59.

calligrapher, theorist, and high-ranking official Dong Qichang (1555–1636), albeit without the European terms. The names of the schools, which are actually artistic genealogies construed a posteriori, were chosen in alignment with the Southern and Northern Schools of Chan Buddhism, which represent sudden and gradual enlightenment, respectively. The Southern School refers to literati painting, which is privileged over the academic and professional modes of the Northern School as exemplified by Ma Yuan (act. ca. 1189–1224) (fig. 1.2).[47] The scheme of the Southern and Northern Schools thus contains a built-in social bias, which Li Baoquan, via his equation of the two schools with naturalism and classicism, transfers onto European painting.

The Chinese painters that Li cites as representative of the "classicist" Northern and the "naturalist" Southern School are those usually identified as such: the Northern School painters begin with Li Sixun and end with the painters of the imperial academies of the Song and Ming dynasties; the Southern School group begins with Wang Wei, includes several painters of the Northern Song dynasty and the so-called Four Masters of the Yuan dynasty, and ends with the orthodox

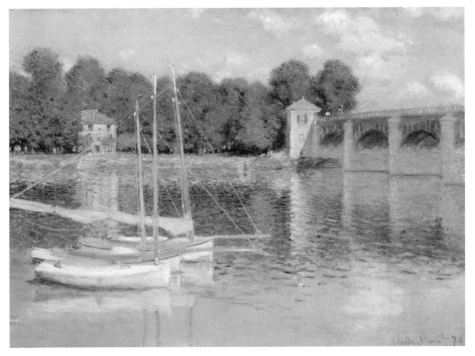

Fig. 1.4. Claude Monet, *The Argenteuil Bridge*, 1874. Oil on canvas, 60.5 × 80 cm. Paris, Musée d'Orsay. Photo: bpk / RMN–Grand Palais / Hervé Lewandowski.
This painting was reproduced in *National Painting Monthly* 1, no. 4 (1935): 79.

literati painters of the early Qing dynasty.[48] On the European side, he names four classicists: Leonardo da Vinci, Giorgione, Claude Lorrain (fig. 1.3), and Nicolas Poussin. Naturalism in European painting begins in the Netherlands in the seventeenth century with Rembrandt, moves on to John Constable and William Turner in England, and, according to Li, finally finds its ultimate expression in French impressionism (fig. 1.4). The history of painting, Li suggests, necessarily follows the development from figure painting to pure landscape, and classicism is but a deviation along that road. He regards landscapes by Ni Zan (1301–74) (fig. 1.5) as the summit of the naturalist expression of the spirit; classicists like Claude Lorrain and Poussin cannot do without a last residue of the human figure. In sum, Li makes out two peaks for "naturalism": Ni Zan's painting, the paradigm of literati painting from the fourteenth century, and late nineteenth-century European impressionism.

The reversed teleology that underlies Li's implicit equation of these two summits is a fundamental revision of the earlier discourse on Song painting as the true representative of Chinese painting, owing to its presumed affinity

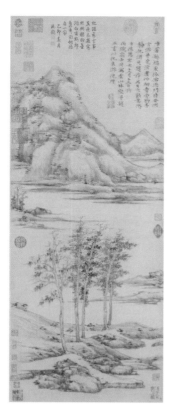

Fig. 1.5. Ni Zan, *Woods and Valleys of Yushan*, 1372. Hanging scroll, ink on paper, 94.6 × 35.9 cm. The Metropolitan Museum of Art, New York. Photo: www.metmuseum.org.

with the visual veracity of European painting since the Renaissance. By equating Southern School painting with impressionism via the construct of "naturalism," Li makes a strong case in defense of literati painting. Impressionism is the central moment around which the accounts of European painting history in the special issue of *National Painting Monthly* are organized. Equated with literati painting, it becomes the point of departure from those realist techniques that were regarded as solutions to the perceived deficiencies of Chinese painting in early twentieth-century discourse. Thus, Li's essay can be seen as part of a larger movement in the Japanese and Chinese art circles of the 1920s and 1930s to rehabilitate literati modes of painting by equating them with modernist concepts and styles, as exemplified by Chen Shizeng's "The Value of Literati Painting," published in 1921 and 1922.[49]

Li's use of the neologisms "classicism" (*gudianzhuyi*) and "naturalism" (*ziranzhuyi*) exemplifies what Lydia Liu has called a "trope of equivalence." According to Liu, the neologism "identifies itself as Chinese and foreign locked in linguistic tension. . . . [O]ne creates tropes of equivalence in the middle zone of interlinear

translation between the host and the guest languages."[50] The "neologistic imag-
ination" at work in Li's text can be explained as owing to nationalist objectives,
primarily the search for the salvation of Chinese culture.[51] Subsuming literati
painting, together with impressionism, under the term "naturalism" positions
the two as equivalents and also gives literati painting historical priority, although
it is "slipping into darkness," according to Li.[52] In this respect, Li's reinter-
pretation of naturalism in terms of literati painting is in keeping with Zheng
Wuchang's explicit and Xie Haiyan's implicit reference to the "Manifesto for the
Construction of a Culture on China's Own Terms."

A text by the modernist oil painter Ni Yide, "The Techniques of Western
Landscape Painting," takes a much less ideological position, by comparison,
showing no concern about questions of superiority regarding international
competition or historical priority.[53] He briefly refers to *guohua* when writing
about rhythm (*yunlü* 韻律, which is important for both oil and ink painting,
according to Ni), but he mainly concentrates on European painting. For the
most part, Ni's essay is an introduction to composition, coloring, and the rela-
tionships between single pictorial elements, and the painters he cites most are
Gustave Courbet (1819–77), Camille Corot (1796–1875), and Paul Cézanne (1839–
1906). These formal considerations are framed by statements regarding the func-
tion of art as a pure expression of the artist's subjectivity. Ni begins by stating
that in the past, European painters had regarded nature as superior to humans
and therefore mimesis was the most important aspect in landscape painting
well into the nineteenth century. But in modern philosophy, Ni writes, nature
is regarded not as an absolute but as something dependent on the perception of
the individual. He cites Descartes's "Cogito, ergo sum," and writes that beauty
in nature is only beautiful because it imitates art, attributing this statement to
Oscar Wilde's preface to *The Picture of Dorian Gray*.[54] It is not clear here which
line in Wilde's "Preface" he is referring to, but it is important to note that Ni
Yide claims primacy for artistic beauty over natural beauty, and in consequence,
for the artist's individual vision.[55] He states that "nowadays, if you pick a motif
from nature, nature itself is secondary, and the most important aspect is the
artist's attitude toward it. In painting, for example, 'vision' is the most import-
ant point." Ni also cites an unidentified author (transcribed as *Feitela*) as stat-
ing that only when thoughts are expressed through language can they become
thoughts.[56] Likewise, he says that one can understand what the author sees in
a landscape only when the landscape is represented in art. He ends his article
with a quotation by Henri Matisse, calling on his readers to make their paint-

ings painterly (*huihuahua* 繪畫化) so that they become pure painting (*chuncui huihua* 純粹繪畫).[57]

While Ni draws from an eclectic array of sources (European throughout), his argument is unequivocal. Painting is first and foremost an expression of the artist's vision of the world, in the double sense of the artist's physical perception as well as emotional reaction to the subject of a painting. Although Ni's reading apparently stems from May Fourth individualism, he shares with He Tianjian's account of Chinese painting theory an emphasis on the artist's subjectivity, or what He terms "inner cultivation" (*neixiu*), which overrides mimetic representation.

This shared nonrealist attitude in contributions to the special issue of *National Painting Monthly* was certainly not incidental. Like the choice of landscape painting as the issue's subject, the individualist attitude of a modernist painter like Ni Yide was more in line with the search for a future of Chinese painting on "*guohua*'s own terms" than the discourse of national salvation that was characteristic of those who called for a reform of Chinese painting by incorporating the principles of realism. As early as the 1920s, Japanese and Chinese artists and critics had drawn parallels between modernist painting and literati painting. These ideas were based on perceived commonalities in such concepts as "subjectivity" and "rhythm/*qiyun*."[58] In the context of the special issue, the cooperation between *guohua* painters and Western-style artists also shows that the ideological lines between artists working in different media and positioning themselves in diverging artistic camps were not as absolute as one might think when reading He Tianjian's, Zheng Wuchang's, and Xie Haiyan's complaints about cultural crisis and artistic decline. Instead, it reveals the importance of the bee metaphor in Zheng's editorial, when he encouraged his reader-colleagues to fly through the gardens of Chinese and Western, ancient and modern art to gather their best nectar.

Despite the rhetoric of a return to the models of Song and Yuan painting to save Chinese culture, the editors of *National Painting Monthly* were not staunchly conservative essentialists; rather, they were part of the cosmopolitan Shanghai art world, teaching at the same art schools, showing in the same exhibitions, and publishing in the same journals and magazines as colleagues who worked in other styles and media. Moreover, their paintings were not historicist interpretations of ancient masterpieces, but were part of the dynamic and diverse creative output of those artistic circles.

Illustrating the Special Issue

A different perspective on the special issue can be gained from a text titled "Comments on the Illustrations in the Special Issue on Landscape Painting Ideas in China and the West," published in the seventh number of *National Painting Monthly*. Collectively authored by the editors, the commentary lists the illustrations in the special issue (the journal's fourth and fifth numbers) and discusses each of them briefly.[59] The special issue's illustrations show Chinese and European landscape paintings from various historical periods, arranged on the pages where the respective artists are mentioned in the articles.

There is a large temporal gap between the Chinese and the European painters whose works are illustrated. Most of the Chinese paintings are attributed to masters of the Song and Yuan dynasties, and two paintings are attributed to Tang dynasty painters, Wu Daozi (fl. ca. 710–ca. 760) and Wang Wei. The most recent Chinese painter in the list is Shitao. For their European counterparts, the earliest artist included is Leonardo da Vinci, and the most recent were still alive at the time of publication of the special issue: André Derain (1880–1954), Henri Matisse, and André Dunoyer de Segonzac (1884–1974). The difference in life dates is again owed to the reverse teleology of the Song-Yuan paradigm that underlies Li Baoquan's grouping of both Ni Zan and French impressionism in the category of "naturalism." The juxtaposition of works by canonical Chinese painters from the past with examples of very recent trends in European painting shows that the underlying rationale for the illustrations, although never explicit, was the equation of Chinese painting with modernist painting.

In "Comments on the Illustrations," the editors explain their strategy of loosely connecting the texts and images in terms of the two different functions they perceive for illustration: to support the argumentation of a text, and to create new insights by confronting readers with unknown material and thus raise the value of the journal. In order to avoid misunderstandings that might be caused by the unfamiliar images, the editors decided to provide background information on each illustration. In the case of Chinese paintings, they include the name of the collection holding the work, the source of the illustration, and comments on matters of authenticity. They omit this sort of information in most cases for the European paintings; instead the paintings and the artists' characteristic styles are briefly introduced to their Chinese readers.

The editors' different treatment of European and Chinese paintings in the commentary indicates that *National Painting Monthly*'s target readership

consisted of people with a strong professional interest in Chinese painting and sound experience in the practices of connoisseurship. When writing about the Chinese paintings, the editors frequently refer to their own viewing experience; in some cases they explicitly leave the question of authenticity open when they have not seen the original. For example, they refer to a painting by Guo Xi after having seen the original in the Shanghai exhibit *Preliminary Exhibition of the London International Exhibition of Chinese Art*.[60] The majority of the illustrations in the special issue, however, show paintings that the editors had not seen in the original and which they reproduced from Japanese publications. Their most important source was a special issue of *Asahi Shimbun* on the exhibition *Famous Paintings of the Tang, Song, Yuan, and Ming Dynasties* that was mounted at the Tokyo Imperial Household Museum and the Tōkyō-fu Bijutsukan (now the Tokyo Metropolitan Art Museum) in 1928. The exhibit had included works from Japanese public and private collections as well as Chinese private collections.[61] None of *National Painting Monthly*'s editors had seen the exhibition in person, but they used the illustrations in *Asahi Shimbun*'s special issue, as well as the collotype reproductions in the lavish four-volume exhibition catalogue published in 1929, titled *Grand View of Famous Paintings of the Tang, Song, Yuan, and Ming Dynasties* (*Tō Sō Gen Min meiga taikan*).

The entry on the Kōtō-in's *Autumn Landscape* (fig. 1.6), may serve to exemplify the discursive openness of the editors' treatment:

> Wu Daozi, *Landscape* (*Wu Daozi shanshui*) – Collection of the Kōtō-in, Kyoto, Japan. In *Famous Paintings of the Tang, Song, Yuan and Ming Dynasties* it is annotated as "Attributed to Wu Daozi." Looking at its brush traces and ink method, it actually looks quite like a Japanese painting. On the other hand, its atmosphere is strong, lush, and majestic; this kind of style already existed in China before the time of the Five Dynasties. Of the surviving landscapes by Wu Daozi, this piece in Japan is quite famous, and it is trusted by many people; in China, it is not easy to find a landscape painting by Wu Daozi of comparable standing. Therefore, we are happy to include it.[62]

The landscape, actually one from a set of two hanging scrolls, was indeed attributed to Wu Daozi in the *Asahi Shimbun* publication.[63] However, by the following year it was annotated as an anonymous Song painting in the catalogue to the *Famous Paintings of the Tang, Song, Yuan, and Ming Dynasties* exhibition.[64] The *National Painting Monthly* editors may well have known this

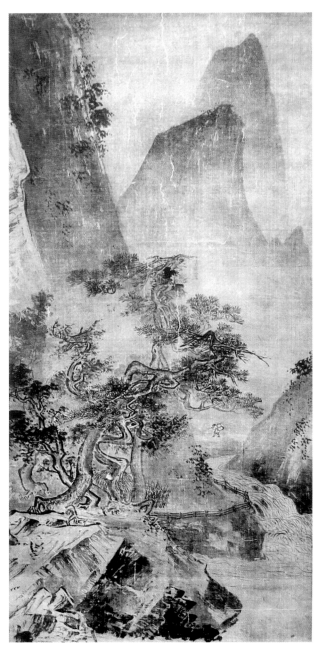

Fig. 1.6. Li Tang, attr., *Autumn Landscape*, ca. 13th century.
Hanging scroll, ink on silk, 98.1 × 43.4 cm. Kōtō-in, Daitoku-ji,
Kyoto. After *Tō Sō Gen Min meiga taikan* (Tokyo: Ōtsuka
Kōgeisha, 1929), vol. 1, no. 20. Photo by the author.
This painting was reproduced in *National Painting Monthly* 1,
no. 4 (1935): 60, as Wu Daozi, *Forest Spring in a Remote Valley*.

second publication, since they illustrated a painting attributed to Ni Zan that was reproduced in the catalogue but not in the *Asahi Shimbun* special issue. For lack of a better example, they decided to take the "Wu Daozi" painting (which Shimada Shūjirō has since attributed to the Song dynasty painter Li Tang, but can be dated to the thirteenth century) as a genuine work.[65] But they also make it clear that they have doubts about the early dating, and that the matter is open for continuing discussion. Thereby, they rhetorically invite readers to engage in the discourse and form their own judgments.

When writing about European paintings, the authors speak in a more authoritative voice about the paintings they chose to illustrate. They do not rely, however, on an established art-historical narrative that they easily could have derived from one of the textbooks translated into Chinese by that time; instead, they insert the paintings into Chinese conventions of art-historical writing. This is clearly seen in the entries on Leonardo's *Landscape Dated August 5, 1473* in the Uffizi Gallery, Florence, and Claude Lorrain's *Landscape with the Flight into Egypt* in the Gemäldegalerie Alte Meister (Old Masters Picture Gallery), Dresden:

> Leonardo da Vinci, *Landscape* (*Wenxi fengjing*), was painted by the saint of painting of the Italian Renaissance, Leonardo da Vinci on August 2 [*sic*], 1473 CE (ninth year of the Chenghua reign of the Ming dynasty); it is the earliest pure landscape in the West. Its drawing style and composition are free and unrestrained, very similar to *guohua*. Now it is in the collection of the Uffizi in Florence, Italy.
> .
> Claude Lorrain, *Landscape* (*Luolang fengjing*), was made by the painter of the Louis dynasty of France, Claude Lorrain (1600–1682) (born in the twenty-eighth year of the Wanli reign of the Ming, died in the twenty--first year of the Kangxi reign of the Qing). The subjects of most of Lorrain's paintings are light and air, in order to describe great nature under the brightness of sunlight. They are full of elements of modern painting.[66]

In the structure of the lemmas on European artists, the editors borrowed from biographical entries in premodern Chinese painting histories and catalogues: the names of the artists are raised over the main body of the text, next follow native place and birth dates (or painting date, in Leonardo's case), and finally the single work or complete oeuvre is characterized using more or less

standardized formulae, such as "free and unrestrained." In these two examples, the fitting of European artists into the framework of Chinese art-historical writing is most obvious in the translation of Gregorian-calendar dates into Chinese reign dates. This was undertaken only for Leonardo and Claude Lorrain, not for the artists introduced later in the same text. Apparently the editors were establishing a comparison between these artists' relatively late dates (to Chinese readers) in the mid-Ming to early Qing period and those of the Tang, Song, and Yuan painters preceding and succeeding them in the list, thereby suggesting historical belatedness for European landscape painting. Many authors of art-historical textbooks written in the 1920s and 1930s (including Zheng Wuchang and Yu Jianhua, who served on the editorial board of *National Painting Monthly*) discarded the biography-centered approach of traditional Chinese art historiography and adopted a nation-centered model of history as progression, based on European and Japanese scholarship.[67] However, the text structure in "Comments on the Illustrations for the Special Issue on Landscape Painting Ideas in China and the West" shows that the former approach still had normative power, especially when addressing a readership whose artistic identity was closely linked to the literati-centered Chinese canon.

The works by Leonardo da Vinci and Claude Lorrain in the "Special Issue on Landscape Painting Ideas in China and the West" illustrate Li Baoquan's article "Classicism and Naturalism in Chinese and Western Landscape Painting," in which Li cites the two artists as representatives of classicism. But the descriptions just quoted serve a quite different strategy. By focusing on Claude's depiction of "light and air" and completely disregarding the narratives in his paintings, the editors present him as a forerunner of impressionism, an implication they underscore by mentioning many modern elements in his work. In the case of Leonardo, they relate his drawing not to modern painting but to classical Chinese painting, explicitly and semantically. What I translate in the entry as "drawing style" (*bizhi* 筆致) can literally mean either the style of the pen or the style of the brush, and by characterizing the drawing style in the work as "free and unrestrained" (*ziyou benfang* 自由奔放), the editors describe it as a painting in the *xieyi* manner.

By virtue of their poor print quality, the illustrations in *National Painting Monthly* support these un-classicist readings. What remains visible of Claude Lorrain's *Landscape with the Flight into Egypt* are the dark silhouettes of trees and mountains against a blank sky and a bright river blinking below (fig. 1.7);

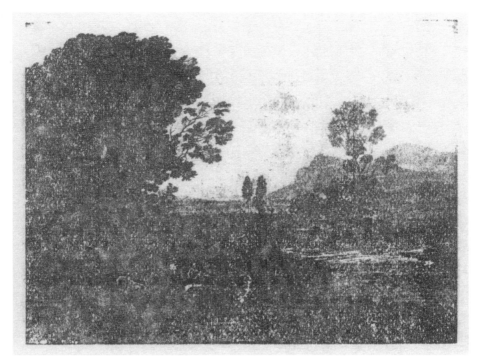

Fig. 1.7. Claude Lorrain, *Landscape with the Rest on the Flight into Egypt*, 1647. Reproduced from *National Painting Monthly*. 1, no. 4 (1935): 59. Harvard-Yenching Library of the Harvard College Library, Harvard University. Photo: Harvard Imaging Services.

the narrative of the flight to Egypt in the foreground is virtually blackened out of the picture, leaving it as a "pure" landscape. The use of human figures that Li Baoquan stressed as characteristic of classicism is obscured to the point of invisibility. In the reproduction of Leonardo's drawing, the linearity of the image facilitates comparison with the ink outlines in Chinese literati painting. The sepia lines are flattened out in the printing process, and densely drawn details, such as the foliage in the woods, become blotchy, resembling foliage dots in the Chinese paintings, whose details appear equally simplified and flattened in the illustrations. In these conditions, Leonardo's landscape drawing (figs. 1.8 and 1.9) becomes strikingly similar to an album leaf of questionable authenticity attributed to Huang Gongwang (1269–1354) from the collection of Zhang Daqian (fig. 1.10), which precedes the Leonardo illustration by several pages.[68] Both show a wooded mountain on the right side of the picture and a river landscape opening to the left, rendered into monochrome black lines on blank paper by the printing process. It almost seems as if the Huang Gongwang leaf was

Fig. 1.8. Leonardo da Vinci, *Landscape Dated August 5, 1473*. Ink on paper, 19 × 28.5 cm. Gabinetto dei Disegni e delle Stampe degli Uffizi, Florence. Photo: bpk / Scala—courtesy of the Ministero Beni e Att. Culturali.

chosen to match the Leonardo drawing and pull the latter onto the common ground of ink landscapes.

In discussing the effect of low print quality on possible readings of an illustration, I do not mean to imply that the editors intentionally chose poor-quality images to induce a particular interpretation. However, they were certainly well aware of their visual impact.[69] The artists working as editors of *National Painting Monthly* were highly sensitive to different publication venues, different printing techniques, and the impact of reproductions of contemporary and historical artworks. The poor reproductions of halftone and collotype images in the special issue allowed for an associative reading by the audience not despite but because of the works' impaired legibility. This corresponds with the editorial decision to connect the special issue's texts and illustrations only loosely, as well as with the diverging and contending views on the relations between Chinese and European painting traditions that together form a multivocal discourse. Put differently, as tonal gradations are reduced to the stark contrasts of a flattened linearity, the visual and discursive gap between the painting traditions of Europe and China becomes shallower and is more easily crossed.

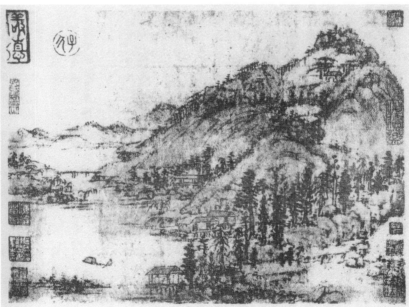

Above: Fig. 1.9. Leonardo da Vinci, *Landscape Dated August 5, 1473*. Reproduced from *National Painting Monthly* 1, no. 4 (1935): 58. Harvard-Yenching Library of the Harvard College Library, Harvard University. Photo: Harvard Imaging Services.

Below: Fig. 1.10. Huang Gongwang, attr., *Boating amidst Autumn Mountains*, former collection of Zhang Daqian, dimensions and present whereabouts unknown. Reproduced from *National Painting Monthly* 1, no. 4 (1935): 52. Harvard-Yenching Library of the Harvard College Library, Harvard University. Photo: Harvard Imaging Services.

The depth of historical time is also leveled by bringing ink painting and oil painting from different moments in history into the same arena in the special issue, both visually and verbally. Zheng Wuchang's editorial statement makes it clear that the ultimate objective of the special issue was not historical or theoretical, but practical.[70] Therefore it is not sufficient to merely analyze the texts in the special issue as what they purportedly were—comparative discussions of the history or theories of Chinese landscape painting, and of European landscape painting before and after the impressionists. To fully understand the meaning of the articles in relation to Zheng and Xie's programmatic statements, they have to be read in relation to contemporary painting practice.

Featuring Contemporary Paintings

Works by contemporary painters were not reproduced in *National Painting Monthly* until its last issue. The first pages of that issue (ten and a half pages out of twenty-nine), however, are completely devoted to illustrations, without any text except the names of the painters and titles of the works. Although the works are not further commented on, they take precedence in the pages of the journal owing to the sheer space that they occupy. They are works by artists who either served on the editorial board of the journal or had previously contributed articles or poems. In order of appearance, the issue features paintings by Huang Binhong, Xia Jingguan (1875–1953), Xie Gongzhan (1885–1940), Chen Xiaocui (1907–68), Yu Jianhua, Wang Yachen (1894–1983), Zheng Wuchang, Dai Yunqi (1910–?), Shi Chongpeng, Ding Nianxian (1906–69), Sun Xueni (1889–1965), He Tianjian, and Hu Zhongying.[71]

The paintings appear to be arranged roughly according to seniority—the first three were done by the oldest artists, followed by the works of painters born in the 1890s, and finally paintings by artists born after 1900. Narrow scrolls with matching compositions were placed on one page. Hu Zhongying's work was accorded a special place at top of the first text page (fig. 1.11); the reason for this may have been the horizontal format of her album leaf. As the responsible editor, He Tianjian humbly put his own work at the end of the sequence (just before Hu's); in a less humble step, he included two of his paintings, while everyone else was represented with only one.

The paintings appear to be the farewell contributions of *National Painting Monthly*'s authors and artists, yet it is more likely that they were a farewell selec-

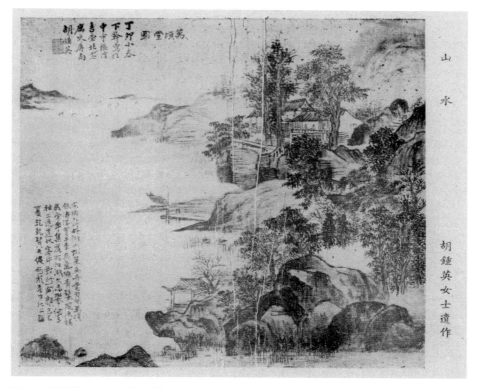

Fig. 1.11. Hu Zhongying, *The Million Acre Thatched Hut*, 1927, dimensions and present whereabouts unknown. Reproduced from *National Painting Monthly* 1, nos. 11/12 (1935): 225. Photo: Shanghai Library.

tion by editor in chief He Tianjian. With the exception of Dai Yunqi's work and his own paintings, the works reproduced in the last issue of *National Painting Monthly* had already appeared in print a few months earlier, in May 1935, in another publication by the Chinese Painting Association for which He Tianjian also served as the main editor: *Collection of Famous Modern Chinese Paintings* (*Zhongguo xiandai minghua huikan*, referred to as *Collection* in the remainder of this chapter).[72] For the illustrations in the last issue of *National Painting Monthly*, He did not use the titles under which the paintings had been published in *Collection*; instead he replaced them with genre designations. All landscape paintings are thus titled *Landscape*, and Chen Xiaocui's painting of Su Dongpo leaving the Hanlin Academy, created after a work by Hua Yan (1682–1756) according to its title in *Collection*, is called simply *Figures* in *National Painting Monthly*. The most specific title in the monthly's last issue is *Goldfish*, for a work by Wang Yachen. Through this change of titles, the paintings become part of a genre typology and represent models for current and future *guohua*.

As the second major publication of the Chinese Painting Association, *Collection* deserves a detailed discussion. Although it contains laudatory prefaces by the high official and collector of ink stones Xu Xiuzhi (1881–1954), the senior painter and businessman Wang Yiting (1867–1938), Wang Qi (1890–1937), another high-ranking official who was also a painter and calligrapher, and Huang Binhong, it is the foreword by He Tianjian that contains an explicit statement of the publication's programmatic intentions.[73] According to He, the idea of editing a catalogue of contemporary paintings was born around the same time as the decision to publish *National Painting Monthly*. As Zheng Wuchang and Xie Haiyan did in their statements for the monthly's special issue, He refers to a crisis of Chinese culture. In response to that crisis, he wrote, the journal's function was to sort out the common knowledge of Chinese painting's history and therefore necessarily reproduce ancient paintings as models. The role of *Collection*, on the other hand, was to showcase a selection of representative works by modern painters—in this case, members of the Chinese Painting Association—that would outline the future direction of *guohua*. The book was to serve several purposes: to make the work of each member of the association known to the others; to facilitate research on modern *guohua* for future art historians, especially in view of the painful lack of historical painting catalogues that offer an overview of a single period; to give readers a synchronic, horizontal overview of the specific moment in time, between the inheritance of the past and the evolution of the future; to serve as a guidebook on modern Chinese painting for foreign visitors interested in art; and finally, to commemorate the work of the Chinese Painting Association itself. Originally, three volumes of *Collection* were planned, but within one month the committee for soliciting paintings had received more than 120 images, and it decided to combine the first two volumes into one and postpone the third until a later date.[74]

Collection is structured in three parts. The first, largest, and untitled section features the works of 103 male artists; the next section, titled "Works by Female Members of the Association," includes paintings by nineteen women. The last section presents four works by deceased members (both male and female). According to an annotation to the table of contents, the works are arranged in the order in which they were received. Despite this seemingly unhierarchical procedure, the seniority of the artists whose works appear on the first pages— the art world leaders Wang Yiting, Chen Shuren (1884–1948), Jing Hengyi (1877– 1938), Feng Chaoran (1882–1954), Qi Baishi (1864–1957), and the descendants of the Qing imperial family, Pu Ru (1896–1963) and Pu Jin (1893–1966)—suggests

that some rearrangement was undertaken to honor their prominence. A similar observation can be made for the section on women painters: it is headed by the senior Lingnan School painter He Xiangning (1879–1972), and core members of the Chinese Women's Calligraphy and Painting Society (Zhongguo nüzi shuhuahui), such as Lu Xiaoman (1894–1964), Li Qiujun (1899–1973), Yang Xuejiu (1902–86), and Feng Wenfeng (1900–1971), occupy the first half of the section.[75]

Probably because of their important roles in Shanghai painting circles, Wang Yiting and Feng Chaoran were each accorded two illustrations. By contrast, much less is known about the two female painters who were given two illustrations, Xie Peizhen (1898–1979) and Hu Zhongying, the latter being represented with two out of the four works by deceased painters. Xie was the student and life partner of Feng Chaoran, who inscribed many of her paintings; this may explain why she was granted the same number of images as he was.[76] Even less is known about Hu Zhongying. To my knowledge, the only sources of information about her are *Collection* and *National Painting Monthly*. One can only speculate as to why she was overrepresented with two paintings; her paintings reproduced in *Collection* appear rather weak in comparison with others in the same book. However, the inscriptions on the paintings do suggest personal ties to more prominent colleagues. Her landscape in the style of Shitao, dated to 1931, bears an inscription by Zhang Daqian, and her work *Million Acre Thatched Hut* of 1927, which is also reproduced in the last number of *National Painting Monthly*, is inscribed by He Tianjian (see fig. 1.11). Presumably it was He, as editor of both *Collection* and *National Painting Monthly*, who gave her preference over her more prominent female colleagues by placing reproductions of her work in both publications; he also included two short texts by her in the "Special Issue on the Ideas of Landscape Painting in China and the West."[77]

Another source pointing to a close, or even romantic, relationship between He Tianjian and Hu Zhongying is the painting *Plucking Water Caltrops (Cailing)*, which He painted in the autumn of 1935 (fig. 1.12).[78] The theme of the painting is a recurring motif in Chinese poetry (and subsequently in painting) that can be traced back to a tune title mentioned in the poem "Summoning the Soul," traditionally attributed to Qu Yuan (ca. 340–278 BCE), from the *Songs of Chu (Chuci)*.[79] Poems on this theme describe the sight of young girls boating on a river as they pluck caltrops, implying a romantic relationship with a male persona watching them.[80] He Tianjian's painting depicts two ladies whose hair and dress are in the style of the Tang dynasty court. One of them stretches her hands into the plants to pluck the fruit, the other is contemplating the scene.

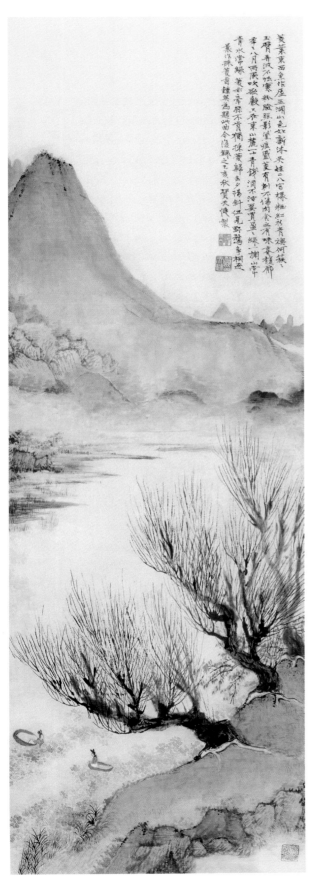

菱葉東西魚作屋 五湖水色如新沐 吳娃二八宮樣粧 紅祆青褐何稹
玉臂青泛不怯寒 紋臉粧影望望痕 菱有刺不傷閑食之肯味棄椎
秋八月雨風吹孤藪之卒 東山麓二卉錄潤不沽 要買菱二綠一爛当
青水常綠 菱前等架不肯 獨株菱解去夕陽斜 但見野蕩争榴奇
兼隆綵菱肯鍾芙為題此曲今漫錄之 乙亥秋 賀天健製

Fig. 1.12. He Tianjian, *Plucking Water
Caltrops*, 1935. Ink and colors on paper,
120 × 40.5 cm. Duo Yun Xuan Auctions,
Modern Chinese Paintings, December
14, 2011, lot no. 37. Photo: Duo Yun Xuan
Auctions.

In contrast to their elegant appearance, they are not seated in boats, as in other paintings on this theme, but in swimming tubs like those used by peasants for harvesting water plants.[81] The river is dotted with the leaves of the water caltrop, painted in transparent patches of light blue and ochre. The nearby embankment and the mountain in the background are painted in bright blue and green, with tinges in ochre suggestive of autumn. The riverbank in the foreground is dominated by the black silhouettes of three gnarled, bare willows with slender, brittle twigs that give the picture a chilly atmosphere. Above the willow branches, He transcribed a long poem on the theme of gathering water caltrops, in refined, slender writing that alludes to the style of Emperor Huizong (1082–1135, r. 1100–1125). He noted that Zhongying had originally inscribed this song, which he was now inscribing again.

The painting can be understood as a commemoration of Hu Zhongying, not only in the reinscription of a poem possibly authored by her but also in the painting style and imagery of bare winter trees, which symbolize old age and the end of life. The willows in He's painting, however, are not old and withered; they look vigorous, with long, young twigs stretching up, bare before their time, evoking the fact that Hu Zhongying may have died at a young age. Their frosty image contrasts with a harvest scene that normally takes place in autumn, just as their stark black and dark gray trunks contrast with the delicate yet brittle twigs and the subtle hues of the waterscape and the bright blue and green coloration that imbues the landscape with a paradisiacal and unworldly connotation.[82] The motif of women gathering water caltrops gains an unreal quality in the painting, as the action is carried out by representatives of a timeless, almost fairy-like female beauty who are presented in very rural vessels. The poetic theme of *Plucking Water Caltrops*, in combination with refined, feminine aesthetics and an otherworldly setting, make it highly probable that this painting is an homage not merely to a deceased friend or student, but to a lover.

Although *Collection* claims for itself a democratic approach of printing one illustration per painter, presented in order of receipt, the book reflects the male-dominated hierarchies inherent in the Shanghai art world. Even though a significant number of female artists were members of the Chinese Painting Association and were present in numerous exhibitions and publications, it was apparently their personal connections with powerful men (as in the case of Xie Peizhen and Hu Zhongying) rather than their professional success that granted them heightened visibility in the association's most representative catalogue.

In terms of historical importance, *Collection* was not as unique as He Tianjian suggests in his foreword. Most notably, the Chinese Painting Association's predecessor, the Bee Society, had already published two catalogues of members' paintings, *The Bee Painting Selection* (*Mifeng huaji*, 1930) and *Sea of Paintings by Famous Contemporary Artists* (*Dangdai mingren huahai*, 1931).[83] Both follow the principle of one illustration per artist. *The Bee Painting Selection* is a relatively thin and exquisite string-bound book, with only seventeen collotype illustrations of works by core members of the Bee Society, preceded by short biographical entries. With its string binding, blue cloth cover, high-quality collotype reproductions on *xuan* paper, and small number of images, *The Bee Painting Selection* followed the typical format of artist catalogues of the Republican period. *Sea of Paintings*, edited by Zheng Wuchang, is a folio-format, string-bound hardcover book. It was published by the Zhonghua Book Company (Zhonghua shuju), one of the three leading corporate publishers in Republican Shanghai, where Zheng served as head of the art division from 1924 to 1932.[84] The book appeared in several editions over the course of the 1930s.[85] It contained works by 127 artists and is thus comparable in scope to *Collection*. As in *The Bee Painting Selection*, the paintings are reproduced in collotype.

For collotype printing, light-sensitive gelatin is applied to a glass plate; the reproductions obtained through this process have an extremely fine grain. The technique was therefore regarded as ideal for reproducing the gradations of ink washes. But because the collotype printing process is very time-consuming (only around 500 prints can be made per day, one plate renders only 1,000 to 1,500 prints, and the printing process requires close control), it was more costly than other printing techniques.[86] Moreover, the technique is not appropriate for printing text, which must be added to the page by letterpress.[87] The layouts of both *The Bee Painting Selection* and *Sea of Paintings* are typical for many Chinese painting catalogues published in the 1920s and 1930s; because collotype was not convenient for text printing, texts were concentrated on the opening and closing pages; the remaining pages were reserved solely for the illustrations and printed on only one side (fig. 1.13). The visual isolation of the illustrations and the abundance of white paper surrounding each image added a sense of value to the reproductions; in its visual effect, this mode of reproduction came as close as printing could get to mounting ink paintings as album leaves.

By contrast, *Collection* is more like a handbook. It is printed with halftone illustrations, allowing author and title of each painting to be printed next to

Fig. 1.13. Two-page spread from *The Bee Painting Selection* (*Mifeng huaji,* ed. *Mifeng huashe*) (Shanghai, 1930), unpaginated, with a collotype reproduction of Zheng Wuchang, *Landscape*, 1930, dimensions and present whereabouts unknown. Photo: Zhejiang Provincial Library.

the images. Both sides of a page are printed, often with two illustrations on one page. In keeping with this more economical layout, the book is smaller in size and bound as a modern hardcover. It also includes numerous advertisements (fig. 1.14). The chapter structure, differentiating artists according to gender and whether they were living or dead, further adds to its documentary character, as opposed to the design of the Bee Society publications, which addressed connoisseurial tastes. Moreover, the extra space given to women painters, although in a slightly imbalanced way, gave their work a heightened visibility. In comparison, the *Sea of Painting* presents the work of only six women, and their paintings are interspersed among those of their male colleagues.[88] *The Bee Painting Selection* includes only one work by a female painter, Yang Xuejiu.

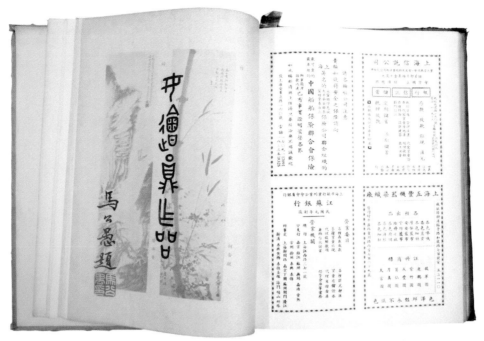

Fig. 1.14. Two-page spread from *Collection of Famous Modern Chinese Paintings* (*Zhongguo xiandai minghua huikan*, ed. Zhongguo huahui bianyibu) (Shanghai, 1935), with the title page for the section "Works by Female Members of the Association" with seal script calligraphy by Ma Gongyu and commercial advertisements. Shanghai Museum Library. Photo by the author.

Besides their different editorial strategies, *The Bee Painting Selection*, *Sea of Paintings*, *Collection*, and the last issue of *National Painting Monthly* all endeavored to promote contemporary *guohua* through institutional structures and publications aimed at reaching a wide audience. Most important, their illustrations were the selections of the artists themselves, granting us insight into what they deemed most representative of their own work at a given moment in time. Editorial interference notwithstanding, they give us a contemporary overview of *guohua* practice in the early and mid-1930s and its stylistic diversity. Most of the submissions in these four publications are landscapes, followed by flower paintings. The styles range from conservative literati modes to loose compositions in splashed ink, and several works employ strong shading or central perspective. This diversity makes it impossible to generalize about *guohua* in the 1930s other than to remark on its variety. It also underscores the fact that the Chinese Painting Association, and before it the Bee Society, served primarily as social, public, and political platforms for artists. Despite—and one might even say in contrast to—the repeated calls to save Chinese painting from decline and for a "new Chinese painter," these organizations represented artists who shared

a common medium, *guohua*, but not a common style. Rather, they formed and reinforced a strong social network of *guohua* artists that was essentially pluralistic in outlook and in practice.

The End of *National Painting Monthly*

When *National Painting Monthly* ceased publication after its twelfth issue, He Tianjian explained the reasons in his final editorial. Judging from his text, he had shouldered the main responsibility for the publication and the editorial work, following Xie Haiyan's resignation after the seventh number. Apparently, He was no longer willing to bear the workload. In addition, the journal's revenues could not fully cover its expenses. But both He's admonitions to the readers in his farewell editorial and Zheng Wuchang's introductory editorial in the successor publication *National Painting* indicate that, in the end, He Tianjian lacked support from other core members of the Chinese Painting Association who regarded his working style as hegemonic and his propositions for the salvation of Chinese painting as too prescriptive.

He Tianjian's last admonitions to his readers can be summarized as follows: (1) when studying art, one should develop one's individual talent, but without disregarding the experience of others, which can be acquired through collective study; (2) true fame is not dependent on monetary income, but on the real value of art; (3) to develop the national culture, a strong and encompassing organization (such as the Chinese Painting Association) is necessary; (4) one has to follow one's heart with firmness and resolution, and not let oneself be distracted by the lures of the city or the hardships of rural life.[89] The programmatic tone of this combination of bohemian romanticism, literati ideals, and organizational pragmatism, a tone that marks several of He's articles in *National Painting Monthly*, was turned into actual verbal prescriptions in the list of "Creeds to Be Heeded by the Painter" that appeared in every issue of the journal beginning with the eighth issue, and twice in the two double numbers, 9/10 and 11/12:

1. Be a part of society, and serve it loyally
2. Always take a noble stand
3. Do not strive for honor and material gains
4. Do not care about vain fame
5. Do not work for payment

6. Read more useful books
7. Practice calligraphy on a regular basis
8. Study many ancient paintings
9. Pay the same amount of attention to technique and theory
10. Travel to famous mountains and great rivers frequently[90]

By dint of sheer repetition, these "creeds" amounted to an attempt at indoctrination that may have alienated other painters on the editorial board of *National Painting Monthly*. This conclusion may be drawn from Zheng Wuchang's introduction to *National Painting*, the bimonthly journal that followed *National Painting Monthly* and was first published in January 1936. Zheng explained the name change—made by omitting the two characters *yuekan* for "monthly"—stating that although officially *National Painting Monthly* had been the journal of the Chinese Painting Association, He Tianjian had in fact regarded it as his personal publication. The association's reappropriation of the journal as the collective mouthpiece of *guohua* painters had made the name change necessary. Zheng also points out that Xie Haiyan had given up his position as editor in chief after a "misunderstanding" with He.[91] Zheng Wuchang thus introduces *National Painting* as essentially *National Painting Monthly* without He Tianjian; Xie Haiyan returned as editor in chief, and the contributors were more or less the same as in the previous publication—with the exception of He Tianjian, whose name does not appear among the authors. The change in name and editorial staff for *National Painting* reveals that the search for a future Chinese painting, while perceived as essential by many painters, was multifaceted and not without conflict.

Despite its short lifespan, *National Painting Monthly*'s editorial statements and decisions, as well as the debates on the history and future of Chinese painting that appeared in its pages, serve as a magnifying glass for viewing the formation of modern *guohua* and its theoretical implications. The journal therefore serves as the thread running through the subsequent chapters of this book, and I will return to the contributions to the special issue by He Tianjian, Yu Jianhua, and Huang Binhong in discussions of their writings and paintings. Likewise, the paintings that these artists submitted to *The Bee Painting Selection*, *Sea of Paintings*, *Collection*, and other contemporary publications illustrate which works they considered to be representative of their oeuvre, and as such they will receive special attention.

Canon and Place in the Paintings of He Tianjian

As discussed in the previous chapter, a major goal of the publications of the Chinese Painting Association, and of *National Painting Monthly*'s "Special Issue on the Ideas of Landscape Painting in China and the West" in particular, was to "strive diligently for the renaissance of the art of our nation."[1] With this in mind, the historical and comparative issues discussed in these publications can justifiably be regarded as stand-ins for questions of contemporary artistic practice. What contributors wrote about in the pages of the special issue of *National Painting Monthly* was not, or at least not primarily, how to address the painting histories of China and Europe, but how to paint modern Chinese paintings.

One of the most prescriptive outcomes of the "Special Issue on the Ideas of Landscape Painting in China and the West" was He Tianjian's list "Creeds to Be Heeded by the Painter," which he repeatedly iterated in the last numbers of *National Painting Monthly*. In it, he declares that painters should loyally serve society and not strive for honor and material gain, but should instead spend their time reading books, practicing calligraphy, and traveling to famous mountains and rivers. The creeds are a condensed version of one of He's contributions to the special issue, titled "The Symptoms of Morbidity in Contemporary Chinese Landscape Painting and Methods of Rescue."[2] Those "methods of rescue," I propose, were essentially based on He's own experiences. In this chapter I will take He's diagnosis of contemporary painting's deficiencies and his curative propositions as a point of entry for discussing his own painting practice. The essay on the "symptoms of morbidity," which opens the fifth number of *National Painting Monthly*, tackles head-on what He Tianjian saw as the problems of contemporary *guohua*. He enumerates the symptoms as:

1. thinking that when you closely copy the works of the ancients you will not lose the ancient method;
2. thinking that an enlarged copy of a print reproduction makes for a work of your own;
3. mistaking eclecticism for original work;
4. mistaking smearing around for original work;
5. being ignorant of [the paintings of] the Song, Yuan, Ming, and Qing dynasties and thinking you can do an original work on your own;
6. thinking that using Western painting methods in Chinese painting suffices for an original work.[3]

He links these six symptoms to six causes—exploiting one's personality and being ignorant of method; not engaging in study and remaining confined by the methods of the ancients; practicing copying without engaging with theory; not studying thoroughly; being overly self-confident and eagerly following fashions; and blindly following others.[4] He Tianjian's polemic can be boiled down to the following: He criticizes his colleagues for blindly copying either premodern Chinese or Western paintings without generating original works, for being overly innovative without having a solid foundation in traditional painting techniques, and for lacking a theoretical foundation.

The remedy that he proposes in his essay sounds rather conservative. As he does not have much faith in his own generation, He Tianjian suggests a specific training regimen for future generations of painters. The first training phase has three components: students should make tracing copies of ancient paintings, but only of the outlines, to practice brushwork; practice large and small seal script, and the style of the stele inscriptions of the (Northern) Wei dynasty (386–535); and read ancient painting treatises. For this foundational period in their training, He Tianjian allots three years. The second step is to make freehand copies of ancient paintings to practice ink technique, and to read more theoretical works; students should continue this for four years. At this point, He says, after seven years, students may start creating original work, which they can go about in three ways: by exploring and transforming the formal means of the ancients, studying the historical development of different schools and theories, or traveling to famous mountains and great rivers to explore the sources of ancient painting. They should continue this practice for another ten years.[5]

Judging from He's diagnosis of the diseases plaguing *guohua* and his prescription for a cure, Chinese painting as he understood it was necessarily based on the work of premodern painting masters, whose modes, techniques,

and theoretical work should form the basis of the modern painting practice. The practices of orthodox literati painting that were so harshly attacked in the early twentieth century seem to emerge unaffected. Learning by copying from ancient masters (as opposed to drawing from life, the hallmark of a modern art curriculum) was the core element of artistic training as He conceived it.[6] The main "disease" in contemporary painting practice was not the practice of copying from ancient masters or even from collotype reproductions of their work; it was that the techniques thus learned were not being put to correct use in instances of mere uncreative copying. However, the modes and techniques of the ancients were conceptually linked to the visual experience of real landscapes. Like many of his contemporaries, He Tianjian assumed that early landscape painters developed their methods by painting real mountains and rivers, and he identified the reenactment of this purported experience as one of the formative exercises for the advanced student of painting.

The main points in He Tianjian's training program for future artists are all included in "Creeds to Be Heeded by the Painter," which he first published three months after the special issue, in the eighth issue of *National Painting Monthly*: the study of painting theory, the practice of calligraphy, and the travel to famous landscapes. He thus proposed those practices as normative for all painters, not only for the generations to come. Moreover, his book *Learning to Paint Landscapes: A Self-Account* (*Xue hua shanshui guocheng zishu*), completed much later in 1960 and published in 1962, indicates that his prescriptions were actually based on his own experience of learning how to paint.[7] It also becomes clear from his book that in teaching, he followed a program very similar to his prescriptions for curing the "diseases" of Chinese painting.

In an autobiographical chapter of his book, He writes that he had liked painting from an early age and learned by copying paintings that he borrowed from a neighbor. As a child, he writes, he had regarded mountains in paintings and poems and the mountains in nature as unrelated and had deemed the former more beautiful than the latter. But then he started to trace the sources of the Song and Yuan masters, on whose painting modes the painters of the Ming and Qing constantly based their works. Lacking access to Song and Yuan paintings, he turned to painting histories, and from his reading he realized that those paintings were of such a high quality because the painters had actually painted from "real landscapes" (*zhenshan zhenshui*)—the landscapes in paintings were actually derived from this-worldly landscapes. He's early efforts to paint from nature, however, were frustrating. First, he could not find any paintable mountains in

the vicinity of his native Wuxi, as none seemed to feature the sort of "strange peaks" that the seventeenth-century painter Shitao had referred to in his motto "I search out strange peaks to make sketches" (*soujin qifeng da caogao* 搜盡奇峰打草稿).[8] Finally, he set about painting the Stone Gate (Shimen) at local Mount Hui, a formation of two large rocks that resembled the rocks he had seen in paintings. But despite this similarity, and although he tried again and again, he was not able to paint the site satisfactorily.[9] The revelatory moment that solved his problems occurred when he was fifteen years of age, probably in 1905. He went to Yixing on a family errand, and while traveling home by oxcart he suddenly realized that the mountains in the distance actually displayed the "hemp-fiber" and "unraveled rope" texture strokes (*pimacun* 披麻皴 and *jiesuocun* 解索皴), the texture strokes most widely used in literati painting. He even recognized Mi Fu's technique of horizontal dots (*luoqiefa* 落茄法) in a landscape clearing after a rain. Being thus convinced that the canonical, highly formalized texture strokes were actually derived from the natural landscape, he was finally able to paint the Stone Gate in the manner of Jing Hao (ca. 855–915) and Guan Tong (fl. ca. 907–23).[10]

Yi Gu has observed that He's search for a correspondence between landscape formations and highly conventionalized painting techniques was not a singular project but part of a broader trend that attached texture strokes (*cun*) to topographical features.[11] By the late 1920s *guohua* artists had adopted the concept of sketching from nature, or *xiesheng*, and identified it as underlying early Chinese painting from the Tang and Song dynasties, as He did in his proposed remedies for contemporary painting. By the 1930s, outdoor sketching had become a widespread practice among *guohua* artists and was regarded as a major remedy against the unwholesome practices in later literati painting of engaging with the brush modes of earlier masters. This changed conception of the origins of Chinese landscape painting, however, does not imply that artists now adapted texture strokes to serve veristic representations of mountainscapes. Quite the contrary; as He Tianjian's moment of revelation on his journey from Yixing to Wuxi shows, he suddenly perceived the mountains as if they were painted. The ultimate points of reference were the painting methods of the Song and Yuan masters, which He reconfirmed by identifying them in the actual mountains and rock formations.

Therefore, the curriculum that He Tianjian envisions in his *National Painting Monthly* essay on the "symptoms of morbidity," and which he describes as his teaching practice over large sections of *Learning to Paint Landscapes*, is based on extensive copying from ancient masters, from details to large compositions,

from exact tracing to painting from memory, and always in chronological order.[12] He's goal was to turn the painter's brain into a storeroom of styles, techniques, and compositions that could then be freely rearranged and reinterpreted in individual creations.[13] "Learning from nature" (*shifa zaohua* 師法造化) was only the advanced step that followed this foundational training, and it included the verification of the acquired reservoir of painting instruments in nature.[14] The title of another essay that He Tianjian published in 1935 is telling in this regard: "Record of Verifying the Landscape of Eastern Zhejiang in Painting" ("Zhedong shanshui zai huaxue shang zhi zhengyan ji").[15] In this text, he discerns the methods of various ancient masters in the mountains of Eastern Zhejiang; the actual landscape thus serves to verify that the conventionalized techniques of Chinese painting were actually describing real features of the land. The importance of this view of the relationship between painting methods and nature in understanding He's work is underlined by the fact that he transcribed a large portion of that essay in his *Learning to Paint Landscapes*, in explaining his concept of "verifying the rules" as part of "learning from nature."[16] It is natural landscape that serves to confirm the painting conventions, not the painting techniques that are employed to achieve a mimetic representation of a given site.

Site-Specificity and the Canon of Chinese Painting

The episode of first failing and then succeeding to paint the Stone Gate marks a pivotal moment in He's autobiography. It epitomizes the process of learning to see natural rock formations as if they were painted and describes how a training method based on copying old masters, on the one hand, and landscapes encountered in life, on the other, could be reconciled. He Tianjian writes that he painted the Stone Gate once more in his early twenties, using "Wang Hui's interpretation of Li Tang."[17] A painting of the Stone Gate dated 1929 was also reproduced in *The Bee Painting Selection*, the catalogue of paintings by selected members of the Bee Society (fig. 2.1).[18] The choice of this particular painting for this representative publication also points to the importance of the motif for He.

The painting shows how He was grappling with the issue of which painting mode was best suited to render the actual place; it also shows his eclectic use of different modes retrieved from the "painting storeroom" of his memory. The composition is divided diagonally into two parts. The lower right part shows a steep mountainside painted with broad and moist hemp-fiber strokes

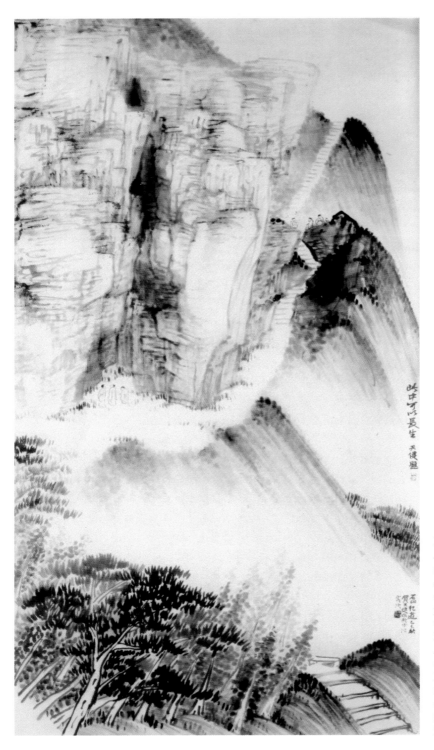

Fig. 2.1. He Tianjian,
*Here One Can Live
a Long Life (Visit to
Stone Gate)*, 1929,
dimensions and
present whereabouts
unknown.
Reproduced from *The
Bee Painting Selection*
(*Mifeng huaji*, ed.
Mifeng huashe)
(Shanghai, 1930),
unpaginated. Photo:
Zhejiang Provincial
Library.

and foliage dots, stylistic elements associated with the repertoire of the Dong Yuan mode. The upper left part is filled by the two rock cliffs of the Stone Gate. They are formed by rectangular strokes that are densely layered on top of each other to suggest spatial recession. In their organization of volume and space, they closely resemble a sketch in *Learning to Paint Landscapes* that illustrates Li Tang's method for painting rocks (fig. 2.2). The texture strokes, on the other hand, show similarities with a sketch in the same book that demonstrates Dai Jin's method (fig. 2.3). Both sketches fail to conform exactly to the characteristic styles of the respective painters as one would conceive them today. But during the Republican period, Song and Yuan paintings were not easily available. Paintings in private collections in the Jiangnan region, as well as those reproduced in the periodicals *Famous Chinese Paintings* (*Zhongguo minghua*) and *Glories of Cathay*, mostly dated from the Ming and Qing dynasties. As he states in his autobiography, He Tianjian solved this problem by reconstructing the styles of ancient masters of the Song, Yuan, and even the Tang dynasty by studying the works of Ming and Qing painters. This practice is also evident in his decision to paint the Stone Gate in "Wang Hui's interpretation of Li Tang." Wang Hui, who like other painters of the seventeenth century frequently painted in the manner of an earlier master (*fanggu* 倣古), thus served as an intermediary whose interpretation of a certain painting mode served as the foil for a reconstructed style of more ancient pedigree.

Regardless of how much Li Tang or Dai Jin is perceptible in the rendering of the rock formations, the picture is dominated by two contrary painting modes. The style of the tenth-century painter Dong Yuan is the hallmark style of literati painting and is associated with the lush vegetation and soft rolling hills of southern China (where the depicted scenery is located). The paintings of Li Tang, whose career spanned the end of the Northern Song dynasty and the establishment of the Southern Song painting academy in Hangzhou, are characterized by rough-edged rock formations that stand for the steep mountains of North China. The early Ming painter Dai Jin based his painting style on the vocabulary of the Southern Song academy, for which Li Tang had laid an important foundation. In terms of the genealogies of the Southern and Northern Schools, which still shaped perceptions of Chinese painting history well into the second half of the twentieth century, Dong Yuan belonged to the former, and Li Tang and Dai Jin to the latter. Before the twentieth century the two modes would not have been used together in one painting. But in He Tianjian's image of the Stone Gate, they are disassociated from these genealogies and their respective

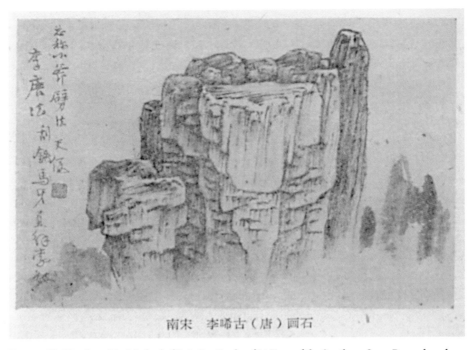

南宋　李晞古（唐）画石

Fig. 2.2. He Tianjian, *The Method of Painting Rocks of Li Tang of the Southern Song*. Reproduced from He Tianjian, *Learning to Paint Landscapes: A Self-Account (Xue hua shanshui guocheng zishu)* (Beijing, 1962), 57. Photo: Staatsbibliothek zu Berlin–Preußischer Kulturbesitz.

connotations.[19] This point is also evidenced in an essay by He Tianjian titled "Exploring the Scenery of Stone Gate," published in 1929, the year in which the painting discussed here was created, but describing a visit he had made in 1923. In the essay, He does not mention his profession; there is only one brief instance in which he makes a reference to painting: describing rocks in a spring below the cliffs, he notes that "the rock patterns form ax-cut strokes," the texture stroke most closely identified with the Northern School mode.[20]

In He's painting, the Dong Yuan and Li Tang/Dai Jin-mode portions of the mountain are separated by a path that leads the viewer's gaze upward, marking a diagonal line across the picture. One group of visitors has climbed far up the path and is taking a rest while waiting for a second group of three men who are standing at the entrance of the Stone Gate. These three are gazing at the narrow cleft between the vertically rising cliffs in front of them. The men, dressed in the gowns of Qing literati and modeled after travelers in paintings by Shitao, probably represent He Tianjian and his companions on the visit that the painting commemorates, according to its inscription. He depicts his alter ego(s) in an act

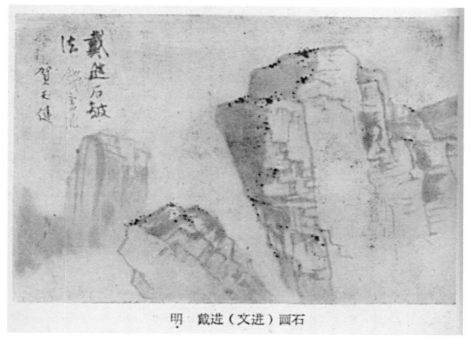

明　戴进（文进）画石

Fig. 2.3. He Tianjian, *The Method of Painting Rocks of Dai Jin of the Ming*. Reproduced from
He Tianjian, *Learning to Paint Landscapes: A Self-Account* (*Xue hua shanshui guocheng zishu*)
(Beijing, 1962), 64. Photo: Staatsbibliothek zu Berlin–Preußischer Kulturbesitz.

of intense observation of the site and its peculiar topography.[21] The intensity of
their viewing correlates with He's prolonged engagement with the place and the
question of how to paint it.

The site-specificity of the painting is also reflected in the tightly framed
composition. The image shows only the rocks of the Stone Gate and the slope
leading up to it. Although just a small portion of the mountain is illustrated, it
fills almost the entire picture plane. In premodern Chinese painting, this kind
of close-up view of a specific site was almost exclusively reserved for album
leaves. In the Republican period, it became a widely used device for portraying
specific places on large hanging scrolls. The framing is ultimately derived from
photographic view-taking (*qujing* 取景) and its adaptation since the 1920s for
outdoor sketching.[22] As such, it indicates that the painting is based on on-site
experience. As an indicator of a personal viewing experience, "zooming in" on
a selected portion of a site is not necessarily linked to mimetic representation
or even linear perspective, despite its origins in photographic viewing practices.
The viewpoint in He's painting is suspended in midair, and he relies on the

figures inside the picture to relate the experience of looking at the landscape. In this regard, He follows the conventions of premodern travel painting.

With its conflicting elements—the stylistic signifiers of the Southern and Northern Schools; their highly conventionalized formulae and a claim to realism derived from the practice of outdoor sketching; photographic framing and staffage figures that guide the viewer—*Visit to Stone Gate* is a highly programmatic painting. It applies the methods acquired through copying ancient paintings to the representation of an actual site, a place with which the painter was well acquainted through numerous visits. The painting thus illustrates three basic elements in He Tianjian's curriculum for the advanced student of Chinese painting, which he also envisions as the recipe for rescuing Chinese painting from its "diseases": exploring and transforming the formal means of the ancients, studying the historical development of different schools and theories, and traveling to famous mountains and great rivers to explore the sources of ancient painting.

These three points can be regarded as the three main themes in He Tianjian's paintings of the 1930s. *Visit to Stone Gate* is rather special in its display of different painting modes and its illustration of He's search for the correct texture stroke to depict certain rocks. Most of He's works from the following years either engage with painting genealogies, or specific sites, or they "explore and transform the formal means of the ancients." I will discuss these three aspects of his work separately.

Learning from Old Masters

He Tianjian took pride in being able to paint in any stylistic idiom of classical Chinese painting, and he put this ability into practice. He modeled his works on various distinct painting modes and added detailed inscriptions on their techniques, historical usage, or how he himself engaged with them. Despite his claim that he studied the different styles and techniques in a chronological way to understand them in terms of their historical development, his actual concern was not with art history or painting genealogies, but with his own painterly and emotional engagement, which differed significantly from earlier practices of *fanggu*, or painting in the manner of old masters. As in He's treatment of historical painting theories in his essay for the *National Painting Monthly* special issue, discussed in the previous chapter, the different modes become effectively

dehistoricized and also disassociated from specific lineages. They now become the plurality of what makes up "Chinese painting"—a timeless stylistic reservoir from which the Chinese painter can freely choose. Four paintings from the early to mid-1930s serve to illustrate this point. All four are large hanging scrolls measuring approximately five *chi*, or Chinese feet, in height, and the inscriptions on all four paintings discuss matters of style and method. But in terms of painting method, they differ widely.

A painting from 1931, published under the title *Mountain Path* (*Zhandao tu*, fig. 2.4), appears to be the result of a digestion of classical models related to one specific painting, according to the inscription:

> Dong Yuan once painted *Traveling in Autumn Mountains*, and Wang Hui copied it in its broad structures. I kept its scenery and changed it to light coloring and flat textures. Now it seems to have a new appearance. There is a saying by Shitao, "The whiskers and eyebrows of the Ancients do not grow on my face."[23] Therefore, there is no need that [the methods of] Dong Yuan or Wang Hui should be [discernible] in this painting.

The painting that He Tianjian refers to here is probably Wang Hui's copy of Wang Meng (ca. 1308–85), *After Dong Yuan's "Traveling in Autumn Mountains"* (fig. 2.5), a leaf from the album *To See Large within Small* (*Xiao zhong xian da*), a set of reduced-size copies of Song and Yuan paintings from the collection of Wang Shimin (1592–1680). This album, now in the collection of the Shanghai Museum, was formerly owned by the Shanghai real-estate entrepreneur and collector Zhou Xiangyun (1878–1943) and may well have been known to He.[24] Wang Hui's album leaf shows a bird's-eye view of a valley between steep mountains. The valley is filled with peasants' houses, stables, carts, waterside buildings, boats, and further up, beneath the extremely high horizon line, an expanse of water. The ridge of the mountain to the left rises almost vertically; it is marked by so-called alum-head boulders and is densely modeled with soft hemp-fiber strokes.

If this painting indeed is the source for He Tianjian's composition, then the only elements that he has kept are the densely clustered alum heads, the elongated vertical composition along a central valley, and the hemp-fiber strokes. As he himself states in the inscription, not much of the original painting is recognizable in this result of a quadruple transfer process—He Tianjian painting after the seventeenth-century artist Wang Hui, who copied a work by the fourteenth-century painter Wang Meng in the manner of Dong Yuan, who lived in the

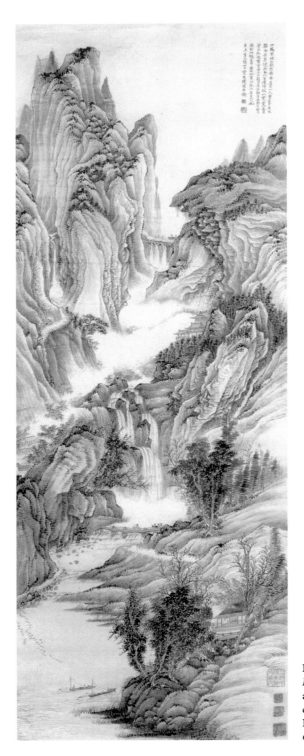

Fig. 2.4. He Tianjian, *Mountain Path,* 1931. Hanging scroll, ink and light colors on paper, 138 × 50 cm. Shanghai Institute of Chinese Painting. Photo: Shanghai Institute of Chinese Painting.

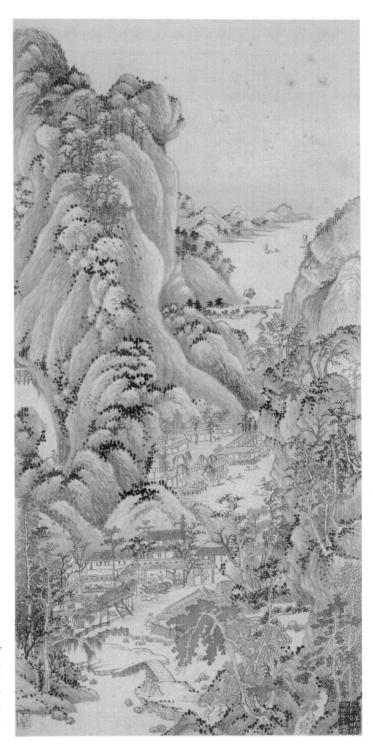

Fig. 2.5. Wang Hui, copy of
Wang Meng's *After Dong Yuan's
"Traveling in Autumn Mountains."*
Leaf from the album *To See Large
within Small*, 1672, ink on paper,
55.5 × 34.5 cm. Shanghai Museum.
Photo: Shanghai Museum.

tenth century.[25] He's painting begins in its lower part like a conventional literati landscape painting, with a mansion between trees by a lake, boats moored at the shore, and a path leading into the depth of the picture, over a wooden bridge and into the mountains. But beyond this bridge, the picture becomes an assemblage of bizarre rock clusters undulating in different directions, unhindered by tectonic coherence or gravity. Travelers ride unperturbedly through this agitated landscape, ascending to ever greater heights. Only in the highest peaks does the landscape finally return to the more tranquil formations that also characterize the mountains in the Wang Hui leaf.

This idiosyncratic composition is a literal visualization of the stylistic reference spelled out in the inscription. The insertion of the protruding and undulating rock formations in the middle section of the painting cite the pictorial idiom of Shitao and correspond to the verbal insertion in the inscription of the seventeenth-century painter's famous saying that the beards of the ancients do not grow on his face. Shitao's statement was a direct attack against the practice of painting in the manner of older masters that played such a central role in late-Ming and early-Qing literati painting. For this reason, the phrase became extremely popular in the twentieth century as an indigenous counter to what, in the light of evolutionist thinking, was regarded as the backward and uncreative self-referentiality associated with the "Four Wangs," one of whom was Wang Hui. The insertion of a double reference to Shitao (visual and verbal) in a painting that sets out as being done in the manner of a copy by one of the Four Wangs of an image painted, in turn, by one of the most canonical literati painters in the manner of an even more ancient artist points to the paradox *guohua* painters were grappling with in the early twentieth century.

In *Learning to Paint Landscapes*, He Tianjian recalled that when he arrived in Shanghai as a young man, paintings in the style of the Four Wangs were virtually the only works that sold on the Shanghai market, despite the attacks against them by reform-oriented intellectuals, such as Chen Duxiu, who wanted to launch a "revolution" against them.[26] The next trend, according to He, was the freehand style practiced by followers of Shitao, which he thought resulted in unsubstantial, bravura paintings. Therefore He himself turned to the styles of the Song and Yuan masters.[27] As noted, he reconstructed those styles on the basis of Ming and Qing paintings—that is, through the lens of the orthodox transmission and interpretation of earlier painting styles that the Four Wangs represented. Paintings like *Mountain Path* suggest a strong, if only partly acknowledged, reliance on the model of Wang Hui. The most technically

accomplished and stylistically versatile of the Four Wangs, Wang Hui displayed a proficiency that He shared. He Tianjian obviously based his manner of outlining billowing clouds, and the sharp yet fluid modeling strokes in the textures of the mountains, and in the trees and the grasses, on Wang Hui's model. Likewise, Wang's synthesis of different styles can be regarded as a precursor to the blending of canonical styles by He Tianjian.

The importance of Wang Hui's precedent for He Tianjian can also be discerned in *Mountain Pass* from 1936 (fig. 2.6). In the inscription to this painting, He claims for himself the models of the tenth-century painters Jing Hao and Guan Tong; he juxtaposes them with the "school" of the Yuan literati painters Huang Gongwang and Ni Zan, stating that he always found the latter too plain and unassuming. He also claims that paintings emerge from under his brush as created by nature. While the composition of *Mountain Pass* corresponds to the monumentality associated with the Jing Hao and Guan Tong mode, the inscription effectively serves to disavow the actual models that the painting cites: the surfaces of the mountainsides are modeled with the long texture strokes that typify the style of Huang Gongwang, the paragon of literati painting that He decries as too "unassuming" in the inscription. Perhaps to counter this fault, He renders the texture with sharp, fluid strokes that turn the soft quality of hemp-fiber strokes into hard-edged crispness.

The clearly drawn paths that wind steeply up the valley in *Mountain Pass*, including travelers and a roofed bridge, are clear references to another Yuan master, Wu Zhen (1280–1354). A probable source for He's interpretation of his mode is again a leaf from the album *To See Large within Small* (fig. 2.7). The modeling of the main peak in He's painting, with dense vegetation on its top, points to yet another emblematic mode, that of Fan Kuan (d. after 1032) of the Northern Song dynasty. He's interpretation of this model is closer to Wang Hui's copy of Fan's *Travelers among Mountains and Streams* in the album *To See Large within Small* (fig. 2.8) than to the eleventh-century original. In the inscription to *Mountain Pass*, however, He Tianjian does not refer to Fan Kuan, Wu Zhen, or Wang Hui.

In *Learning to Paint Landscapes*, He half self-critically recalls that when he was around forty years of age, that is, around the time when he created the paintings discussed here, he boasted that he could paint in any master's style, at any time, without further preparation and that no other contemporary painter could compete with him in this regard.[28] This is again indicative of the paradoxical situation in which He Tianjian found himself. Although he claimed to

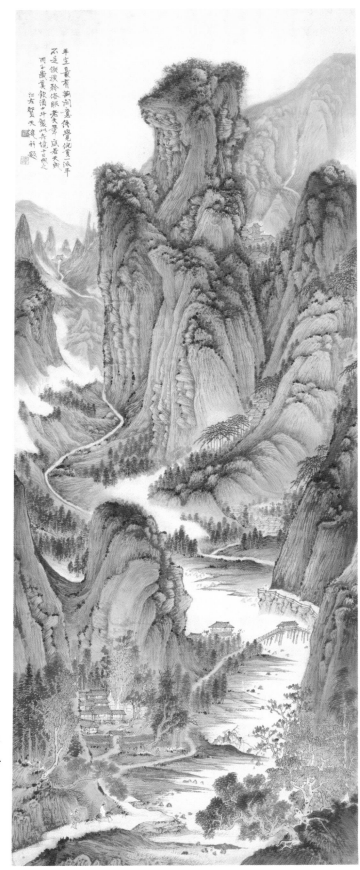

Fig. 2.6. He Tianjian, *Mountain Pass*, 1936. Hanging scroll, ink and colors on paper, 179.8 × 69.2 cm. National Art Museum of China, Beijing. Photo: National Art Museum of China.

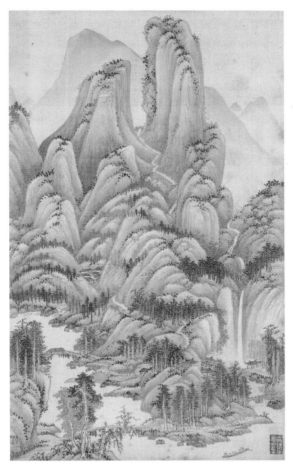 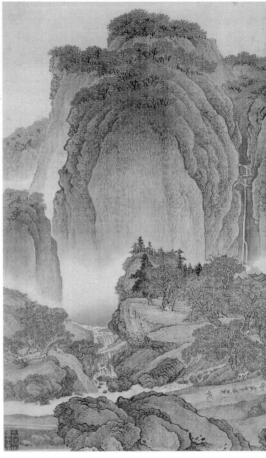

Left: Fig. 2.7. Wang Hui, copy of Wu Zhen, *Mountain Pass on a Clear Autumn Day*, ink on paper.
Right: Fig. 2.8. Wang Hui, copy of Fan Kuan, *Travelers among Mountains and Streams*, ink and colors on silk.
Two leaves from the album *To See Large within Small*, 1672, each leaf 55.5 × 34.5 cm. Shanghai Museum. Photo: Shanghai Museum.

have a historicist view on the development of the various painting styles and techniques, and probably also subscribed to an evolutionist view of history, he and many of his colleagues de facto saw "Chinese painting" as the sum of these historical precedents. The framework of "Chineseness" thus outweighed any stylistic, genealogical, or social differentiation.[29] The formal vocabularies of pre-twentieth century Chinese painting in total were what marked the difference to the European painting traditions. This might also explain why it was so essential for an artist like He Tianjian, who identified himself as painter of *guohua*, to recognize the right texture strokes in the mountains.

He also tackles the dilemma of how to position oneself vis-à-vis the inherited vocabulary in his lengthy inscription on a work painted in yet another manner, a hanging scroll from 1933 published under the title *Traveling in the Mountains of Shu* (fig. 2.9).

> The absence of method engenders the presence of method; it evolves from nature and enters the human realm. The purposeful return from the presence of method to the absence of method evolves from the human realm and enters nature. Without humans, nature cannot manifest itself, and without nature, humans have nothing they can rely on. Therefore it is impossible to have no method, but it is equally impossible to have it. Therefore the method of having method is the basic method; the method of no method is the transformation of method. The people of today have the method of having method, but they don't understand it and carelessly claim that theirs is the method of no method. By now, method is in danger. Alas! We are unlucky to be born after thousands of ancient masters, because they have already created the methods before us. We are also lucky to be born after the ancient masters, because we can grasp their methods and develop them. To be familiar with the old and know the new is the highest principle of learning. But today, people are either [too] familiar or [too] unfamiliar [with the ancient masters]. Those who are familiar [with the ancient masters] take them as the highest possible achievement until the end of their lives, and become the ancient master's printmakers. Those who prefer to stay unfamiliar boast about their creativity; they are all committing crimes against culture. Someone might say: "So what about this painting of yours?" I say: I have been dabbing around since I was seven years old, and have been painting for over thirty years now. I adhered [to the methods of the ancients] for twenty years, and I let go of them for ten years. Now I begin to achieve the spirit of this painting. So what about it?

With the opening sentences, He Tianjian paraphrases Shitao's *Discourses on Painting by the Monk Bittermelon*. He begins with a quotation from the first chapter, where Shitao introduces his concept of the One Brushstroke, or *yihua*: "The establishment of the method of the One Brushstroke sees the absence of methods engender the presence of methods, and the presence of methods embrace the multiplicity of methods."[30] He Tianjian then reinterprets in a synthesizing manner Shitao's discussion of what nature bestows upon humans, of the agency of the artist in the creational act of painting, and of the transformation

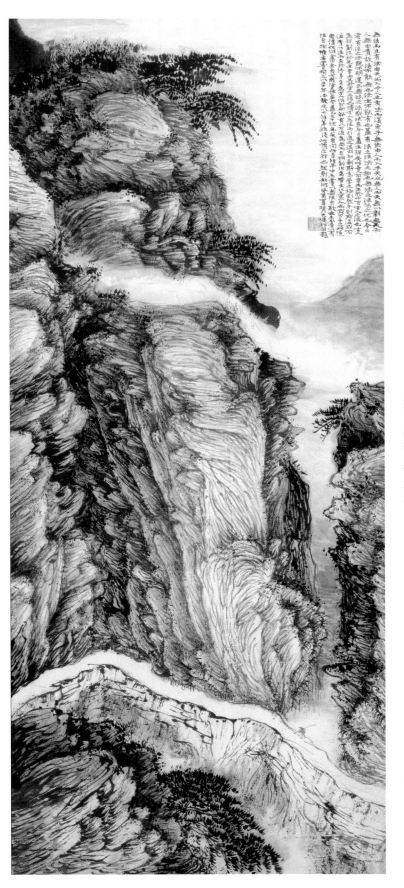

無法品中生有法由夫師之手之有高渾羊子典宋由心之，手尤近典余會無
人無真實故法古亦者有也蓋有法之詩法古法之也含今
者有法於深而中重雖亦微此重至平香
為到剤者者用非法不盡
其本初之剤新重至香

Fig. 2.9. He Tianjian,
*Traveling in the Mountains
of Shu*, 1933. Hanging
scroll, ink on paper,
136.7 × 57.3 cm. Shanghai
Tianheng 2012 Spring
Auction, July 11, 2012, lot
no. 219.

of received methods. Crucial to his argument is the notion of transformation as it is conceived by Shitao in the third chapter of his treatise: "'Antiquity' is but a tool of knowledge; 'transformation' involves recognizing it as but a tool while refraining from using it in this way."[31] This is the point from which He directly addresses the dilemma of the modern artist: to have so many ancient models at one's disposal is both predicament and privilege; one could be caught in the pre-set formulas of tradition, but one could also use them to further progress. His critique of his contemporaries—that they either serve as the printmakers (*yinshuashi* 印刷師) of the ancients or violate Chinese culture by disregarding the inherited methods—anticipates his diagnosis of the "symptoms of morbidity in Chinese painting" published in *National Painting Monthly* two years later and discussed earlier in this chapter. As for himself, He claims, of course, that he does not belong to either group; after having been steeped in ancient methods, he is now able to transform them.

The painting itself, however, is a forthright homage to Shitao. The picture plane is almost completely covered with vertically rising, twisted rock formations. The dense and swirling strokes that cover the stone surfaces give the impression of an almost organic growth. The cliffs' dense arrangement over the painting surface creates a spatial ambiguity that is underscored rather than mediated by the white band of a mountain path with a wanderer in the lower part of the painting and a wisp of clouds echoing the path's contours higher up. In this ambiguity, the painting is comparable to Shitao's *Thirty-Six Peaks of Mount Huang Recollected*, now in the Metropolitan Museum of Art in New York. A more immediate source for the diagonally projecting rocks and the animated brushwork in the densely textured surfaces of He Tianjian's painting is Shitao's *Cinnabar Cliff and Deep Valley* (fig. 2.10). Now in the collection of the Palace Museum, Beijing, it was on display in the 1928 Tokyo exhibition *Famous Paintings of the Tang, Song, Yuan, and Ming Dynasties* and was illustrated in *Asahi Shimbun*'s special number on the exhibition.[32] According to the special number, it was on loan from the Beijing collection of the government official Guan Mianjun (1876–1933). More important for this discussion is the fact that it was reproduced in the fourth number of *National Painting Monthly*, as an illustration accompanying He Tianjian's article "Why Landscape Painting Is the Primary Painting Genre in China."[33]

A painting that more clearly shows how He Tianjian attempted to "grasp the method of the ancients and develop them," as he phrased it in the inscription on the 1933 *Traveling in the Mountains of Shu*, is the painting *Donkey Rider*,

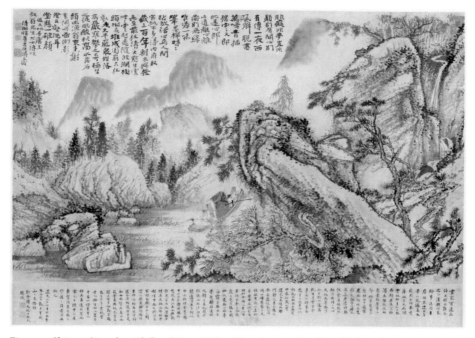

Fig. 2.10. Shitao, *Cinnabar Cliff and Deep Valley*. Hanging scroll, ink and light colors on paper, 104.5 × 165.2 cm. The Palace Museum, Beijing. Photo: The Palace Museum.
This painting was reproduced in *National Painting Monthly* 1, no. 4 (1935): 55.

dated 1936 (fig. 2.11). The loosely painted composition centers on what can be considered He Tianjian's most ubiquitous painting elements: a path of wooden planks clinging to a steep cliff and a traveler riding on a donkey.[34] Visually, the image is dominated by the elongated crisp strokes that appear in several of He's paintings from the 1930s. In the inscription he explains them as follows: Wang Meng had used the brush technique of seal script in his painting, thus establishing his own style, while he himself, He Tianjian writes, had combined the techniques of cursive script with the methods of the Song and Yuan masters, likewise establishing a new path. What He describes as cursive script technique here apparently refers to the swift, fluid movements of the brush over the paper surface, varying from dry to wet strokes, from lighter to darker ink. The rock formations within the mountain peaks are differentiated through variations in the orientation and density of the strokes, as is the overall spatial structure. The speed of the brush and the loose texturing generate a general impression of spontaneity, and the brushwork thus conforms to the aesthetic ideal associated with cursive script calligraphy. Only in the lower part of the painting does the landscape materialize in more legible detail, with the two donkey riders

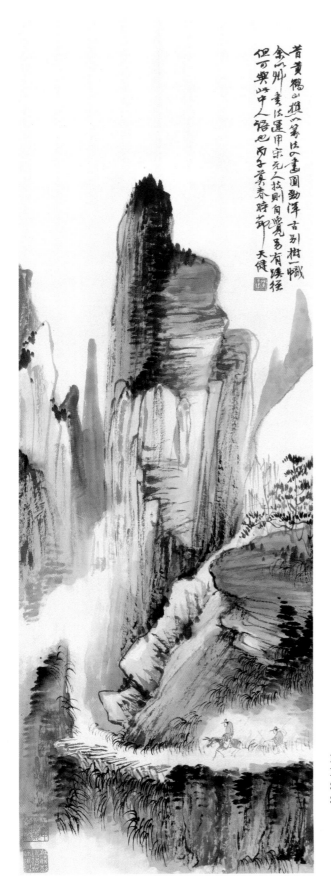

昔黃鶴山樵以篆法入畫圓勁渾古別樹一幟
余此幀畫法運用宋元人技則自覺易有溪徑
但可與此中人語也丙子莫春時節 天健

Fig. 2.11. He Tianjian, *Donkey Rider*, 1936.
Hanging scroll, ink on paper, 115 × 38 cm.
Shanghai Institute of Chinese Painting. Photo:
Shanghai Institute of Chinese Painting.

proceeding on a clearly defined path amid grassy vegetation. The allusion to the "techniques of the masters of the Song and Yuan" remains fairly vague; He was probably referring to the totality of brush methods available to him, which he applied in the speedy and spontaneous-looking mode of cursive script. He thus has interpreted the "methods of the ancients" in a new way. Moreover, in claiming to have created a new style, he places himself on a par with Wang Meng, one of the Four Masters of the Yuan and a paragon of literati painting.

The Song, Yuan, and early Qing models that He cites in these paintings form the majority of the pool of methods from which He Tianjian drew to develop his own style. In the next section, I discuss how he put those methods to use in paintings that make no explicit reference to earlier masters and can therefore be held as painted with He's own method, analyzing those works that He himself chose for illustration in the publications he edited: *Collection of Famous Modern Chinese Paintings* and the final issue of *National Painting Monthly*.

Reinterpreting the Canon

Several characteristics of the paintings just discussed appear in the work that He Tianjian chose to publish in *Collection of Famous Modern Chinese Paintings*, the catalogue of members of the Chinese Painting Association published in May 1935. The painting's title is given as *Flying Current (Feiliu)*, and it dates from the same year, 1935 (fig. 2.12). Its present whereabouts are unknown, but so far as can be discerned from the halftone reproduction, it is an eclectic pastiche combining motifs that are also found in He's explorations of different painting styles during the 1930s. Again we see a donkey rider on a mountain path (no planks this time) amid vertically rising cliffs. He pauses to gaze across the white chasm of a bottomless valley, toward a waterfall cascading in two streams over a rock face. The handling of the waterfall is awkward: four streams feed into it, two of which emerge out of the cliff shortly before the confluence. No hint is given of their source. Instead, it looks as if the rocky surface of the cliff is melting into the waterfall. The mountains proper are also marked by formal inconsistency. They emerge as densely structured round boulders in the lower part of the picture; higher up they are formed out of twisting and curling shapes reminiscent of the Wang Hui–Dong Yuan–Shitao stylistic mix in *Mountain Path* (see fig 2.4). They are topped by pines that resemble those on countless paintings of Mount Huang produced during the Republican period. The main peak rising above the

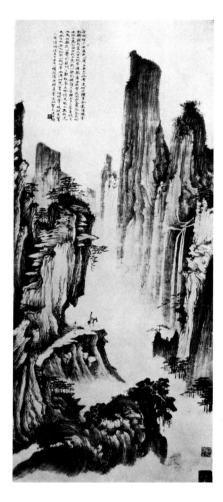

Fig. 2.12. He Tianjian, *Flying Current*, 1935,
dimensions and present whereabouts unknown.
Reproduced from *Collection of Famous Modern
Chinese Paintings* (*Zhongguo xiandai minghua
huikan*, ed. Zhongguo huahui bianyibu) (Shanghai,
1935), unpaginated. Shanghai Museum Library.
Photo by the author.

waterfall is, in turn, an elongated version of the Fan Kuan–mode mountaintop
seen in the 1936 *Mountain Pass* (see fig. 2.6), here rendered in He's "cursive script
technique," with long, swiftly painted but densely layered brushstrokes.

The inscription above this assemblage of disparate elements frames them as
the objects of inner vision. It is not entirely legible in the reproduction, but from
what can be read, it is rather self-aggrandizing, with the character "I" appearing
over and over again, mostly in the compound *wo xin* 我心, or "my heart-mind."
One passage reads, "The marvels of the five marchmounts and the three moun-
tains are in my heart-mind," and another, "The greatness of heaven and earth is
not greater than my heart-mind." The emphasis on individual perception echoes
Shitao's *Discourses on Painting*, as does the phrase "The ten thousand differences
in things are unified by me."

In Shitao's treatise, the relation between one (*yi*) and ten thousand (*wan*), or the totality of things (*wanwu*), is a recurrent theme, beginning with the first chapter. Shitao writes that the One Brushstroke "is the origin of all things, the root of all phenomena"; in the concluding sentences of the same chapter, he states that it makes all things visible.[35] According to Jonathan Hay's reading of the first chapter of *Discourses on Painting*, "Oneness (*yi*) denotes the continuity of being that unites the Self (*wo*) and the phenomenal world. . . . Materialized in the One-stroke, Oneness is an affair of the body as much as the mind."[36] The issue of one and ten thousand is again taken up in a passage in the eighth chapter, "Mountains and Streams," where Shitao writes: "If Oneness is not clearly understood, then inhibitions will arise in the depiction of the ten thousand things. But if it is thoroughly understood, then the ten thousand things can be fully depicted. The natural order of the painting and the methods of the brush are nothing other than the substance and the exterior appearance of Heaven and Earth." Shitao conceives the process of representation as a form of communion of landscape and self, which he describes almost as a mutual embodiment later in the same chapter: "Landscape is born out of me and I am born out of it. I seek out extraordinary peaks to turn into paintings; our spirits meet and all traces of us disappear."[37] Anne Burkus-Chasson has discussed this latter passage in relation to ideas about sensory perception in the writings of the Ming-dynasty philosopher Wang Yangming (1472–1529), most notably the notion that "the mind is one body with all the myriad things."[38]

What is described in He Tianjian's inscription, however, is not a spiritual communion with nature, despite its intertextual resonances with Shitao's *Discourses on Painting*. Here, nature is thoroughly internalized and turned into an instrument for expressing individual moods and the painter's conception, or *yi*. This term, which denotes another central concept in Chinese painting theory, is commonly translated into English as "idea" or "conception." He Tianjian, in his article "Why Landscape Painting Is the Primary Painting Genre in China" in the special issue of *National Painting Monthly*, glosses it as "what in psychology is called 'imagination,'" using the neologism *jiaxiang*.[39] Landscape is completely internalized and fictitious, and it can be rearranged in fantastic forms that even surpass nature. The importance of artistic imagination that underlies He's neologistic usage in his article, which was published only a few months before the painting, is more in keeping with Ni Yide's insistence on the priority of artistic vision over nature in his contribution to the special issue than with Shitao's mutual embodiment with mountains and streams.[40] Thus, while

the phrase "my heart-mind" seems to draw on the philosophy of the School of Mind and Shitao's writings, the sheer repetition of the phrase accords a central role to the self that points to a modern conception of artistic genius, for which Shitao's writings serve as the native foil.[41]

Another aspect that should be considered in the context of He's confident exposure of the self in the inscription is the venue where the painting appeared. As discussed in the previous chapter, *Collection of Famous Modern Chinese Paintings* was mainly published for the members of the Chinese Painting Association. Its goal was to make individual members' work known to the other members throughout the country. As such, it can be seen as a prime venue in which to advertise one's paintings; as a matter of fact, a number of commercial advertisements were also included in the book.[42] He Tianjian, as the editor of *Collection*, was highly sensitive to issues of visibility and promotion. As we learn from his autobiographical account in *Learning to Paint Landscapes*, he did not lack self-confidence; this is also evidenced by the more genealogical inscriptions in the works just discussed, which all end with a confident self-assessment. He may well have taken the opportunity to make an even stronger, if barely legible, statement on his artistic capacities in a publication addressed to his peers.

He Tianjian did not republish this painting in the last issue of *National Painting Monthly*, although he took almost all the other illustrations for that number from *Collection*. Instead, he illustrated two other paintings of his, both dated 1935. Like the other landscape paintings in that issue, both of his works have the plain title *Landscape (Shanshui)*. One painting shows a lake outside a city wall; the other is a mountainscape.

The mountain scene was later published under the title *Town Wall by a River and Floating Clouds (Jiangcheng xingyun)* (fig. 2.13).[43] According to the inscription, it depicts a scene that He had seen in a dream the night before. He said he dreamed of climbing a steep mountain path and passing beyond the clouds. In the inscription he describes the swirling "heads" of the clouds in his dream as an exceptionally strange and fantastic view (*qiguan* 奇觀). The painting itself shows a band of billowing clouds streaming down the mountainside like a waterfall, indeed conveying a dream-like quality. The dreamer can be identified as one of the donkey riders about to enter the cloudy whiteness on another path of wooden planks. The strangeness of the view is also underscored by the twisted rock formation leading up to the main peak and by the painting's palette of transparent green and ochre. The twisted rocks are again a reference to Shitao. This reference is efficacious in conveying the notion of the *qiguan*, the strange

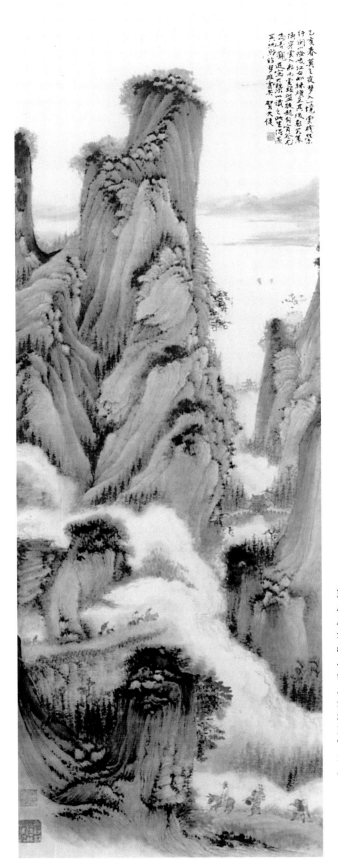

乙亥春莫之夜夢入一境雲戀蒼蒼
行間按近江石如綠樓正其後點萬率
臨溪寒小船水蒼路極起有青發光
為考聞逸偽不樂一誤之地生蒼墨
五池野路萬雅蒼染 賀天健画

Fig. 2.13. He Tianjian,
Landscape (*Town Wall by a
River and Floating Clouds*),
1935. Hanging scroll, ink
and colors on paper, 121 ×
44 cm, present whereabouts
unknown. Reproduced from
He Tianjian huaji (Shanghai,
1982), plate 13. Photo:
Staatsbibliothek zu Berlin–
Preußischer Kulturbesitz.
This painting was
reproduced in *National
Painting Monthly* 1, nos. 11/12
(1935): 223.

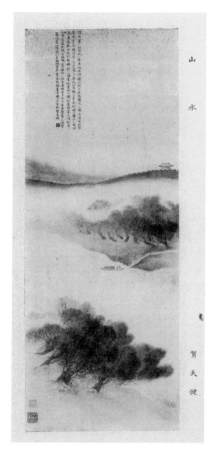

山

水

賀

天

健

Fig. 2.14. He Tianjian, *Landscape (Parting at Xuanwu)*, 1935, dimensions and present whereabouts unknown. Reproduced from *National Painting Monthly*. 1, nos. 11/12 (1935): 224. Photo: Shanghai Library.

and fantastic view, and a dream-like vision, as the pictorial idiom associated with Shitao represents the highly personalized experience of perception.

Shitao is not the main stylistic reference in the painting, however. The principal mountain peak blends the formal idioms associated with Fan Kuan and Wu Zhen, much like the image in *Mountain Pass*, which He painted the following year (see fig. 2.6). Again, the modes of these Song and Yuan masters are rendered in a synthesizing manner that points to their interpretation by Wang Hui as He Tianjian's source. Similar to *Flying Current*, the painting combines diverse stylistic modes that are not fully compatible, but here they harmonize much more smoothly. The resulting composition is less eccentric, despite the dreamy quality evoked by the flowing clouds crossing the picture and the slightly otherworldly palette of cool grayish-green tones.

The second painting that He Tianjian published in the last number of *National Painting Monthly* is quite different in composition from the landscapes discussed thus far (fig. 2.14). There are no steep mountain peaks and deep valleys, and no travelers are making their way on narrow mountain paths. Instead, the painting shows a view over the embankments of a body of water that divides the picture on an approximate diagonal. The movement of the blank water surface is countered in the background by a white band of mist swallowing the rear part of a grove. The course of the mist is paralleled and overlain by the levitating contour of a city wall. The narrative component of the painting centers on the figures of two men, visible only as white schemes in the *National Painting Monthly* reproduction; they stand at the end of a path leading to the lakeshore, where a boat has moored and is now about to set out. The two men seem to be bidding their farewells— one of them will make a trip on the boat, the other will return to the city hidden behind the wall in the background.

The inscription identifies the site as Xuanwu Lake in Nanjing. Unfortunately the inscription is basically illegible in the reproduction, and the end of the text, which appears to be a personal account of the circumstances of the painting's

creation, cannot be deciphered. On a forgery that appeared on the auction market in 2001 that is very close to He's original, about two-thirds of the original inscription is transcribed, a long poem in classical style on the poetic trope of "remembering the past at Jinling" [i.e., Nanjing].[44] The melancholic tone of the poem combines the grief associated with the coming of autumn with the commemoration of fallen dynasties at the location of their former capital.[45] This is translated into the painting in its detached view over the curving lake and the agitated willow trees in the foreground, whose branches blow to the left against the direction of their trunks, which lean to the right over the bank, while the walls of Nanjing serenely sway in the background. The narrative theme of the parting scene adds to the atmosphere of sadness.

This painting, with its wide vista and delicately painted, lively foliage, represents a mode in which He Tianjian executed several paintings. In a work from 1933, *Waiting for the Ferry in Willow Shades, after Ma Hezhi* (fig. 2.15), He inscribed a brief discourse on the historical sources of his method for dotting willow foliage, its technical difficulties, and his own practice. Locating the beginnings of this method in the Tang dynasty, he names two particular Song-period painters, Zhao Lingrang (fl. ca. 1070–after 1100) and Ma Hezhi (fl. second half 12th c.), who excelled in the technique. He states that he created his own painting from memory after a work by Ma that he had previously failed to copy successfully. However, a painting like *River Village in Autumn Dawn*, attributed to Zhao Lingrang in the collection of the Metropolitan

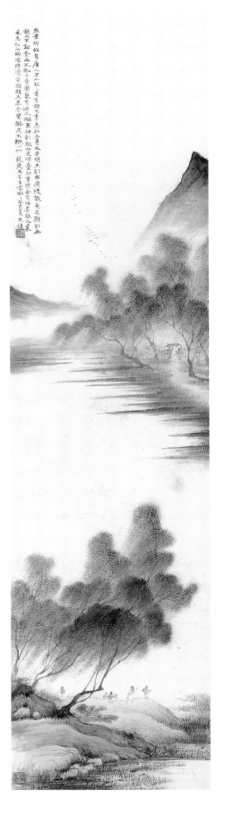

Fig. 2.15. He Tianjian, *Waiting for the Ferry in Willow Shades, after Ma Hezhi*, 1933. Hanging scroll, ink and colors on paper, 132 × 32 cm. Sungari Ltd., 2014 Autumn Auction: Daobotang Private Collection, December 6, 2014, lot no. 525. Photo: China Guardian Auctions.

Museum of Art in New York, appears to be an equally important source for He's lakeside vistas and willows with downy foliage and exposed roots on the banks.

In *Parting at Xuanwu Lake*, He combines the poetic trope of "remembering the past at Jinling" and a pictorial formula based on Southern Song models to illustrate a personal memory of a certain time and place. The way in which he deploys poetic and pictorial conventions to depict this site differs markedly from *Visit to Stone Gate*, discussed earlier. This difference is in fact characteristic of He Tianjian's paintings. Not only did he apparently enjoy switching from one mode to another, but his theory of verifying the ancient models in nature also led him to adopt different styles and techniques for different landscapes when he painted specific places.

Learning from Nature

One instance in which He Tianjian combined what might be called his lake mode with his mountain mode to strong visual effect is the painting *Near Lanxi*, dated 1936 (fig. 2.16). It shows a view across a broad expanse of water with flat, marshy shores, closed off on the far side by a steadily rising mountain slope. Set off against this plain and placid background is a steep rocky cliff that blocks the view on the left side of the painting. Drawn in fluid lines and colored in deeper tones, the cliff contrasts with the subdued brushwork, diluted pigments, and undefined spatiality of the background slope. Navigating between these two contrasting shores are two sailing ships and a smaller boat. The inscription locates the scene at the head of Seven Mile Gorge (Qililong) and states that it was painted in memory of a journey to Eastern Zhejiang. He Tianjian documents this journey, undertaken in 1934, in several paintings, as well as in his aforementioned essay "Record of Verifying the Landscape of Eastern Zhejiang in Painting," which was published in the travel anthology *In Search of the Southeast* in March 1935.[46] He also refers to it repeatedly in *Learning to Paint Landscapes*. As such, the trip can be regarded as a crucial point in He's career with regard to painting from nature.

He's journey was one of the trips organized in the context of the Southeastern Infrastructure Tour, which led to the publication of *In Search of the Southeast* and will be discussed in the next chapter. One of the tours led south from Hangzhou along the newly built railroad that crossed the provincial border into Jiangxi. The route followed the fluvial system of the Qiantang River; it also included an

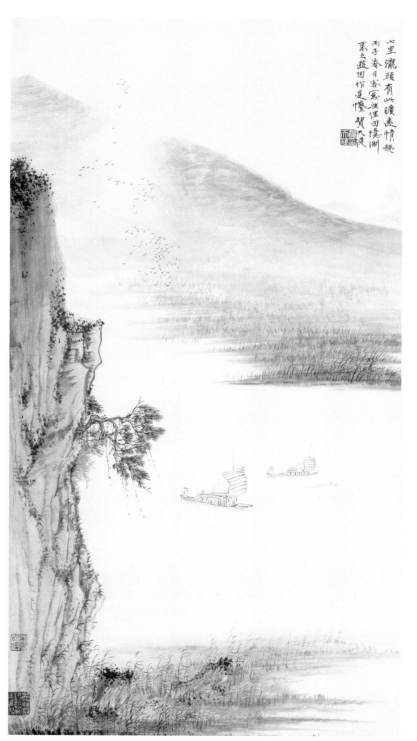

七里瀧頭有此曠遠情趣
丙子春日客寇興俚曰憶湖
東之遊因作是懺 賀天健

Fig. 2.16. He Tianjian,
Near Lanxi, 1936.
Hanging scroll, ink and
colors on paper, 101.8
× 54.3 cm. National
Art Museum of China,
Beijing. Photo: National
Art Museum of China.

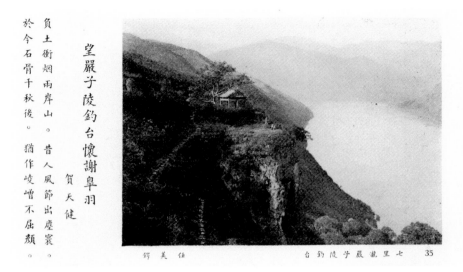

Fig. 2.17. Ren Mei'e, *The Yan Ziling Fishing Terrace in the Seven Mile Gorge*, ca. 1934, photograph; and a poem by He Tianjian, "Gazing at Yan Ziling's Fishing Terrace and Thinking of Xie Gaoyu." Reproduced from *In Search of the Southeast* (*Dongnan lansheng*) (1935), "Along the Hangzhou-Yushan Section of the Zhejiang-Jiangxi Railroad, the Hangzhou-Guangfeng Highway, and the Fuchun River," 31. Photo: Shanghai Library.

excursion over the Xianxia Ridge at the border with Fujian Province. He Tianjian was a major contributor to the section of *In Search of the Southeast* dedicated to this route, authoring eleven poems on his experience of the landscape. The title of one poem is "Gazing at Yan Ziling's Fishing Terrace and Thinking of Xie Gaoyu." Yan Ziling's Fishing Terrace is a famous site along the Seven Mile Gorge; the mountain terrace high over the river became iconic thanks to multiple representations of it in Republican-era photography.[47] One such photograph, taken by Ren Mei'e (1913–2008), was printed next to He's poem in *In Search of the Southeast* (fig. 2.17).[48] Ren's photograph shows the Fishing Terrace as a mighty, dark mountain silhouette with a rocky cliff highlighted by the sun. It looms against the pale band of the river and a mountain ridge in the background that is veiled in misty sunlight. The river, viewed from above, stretches upward from the lower part of the image until the view of it is blocked by the mountains that line its banks. The composition of this photograph clearly served as the model for He Tianjian's painting, although his much lower viewpoint below the cliff is incongruent with the spatiality of the river and the background slope, both of which rise on a tilted picture plane. The cliff in He's painting can be identified in the surface of the rock cliff directly below the Fishing Terrace in the photograph, complete with a pine tree hanging out over the river.

What He Tianjian describes in the inscription as his memory of his visit to the site is mediated by the interpictorial reference to the photograph by Ren Mei'e. The contrast in tonality that marks Ren's image is transformed into contrasts in perspective, brushwork, and pictorial mode in the handling of foreground cliff and background slope in He's painting. The photographic view on which the composition is based is obscured in the painting, which shows no obvious traces of any pictorial devices stemming from realist painting or photographic image making. Quite the contrary, the discrepancy between the two sides of the painting and the unresolved spatiality pull it away from realistic representation. But they equally mark the difference between classical Chinese painting conventions and this work, which is genuinely modern.

In his essay "Record of Verifying the Landscape of Eastern Zhejiang in Painting," He describes the main scenic sites that he encountered during the journey from the perspective of a painter. As in his account of his teenage revelation when he began to discern distinct texture strokes in actual mountains, He describes the mountains and rivers of Eastern Zhejiang in painting terminology. He renders his travels through particular landscapes as sequences of encounters with the various texture strokes associated with different painters. Not only does he describe the landscape in relation to how it could be painted, but as he perceives geographical formations in terms of pictorial means, the landscape itself seemingly becomes a painting. This voyage across painting modes takes on a particular intensity in the section recounting the journey by boat on the Lan River upstream from Seven Mile Gorge, when the speed of the boat accelerates He's passage by the landscape's painting modes:

> Lan River is the part [of the Qiantang River fluvial system] from Lanxi to Yandong Pass. Ridges, foothills, peaks, cliffs, turrets, summits, rock faces, and valleys are endlessly layered in a panorama; the dragon veins form a tight rhythm. As a painting, it belongs to the school of Dong Yuan, Juran, and Wu Zhen. For texture strokes, use "unraveled rope," "broken band," "hemp fiber," and "bean husk" strokes. Our boat traveled in the midstream current, and at this time the clouds and mists gathered, wind and rain suddenly set in, with every step the forms changed, to every side there was a new realization, some [views] resembled the method of the Elder and the Younger Mi [i.e., Mi Fu and his son Mi Youren]. "Holistic dots" [*hundian* 渾點] were densely layered. In painting, the ink methods you would have to use are the "broken," the "spread," the "splashed," and the "layered." For

coloring, use "snail blue" [*luoqing* 螺青] and add a little black-green [*youlü* 黝綠], then you will grasp its spirit.[49]

In this brief and swiftly evolving account, the listing of diverse landscape formations, painting schools, texture strokes, and ink methods forecloses any coherent advice on how to paint the landscape one sees while traveling by boat along the Lan River. At first, He appears to prescribe how to paint it, for example when he writes very precisely which pigments should be used. However, the other techniques that he names are too diverse to be combined in a single painting. Instead, they serve as descriptive means of translating the visual impressions. He gathers them, in quick succession, into a terminology that enables a readership familiar with painting terminology to reproduce the vistas in their minds.

In his account of his visit to the Five Cataracts, a series of waterfalls in the vicinity of the town of Zhuji, He again lists various techniques and drops the names of numerous earlier artists.[50] Here the list is engendered not by the author's swift movement through a changing landscape under varying weather conditions, but by the mountain forms, rock surfaces, and boulders that call to mind the multitude of pictorial devices required to adequately depict them. How He Tianjian in fact translated these multiple visual impressions into painting can be studied in the work that accompanied his essay as a color reproduction (fig. 2.18). In the inscription on *The Fourth Cataract of the Five Cataracts in Zhuji*, he recounts his visit to the Fourth Cataract in a narrative very similar to that recounted in the essay; in the following summary I combine both versions. The Fourth Cataract was so difficult to reach that only birds and monkeys could go there; no one from the tour group had seen it. He and Zeng Shirong (1899–1996?)—a railroad engineer in the service of the Zhejiang Province Bureau of Reconstruction who contributed several photographs to *In Search of the Southeast*—climbed up from the Fifth Cataract by holding on to vines and stepping on protruding stones in order to get a glimpse of its rare and beautiful scenery.[51] Again wind and rain set in, making the climb the most dangerous but also the most precious moment of the whole trip. At this point in the inscription, He adds a remark that is omitted in the essay, but which is nonetheless crucial for understanding his painting. He writes that only immortals could have taken a photograph of the site (presumably because they are able to fly), and therefore he made the painting to commemorate the event. At this point, the conception of natural landscapes in terms of conventionalized brushwork serves as an effective aide-mémoire. At the end of the inscription He notes the

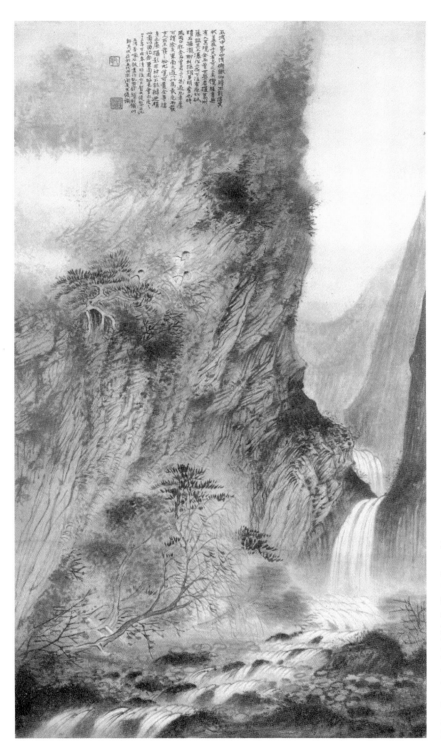

Fig. 2.18. He Tianjian, *The Fourth Cataract of the Five Cataracts in Zhuji*, 1934. Ink and colors on paper, dimensions and present whereabouts unknown. Reproduced from *In Search of the Southeast (Dongnan lansheng)* (1935), "Miscellany," 1. Photo: Shanghai Library.

modes in which this particular site was to be painted: "The texture strokes for the peaks at the Five Cataracts should be 'entangled brushwood,' 'nail head,' and 'scratched iron,' then you can learn from its appearance. It is between [the painting modes of] the Five Dynasties and the Northern Song." This advice on texture strokes applies perfectly to the strokes He actually employed to model the cliffs in his painting. The reference to Five Dynasties and Northern Song painting serves to underscore the fact that the viewer is confronted with steep and rocky mountains.

The moment of viewing the inaccessible Fourth Cataract is figured on two levels in the painting. On one level, He represents it in the three figures precariously perched on the cliff and leaning forward to catch a glimpse of the cataract gushing through the gorge below them. The two figures in white are easily identified as He Tianjian and Zeng Shirong; the third, who is slightly set apart, is not mentioned in He's texts and might be a local guide. Their dangerous climb, which was only possible by taking hold of the vegetation, and their eagerness to look are captured in the group as they sit in the grass and the tree, clinging to the cliff and all looking in the same direction.

On a second level, the act of viewing is represented in the perspective that He employed in the painting. The viewpoint is very low, roughly at the level of someone standing on the bank of the stream in the foreground. Basically following a linear perspective, He leads the viewer's gaze into the depths of the gorge, following the current upstream. To both sides and in the background, the view is blocked by almost vertical cliffs. The painting thus adopts the position of a photographic view, deliberately deploying the confinement of a camera viewfinder's rigid frame. *Guohua* painters of the 1930s often modeled their ink paintings on photographic compositions.[52] However, as Yi Gu has remarked, "many waterfall paintings of the Republican era suggest that painters remained uneasy about their ability to reconcile their knowledge of framing with their desire to produce the wide vista hailed in painting conventions."[53] Artists therefore sought recourse in a high vantage point that would enable them to paint a panoramic view of a certain place. The use of a decidedly photographic perspective for the *Fourth Cataract*, which is very unusual in He's oeuvre, underlines the circumstances in this case; painting achieves what would be impossible for photography, unless the photographer were a flying immortal: to make a picture of this inaccessible place.

Only one photograph taken at Five Cataracts Mountain is included in *In Search of the Southeast*. The picture, taken by Shi Zhenhuai, shows a close-up

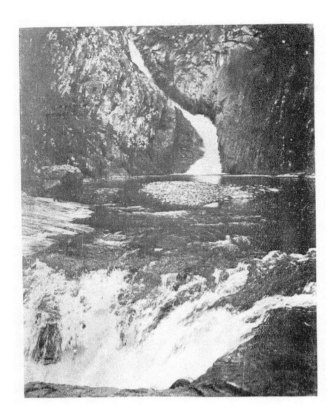

Fig. 2.19. Chen Wanli, *The Fourth Cataract of the Five Cataracts (Zhuji)*, ca. 1928, photograph. Reproduced from *Scenic Sites in Eastern Zhejiang* (*Zhedong jingwu ji*, ed. Hangzhou tieluju) (Hangzhou, 1933), unpaginated. Photo: Zhejiang Provincial Library.

view of the currents and conveys nothing of the inaccessible cliffs described by He Tianjian.[54] Since *In Search of the Southeast* is essentially a photo book with only a few reproductions of paintings and with sequences of photos dedicated to most of the featured places, the lack of photographs of the Five Cataracts might serve as proof of the difficulty of taking pictures at that specific site. He's remark, that only an immortal would be able to take a photograph of the Fourth Cataract, also hints at the fact that his companion Zeng Shirong, one of the most prolific contributors of photographic images to *In Search of the Southeast*, was apparently unable to do so—no photograph of the Fourth Cataract appears in the book.

However, He Tianjian's statement can be countered with a photograph that he very likely knew. Chen Wanli (1892–1969) took a photograph of the Fourth Cataract, probably during a visit in 1928 (fig. 2.19). It was reproduced in *Scenic Sites in Eastern Zhejiang* (*Zhedong jingwu ji*), a predecessor to *In Search of the Southeast* published in 1933.[55] The viewing angle in Chen's photo is almost identical to the one construed by He in his painting, making it very likely that He

was actually citing Chen's image. The fact that He Tianjian disavows his indebtedness to photography by pushing it into the realm of the fantastic speaks to the competitive nature that characterized intermedial references between painting and photography in modern China.

Such intermedial references underlay much of Republican-era *guohua*. The relationship between these two media was one of mutual borrowing: many ink painters adopted photographic framing in their compositions, and many photographers strove for a pictorialist aesthetic based on Chinese landscape painting.[56] But it was also one of competition, at least from the point of view of the *guohua* painters who felt themselves struggling for cultural survival, as the discussions in *National Painting Monthly* amply demonstrate. The idea that the inherited techniques of ink painting were better suited than photography to depicting the landscapes of China, as proposed by He Tianjian in the case of the Fourth Cataract, was an argument of essential importance. The complex and creative relationship between *guohua* and photography is a recurrent theme in the following chapters. The travel anthology *In Search of the Southeast*, the subject of chapter 3, played a crucial role in the transmedial practices that characterized this competitive liaison.

In Search of the Southeast
Writing and Picturing Travel

On first impression, *In Search of the Southeast* is an anthology of travel literature, learned essays, landscape photography, and painting. This perception is supported by its Chinese title, *Dongnan lansheng*, which translates literally as "Searching out scenic sites in the Southeast." Its English title is more poetic and might be an allusion to Marcel Proust's novel *A la recherche du temps perdu* (*In Search of Lost Time*, 1913–27). The background to the volume's production, however, was more pragmatic and closely tied to the GMD government's modernization and nation-building efforts.

In Search of the Southeast was published in 1935 by the Southeastern Infrastructure Tour Propaganda Group, under the auspices of the National Economic Council (hereafter NEC), the government agency responsible for highway construction.[1] The Southeastern Infrastructure Tour was conceived as a publicity campaign for an infrastructure project spanning five provinces in southeastern China; the name also became a synonym for the planning group and other events related to the tour. *In Search of the Southeast* proved to be the campaign's major outcome, but in its initial stages the campaign was expected to be much broader. One can trace the tour's planning through its coverage in the Shanghai newspaper *Shenbao*.

In February 1934, *Shenbao* reported that Jiang Jieshi had ordered an infrastructure campaign to speed up the construction of new highways and connections to the existing highways that linked the five provinces of Jiangsu, Zhejiang, Fujian, Anhui, and Jiangxi. The campaign's declared objective was to "further cultural progress, the development of transportation, the flourishing of trade,

convenience for the military, defense against bandits, and the enhancement of public security." The person responsible for executing the campaign was Zeng Yangfu (1898–1969), who served as director of the Construction Bureau of Zhejiang Province from 1931 and 1935 and was appointed head of the Fujian-Zhejiang-Anhui-Jiangxi Border Region Highway Office.[2] Road construction was a high priority for the Nanjing government, and it progressed at a rapid pace.[3] Construction work on the transprovincial roads was supposed to be completed by the end of June of that year.

To celebrate the project's completion, a twenty-day Southeastern Infrastructure Tour was planned, with exhibitions of local produce and customs as well as of educational material on road safety to be presented at designated stations. Stops on the tour included places famous for their scenic beauty, such as Mount Yandang in Zhejiang Province and Tiger Hill in Suzhou, Jiangsu Province.[4] But apparently the construction work did not move along at the expected speed. The tour had to be postponed, and by early May its start had been rescheduled for October 10, the National Day of the Republic.[5] Plans for the tour were presented in more detail in a supplement to *Photography Pictorial* (*Sheying huabao*) in August: a group of high government officials, foreign diplomats, and businessmen would tour the southeast for one month, apparently at the government's expense. A second, commercial tour was also planned. Tour participants would enjoy superior accommodations, ambulances along the road, various car services, radios, and long-distance telephone facilities. Travel guides would provide information on the famous sites at each destination. The text in *Photography Pictorial* also explained the political purpose of the enterprise: to promote the economic development of rural regions through tourism.[6] However, owing to natural disasters that struck the southeastern provinces, preparations for the tour were again suspended in September 1934 in order to concentrate efforts on relief aid.[7]

In the end, the actual Southeastern Infrastructure Tour was never realized as planned, but more than one hundred people did travel the tour's routes at government cost.[8] On April 1, 1934, *Shenbao* reported that the prominent writer Wu Zhihui (1865–1953), a member of the National Construction Commission who had personal ties to Jiang Jieshi, and thirty other "writers of travel literature" had departed from Hangzhou to visit Mount Tianmu, and from there to travel on to the Huangshan region. Another seventy-six persons from the literary and artistic fields were expected to arrive in Hangzhou from Shanghai the next day.[9] Five days later, a group of ten travel writers was reported to be traveling through

Zhejiang Province on the first route of the Southeastern Infrastructure Tour.[10] And in June, *Shenbao* readers were informed that the Construction Bureau of Zhejiang Province had invited a group of photographers from Shanghai to travel to Mount Huang to take pictures for a new publication that would serve as a transportation guide to the five southeastern provinces.[11] This was the first mention of the publication that would become *In Search of the Southeast*. The book's title was introduced one month later in an article announcing an exhibition of works by young authors and artists solicited in preparation for the Southeastern Infrastructure Tour and for possible inclusion in the book.[12] Its publication was officially announced in August, and despite the suspension of the actual tour, the book was published in March 1935.[13]

The Chinese and English prefaces to *In Search of the Southeast* suggest that Zeng Yangfu was the driving force behind the project.[14] During his tenure as head of the Construction Bureau of Zhejiang Province from 1931 to 1935, he was responsible for the ongoing construction of the Zhejiang-Jiangxi Railway, completed in 1937.[15] He also initiated the construction of the Qiantang River Bridge, which was built between 1934 and 1937 and connected the new railroad with the existing Shanghai-Hangzhou line.[16] These two important infrastructure projects played key roles in the nation's military defense, especially in light of the Japanese invasion of Manchuria in 1931 and armed conflicts with Communist forces, as Zeng Yangfu stressed in several speeches and articles on infrastructure politics.[17] A second objective behind their construction was economic development, and it was that context that was particularly relevant for the unrealized Southeastern Infrastructure Tour, as well as for *In Search of the Southeast*, which was published the year Zeng's tenure in Zhejiang ended. In Zeng's preface to the book, he reiterated the objectives of the tour, claiming that the main purpose of the publication was to praise the newly constructed roads and railways and inspire tourism.[18]

The two goals of *In Search of the Southeast* were personified in its two editors, Jiang Jiamei, a secretary at the Zhejiang Construction Bureau, and Zhao Junhao, editor in chief of China's principal travel magazine, *The China Traveler* (*Lüxing zazhi*).[19] Their cooperation on *In Search of the Southeast* exemplifies the collaboration between the political sphere and the burgeoning tourism sector. The publication's editorial board also reflects the undertaking's high political profile: it reads like a Who's Who of the political, intellectual, and artistic circles of the Shanghai-Hangzhou-Nanjing region. The list of board members begins with Ye Gongchuo, a member of the NEC, former minister of transportation, and

renowned calligrapher who was involved in a wide range of official and unofficial cultural activities, including initiating the founding of the Chinese Painting Association, as mentioned in chapter 1.[20] The second person named is Xu Shiying (1873–1964), chairman of the nation's Relief Commission and a former minister, who founded the Huangshan Reconstruction Commission in 1934 to develop tourism at the famous scenic mountain, which I discuss in more detail in chapter 5. Among the other members of the board of editors were academics, writers, painters, and several editors of the magazine *Modern Miscellany* (*Shidai*).[21] Several painters who were involved with *National Painting Monthly* are also named on the editorial board, among them Huang Binhong and Yu Jianhua. He Tianjian was not on the board, but he was a major contributor to the book.

The political prestige of *In Search of the Southeast* and the infrastructure projects it promoted were most clearly and prominently manifested on the cover (fig. 3.1). The title was brushed by Jiang Jieshi and printed in gold on the book's dark blue linen cover; the lower half shows a design drawing of the Qiantang River Bridge, which was still under construction at the time of publication. This cover image is, however, not representative of the book. In fact, of the texts and images inside the book, only a tiny fraction describe or represent highways, railroads, or bridges in a straightforward way. Instead, roads form the structural basis for what at first sight seems to be an engagement with much older cultural practices, namely literary travelogues and poetry. These writings are complemented by numerous photographs and several paintings.[22] The book also includes five "scientific travelogues," as editor Jiang Jiamei termed them, on the geography of Zhejiang Province, on medicinal herbs that originate there, and on the history of Mount Huang, the mountain in neighboring Anhui Province that had become a major target for touristic development.[23] He Tianjian's essay on verifying the painting methods in the landscape of Eastern Zhejiang, discussed in chapter 2, also belongs to this group.

At first it may seem paradoxical that a book project celebrating road and railway construction, which is linked to the highest echelons of the Nationalist government and stands for the highly symbolic enterprise of national construction originating with Sun Zhongshan, should assemble texts that mostly pertain to premodern literary genres—the majority being poems—and illustrate them with landscape paintings and photographs.[24] This seeming paradox can be explained at least in part by the fact that *In Search of the Southeast* was actually the high-end product of a the publicity campaign surrounding the Southeastern

Fig. 3.1. Cover of *In Search of the Southeast* (*Dongnan lansheng*) (1935), with title calligraphy by Jiang Jieshi and a design drawing of the Qiantang River Bridge (constructed in 1934–37). Photo: Shanghai Library.

Infrastructure Tour, aimed at the development of tourism in the region. The volume shares several texts and illustrations with other books edited by the national and provincial authorities, and with other travel-related publications.[25] It also served as a platform for members of the cultural and political spheres, where they could socialize and cooperate in ways that were modeled on the time-honored leisure activities of the literati: travel, poetry writing, painting, and calligraphy. The book's function as a social platform can be seen, for example, in the title writing. Not only did Jiang Jieshi write the book's main title for the linen cover (see fig. 3.1), but every section in the volume has a separate title page, each brushed by another prominent figure. The first two section titles were written by Zhang Renjie (1877–1950), former governor of Zhejiang, chairman of the National Construction Commission, and member of the NEC, and Ye Gongchuo, another member of the NEC. Jiang Weiqiao (1873–1958), Huang Yanpei (1878–1965), and Xia Jingguan, prominent scholars and officials who served on the board of editors, also graced the book with their calligraphy, as did Huang Binhong and He Tianjian.

This chapter looks at how *In Search of the Southeast* straddled its different ambitions: to promote modern transportation, to serve as a survey of the region, and to cater to traditional genres and formats of travel culture. The editors carefully orchestrated photographs and accompanying texts throughout the book, employing the specific qualities of the photographic medium to reconcile its potentially conflicting aims.

Mapping the Landscape

As stated in the book's English-language preface by Ye Qiuyuan (1907–48), the Zhejiang Construction Bureau invited "people of repute" to contribute to the publication, including painters, photographers, writers, journalists, educators, geographers, and engineers.[26] They were to travel along the Southeastern Infrastructure Tour's designated routes, which are charted on a map in the opening section of the book (fig. 3.2), writing about, photographing, and painting what they saw. The map indicates three different routes that begin and end in Hangzhou, the capital of Zhejiang Province. Famous sites along the routes are marked out as well. The first route leads south to Mount Wuyi in Fujian Province, then into Jiangxi and back to Hangzhou along the Fuchun River; tour number two explores the eastern part of Zhejiang including the coastal region;

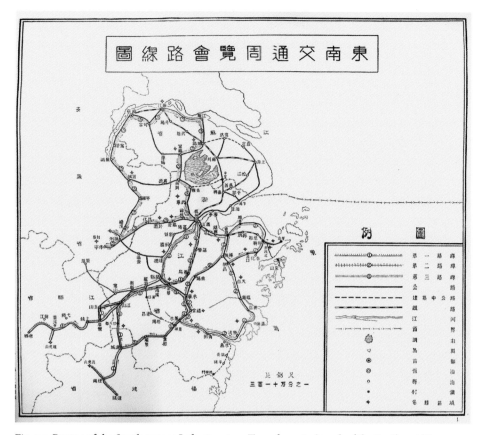

Fig. 3.2. Routes of the Southeastern Infrastructure Tour, from *In Search of the Southeast* (*Dongnan lansheng*) (1935), "General Introduction," 1. Photo: Shanghai Library.

the third tour route heads west to Mount Huang in Anhui Province, then north to Nanjing and back along Lake Tai. The map is followed in the book by an annotated chart for each route, detailing means of transportation, stations, and distances covered; a fourth chart lists the routes and distances from Hangzhou to various sites of touristic interest in the region.

The subsequent sections of *In Search of the Southeast* divide the basically circular routes into more linear sequences linked to the courses of roads and railways. The sections have titles such as "Along the Nanjing-Hangzhou Highway, and the Lake Tai Region," "Along the Hangzhou-Huizhou Highway," and "Along the Hangzhou-Yushan Section of the Zhejiang-Jiangxi Railroad, the Hangzhou-Guangfeng Highway, and the Fuchun River." The logic of the tours as mapped out is thus transformed into the image of a network of roads and railways extending from Hangzhou.

It remains unclear whether the routes on the map were the exact routes along which the artists and writers actually traveled; indeed, it is more likely that the book's authors and artists traveled in different groups along different sections of the routes, and also at different times—several contributions to *In Search of the Southeast* were reprinted from earlier publications. However, the tables of contents for each of the book's sections offer insights into the members of the distinct tour groups. He Tianjian, for example, contributed to the section on the Zhejiang-Jiangxi Railway; Yu Jianhua traveled on the Hangzhou-Fuzhou highway, but not all the way to Mount Yandang, which he had climbed and sketched extensively in 1931. Huang Binhong, who apparently did not participate in the tour, wrote a survey on Mount Huang. Depending on the composition of the tour groups and the characteristics of the regions, the sections of the book vary in their inner structure as well as their literary and pictorial formats.

The landscape of Zhejiang served as the ground on which long-established practices of elite travel and related forms of literature, visual culture, and aesthetic appreciation could be reconceived under the conditions of modern transportation, image-making techniques, and academic fields. Besides the scientific travelogues, many texts collected in *In Search of the Southeast* belong to the traditional literary travelogue genre, and the majority are in fact poems written in the classical style. The texts are arranged in the sequence of the journey along the roads indicated in the section titles. With few exceptions, their titles refer to specific places—the famous sites in the southeast that were sought out on the tours. The sites named in the literary texts, as well as in the scientific writings, charts, and illustrations, are for the most part not built structures but natural landscape formations, such as rocky cliffs, caves, waterfalls, mountain paths, streams, and rivers. They are grouped according to what might be called scenic areas, and these areas are in most cases defined by mountains, such as Mogan, Tianmu, Tiantai, Yandang, and Beishan (North Mountain).

Preceding the route-based sections in the book is one of the scientific travelogues, a long piece titled "General Discussion of the Landscape of Zhejiang Province," by Zhang Qiyun (1901–85).[27] Zhang was one of the most eminent geographers of Republican China and is best known for his contributions to historical and human geography.[28] It is likely he was invited to participate by the Southeastern Infrastructure Tour Committee because of his previous work on the historical geography of Zhejiang.[29] In "General Discussion," he applies a broad range of geographical methods, moving from physical geography to anthropogeography, explaining the characteristics of the regions of Zhejiang

and its most spectacular landscape formations in relation to the province's topography, geology, watercourses, seasons, regional products, architecture, and settlements. He begins by discarding the ancient denomination of regions according to administrative units and instead structures the land according to fluvial systems, thereby supplanting political designations with physical geography.[30]

Zhang Qiyun's renditions of the topographical, geological, climatic, and economic influences on the landscape as a site of travel represent the state of the art in modern Chinese geography. But what makes this specific contribution stand out is that geographical data are presented alongside poetic eulogies on the marvels of the scenery and the pleasures of tourism. Zhang's section on geology explains the formation of spectacular rocks and their coloration; the section on waterways includes descriptions of the most famous waterfalls, obviously for purely aesthetic reasons; much emphasis is put on blossoming trees in the discussions of seasonal change; and the section on settlements begins with the smallest form of settlement, the hermitage of the mountain recluse, and extols the beauty of a simple life lived amid forests and streams. This combination of modern science with an aesthetic appreciation of the landscape is reminiscent of the travel writings by Xu Xiake (given name Xu Hongzu, 1587–1641), who was regarded by Zhang and his contemporaries as a forerunner of modern Chinese geography.[31]

More important in the context of *In Search of the Southeast* is that in Zhang's account, science forms the basis for a deepened aesthetic appreciation of the mountains, waterfalls, flowers, and local produce. Put differently, science, too, serves the aim of the book, to advertise the scenery of Zhejiang to potential tourists. At the same time, the volume's scientific travelogues provided the erudite traveler with modern and historical knowledge about the geography, history, and botany of the region, as well as the appropriate methods for painting the sites.

The means of transportation by which the tourist got to these scenic sites— the highways, railroads, and bridges built by the NEC and the Construction Bureau of Zhejiang Province—play only a minor role in Zhang Qiyun's account. They are, however, described in one paragraph in the section "Architecture and Landscape" with statistical precision: Zhang lists the number of passengers on the Qiantang River Ferry, the location and length of the two-tiered bridge under construction, the course and length of the Hangzhou-Jiangshan Railway (Hang-Jiang tielu), and its construction costs in sum and per kilometer. As for roads, the most important fact he highlights is that the foothills of any important scenic site in the province may be reached directly by car from Hangzhou.

This downplaying of the vital function of roads, which are treated only as the means to bring the traveler to the mountain, is characteristic of *In Search of the Southeast* as a whole. Although sections of the book are named after highways, these remain largely unmentioned in the texts, running underneath the text as a thread that guides the experience of travel. Also, besides the chart on the routes and distances from Hangzhou to certain mountains, the book provides little practical information on how to travel—means of transportation, time-tables, and other services for the traveler are rarely discussed. For example, in a travelogue on a tour group's visit to Mount Tianmu, Yu Dafu briefly mentions the two alternative bus stations by which this destination may be reached.[32] But the movement through the landscape that he goes on to describe is undertaken in sedan chairs or on foot. He describes the temples where his group stayed overnight in romantic terms, but he gives readers no practical information on accommodation costs or the like.[33]

The poems and travelogues in *In Search of the Southeast* follow the established modes and forms of their respective genres, thereby claiming a continuity with the premodern literary traditions that were by then perceived as national.[34] The travelogues relate the experience of travel through detailed descriptions of visits to specific places (normally not including the journey to get there)—their most important topographical features and built structures, comparisons of the sights encountered with historical and literary records, and the corporeal, emotional, and aesthetic reactions the locations engendered in the visitor. The travel destinations and the traveler's reception of the scenic sites are thus foregrounded, while the railways and roads, the completion of which had occasioned the journeys, remain in the background; mentions of them are restricted to introductory sentences, at most. The texts relate the aesthetic and intellectual experience of travel and sightseeing, not their more mundane aspects. But within the seemingly conservative forms of landscape representation, the editorial strategies of *In Search of the Southeast* and other contemporaneous travel-related publications shaped new ways of perceiving and describing the experience of modern mobility.

Bringing the Hinterland into View

One of *In Search of the Southeast*'s main sections is devoted to scenic sites along the Zhejiang-Jiangxi Railway. This rail line, which was called the Hangzhou-

Jiangshan Railway in its early construction phase, was the core infrastructural project realized in Zhejiang during the Nanjing decade. Initiated by Zhang Renjie during his tenure as governor of Zhejiang from 1928 to 1930, it linked the Shanghai-Hangzhou Railway with one of the country's main rail lines, the Hankou-Guangzhou line.[35] The Zhejiang-Jiangxi Railway's first section, from the southern bank of the Qiantang River near Hangzhou (which is located north of the river) to Lanxi, was built between 1930 and 1932; the second section, from Jinhua to Yushan across the Jiangxi border, was completed in November 1933; and the connection between Yushan and Nanchang was opened in January 1936. The Qiantang River Bridge, constructed between 1934 and 1937, had two tiers, one for motor traffic and one for the railroad. With the bridge's completion, the Shanghai-Hangzhou and Zhejiang-Jiangxi lines were connected.[36]

The new railway brought the remote hinterland of Eastern Zhejiang, previously connected to the Yangzi River delta only by time-consuming boat travel, within the reach of tourists from Shanghai and Hangzhou.[37] As the region had no significant historical record as a travel destination beyond the Qiantang River basin and its economic centers Lanxi and Jinhua, it had to be brought to the attention of potential visitors; *In Search of the Southeast's* section about the route along the railway was part of a concerted campaign to publicize the travel destinations newly connected by its line.

To this end, the editors of *In Search of the Southeast* chose a strategy that can be observed throughout large portions of the book, but which is most obvious in the section on the Zhejiang-Jiangxi line. As mentioned, the sections of the book are basically structured around specific mountains and rivers. This arrangement intersects with another structure: the texts and illustrations also follow topical sequences. In the section under discussion, a sequence on mountain streams is followed by others on caves, mountain passes, and finally rivers. Within these topical sequences, texts with similar or even identical titles, written by different authors, are complemented by photographs of related motifs and equally similar titles. In this way, the collective experience of the tour is inscribed in the book, regardless of whether the authors actually participated in the tour. The arrangement also underscores the temporal sequence of the travelers' movement through space.

One of the most obvious instances of this editorial strategy is a sequence of pages approximately in the middle of the section on the Zhejiang-Jiangxi Railroad (figs. 3.3–3.6). It begins with a page that presents two poems bearing

曾世榮　　　　　　　　　　北山道中　7

北山途中　　馮爾和

泉聲嵐氣雨無窮。身在清湘畫稿中。
最愛漫山烏桕樹。秋深應照滿溪紅。

北山道中　　沈軼劉
羅村為入山孔道

娄城山勢掩安徽。誰汲冰壺一勺歸。
卅里晚途嵐琴合。四山人影殿斜暉。
烏帽黄塵不譚癡。竛扶山橋去尋詩，
來時清福鏡誰健。輸與羅村打柏兒。

Fig. 3.3. *In Search of the Southeast* (*Dongnan lansheng*) (1935), "Along the Hangzhou-Yushan Section . . . ," 7, with a photograph by Zeng Shirong, *On the Way to North Mountain*, and poems by Tang Erhe, "On the Road to North Mountain," and Shen Yiliu, "On the Way to North Mountain." Photo: Shanghai Library.

金華北山之澗水

史蒙漾

8

金華北山溪橋前

董孝遠

9

北山曉發　鄧糞翁

庖車謝人間。
何年睨塵鞅。
豹變不如豹。
雲窨相斡旋。
迢遞卅里間。
青松撼怒濤。
重岡轉紆曲。
濕草幽無人。
佟晨出北郭。
卧指白雲起。
徒倚五截雲。
木臠顏同羆。
又失泉山矣。
奇境百千徙。
人影側在地。
山容呈淑詭。
空山靜如死。
宿露猶泥泥。
夠山住山裏。
夢境十州水。
朝慕伴山靈。
散髮陽與洧。

天風撼生寒。
曉色薄濛汜。
肩輿上陂陀。
喘息緯蹕趾。
林花倚石角。
泉聲鳴足底。
歷歷窮劬圮。
天隨山轉移。
人同旋磨蟻。
嗟予苦行役。
低首眼鞍極。

8

Fig. 3.4. *In Search of the Southeast (Dongnan lansheng)* (1935), "Along the Hangzhou-Yushan Section . . . ," 8, with photographs by Shi Zhenhuai, *Creek in North Mountain, Jinhua*, and Dong Xiaoyi, *In Front of the Bridge of North Mountain Stream, Jinhua*, and a poem by Deng Fenweng, "Setting Out for North Mountain at Dawn." Photo: Shanghai Library.

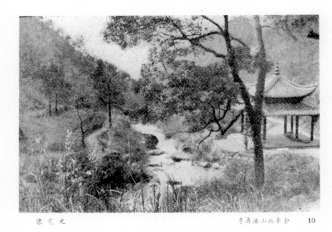

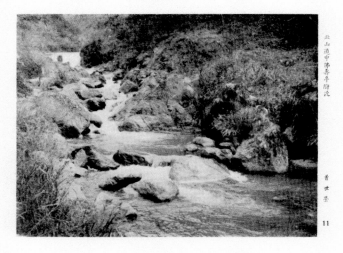

9

Fig. 3.5. *In Search of the Southeast* (*Dongnan lansheng*) (1935), "Along the Hangzhou-Yushan Section . . . ," 9, with photographs by Shi Zhenhuai, *Buddha Longevity Pavilion at North Mountain, Jinhua*, and Zeng Shirong, *Near Buddha Longevity Pavilion on the Road to North Mountain*. Photo: Shanghai Library.

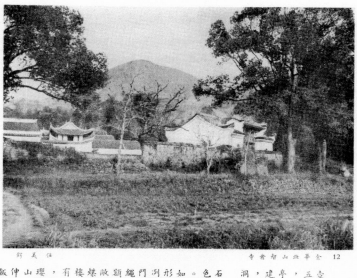

任美鍔　　　　　　　　　　　　金華北山智者寺　12

北山三洞遊記　徐且容

五月十六日由蘭溪出發，遊金華北山雙龍冰壺朝真三洞，乘車至竹馬館後，望芙蓉峯而趨。

五里至西吳村，西吳多養佛手花圃，其灌溉之水，來自雙龍洞。沿洞五里，至北山山麓，有佛壽亭，亭為金華蔣蓮僧先生等，崇奉佛祖，募資新建；朱漆殷紅，在青山流水間，顧鏡盡意。精憩。

洞口有于右任題三十六洞天五字，洞府軒豁。

雙龍洞

能容十人，石質賦潔，故如肌理，石乳下垂，泉水時一下滴，如灑冰雪。洞右有赭色石，斬然倚壁，粗三四圍，高丈五，鮮艷耀目。旁有石竈，余攀登其上，有蝙蝠唐洞中。石有如螳，如龜，如獅，如虎者，皆神工鬼斧所施，形狀宛然。洞中流泉一支，穿內洞底而出，清敷無比。俯視隘口，高二尺，廣丈許，以木檻為門，置腋形木盆于門口，人伏盆底，一人先入引繩，徐徐進。崖距人面僅寸許，有去鼻破額之懼，屏息不敢稍動。進約三四丈，又豁然高敞，大倍于前，是為內洞。同游者一一盆入，恍如置身瑤琅，如歐蹲者，排列數丈，有粗數圍而細如臂者，如雲如樓玉闕中，洞頂有黃龍青龍各一，故名雙龍洞。又有鐘樓玉柱穴泉之具。鐘乳下垂如煤汽燈前導，綺窗珠簾，羅列萬狀，環山，如海濤積玉，不可名狀。一石薄如板，離地伸出，如踞坐其上，陰氣中人甚冷，游畢出飯。

飯後從左口上行，探冰壺洞。

Fig. 3.6. *In Search of the Southeast (Dongnan lansheng)* (1935), "Along the Hangzhou-Yushan Section . . . ," 10, with a photograph by Ren Mei'e, *Zhizhe Temple at North Mountain, Jinhua*, and the opening section of a travelogue by Xu Qierong, "Visiting the Three Caves at North Mountain." Photo: Shanghai Library.

more or less the same title, "On the Road to North Mountain" by Tang Erhe (1878–1940) and "On the Way to North Mountain" by Shen Yiliu (1898–1993), illustrated by a photograph by Zeng Shirong, again titled *On the Way to North Mountain*. The next two pages display photographs that appear to have been taken along the way, and a poem by Deng Fenweng (1898–1963) with the title "Setting Out for North Mountain by Dawn." The sequence ends with a travelogue describing a visit to the three caves on North Mountain that marks the beginning of another topical sequence focusing on the caves.

The poems on these pages are written in classical style, and in their content they follow the conventions of classical landscape poetry as well. "On the Road to North Mountain" by Tang Erhe, a seven-syllable quatrain (*jueju*), is typical in this regard:

泉聲嵐氣雨無窮	Sounds of springs and mist from hills, rains without end
身在清湘畫稿中	Finding myself in a painting by Qingxiang [Shitao]
最愛滿山烏桕樹	What I love most are mountains covered with tallow trees
秋深映照滿溪紅	In deep autumn they are mirrored, the streams all in red[38]

Site-specificity is achieved through the title and through learned allusions, in this case to the red leaves of the tallow trees that are characteristic of the region, according to Zhang Qiyun, and that are also mentioned in the second poem on the page, "On the Way to North Mountain" by Shen Yiliu.[39] Both poems describe the subjective experience of being in a place. They respond to or create poetic images that encapsulate certain characteristics of the site's environment, such as the flora, the topography, historical events that took place there, or simply the weather conditions. This practice of place-related landscape poetry played an important role in the Chinese culture of travel. As Richard Strassberg has remarked, a place "became significant and was mapped onto an itinerary for other travelers" through textualization.[40] The poems of *In Search of the Southeast* likewise serve to render the landscape coded and recognizable. They make the journey along the routes meaningful (an aspect of particular importance for formerly remote mountain or border regions such as those reached by the new railway), and they enhance the importance of already well-known places by

adding further cultural layers and by directing the aesthetic response of future travelers.

The photographs by Zeng Shirong, Shi Zhenhuai, Dong Xiaoyi, and Ren Mei'e that accompany the poems serve a different purpose. In their captions, the pictures of mountain roads, rushing streams, small bridges, and pavilions are mapped onto the route with topographical precision, thus combining pictorialism with documentation. By way of the editorial arrangement of the book, they become a sequence that unfolds from the beginning of the road that runs along the banks of a stream into the depth of the photo, and then ascends the mountain along the courses of streams that similarly lead the viewer's gaze into the depth of the picture and the valley. Finally the gaze is turned back to capture the image of a roadside temple that the traveler has already passed. The sequence of similar compositions showing paths and streams leading uphill anticipates the movement of the traveler along the road, and follows the visitor's ongoing movement in the case of the roadside view of a temple. The photographs do not direct the reader/viewer/future traveler's impressionistic response to the scenery or to the situation of being on the road. Rather, they project their gaze *toward* the road that is yet to be traveled or *from* the road, in views from an oblique angle toward scenic sites that are not portrayed, but passed by and left behind.

Taken alone, photos such as *Buddha Longevity Pavilion on North Mountain, Jinhua* by Shi Zhenhuai (see fig. 3.5), which shows generic landscape elements to be found almost anywhere in China, create a seemingly timeless ideal landscape that is at the same time local and generalized, as is the case with the poem by Tang Erhe quoted above. But by placing Zeng Shirong's close-up view of the same stream right beneath Shi's work and giving it an almost identical title, the two images are bound into a sequence. It is important to recognize here that the photographs are taken by different artists; they form a sequence that does not reflect a single person's view of the landscape, but a collective gaze and a collective experience of traveling along those roads and paths. Through the medium of photography, a collective subject is formed whose experience of movement through the landscape forms the main narrative of the book. This experience is shared with the authors of the poems and travelogues, whose texts likewise are variations on related motifs. The collective nature of the experience also allows readers to more easily imagine themselves being a part of it.

Motorized Travel and the Omission of a Deserted Village

One group of texts in the Zhejiang-Jiangxi Railway section is notable for bringing the experience of motorized travel to the fore. Three poems by He Tianjian and a travelogue by Yu Dafu describe the experience of crossing Xianxia Ridge, a mountain ridge on the border of Zhejiang, Jiangxi, and Fujian provinces, by car. The titles of He Tianjian's poems, "Early Departure from Jiangshan," "Arriving in Shuangxikou," and "Crossing Xianxia Ridge," form a sequence that suggests the process of beginning a journey, reaching a destination, and being on the road again.[41] Written in classical style, they describe the beauty of the landscape, the seclusion of mountain villages, and the feeling of having left the bustling world behind. Both subject and mode of expression are seemingly uninfluenced by modern technologies. However, the poems are structured by a compression of time and space; every line evokes a new scene, corresponding to the speed of a car moving over the mountains and across the land. Fittingly enough, the photograph by Wu Bin illustrated on the same page as the first two poems is one of the rare instances in which the road is actually the main motif of the image (fig. 3.7). The experience of motorized travel is most clearly expressed in the third and longest poem of the sequence, "Crossing Xianxia Ridge."[42]

鑿通東南半壁天	Chiseled into the Southeast's half of the sky
盤空一線徑迴	Circling through the void a thread of a road is winding up
峰巒百折挐雲起	Hundred bends of peaks and ridges rise against the clouds
巖壑千重響野泉	Thousand layers of cliffs and gorges resound with wild creeks.
我挾東風入幽谷	Clasping the east wind I enter the remote vale
山村花事正宜目	The bloom in the mountain village promptly pleases the eye
雙溪原是度嶺初	Shuangxi once was the departure point to cross the ridge
不斷桃花間綠竹	Unceasingly, between the peach blossoms green bamboo
人家住處山水間	People here live amid mountains and waters
溪流如練繞蒼麓	The stream like a ribbon encircles the deep-green hills

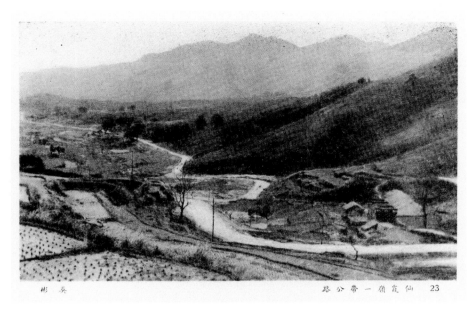

Fig. 3.7. Wu Bin, *The Highway near Xianxia Ridge*, ca. 1934, photograph. Reproduced from *In Search of the Southeast (Dongnan lansheng)* (1935), "Along the Hangzhou-Yushan Section . . . ," 19. Photo: Shanghai Library.

碧草徧崖垂龍鬚	Jade-green grasses cover the cliffs like dragon whiskers
水碓引泉鳴轉轂	The watermill draws from the source to the song of the wheel
大塢歇腳路漸高	Resting our feet in Dawu, the road is climbing higher
各出餱糧以果腹	Each takes out his provisions to fill the stomach
從此山高徑亦高	From here on the mountains are high, and so is the path
竹箭滿地雜蓬蒿	Amid the bamboo, the ground is covered with grass
凌空愁與鳥爭道	We cross the skies, anxious to fight with the birds for their path
入墟笑同蟻逐槽	Entering the vale, we laughingly file like ants into the trough
烟橫西岸紗籠髻	The mists over the western cliffs, a veiled topknot
雨過南嶠躍海鼇	Rain clouds cross the southern pass, skipping Sea Tortoise
嶂隨車轍開生面	The ridges present new scenes as the car proceeds
人裂肝胆絕處敎	Our spirits crack as we pass the highest point
峻崖突	A steep cliff rises

去塗沒	The road behind us disappears in dust
御者執樞憑掎扣	The driver grasps the steering wheel, it's whirling free
軸摩隈稜揭境新	The axle scrapes the edges of the bays, uncovering new realms
小竿嶺頭悚毛髮	Small Stalk Ridge raises our hair with fear
天南奔蕩八閩近	South of the sky we rush, the Eight Prefectures of Min [Fujian] coming close
群峰斜下勢岸兀	Countless peaks lean downward over vertical cliffs
縱車一逝落千尋	The car rushes on, falling a thousand fathoms a moment
回頭路與雲煙扢	Looking back, the road is immersed in clouds and mists
嶺巘四合森開張	Over ridges and peaks to all sides forests spread
形勝天然鳥難越	Forms superbly created by nature, barely surmountable for birds
浦城煙樹人迷離	Amid the mists and trees of Pucheng, people are lost
二十八度春恍惚	In Ershibadu, beclouded springtime
登原有如釜底蹲	Stepping in the open we feel caught in a trap
戍壘號風卓嵂嵂	The garrison in howling winds stands lofty and high
吁嗟乎	Alas!
戍壘號風卓嵂嵂	The garrison in howling winds stands lofty and high

In the first lines, the road entering the high mountain ridge is described as seen from afar; in its evocation of the majestic mountains, with the road's threading upward, the verses largely conform to topical landscape imagery. The same is true of the image of an idyllic and secluded mountain village. But as the car drives higher up, the poem gathers speed, juxtaposing contrasting metaphoric images of the landscape in each line, as the travelers fight with birds over their lofty paths, file like ants into the valley, pass a cloud-wrapped peak resembling a hair knot, and finally skip a tortoise—probably the name of another peak. The drama heightens as the travelers cross the pass, marked by a deviance from the seven-syllable meter with an abrupt insertion of two three-syllable verses. From this point, the car plunges down the Fujian Province side of the pass; He Tianjian again uses landscape images that contrast height and depth to underscore the precipitous drive. The narrative of the poem ends in an unsettling place called Ershibadu ("Village Twenty-Eight") and concludes with an evocation of the fortified mountain pass as symbol of military power.

He Tianjian's poems are followed by Yu Dafu's prose text "The Steepness of

Xianxia."[43] Although the two authors did not travel together, Yu Dafu's description of the landscape as seen from a car, written not in classical Chinese but in the vernacular, resembles He's "Crossing Xianxia Ridge" in several respects. The experience of landscape is guided by the road, which was "newly built beginning from Ershibadu outside the [Xianxia] Pass, leading along the two big streams deep in the mountains, Longxi and Longhuaxi, to Jiangshan." Geographical information on mountains seen along the road, a self-aggrandizing view of the landscape, and reference to the speed of the car ("although we covered eighty or ninety *li* since leaving Jiangshan, driving in the car it just took us something like two to three hours") give way to a lost sense of direction as the car drives up winding mountain roads, each bend bringing a different scenery into view. The climax is reached midway through the text, when the car drives past the fortified pass and the author comes to the conclusion that whoever wants to "see the winding of the landscape, try out the twisting of a road, test his fate, tread the line between life and death, and go to the utmost risk has to go to Xianxia Ridge," especially on the new motor road. Then the narrative slows down; the group climbs back over Xianxia Pass, a local guide appears, and the text offers some historical information. But the account is still dominated by the motif of modern transportation; Yu speculates that with the opening of new motor roads, the pass itself and the more than forty newly built watchtowers (*diaolou* 碉樓) in the vicinity will become obsolete and turn into "ancient sites" (*guji* 古蹟). The report ends with the departure of the car; the traveler turns his head to take one last look at the mountain pass, now hidden in clouds. The movement through the landscape that structures Yu Dafu's text, driving upward along steep mountain roads, glimpsing places of particular beauty or historical fame, and glancing backward as the movement continues, corresponds closely to the arrangement of the photographs that illustrate the pages of *In Search of the Southeast*.

Two of the three photographs that appear with Yu's text in *In Search of the Southeast* show views of valleys taken from a high vantage point, most likely from one of the steep roads leading up the mountain to Xianxia Ridge. A third photograph shows the monumental structure of a roofed bridge (fig. 3.8). It was taken by Zeng Shirong, the photographer-cum-railroad engineer who also climbed the Fourth Cataract together with He Tianjian (see chapter 2). Although the bridge is apparently neither the fortified mountain pass nor a *diaolou*, the image connects with the text, and the bridge becomes one of the unmodern structures that will be superseded by modernization and turn into an "ancient site."

，「萬夫莫開」，宋史浩方把石路鋪起來的仙霞關口一面，叫空車子仍遵原路，繞到仙霞關北面相去五里的保安村去等候我們，好讓我們由關南上嶺，關北下山，一路上看看風景。

據書上的記載，則仙霞嶺高三百六十級，凡二十四曲，有五關，×十峯等等，我們因為是從半腰裏上去的，所以所走的只是關門所在的那一段。第二關的邊上，將近頂邊的地方，有一座新築的碉樓在那裏，江山近旁，共有碉樓四十餘處，是新近續築起來的，但汽車路一開，這些碉樓，遠座雄關，將來怕都要變成些虛有其名的古蹟了。

仙霞關內嶺頂，有一座霞嶺亭，亭旁住著一家人家，從前大約是守關官吏的住所，現在卻只剩了一位老人，在那裏賣茶給過路的行人。此面出關，下嶺里許，是一個關帝廟。規模很大，有觀音閣，浣霞池亭等建築，大約從前的閣浙官吏來往，總是在遠廟中寄宿的無疑。現在東面浣霞池的亭上，還有許多周亮工的過關詩，以及清初諸名宦的唱和詩碼，嵌在石壁的中間。

在關帝廟裏喝了一碗茶，買了些有名的仙霞關的綠茶茶葉，晚霞已經圍住了山腰，我們的手上臉上，都感覺得有點潮潤起來了，大家就不約而同的叫了出來說：

啊！原來這些就是仙霞！不到此地，可真不曉得這關名之妙喂！

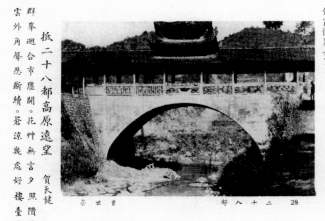

下嶺過溪，走到溪旁的保安村裏，坐上車子，再探頭出來看了一眼曾經我們走過的山嶺，遠座東南的雄鎮，卻早已羞羞怯怯，躲入到一片白茫茫的仙霞懷裏去了。

抵二十八都高原遠望　賀天健

群峯迴合市廛開。花艸無言夕照隤。

雲外角聲悲斷續。蒼涼幾處好樓臺。

曾世榮　　　二十八都　28

23

Fig. 3.8. *In Search of the Southeast* (*Dongnan lansheng*) (1935), "Along the Hangzhou-Yushan Section . . . ," 23, with the last section of a travelogue by Yu Dafu, "The Steepness of Xianxia," a photograph by Zeng Shirong, *Ershibadu*, and a poem by He Tianjian, "Arriving at the Plateau of Ershibadu and Gazing into the Distance." Photo: Shanghai Library.

The story behind Yu Dafu's text and Zeng Shirong's image is, however, more complicated than it seems to be at first. Both had been published previously, albeit in different contexts. Yu's travelogue was first published in December 1933 as one of four sections of his "Brief Account of Scenic Sites in Eastern Zhejiang," which formed part of a book edited by the Hangzhou Railway Bureau, *Scenic Sites in Eastern Zhejiang: An Anthology of Travel Guides to the Hangzhou-Jiangshan Railway* (*Zhedong jingwu ji: Hang-Jiang tielu daoyou congshu zhi yi*).[44] This anthology, although much narrower in scope and less sumptuous in its production, can be regarded as a precursor to *In Search of the Southeast*. Around the time it was published in December 1933, "The Steepness of Xianxia" was also published in two parts in *Shenbao*.[45]

The versions of the text printed in *In Search of the Southeast* and *Scenic Sites In Eastern Zhejiang*, the two books published by Zhejiang authorities, are identical. A comparison of those versions with the one printed in *Shenbao* reveals that a significant portion of Yu's essay was omitted in the books. The *Shenbao* version includes Yu's account of an abortive visit to Ershibadu, the village just south of Xianxia Pass that stands at the closure of He Tianjian's poem. Yu and his fellow travelers find it virtually deserted, inhabited only by a few traumatized and ghostlike figures who refuse to speak, and by soldiers.[46] One of the soldiers informs the group that the village had been deserted for more than a year, and that there had been (unspecified) rumors the night before. Deeply frightened, they decline the offer of a meal and leave immediately.[47]

The omission of this passage from *In Search of the Southeast* and *Scenic Sites in Eastern Zhejiang* is probably owed to its evocation of armed conflict, which would have been detrimental to the books' propagandistic aim of praising the beauty of the Zhejiang landscape and encouraging travelers to go there. The effect of the omission on Yu's text was to make the focus on road-bound travel even stronger and the speed of modern travel more palpable. The enigmatic and equally disquieting appearance of Ershibadu in He's poem, where it is described as a place where spring is beclouded and the authorial persona feels endangered when stepping out into the open, may have been included because it is less explicit. References to the conflict are not entirely eliminated, however; it resurfaces in Zeng Shirong's photograph of the roofed bridge.

Zeng's photograph, titled *Ershibadu* in *In Search of the Southeast*, had likewise been published earlier, albeit anonymously. It dominates a page dedicated to Xianxia Pass in another monumental publication, *China As She Is: A*

Comprehensive Album (*Zhonghua jingxiang: Quanguo sheying zongji*), published in 1934 (fig. 3.9). *China As She Is* at once both more comprehensive and more condensed than *In Search of the Southeast*. The imprint lists six editors and four photographers, but the example of the image by Zeng Shirong, who is not on the list, shows that the volume includes material from other sources as well. According to the foreword, the photographs reproduced in the album resulted from an extensive tour by a select group from the pictorial *Liangyou* through every province of China. The tour was widely publicized in *Liangyou*, and photographs taken during the journey were reproduced in several issues. The choice of illustrations for *China As She Is* followed a standardized scheme in their form and content. In the foreword, the editors claim to have had "a purely objective standard" and the aim of "exposition and interpretation—not propaganda."[48] Accordingly, the photographers' names are not given separately for each photograph and their individuality is suppressed.

Structured according to provinces, the vast majority of the photographs in *China As She Is* are landscapes—namely, the famous mountains and big rivers of each region—although some show modern cities, temple sculptures, social customs, and even roads. Space allocations range from a maximum of nine pages (accorded to the capital city of Nanjing) to the more typical single page given to the places chosen for highlighting in each province. Two to four photographs were printed on each page, with brief captions in Chinese and English. Thus the editors selected the most representative sites, and the most representative views of those sites, thereby standardizing them and filtering out all but the information that was deemed most relevant.

In *China As She Is*, the image of the roofed bridge becomes the representative image of Xianxia Pass, with two photographs of the village of Ershibadu printed below it (see fig. 3.9). Consistent with the practice throughout the book, no photographers are named. However, the Chinese and English captions provide information that link us back to the discomforting account of the visit to Ershibadu in Yu Dafu's travelogue. The more detailed Chinese text states that "Xianxia Pass is on the border of Zhejiang and Fujian Provinces; it is an important strategic point. As can be seen in the image, sandbags are piled up on the bridge, and across the river there is a dense array of electric wires. In the upper right corner, soldiers can be seen standing on guard."[49] The English caption includes the additional information that the photograph was taken during the Fujian Rebellion. During this rebellion, which lasted from November 20, 1933,

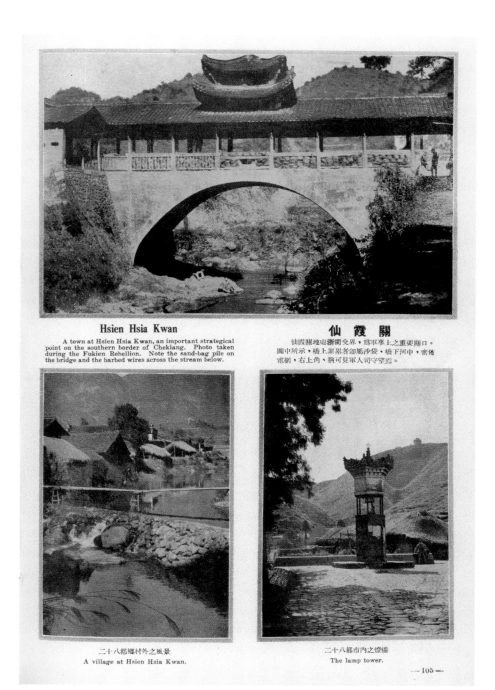

Hsien Hsia Kwan

A town at Hsien Hsia Kwan, an important strategical point on the southern border of Chekiang. Photo taken during the Fukien Rebellion. Note the sand-bag pile on the bridge and the barbed wires across the stream below.

仙　霞　關

仙霞嶺地處浙閩交界，為軍事上之重要關口。圖中所示，橋上累累者卽屬沙袋，橋下河中，密佈電網，右上角，猶可見軍人司守望焉。

二十八都鄉村外之風景
A village at Hsien Hsia Kwan.

二十八都市內之燈幢
The lamp tower.

Fig. 3.9. Wu Liande, ed., *China As She Is: A Comprehensive Album* (*Zhonghua jingxiang: Quanguo sheying zongji*) (Shanghai, 1934), 105, with photographs of Xianxia Ridge. Widener Library of the Harvard College Library, Harvard University. Photo: Harvard Imaging Services.

to January 22, 1934, Fujian Province declared its independence from the Nanjing government and formed the People's Revolutionary Government.[50] In the quick suppression of the rebellion, the Zhejiang-Jiangxi Railroad played a crucial role, as it enabled the central government to swiftly dispatch soldiers to the Zhejiang-Fujian border, which is formed by Xianxia Ridge.[51]

The photograph's caption in *China As She Is* gives us the historical background to Yu Dafu's anecdote about the deserted village, in which he vividly describes war-inflicted bleakness but does not mention the actual conflict. Yu's visit must have more or less coincided with the beginning of the Fujian Rebellion. Another travelogue by Yu, "Itineraries of a Short Journey along the Hangzhou-Jiangshan Line," which was also published in the Hangzhou Railway Bureau publication *Scenic Sites in Eastern Zhejiang*, describes the first part of the journey ultimately leading to Ershibadu. He wrote it in the form of a diary, with entries dated November 9 to 15, 1933. The last entry date was just five days before the outbreak of the Fujian Rebellion on November 20.[52] The "rumors" mentioned by the soldier in "The Steepness of Xianxia" most likely refer to that incident. The year before, in September 1932, nearby Pucheng had been occupied by Communist forces; according to a report in *Shenbao*, the Nationalist government had sent the military to Ershibadu at that time to protect the Zhejiang border.[53] This was why Ershibadu had already been deserted, as the soldier explained to Yu.

In *China As She Is*, the photograph of the roofed bridge refers to a specific historical moment, the Fujian Rebellion, and the site's strategic role therein. *In Search of the Southeast* reproduces the same image on a smaller scale and without any further information, and because the editors excised any hint of military conflict from Yu Dafu's text, the electrical wires, sandbags, and soldiers are easily overlooked. Instead, the imposing structure of the bridge appears as one of those infrastructural elements that were about to become superfluous with the advent of motorized travel and would soon turn into "ancient sites," according to Yu Dafu's statement on the same page.[54] The photograph of the bridge becomes a glimpse of a past that is about to vanish, as the movement of travel that produced the image bypasses the structure, spatially and temporally. With these two framings of the photograph, the transformation of the landscape by modern infrastructure and by the speed of engineered transportation is doubly projected onto the bridge: as an effect brought about by armed conflict and as an effect of modernization that renders the bridge a relic of the past.

The Zhejiang-Jiangxi Railway, Landscape Photography, and Travel Literature

Yu Dafu's travelogue and Zeng Shirong's photograph exemplify how the Zhejiang-Jiangxi Railway section of *In Search of the Southeast* was part of a larger publication campaign that spanned several years and involved major Shanghai publishers. An early product of this campaign was *Scenic Sites in Eastern Zhejiang*, which was published in December 1933 by the Hangzhou Railway Bureau as a travel guide for the newly opened line. It included a map of the railway and adjacent scenic sites, travel information, and timetables, but the main body of the book features landscape photographs by renowned photographers printed on glossy paper, and travelogues. The latter are texts expressly commissioned for the book as well as others reprinted from such sources as *The China Traveler*.[55] The publisher requested two texts from Yu Dafu, as he writes in the first of the two, "Itineraries of a Short Journey." The opening sentences of this text shed light on how *Scenic Sites in Eastern Zhejiang* was conceived, and how potential authors of travelogues for both this book and *In Search of the Southeast* were approached by provincial authorities who wished to promote their infrastructure projects:

> Several days ago, the head of the Wagon Bureau of the Hangzhou-Jiangshan Railway, Mr. Zeng Yinqian, came to talk to me upon our introduction by friends. His intent was to invite me to travel all around Eastern Zhejiang, and that I would introduce in detail the scenic sites that I saw and heard about to domestic and foreign travelers coming to Zhejiang. Furthermore, the railway to Yushan has already been completed, and is to open for traffic by the end of December. At the same time, the Railway Bureau will publish a travel guide sort of book, which could also include some travelogues to help avoid the dryness of Baedeker-style travel guides.[56]

It seems that the group thus organized was quite small. In "Itineraries of a Short Journey," Yu Dafu mentions only three persons by name: Zeng Yinqian of the Hangzhou-Jiangshan Railway, who invited him to the journey and accompanied him on the train ride, and the photographers Chen Wanli and Lang Jingshan (1892–1995), who were to join them in Jinhua on November 17.[57] Chen Wanli is also the only person mentioned by name in "Brief Account of Scenic Sites in Eastern Zhejiang," in the context of the Ershibadu episode.[58] This is another

indication that the two travelogues by Yu actually describe different episodes on the same journey. "Itineraries of a Short Journey" precedes "Brief Account of Scenic Sites in Eastern Zhejiang" within the book as well as in time. It is also much more precise about the circumstances of the journey. Written in the form of a diary, it covers the period of one week, from Thursday, November 9, to Wednesday, November 15, 1933, and describes visits to the Five Cataracts in Zhuji and North Mountain near Jinhua, among other places. As mentioned earlier, the dates indicate that the visit to Xianxia Ridge and Ershibadu further down the railway line occurred just a few days later and may have actually coincided with Fujian's declaration of independence on November 20.

The photographs in *Scenic Sites in Eastern Zhejiang* are arranged in the sequence of the route and ordered according to the train stations nearest to each site. Like the illustrations in *In Search of the Southeast*, they trace the route that readers are invited to take themselves and suggest a unified common experience. But also like the contributions to the later book, they were probably produced on different journeys.

The photographs of Xianxia Ridge and Ershibadu by Chen Wanli and Lang Jingshan (fig. 3.10) were almost certainly taken during the trip described by Yu Dafu in "The Steepness of Xianxia." Lang Jingshan's photograph of Ershibadu, on the left, portrays the village as a structure of horizontal bands of walls without any entrance, set back in the middle ground of the picture and further blocked from view by barren fields and a tree. The psychological inaccessibility of its inhabitants described by Yu Dafu is mirrored in the visual closure of the village. Similar to Zeng Shirong's photograph of the covered bridge, Lang's image preserves the experience of trauma that was suppressed and edited out of Yu's travelogue. Chen Wanli's *Looking South from Xianxia Ridge* (fig. 3.10 right), by contrast, is strikingly similar to a photograph attributed to the pictorial *Modern Miscellany* that accompanies Yu's travelogue in *In Search of the Southeast*, where it appears with the caption, "The mountains below Xianxia Ridge are dense and layered; the road at the foot of the mountains is a strategic thoroughfare connecting seven provinces."[59] While the horizontally structured and distancing composition in Lang Jingshan's photo of Ershibadu fixes its subject in time and space, Chen's picture matches the description of fast motorized travel over high mountain passes in Yu's text and He Tianjian's poem "Crossing Xianxia Ridge."

Other illustrations in *Scenic Sites in Eastern Zhejiang* were produced on different occasions. Chen Wanli's photograph of the Fourth Cataract (see fig. 2.19) was probably taken several years earlier; a travel diary of a visit he made

江山 卅八都　　　　　　彙靜山　　　江山 仙露嶺上南望　　　　緑萬里

Fig. 3.10. Two-page spread from *Scenic Sights in Eastern Zhejiang* (*Zhedong jingwu ji*, ed. Hangzhou tieluju) (Hangzhou, 1933), with photographs by Chen Wanli, *Looking South from Xianxia Ridge* (right) and Lang Jingshan, *Ershibadu* (left). Photo: Zhejiang Provincial Library.

to the Five Cataracts in 1928, first published in *The China Traveler*, is reprinted in *Scenic Sites in Eastern Zhejiang*. Also reprinted from that journal is a text by Ji Guanghua, who had been dispatched in autumn 1932 by *The China Traveler* to take photographs along the railway, which then extended only to Lanxi.[60] Two of the three images by Ji in *Scenic Sites in Eastern Zhejiang* are almost identical to photos illustrated in that earlier edition of his essay. The strategy of using slightly different versions of photographs published earlier was also practiced by editors of *In Search of the Southeast*, as we have seen with Chen Wanli's *Looking South from Xianxia Ridge* (see fig. 3.10 right). Zeng Shirong's picture, *Near Buddha Longevity Pavilion* in *In Search of the Southeast* (see fig. 3.5 bottom), likewise has a counterpart in *Scenic Sites* that he took from a slightly different angle. Another instance of cross-usage are the photographs by Ren Mei'e reproduced in *In Search of the Southeast*. They were probably

taken during a tour of Zhejiang on which he accompanied Zhang Qiyun as his student, and which resulted in Zhang's article on the province's geography.[61] Two of Ren's images were also illustrated in an earlier edition of Zhang's text published 1934 in *Acta Geographica Sinica* (*Dili xuebao*).[62]

This pool of visual material and texts shared among different publishers (private and government-sponsored), publication formats (travel guides, academic journals, pictorials, and photographic atlases), and editorial boards gives us a picture of the personal networks and common political and cultural interests that brought these publications about, which I will discuss further in chapter 5. It also testifies to the importance accorded to the literary and artistic fields in the project of building a unified national infrastructure and developing local economies through tourism. And it shows that the means of transportation per se inspired only limited interest in the artistic and literary imagination in 1930s China.

The closed capsule of a car speeding over mountain passes and winding roads made its impact on contemporary travel writing, but train wagons, locomotives, and railroads played only a remarkably minor role. Even in *Scenic Sites in Eastern Zhejiang*, a publication sponsored by the Hangzhou Railway Bureau, no photograph of a train appears, and the convenience of rail travel is primarily noted in departure and arrival times. Photographs of railroads, stations, construction sites, and trains rushing through narrow valleys and crossing newly constructed bridges (fig. 3.11) were indeed published; however, they were printed in another publication issued in 1933, not by the Hangzhou Railway Bureau but by the Engineering Bureau of the Hangzhou-Jiangshan Railway. That publication, *Concise Account of the Construction of the Hangzhou-Jiangshan Railway* (*Hang-Jiang tielu gongcheng jilüe*), focused entirely on the engineering and construction of the railway and may be regarded as a technocratic pendant to *Scenic Sites in Eastern Zhejiang*.[63] Editors of *Scenic Sites* chose instead to publish photographs of streams, caves, and mountain peaks. This disregard for the aesthetic potential of the railway is shared by the literary texts: the parts of the writers' journeys that receive extended descriptions were those undertaken on foot or by sedan chair. The train apparently remained disconnected from local life and sightseeing, as it closed the traveler off from the environment and a local society that, for the most part, was still moving at walking speed. The premodern forms of travel on which tourists relied as soon as they disembarked from the train established a connection with the experience of travelers from previous centuries, contributing to a relative aesthetic continuity in the conventions of travel writing.[64]

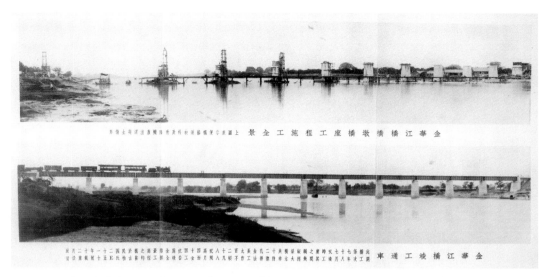

Fig. 3.11. Unidentified photographer, *Complete View of the Construction Work on the Pillars of the Jinhua River Bridge* and *The Jinhua River Bridge Completed and Opened for Traffic*, ca. 1933. Reproduced from *Concise Account of the Construction of the Hangzhou-Jiangshan Railway (Hang-Jiang tielu gongcheng jilüe,* ed. Hang-Jiang tielu gongchengju gongwuke) (Hangzhou, 1933). Photo: Zhejiang Provincial Library.

The intent to establish such a continuity with an aesthetic they perceived as inherently Chinese led the editors to foreground nonmodern aspects of landscape appreciation. Technological modernity served as a device to render that appreciation more convenient.

Despite the overlaps in authorship between *In Search of the Southeast* and *Scenic Sites in Eastern Zhejiang*, the editorial strategies for framing the photographs in the respective publications differed markedly. In *Scenic Sites* the relatively small number of illustrations compared with the later book (just sixteen) and the fact that each image was accorded its own page confers on each picture a higher symbolic value as a single work of art photography. With their well-balanced and stable compositions, most of the illustrations are characteristic of the representations of touristic sites and places of interest that appeared in Republican-period pictorials and travel-related publications. In this regard, the editorial strategy was similar to the approach in *China As She Is*: the photographs showed representative views of representative sites or, as in the case of the Zhejiang-Fujian-Jiangxi border region, what were underrepresented places. Thus they participated in the canonization of the sites and the standardization of their pictorial representation, and they mapped the places onto potential travelers' itineraries, prefiguring how they were to be viewed.

In *In Search of the Southeast*, by contrast, the editors sequenced very similar photographs and inserted them into the accompanying texts. Their individual authorship is thus deemphasized, and they are now characterized by a temporal fluidity, a feature that is most obvious in the section on the Zhejiang-Jiangxi Railroad. The pages take the reader-viewer along mountain paths, streams, and rivers, as in the North Mountain sequence discussed earlier (see figs. 3.3–3.6). By grouping photographs with similar motifs in sequences, with poems and travelogues on the same motifs, the editors created a unifying framework that accommodates a multitude of aesthetic responses to the sites. The effect of a continuous collective movement through the landscape is further heightened by the circumstance that the photographs are sometimes very similar, whether in motif or in composition, and often remarkably unspectacular. In this aspect, *In Search of the Southeast* differs markedly from its contemporaries, such as *Scenic Sites in Eastern Zhejiang* and *China As She Is*, in which the editors sought variation and specificity in their choices of illustrations.

This difference in editorial strategy may account for the fact that well-known photographers such as Lang Jingshan and Chen Wanli, probably the most influential proponents of "art photography" at the time and the creators of numerous pictorialist photographs that appeared in *Liangyou* as well as in *Scenic Sites in Eastern Zhejiang*, are conspicuously underrepresented in *In Search of the Southeast*.[65] By contrast, of the photographers who contributed the largest number of illustrations inserted in the text pages, two were not even known for their photographic work. As previously mentioned, Zeng Shirong, who contributed thirteen photographs (see figs. 3.3, 3.5, and 3.8, for example), was a railroad engineer serving at the Zhejiang-Jiangxi Railroad Bureau; Ren Mei'e (see figs. 2.17 and 3.6), who had fifteen photographs in the book, was still in his early twenties at the time *In Search of the Southeast* was published. He was a former student of the geographer Zhang Qiyun; in 1939 he received a doctorate from the University of Glasgow and later became one of China's most eminent geographers.[66]

Yet it is that editorial strategy that gives *In Search of the Southeast* much of its aesthetic appeal in comparison to its predecessors and other contemporary travel-related publications. It is a varied assemblage of text genres and pictorial formats, a mix of scholarly and literary accounts with shorter and longer poems, documentary and art photography, and painting that enables its readers to undertake a multifaceted armchair journey. Its success in this regard can perhaps be best apprehended in comparison with its forerunner, *Scenic Sites in Eastern*

Zhejiang. Despite the high quality of the reproduced photographs and the travelogues in the book, the journeys described in it all follow more or less the same itinerary—the route of the Zhejiang-Jiangxi Railway. The reader can first trace the itinerary on the map, then in the pictures, and then in Yu Dafu's "Itineraries of a Short Journey" and "Brief Account of Travels in Eastern Zhejiang." Experiences very similar to Yu's are again recorded in texts by Chen Wanli and Ji Guanghua, resulting in an impression of redundancy that is only partly offset by literary variation. *In Search of the Southeast* succeeds in avoiding this form of repetitiveness, as every station on the itinerary is covered by different formats, and every text has a slightly different focus. One perspicuous example is again a text by Yu Dafu, "The Beauty of Bingchuan."[67] This piece was initially published in *Scenic Sites in Eastern Zhejiang*, together with "The Steepness of Xianxia," as one of the four sections of Yu's "Brief Account of Scenic Sites in Eastern Zhejiang." In *In Search of the Southeast*, the editors presented the two text sections with a poem by He Tianjian and two photographs between them, thus treating them as two brief and independent contributions on two distinct places.[68]

One major factor enabling this variety was the lavish production of *In Search of the Southeast*, which permitted the inclusion of high-quality halftone illustrations on the text pages, in addition to even finer-quality black-and-white and color plates. In addition, its large size allowed designers to generously arrange different text and image formats on the pages. The high quality was achieved at a high price, and that fact was conspicuously highlighted in advertisements that ran in *Shenbao* prior to the book's publication, stating that "half a year and several ten thousand yuan" had been spent on its production.[69] Copies of the book sold for eight yuan, around twenty times the price of the lower-priced edition of *Scenic Sites in Eastern Zhejiang*, which cost 0.4 silver dollars.[70] Its size, weight, and price made *In Search of the Southeast* rather impractical as a travel companion; instead, it was a collectible for bibliophiles that worked simultaneously as an appetizer for travel and an efficacious propaganda tool in praise of the national and provincial governments' efforts to modernize the country's infrastructure. It is no wonder, then, that such an obviously discomforting disruption in the narrative of travel and exploration as Yu Dafu's encounter with the traumatized villagers of Ershibadu was cleanly excised by the editors. The military considerations that were so influential in the GMD government's transprovincial infrastructure projects, and the decisive role played by the roads and the railway in moving troops to Ershibadu, are disavowed and veiled by the touristic imagination.

The concerted effort of the Southeastern Infrastructure Tour that led to the publication of *In Search of the Southeast* was never repeated, but the book's formative influence as a medium designed to represent a certain region and to incite tourism and economic development can be traced in several volumes that copied its title. An immediate offshoot was *In Search of Mount Huang* (*Huangshan lansheng ji*), which appeared in print shortly before *In Search of the Southeast*, in 1934, and will be discussed in chapter 5.[71] Another monumental publication most certainly inspired by *In Search of the Southeast* was devoted to its geographic opposite, so to speak: a book with the English title *China's Northwest: A Pictorial Survey* that was published in Nanjing in 1936; it's Chinese title, *Xibei lansheng*, mirrors the title *Dongnan lansheng* (*In Search of the Southeast*).[72] The chief editor of *China's Northwest*, Shao Yuanchong (1890–1936), a Zhejiang native, served in several positions in the central government after a brief five-month tenure as the mayor of Hangzhou in 1927; it is likely that his book was intended as a pendant to *In Search of the Southeast*, which was overseen by the authorities of Zhejiang Province. Despite the obvious connection to its southeastern counterpart in the Chinese title, *China's Northwest* is a more documentary survey, as suggested by its English title. It covers several provinces, and each site is introduced rather matter-of-factly by brief texts. The accompanying photographs by Xu Shishen (1907–?) put a much stronger focus on built monuments than the images assembled in *In Search of the Southeast*; in this regard, *China's Northwest* resembles the voluminous photobooks published by the *Liangyou* editor Wu Liande, *China As She Is* and the earlier *The Living China: A Pictorial Record 1930* (*Zhongguo daguan: Tuhua nianjian 1930*).[73] In 1939 the China Travel Service published *Scenic Beauties in Southwest China* (*Xinan lansheng*), which also in its title cites *Dongnan lansheng*. It included many photographs by Lang Jingshan and will be treated in more detail in the epilogue.[74] With *Scenic Beauties in Southwest China*, the wartime GMD government mapped the formerly remote landscapes of southwestern China that now formed the heartland of the GMD-controlled area with representative scenic sites on a par with those of the southeast, which were by then in large part occupied by the Japanese army. All of these successor publications, however, lack the deliberately artistic quality that characterizes *In Search of the Southeast*, which was achieved through its lavish print quality and beautiful binding, and the inclusion of literary texts, art photographs, and, last but not least, paintings.

The impact of *In Search of the Southeast* on contemporary travel and viewing practices was seen most immediately in the work of Yu Jianhua, who trav-

eled in one of the groups organized by the Southeastern Infrastructure Tour. Yu and his student Xu Peiji (1909–70) were members of a group that took the route from Hangzhou to Mount Yandang, a site that garnered considerable attention in the 1930s as a touristic site and a painting motif.[75] Tellingly, about half of the texts and images in the section "Along the Hangzhou-Fuzhou Highway and the Shanghai-Linhai Highway" in *In Search of the Southeast* are dedicated to this mountain.[76]

Yu Jianhua was probably invited to join the tour because he had published an account of an earlier sketching trip to Mount Yandang in *The China Traveler*. In that report Yu provided the most detailed discussion published in the 1930s on the issue of how to combine *guohua* and outdoor sketching. Moreover, Yu made further trips in the following years that he documented in unique hand-written and illustrated travelogues that were closely linked to the project of the Southeastern Infrastructure Tour. He not only followed the routes described by *In Search of the Southeast* but also variously cited photographic images published in the book, thereby engaging in a competitive dialogue with the photographic medium that can be described as another example of transmedial practice. His travelogues are the subject of the following chapter.

Painting from Nature and Transmedial Practice
Yu Jianhua's Travel Albums

Yu Jianhua was a major proponent of drawing from nature in the medium of ink painting, or *guohua xiesheng*, as it was called in the 1930s, and a prolific writer of travelogues recording his sketching tours. He was also a regular contributor to *National Painting Monthly*, writing an article for almost every issue. In "Sketching from Nature in Chinese Landscape Painting," his essay for the journal's special issue on the ideas on landscape painting in China and the West, Yu proposed the practice of sketching from nature, or *xiesheng*, as a remedy to improve Chinese painting and restore it to its former qualities—those of the Tang and Song dynasties.[1] He thus based his argument on the discursive propositions made by critics of later literati painting as well as by *guohua* painter Hu Peiheng in the years around 1920. In this chapter, I discuss Yu's position with regard to those earlier discussions and in relation to his own extensive and tireless sketching practice, which he documented in numerous illustrated travelogues. While his article for *National Painting Monthly*'s special issue seems to be solely concerned with painting proper, Yu's writings testify to his intense and continuous transmedial engagement with photography, printed material, and their respective visual qualities.

Painting from Nature and the Issue of Progress

In "Sketching from Nature in Chinese Landscape Painting," Yu claimed that prior to the Yuan dynasty, all Chinese painting had been based on drawing from

nature; he even subsumed the myth of Cangjie, who observed the constellations of the stars and the traces of animals and thus invented the pictograms, under this term. Every painting of a specific place created before the Yuan dynasty falls under the category of *xiesheng*, according to Yu's reckoning. As a result, he claimed, there was no surviving painting from the Song period that was not true to nature in every detail. The subsequent and ongoing decline of Chinese painting from the Yuan period onward originated, in his view, in the practice of painting after other masters instead of drawing from nature itself. Yu discerned the turning point toward decline in Chinese landscape painting in the works by the Yuan dynasty literati painters, and in paintings by Ni Zan in particular, who "expressed the untrammeled spirit in [his] breast" (*xie xiong zhong yiqi* 寫胸中逸氣).[2] As a consequence, as Yu put it, "Since the emergence of literati painting in China, its conception became more and more lofty; since the emergence of literati painting in China, its methods fell more and more into decline."[3]

To revive the allegedly long-lost practice of *xiesheng* in Tang and Song painting, Yu Jianhua proposed the adaptation of Western methods as a pragmatic solution—as a detour that would lead artists back to the forgotten origins of Chinese painting. More precisely, he suggested two to three years of training in Western painting techniques for younger artists, or, for older artists, consulting textbooks, art schools, or colleagues working in Western media to gain insights into the basic techniques of drawing from nature.

Despite his advice to consult methods derived from European painting, Yu Jianhua also reminded his readers that unbridgeable differences remained between the Chinese and the Western traditions, the most obvious being the use of perspective:

> While drawing from nature in Western painting, you have to proceed according to the method of perspective. The painter has a fixed position; he may neither move to the left nor to the right, nor advance or retreat. The viewpoint of the painter's eyes has to be fixed as well; it may move neither left nor right, nor advance or retreat. And all the vertical and horizontal as well as angular lines in the painting must be controlled by the viewpoint and the horizon line; there may not be the slightest leverage. What is seen by the eye is painted, and what is not seen by the eye may not be painted. . . . When drawing from nature in Chinese painting [*guohua zhi xiesheng*], by contrast, there is no standing point or viewpoint, not to mention a horizon line. As if sitting in an airplane, the painter flies to the left and to the right; as if standing in an elevator, he moves up and down at will.[4]

Also, it was not necessary, Yu stated, that the result of the observation of nature be actually drawn on the spot. Instead, he suggests that after a sketching trip, when the "complete scenery of the whole mountain is before one's eyes," one should sort out superfluous details and concentrate on the main features of the site, thus achieving a general resemblance that cannot be pinned down to a limited viewpoint. This dis-resembling of resemblance that "discards the appearance and grasps the spirit," unattainable by the "fixed methods of Western painting," was the forte of *guohua xiesheng*.[5] In his conclusion, Yu Jianhua joined in with Xie Haiyan's plea to "strive diligently for the renaissance of the art of our nation," made in the announcement of the special issue.[6] Yu promised that those who revived the prowess of Tang and Song landscape painting and overcame the decline of the Ming and Qing dynasties by means of *xiesheng* would make *shanshuihua* not only the backbone of Chinese painting but also a means of expressing the spirit of Eastern art on a global scale.

Three different concepts of *xiesheng* can be discerned in Yu's essay. First, he identifies *xiesheng* with a mimetic realism that relies on immediate observation; this becomes particularly evident when Yu claims that of the extant Song paintings, none was not true to nature. Second, he understands drawing from nature to be a main feature of Western painting, even though the practice of copying was not unknown to Europeans, as Yu admits. Finally, and most important, Yu claims *xiesheng* does not imply painting in situ after all. Instead, he applies the term to paintings done from memory, based on previous observations of certain places. This twist allows Yu to generously include various toponymic paintings from pre-Yuan times under the term *xiesheng*.

These seemingly conflicting concepts of *xiesheng* can be traced to origins in different moments in the history of the term in the 1910s and 1920s, studied in detail by Yi Gu.[7] *Xiesheng* became a synonym for Western-style art education in the 1910s, when the leaders of the Shanghai Fine Arts School, founded in 1913, vigorously promoted it as their unique selling point. It then quickly became associated with scientific observation and mimetic representation, and as such came to be regarded as the opposite of copying from ancient masters, a view that is pervasive in Yu Jianhua's essay. The practice of copying was widely regarded as the cause for the perceived decline of Chinese painting, and Yu shared this belief. In his response to a reader's letter about his essay in the special issue of *National Painting Monthly*, Yu was particularly explicit about this point, writing that "the defects of Chinese painting in the last few centuries result from the fact that [painters] knew only how to copy the traces of the ancients, and

forgot about their own creativity."[8] Central to this argument by Yu Jianhua and others was the fact that the practice of *fanggu*, the formal engagement with the style or painting mode of another master that was widespread in later literati painting, was equated with copying. This negative simplification of the complex practice of *fang* allowed twentieth-century critics of unreformed *guohua* to criticize it wholesale. Basing landscape painting on *xiesheng* and claiming an early indigenous history for the practice was a solution to the predicament *guohua* painters faced: namely, how to continue painting in the medium in which they were trained—a medium, moreover, that increasingly came to be regarded as representative of their national and cultural identity—while at the same time casting off the negative associations of copying from the ancients.

For many points, Yu Jianhua's article follows a line of argument first put forth by the Beijing-based painter Hu Peiheng in 1921.[9] In his essay "The Question of *Xiesheng* in Chinese Landscape Painting" ("Zhongguo shanshuihua xiesheng de wenti"), Hu, like Yu Jianhua fourteen years later, claimed that Chinese painting had reached its zenith during the Tang and Song dynasties, when "the famous painters all used their creative capabilities to paint nature's fine sceneries." Likewise, he describes the history of post-Song painting as a process of decline, which could be reverted only through the practice of *xiesheng*.[10] The accounts in Hu's and Yu's essays of the rise and decline of *xiesheng* over the history of Chinese painting are similar to a high degree, including the painters they cite to prove the perceived phenomenon. These similarities are indicative of a recent but stable canon of painters. The criterion for inclusion in this group was the alleged practice of *xiesheng*.

The emphasis on painting "from nature" implies a fundamental rewriting of the canon of Chinese painting that stood in an antagonistic relationship to the established (and, for many painters, still valid) canon of literati painting. These conflicting views become manifest in the discussion of Ni Zan's painting. Neither Hu Peiheng nor Yu Jianhua wrote of him in negative terms; however, both identified him as the turning point toward decline. According to their narratives, it was in Ni Zan's work that the observation of nature became irrelevant, and it was the emulation of his model by generations of later painters that led to the degradation of Chinese painting. In the counternarrative in defense of literati painting, by contrast, Ni Zan's central position in the canon was unquestioned. Li Baoquan, for example, also writing in the special issue of *National Painting Monthly*, posited Ni Zan as the paradigm of "naturalism" and representative of the highest achievements in landscape painting, as discussed in chapter 1. The

two views coexisted and influenced each other in an ambivalent, unresolved tension.

That tension was created by the perceived necessity to adhere to a distinctly Chinese mode of painting and, at the same time, to the observation of nature; it is inherent in Hu Peiheng's and Yu Jianhua's articles on *xiesheng*, albeit in different ways. Yu identifies the absence of central perspective as the essential advantage of Chinese painting over European landscape painting. Hu Peiheng, on the other hand, apparently saw the essence of Chinese landscape painting embodied in its representational modes and techniques, such as texture strokes (*cunfa*). These could therefore not be easily discarded, as he clarifies in his statement on how to set about painting from nature:

> I have already written about the ancient painters that practiced *xiesheng*; now if we want to paint from nature, whose method should we use? The landscapes of every region in China are very different, therefore we should not get tangled up with the ancient masters. Still we cannot give up the ancient methods either. The only solution is to combine the true scenery with method, and paint it with the brushwork that the ancient masters excelled in. The outcome will naturally be beautiful.[11]

Hu then adds that one should not be restrained by the bias toward certain schools; he detaches painting methods from distinct school styles and instead traces them back to the characteristics of regional landscapes. Thus they become markers of cultural identity that may not be given up. Hu proceeds to list certain mountain types, such as earthen mountains or rock mountains, and specific views, such as the view from the summit of Mount Yandang of the surrounding mountains, and then associates each of them with specific texture strokes. Hu's identification of texture strokes in actual landscapes is very similar to He Tianjian's description of the topographies of Eastern Zhejiang in *In Search of the Southeast* (see chapter 2); in fact his article was probably a source for the latter.

Hu's article, "The Question of *Xiesheng* in Chinese Landscape Painting," was published in the *Journal for Painting Studies* (*Huixue zazhi*), the periodical of the Research Institute for Painting Methods at Peking University and a major venue for the discussion of painting methods and theory around 1920.[12] It was printed in the journal's third and last number, which featured essays on evolution as well as *xiesheng*, indicating the close connection between evolutionist thinking and representational models associated with scientific veracity. The issue opened with

a series of articles by Cai Yuanpei (1868–1940) that offered an evolutionist view on art and aesthetics from a universalist perspective. In his position as president of Peking University, former minister of education, and founder of the Research Institute for Painting Methods, Cai was one of the most influential intellectuals in Republican China. His essays in *Journal for Painting Studies* reflect his academic training in idealist philosophy and art history at the University of Leipzig, where he had studied from 1907 to 1912; at the same time, he interpreted art and aesthetics in evolutionist terms.[13] The first two articles are on the evolution of art and of aesthetics, respectively. On the evolution of art, Cai discusses the prehistoric origins of the arts in ritual, whereas the text on the evolution of aesthetics is an overview of aesthetic discourses across the history of European philosophy; Cai opens by noting the absence of aesthetics as a systematic discipline in China.[14] In his brief statement on Chinese painting in "The Evolution of Art," the Eurocentric standards underlying evolutionist discourse are explicit: "Chinese paintings are among the most developed in art. But only a few of them are creative, and the majority are imitative. Western painters are constantly establishing new schools. And in painting atmosphere, light, distances, and the characteristics of human figures, they are far more progressive than we are."[15]

The same issue of *Journal for Painting Studies* carried an essay by Chen Shizeng, himself a core member of the Research Institute and Yu Jianhua's teacher, that appears to be an immediate reply to Cai Yuanpei, judging from its title, "Chinese Painting Is Progressive."[16] According to Chen, everything on earth follows the rules of evolutionary progress. However, he writes, he had frequently heard people say that Chinese painting was not progressing (*jinbude* 進步的) but regressing (*tuibude* 退步的); he therefore wanted to state his opinion to the contrary. The remainder of his essay is an outline of the early development of Chinese painting as progressive history. Unfortunately, the essay is incomplete; it was to be continued in a later issue, which was never published.[17] Chen's narrative ends midway through Chinese painting's history, with the emergence of genre painting (*fengsuhua* 風俗畫) in the Ming dynasty. It allows us no conclusion on how he evaluated Qing-period or even twentieth-century painting. But the fact that he introduced genre painting as a Ming-period innovation makes it clear that Chen Shizeng was attempting to insert the history of Chinese painting into an evolutionist framework in an affirmative manner, countering the widespread view of its protracted decline.

Chen's essay immediately precedes Hu Peiheng's "The Question of *Xiesheng* in Chinese Landscape Painting" in the journal's final issue. The two texts share

the goal of accommodating Chinese painting to the predominant evolutionist narrative. Although Hu states that the prospects of art were declining day by day, he suggests that the process could be reverted if painters returned to the state of painting before its decline began.[18] This proposed return to past grandeur does not conform to a strictly evolutionist concept of progressive history, but it grants a vision of survival in the competition of nations and even future grandeur comparable to that of the past.

From Yu Jianhua's essay and He Tianjian's discovery of texture strokes in nature, we can see that in the years since its publication, Hu Peiheng's proposition that Tang and Song painting were based on *xiesheng* had become widely accepted. Hu had argued that texture strokes were actually based on the observation of nature and that European techniques, such as perspective and shading, could be realized by applying more ink washes, thereby downplaying differences between the Chinese and European painting traditions. Yu Jianhua, on the other hand, perceived a "wide gap between Chinese and Western [painting]" that was marked by fundamental differences, the most notable being the use of perspective.[19] Moreover, in his opinion, the nonperspectival rendering of space in Chinese painting was preferable to central perspective. Yu based his claim on his own experience of painting from nature. He gives an account of his own career as a *xiesheng* practitioner and comes to the conclusion that the paintings done from memory that recorded a generalized impression were more satisfying than ones in which he meticulously documented topographical details with perspectival accuracy.[20]

Yu Jianhua had made various sketching strips since 1919 and published several accounts of his journeys. Reports on his early sketching trips through his home province of Shandong appeared in the Beijing newspaper *Chenbao* in multiple installments.[21] Unfortunately, these articles were not illustrated, and none of his early sketches appears to have survived. It seems that the paintings and sketches he created during those tours were "Western-style"—that is, watercolors and pencil sketches. In his 1935 article "Sketching from Nature in Chinese Landscape Painting," Yu highlighted a pivotal moment in which he began to combine sketching from nature with the medium of Chinese ink painting. It occurred in 1931 during a journey to Mount Yandang in southern Zhejiang. His visit to the mountain and the painting albums he produced there marked an important point in Yu Jianhua's career as a *xiesheng* painter.

How to Paint Mount Yandang

Yu Jianhua wrote a detailed account of his journey to Mount Yandang that was published the following year in *The China Traveler*.[22] "Record of Sketching from Nature at Yandang" ("Yandang xiesheng ji") is illustrated with paintings that Yu created during his trip; in the text, descriptions of the landscape are intermingled with accounts of his sketching activities. Readers thus could (and still can) compare the pictures with the written descriptions of the sights of Mount Yandang, and they could also compare his account of how he painted them with the final outcome. In his account, Yu frequently added brief remarks that he "painted a leaf," but in some cases he grants readers very detailed insights into the frustrations he encountered and the solutions he found in the process. Among the major issues he stressed were the shortcomings and advantages of different tools for doing sketches. In particular, he stressed the advantages of brush-and-ink over the disadvantages of drawing tools imported from the West, especially the disadvantages of pencils.

An episode that is crucial in this regard occurs early on in his account. After rather summarily reporting on the stages of his journey of several days from Shanghai to the mountain, his arrival there, and the first tour of some peaks and waterfalls, he abruptly turns to the subject of painting from nature:

> I took my painting utensils to the back of our lodge [at Lingyan Temple] to paint Duxiu Peak. All Western methods to sketch from nature, such as oil painting or watercolors, are convenient to use for painting in situ. Forms and colors will all be captured as in the real scenery [*shijing* 實景], marvelous and mimetic. Landscapes in Chinese painting [*guohua shanshui*] were all painted in situ during the Song and Yuan times. Therefore there was almost no difference between the mountains, rivers, streams, and gorges in painting and in the real scenery. But these methods of painting from nature have long since been lost. Only two of the [ancient] methods are still in use today. One is the method of the "stomach draft" [*fugao* 腹稿] as applied in Wu Daozi's painting of Jialing River. After traveling through the landscape, he created a synthesis of what he remembered and of what aroused his interest, selected the essence and disposed of the superfluous, and thus created an image. The composition of mountains and rivers, and the texture of rocks and stones at first glance closely resemble certain places, but when you observe it closely, it does not compare to the real site. You discard the appearance and keep the spirit, the essentials are highlighted by concentrating on the main features. The works of the famous painters since the

Yuan and Ming dynasties depicting specific landscapes all use this method. The second method is the one described by Dong Qichang: place a small album, brushes, and ink in your bag, and whenever you see something along the road that might be suited for a painting, you can use the utensils to sketch it immediately for later use in an image. Today, one commonly uses a pencil and a sketch pad to roughly make a sketch to take home and use it as the basis for another painting. Formerly, I also frequently used this method, but it has severe shortcomings, too. First, pencils are hard, and one cannot modulate the lines at will. Second, pencils are dry, and unable to convey moistness [yinyun] and tonal gradations. Third, pencils quickly wear off, and as time passes, the lines become blurred and unclear, and [the sketches] suddenly become waste. Fourth, you assume that when you make quick sketches, you can later complete them from your memory. Therefore you are determined to make as many sketches as possible without realizing that when time passes by, the impressions are all gone, and the sketches are of no use. To summarize these four points, although pencil sketching has the advantage of being very convenient, it nonetheless cannot escape the ridicule of being useless. After pondering for a long time, I finally chose another method. The painting tools of *guohua* are generally heavy and clumsy; they are convenient for indoor use but not for outdoor sketching, and even less so for traveling, not to mention for situations when you are on a mountaintop or near rivers and gorges, getting inspired to compose, modulate the colors, and portray the spirit of the mountain. Besides, the paper is also really difficult to handle. Luckily, I practiced Western-style outdoor sketching for many years. Therefore I took some Western-style utensils, such as a tripod stool, a water bottle, and a palette. To this I added one ink stick and an ink stone. Everything is quite light and easy to carry. Last winter I bought several volumes of premounted painting albums to use when sketching from nature. With my utensils well prepared, I experimented with Chinese-style sketching from nature [*guohua xiesheng*]. The first thing I painted was Duxiu Peak. I applied ink and added color. Without, I learned from nature; within, I used the established methods.[23] After about an hour, [the painting] was completed, and it was worth looking at. As I succeeded on the first try, my courage and interest grew, and I wanted to continue painting. But it was time for lunch. After the meal I ordered my student Xu [Peiji] to bring his utensils and try sketching, too.[24]

Prompted and framed by his double mention of Duxiu Peak, this outline details Yu Jianhua's personal method of *xiesheng*. While he never questions his use of the medium of ink painting, his account vividly illustrates the tensions engen-

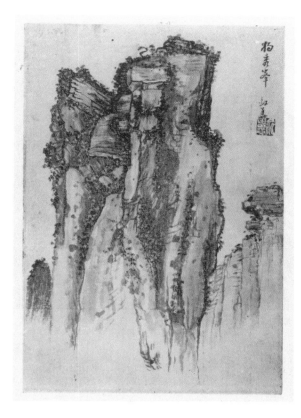

Fig. 4.1. Yu Jianhua, *Duxiu Peak*, 1931. Leaf from the album *Travels on Yandang (1)*. Reproduced from *The China Traveler* (*Lüxing zazhi*) 6, no. 2 (1932): 20. Harvard-Yenching Library of the Harvard College Library, Harvard University. Photo: Harvard Imaging Services.

dered by the choice of the medium, its materials, and its inherited practices, on the one hand, and by the self-appointed task of painting a specific scene as true to nature as possible, on the basis of personal observation in situ. Yu acknowledges that the practice of sketching on site has its origin in European painting techniques in his experiments with different tools and methods—most important, pencil sketches. However, the use of that medium aroused discomfort in him precisely because it did not produce the qualities of ink painting, namely modulation and tonal gradation. Moreover, the sketches did not record every detail and proved unreliable as an aide-mémoire. The only solution to this self-imposed set of problems was to paint in ink on site.

The picture of Duxiu Peak that aroused such excitement in Yu Jianhua is illustrated in his article (fig. 4.1). It shows a rather simple composition, with the vertical formation of the peak filling almost the entire image, its cliffs rising parallel to the edges of the paper. Other peaks are arranged in the background, and depicted as much lower in height. The impression is that of a close-up view from below, giving the image the immediacy of on-site observation. The painting has

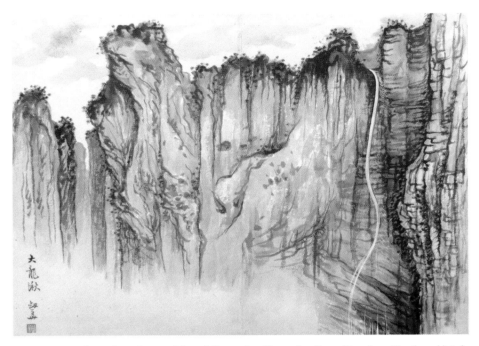

Fig. 4.2. Yu Jianhua, *Great Dragon Waterfall*, 1931. Leaf from the album *Travels on Yandang (1)*. Ink and colors on paper, 30.6 × 22.8 cm. Nanjing University of the Arts Library. Photo by the author.

also retained a certain degree of sketchiness, especially in the lower part of the picture, where the ink lines taper out in the blankness of the paper. This residue of sketchiness, however, is not found in many of the other illustrations accompanying Yu Jianhua's account. Taken from his six albums of Yandang paintings that are now preserved in the Nanjing University of the Arts Library, most of the images are carefully composed and neatly executed views of the mountain that were completed on the basis of the sketches Yu drew in situ (fig. 4.2). According to Yu's travelogue, he completed five of the six albums during his stay at Mount Yandang.[25] However, he is not very explicit about the relationship between the numerous drafts he reports making and the final versions he included in the albums; the latter were probably painted at the temple where he stayed.

The satisfaction Yu Jianhua experienced when sketching Duxiu Peak did not mean that his experiments in search of the best method of practicing *guohua xiesheng* ended there. His account of his Yandang trip should be read as a day-to-day account that constantly reveals new insights gained by its author, each being celebrated as offering a definite solution. Yu sketched Duxiu Peak on the twenty-fourth day of the fifth month (July 10, 1931), the first day of his

stay at Mount Yandang.[26] Following that episode, he frequently mentions drawing pencil sketches; he also variously refers to the hours or even days he spent reworking the sketches made outdoors. Over the course of his stay on the mountain, truth to nature in terms of form-likeness apparently became less important to him. He indicates this in a section of his account on how he painted views seen from a pavilion at the Spirit Peaks (Lingfeng) on the tenth day of the sixth month (July 24). Here, Yu inserts another programmatic statement on method. He writes that if one wishes to grasp the details of a scene, photography is by far superior to brush and ink. When relying on the brush, the artist has to concentrate on depicting the essentials by way of simplification (*danchunhua* 單純化).

> One brushstroke can express countless forms, one [application of] ink can convey countless colors. This is the origin of the most sublime works of art; this is why sketching the idea [*xieyi*] and sketching from nature [*xiesheng*] should be combined. Because if you do not sketch from nature, you stay muddled about the actual configurations of nature. If you do not sketch the idea, then you will be consumed by the details and you will not be able to escape being a slave to nature. Therefore you cannot discard either of the two.[27]

Still, when writing about another instance of on-site sketching a few days later, Yu expressed his frustration about not being able to truthfully depict the fantastic forms he encountered in a gorge.[28]

It is this urge to document the landscape as truthfully as possible that characterizes the project of Yu Jianhua's Yandang albums as well as his travelogue. "Record of Sketching from Nature at Yandang" first gives its readers an exhaustive description of the landscape and of every step Yu took (and every meal he ate) on the mountain. The second half of the text contains extensive lists of the peaks that he sketched every day. Yu apparently attempted to create a complete visual record of Mount Yandang and its multiple peaks from various viewpoints, an endeavor that is manifested in the set of six albums. This attempt at documentation ultimately also forecloses any more expressive and abbreviated renderings of the landscape that would normally be associated with the mode of *xieyi*, or sketching the idea, which Yu claims to be using in combination with *xiesheng*. Although he does resort to abbreviated renderings and canonical formulae that place his works in the tradition of Chinese painting, their execution in carefully drawn lines aims at a close representation of the "real scenery" (*shijing*), as he repeatedly states in his travelogue.

Fig. 4.3. First page of Yu Jianhua, "Record of Sketching from Nature on Yandang," *The China Traveler* 6, no. 2 (1932): 15, with the illustration *The Spirit Peaks at One Glance*, 1931, leaf from the album *Travels on Yandang (5)*. Harvard-Yenching Library of the Harvard College Library, Harvard University. Photo: Harvard Imaging Services.

And despite the emphasis Yu Jianhua placed on the advantages of *guohua xiesheng*, his training in Western techniques is clearly visible in the Yandang paintings. In the first illustration in his travel record, *The Spirit Peaks at One Glance* (fig. 4.3), he used strong foreshortening to emphasize the spatial depth of the valley. Other leaves are marked by the tight framing characteristic of many Republican-period paintings based on in situ observation. Another aspect of Yu Jianhua's Yandang albums that points to his earlier specialization in "Western" painting is his use of color. The Yandang albums are thoroughly colored; Yu employed pigments to describe the qualities of the mountains as well as atmospheric and lighting effects.

Yu Jianhua translated painting techniques, sketching practices, and tools from European-style watercolors and pencil drawing to Chinese-style ink painting, and back. These medial transfers were further complicated by his references to the medium of photography. Yu's transmedial practice was not unidirectional but flexible; actually, he mostly made pencil sketches during subsequent sketching trips, and he frequently cited photographic modes of

representation. The combination of text and images in the travelogue published in *The China Traveler* formed another instance of transmedial practice that Yu further explored in the following years in a series of illustrated travelogues.

Painting along the Zhejiang-Jiangxi Railway

The reproductions of Yu Jianhua's Yandang albums in *The China Traveler* were unable to convey the subtle colorations to which Yu paid so much attention in his paintings. This may be one reason he never published the travelogues that he wrote and illustrated in 1935 and 1936. The first of these, a manuscript from 1935 that he titled *Further Travels in Eastern Zhejiang* (*Xu you Zhedong ji*), seems to be a direct response to the experience of publishing the Yandang travelogue in print. The similarities in the arrangement of titles, text body, and images between the *China Traveler* edition of his "Sketching from Nature on Yandang" (see fig. 4.3) and the travelogues in his *Further Travels* album (fig. 4.4) make it very likely that the *China Traveler*'s layout served as his model for the latter.

Further Travels in Eastern Zhejiang is not mounted as a painting album but string-bound as a book. Yu inserts the illustrations into the handwritten text, framed with clear ink lines and accompanied by image captions. In his introduction to the travelogue, Yu calls this format *shuce* 書冊, or writing album, instead of *huace* 畫冊, or painting album. With this format, he availed himself of the possibilities of a flexible layout while maintaining the personal imprint of handwriting in different calligraphic scripts and of illustrations painted with a brush in ink and color. *Further Travels* and the three other manuscript travel albums Yu created in the following years were not reproduced until 2009, and indeed the *shuce* format itself might seem to make a printed version appear redundant, were it not for the purpose of distribution to a wider public.[29] Distribution does not seem to have been Yu Jianhua's main interest; he kept the albums in his personal collection. At a later point, he collected the four albums into one folding case, which he titled *Yu Jianhua's Illustrated Albums of Sketches and Travelogues of Famous Mountains* (*Yu Jianhua mingshan xiesheng jiyou tuce*).

With the *shuce* format, Yu Jianhua found a way to combine writing and painting, which he had previously practiced in separate domains: his earliest accounts of sketching tours in Shandong were published without illustrations; his Yandang travelogue was illustrated, but the albums from which the illustrations were taken still formed an independent set of paintings, and they were reproduced with a great loss of quality. With the *shuce* albums, Yu circumvented

the issue of publication and reproduction altogether, controlling the visual quality of his own images and the interrelation of texts and illustrations. The albums testify to Yu Jianhua's keen awareness of the aesthetic properties of different pictorial and print media, as well as different text formats. He experimented with different aspects in each of the albums.

Between 1935 and 1936, Yu Jianhua created three illustrated travel albums: *Further Travels in Eastern Zhejiang*, dated 1935, and *Traces of My Sandals along the Zhejiang-Jiangxi Railway* (*Zhe-Gan jihen*) and *Yu Jianhua's Illustrated Album of Travels in Southern Anhui* (*Yu Jianhua Wannan jiyou tuce*), both created in 1936. He made a fourth, *Album of Travel Pictures of Wuyi and the Nine Bends* (*Wuyi Jiuqu jiyou tuce*), in 1942, during his wartime exile in Fujian. Like the four-part article "Record of Sketching from Nature at Yandang," the texts in the manuscript albums by and large follow the conventions of the established literary genre of the travelogue. They record the details of the journeys, including prices for transportation and lodging; the scenic sites Yu Jianhua and his traveling companions visited and their emotional as well as physical response to them; and, finally, geographical information. The illustrations have a similar scope: they range from close-up views of particularly spectacular sites, such as waterfalls or caves, or even waterfalls within caves, to views over wide vistas of river basins or mountain ranges, to a veritable panorama of the Thirty-Six Peaks of Yiyang in Jiangxi that extends over fourteen pages of Yu's album *Traces of My Sandals*. Some are in monochrome ink, but the majority are in color. Moreover, in the Zhejiang-Jiangxi and the Southern Anhui albums, photographs shot by Yu Jianhua's student Yu Guiyi (1913–2007), better known under his *zi*, Xining, during their travels are pasted onto the last pages.

Seen together, the three albums made in 1935 and 1936 reflect Yu's endeavor to record the landscape of Southeast China on at least two levels: first as a documentary record of the physical appearance of the terrain, and second as a record of the author's personal response to his bodily and visual encounter with the land. The albums also respond to contemporary travel-related publications that mapped the Chinese landscape through the medium of photography. In particular, they are closely related to the project of the Southeastern Infrastructure Tour and *In Search of the Southeast*.

As mentioned in chapter 3, Yu Jianhua and his student Xu Peiji both contributed to the section "Along the Hangzhou-Fuzhou Highway and the Shanghai-Lin'an Highway" in *In Search of the Southeast*. Besides this published evidence of Yu's participation in the Southeastern Infrastructure Tour, a document preserved in the Nanjing University of the Arts Library sheds additional light on the tour

project. It is a painting album in the same premounted leporello format that Yu used for his sketching pads on Mount Yandang. Titled *Famous Sites Sketched While Traveling through Zhejiang (You Zhe jisheng)* and dated 1934, it is a collection of rather conventional paintings of various scenic spots. The most interesting aspect of the album is a double page that Yu provided with the caption "Signatures of my fellow travelers" and signed "recorded by Yu Jianhua in the second month of the *jiaxu* year on the banks of West Lake," that is, in Hangzhou. Among the forty-four names on the leaf are those of several officials of the Zhejiang Construction Bureau, the director of the Zhejiang-Jiangxi Railway Bureau, and the prefect of Lishui County; members of the editorial board of *In Search of the Southeast,* such as Ye Qiuyuan and Lin Yutang; Huang Yanpei, Guo Butao, and others who traveled on the road to Mount Yandang; the geographer Zhang Qiyun; and contributors to the "Along the Zhejiang-Jiangxi Railway . . ." section of *In Search of the Southeast,* most notably He Tianjian, Yu Dafu, and the photographers Ren Mei'e and Zeng Shirong. The date given by Yu Jianhua, the second month of the *jiaxu* year, corresponds to March 15 to April 13, 1934, and coincides with the first reports in *Shenbao* on travel activities in the context of the Southeastern Infrastructure Tour.[30] More clearly than *In Search of the Southeast* or the brief reports in *Shenbao,* the list of signatures in Yu Jianhua's album shows how the technocrats of the Zhejiang Construction Bureau invited numerous writers, painters, academics, and professional and amateur photographers to Hangzhou and set them en route to the various destinations of the tour.

The existence of this album created in the context of the tour explains why *Further Travels in Eastern Zhejiang* has the word "further" in its title. It is, in fact, a sequel to the Southeastern Infrastructure Tour as well as to the texts and images created in the context of the tour, including Yu's album from 1934; it documents a journey made between March 30 and April 8, 1935, and thus after Yu Jianhua's travels on the highway to Mount Yandang that were published in *In Search of the Southeast*; and finally, it follows the itinerary along the Zhejiang-Jiangxi Railway that had become almost compulsory since the publication of Yu Dafu's travel diaries in *Scenic Sites in Eastern Zhejiang*; inter alia, it includes visits to the Five Cataracts in Zhuji, the Three Caves in Jinhua, and the Fang Cliffs in Yongkang.

Yu Jianhua not only followed the routes laid down in the existing Zhejiang-Jiangxi Railway literature but also borrowed the structure of thematic sequences that marks the editorial strategy in *In Search of the Southeast.* Like the photographs in the Zhejiang-Jiangxi Railway section in *Search,* the painted illustrations in *Further Travels in Eastern Zhejiang* lead the viewer into a certain place

Fig. 4.4. Yu Jianhua, *Further Travels in Eastern Zhejiang (Xu you Zhedong ji)*, 1935, first page from the chapter "Visit to the Five Cataracts in Zhuji," 3a, with the illustration *The Fifth Cataract*. Page from an illustrated manuscript, ink and colors on paper, 36.2 × 24.1 cm. Nanjing University of the Arts Library. Photo by the author.

and depict it from different angles, while also illustrating the accompanying travelogue. Yu's depictions of the Five Cataracts exemplify this strategy.

As noted earlier, images of the Five Cataracts were scarce, in spite of the fact that they had been highlighted as a standard sightseeing destination along the new railroad in numerous travelogues of the mid-1930s. The reason may lie in the circumstance that the Fourth Cataract in particular was extremely difficult to access, as was unanimously stressed in contemporary travel writing. As discussed in chapter 2, He Tianjian's painting of the Fourth Cataract, reproduced in *In Search of the Southeast* (see fig. 2.18), lays claim to topographic accuracy, underscoring the claim by employing linear perspective and an angle based on a photograph by Chen Wanli (see fig. 2.19). Yu Jianhua, in his five images of the Five Cataracts, seems to counter He Tianjian's pictorial strategy by deemphasizing perspectival vision. Instead, Yu used the long vertical format of a hanging scroll to relate the sheer height of the waterfalls as well as their topographical relationship. As Yu explained in the album's introduction, with his choice of the *shuce* format he wanted to avoid the restrictions of the painting album (*huace*). The

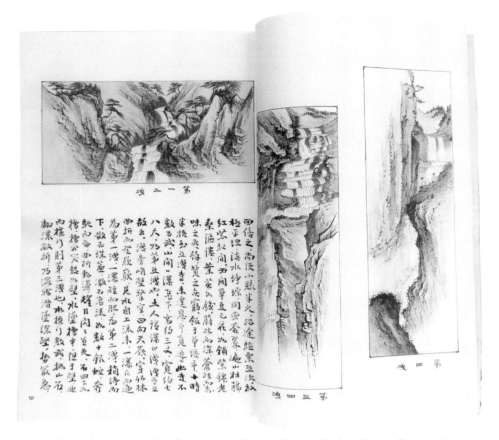

Fig. 4.5. Yu Jianhua, *Further Travels in Eastern Zhejiang (Xu you Zhedong ji)*, 1935, "Visit to the Five Cataracts in Zhuji," 3b–4a, with the illustrations *The Fourth Cataract* (3b, right) and *The Third and Fourth Cataracts* (3b, left), and *The First and Second Cataracts* (4a). Two-page spread from an illustrated manuscript, ink and colors on paper, 36.2 × 24.1 cm. Nanjing University of the Arts Library. Photo by the author.

shuce offered flexibility in the illustrations' format and scale; he could transpose his travel sketches into the format of an album leaf, a hanging scroll, or a handscroll. Yu made full use of this flexibility in his paintings of the Five Cataracts. The illustration on the opening page of the section titled "Visit to the Five Cataracts in Zhuji" (fig. 4.4) has a vertical format reminiscent of hanging scrolls. It shows the Fifth Cataract, set back into the middle distance and framed by steep mountains, plummeting downward approximately along the central axis. In the gorge leading toward the waterfall, we see two travelers—Yu Jianhua and Xu Peiji in the guise of Shitao-esque seventeenth-century scholars. A flight of steep stone steps in the lower right corner indicates the path leading up to the other four cataracts.

On turning the page, the reader encounters the travelers again (fig. 4.5). Now they are perched on a cliff above the Fourth Cataract, gazing downward; the

view is drawn from a point close to the precipitously rising rock faces that fill almost the entirety of the elongated vertical picture plane. They also hide a major part of the waterfall. The cataract becomes fully visible only in the adjacent image, which constructs a view from a greater distance and shows the Third and Fourth Cataracts together. By pairing the two images on one page, Yu created an effect of zooming in and out on the same motif, thus bringing different details into view—the gazing travelers in the close-up and the larger environment from farther away. This arrangement echoes the editorial strategy, applied in *In Search of the Southeast*, of combining photographs of one place taken from different angles (see fig. 3.5). It also plays on the ability of painting to overcome the limitations of a fixed viewpoint, a fixed camera frame, and linear perspective by extrapolating a view of the Fourth Cataract from midair and extending it upward to include the Third Cataract. Yu's painting might also be a response to He Tianjian's painting of the Fourth Cataract that claims the superiority of painting by referencing the monocular vision of photography and central perspective. Yu Jianhua makes the same claim by negating perspective; instead, he follows his own pronouncement in *National Painting Monthly*, that Chinese-style sketching allows the painter to fly to the left and to the right, and to move up and down as if standing in an elevator.[31]

Whereas the paired images of the Third and Fourth Cataracts reference photography indirectly, the illustration on the facing page addresses it in a straightforward manner. It shows the First and Second Cataracts frontally, in a horizontal format. The tight framing of the composition and the view leading back into the narrow gorge carved out by the cataracts is based on perspectival vision and photographic view-taking. Moreover, Yu self-consciously highlights this reference to photography by means of a distinct palette. Whereas most of the illustrations in the album are colored with subtly graded blue-green and ochre tones, Yu applied an even layer of ochre over the whole image in this case; with the reduction of the palette to ink and ochre, he achieves a monochrome effect. The only parts of the image that are not dyed in ochre are the cataracts. They are highlighted with white pigment, thus further underscoring the ochre-black darkness of the mountain parts. The monochromatic effect alludes to the sepia tones of early photography, a reference he emphasizes with the tight image frame and visual foreshortening. Yu Jianhua's use of these strongly elongated vertical and horizontal formats heightens the dramatic effect of the landscape in a manner he probably would not have been able to achieve in the conventional album format of the Yandang series.

Yu closes his visual documentation of the site with an illustration titled *Composition of a Complete View of the Five Cataracts* (fig. 4.6). In this long and narrow picture, he combined the compositions of the preceding illustrations. The bottom part is an approximate copy of his image of the Fifth Cataract; above it, the image of the Fourth and Third Cataracts follows almost seamlessly. The First and Second Cataracts are more elongated and rendered in color to fit into the picture; the composition is topped by a combined miniature version of the two illustrations that immediately precede the *Complete View*. The construed nature of this "complete view" (*quanjing* 全景), which harks back to premodern painting and mapping practices, is consciously pronounced by Yu in his title: by calling this image a "composition" (*goutu* 構圖), he marks it as a collage of separate views brought together into a whole. He thereby inserts his own practice of *guohua xiesheng*, or Chinese-style sketching from nature, into older native practices of topographical painting, while at the same time referencing contemporary photo books.

That Yu Jianhua actually aimed at mapping the places he traveled through becomes evident in the illustration at the end of his "Visit to the Five Cataracts in Zhuji" (fig. 4.7). Set on the top half of an otherwise blank page, it shows a view from a mountain top over the town of Zhuji and its environs. The painting bears no caption; instead Yu lists the names of the most important topographical features. It provides the viewer with information on the layout of the town, scenic spots in its vicinity, such as the Shrine of Xi Shi, and the course of the Wansha River. It also includes a rare image of the dominant but largely invisible structure that underlay

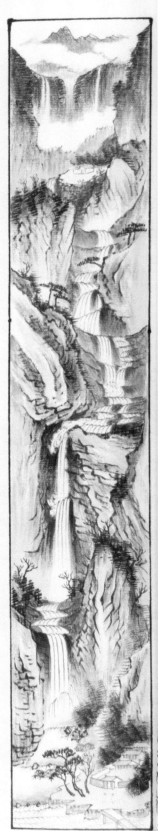

五淺全景構圖

Fig. 4.6. Yu Jianhua, *Composition of a Complete View of the Five Cataracts*, in *Further Travels in Eastern Zhejiang (Xu you Zhedong ji)*, 1935, "Visit to the Five Cataracts in Zhuji," 5b. Ink and colors on paper. Nanjing University of the Arts Library. Photo by the author.

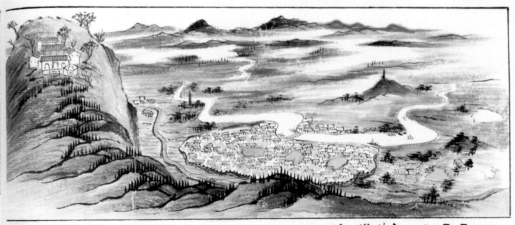

蔓 公 胡　　路 銕 江 杭　城 暨 諸 暨　江 纱 浅 塔 鷄 金　祠 子 西

Fig. 4.7. Yu Jianhua, View of Zhuji and its environs, in *Further Travels in Eastern Zhejiang* (*Xu you Zhedong ji*), 1935, "Visit to the Five Cataracts in Zhuji," 6b. Ink and colors on paper. Nanjing University of the Arts Library. Photo by the author.

so much of mid-1930s travel literature and imagery: the tracks of the Zhejiang-Jiangxi Railway.[32]

The kind of topographical information given in the picture-map of Zhuji accompanies several illustrations in *Further Travels in Eastern Zhejiang*.[33] The most expansive is a series of four images that extend over the recto and verso sides of a spread in "Visit to the Cliffs and Caves of Lanxi," the last section of the travelogue about Eastern Zhejiang (fig. 4.8). With their long, horizontal format the illustrations not only imitate the dimensions of a handscroll, but of a handscroll reproduced in four continuous sections. Their viewing direction, however, is from left to right. The title, *Boating at Lanxi*, suggests the depiction of a leisure outing in the literati tradition, but despite a few alibi boats, the series' main purpose is to map the topography of a substantial stretch of the Lan River, employing a bird's-eye view to encompass a greater scope. Yu again names the main landmarks, beginning with a mountain called Mount Heng (Hengshan), passing the prefecture town of Lanxi, and continuing with pagodas, a pavilion, and a pontoon bridge.

In combining allusions to literati landscapes and topographical documentation in one long, continuous set of images, Yu Jianhua was responding to a sequence of three photographs of the same place in *In Search of the Southeast* (figs. 4.9–4.11): *Complete View of Mount Heng* by Zeng Shirong, which shows the mountain from

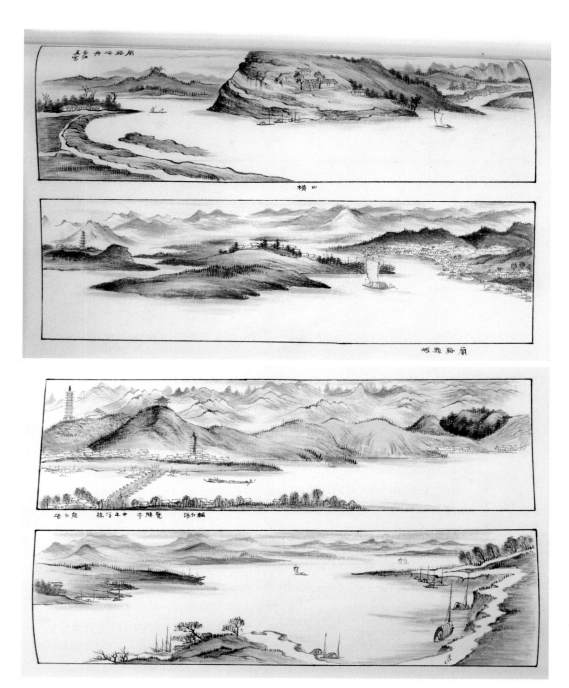

Fig. 4.8. Yu Jianhua, *Boating at Lanxi*, sections 1–4, in *Further Travels in Eastern Zhejiang* (*Xu you Zhedong ji*), 1935, "Visit to Cliffs and Caves of Lanxi," 24a–24b. Ink and colors on paper. Nanjing University of the Arts Library. Photo by the author.

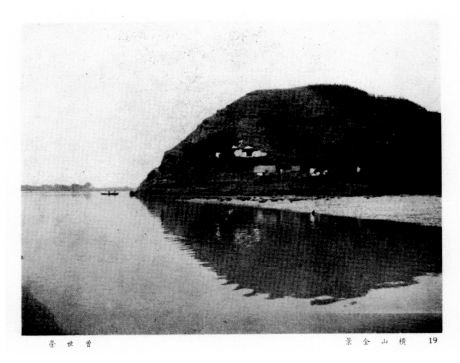

曾世荣 横 山 全 景 19

Fig. 4.9. Zeng Shirong, *Complete View of Mount Heng*, ca. 1934, photograph. Reproduced from *In Search of the Southeast* (*Dongnan lansheng*) (1935), "Along the Hangzhou-Yushan Section . . . ," 16. Photo: Shanghai Library.

the level of the riverbank, with a boat sailing next to it; *Lanxi* by Dong Xiaoyi, showing the town with its landmarks at the far end of an expanse of water, the scenery framed by the silhouettes of two trees; and Wu Bin's *View from Mount Heng toward Lanxi*, which depicts the river stretching into the distance, seen through a row of young pines. The motifs and compositions of the photographs correspond closely to the first, middle, and fourth sections of Yu Jianhua's "handscroll" image. They are more pictorialist than documentary; the artists aimed at capturing the beauty of the landscape and consciously heightened the pictorial effect by deploying trees and sandy shores as framing devices. Yu Jianhua borrows the same motifs but renders legible and names those landscape elements that blur into the distance in the photographs. In this way, he discards the pictorialist quality of the photographs and replaces it with thorough delineation and visibility, thereby implicitly countering the claim to visual veracity that was commonly associated with photography in modern Chinese discourse.[34] Moreover, by citing the most expansive format available in Chinese painting, the handscroll, Yu makes the framings of the photographs appear as the limitations of a technical device.

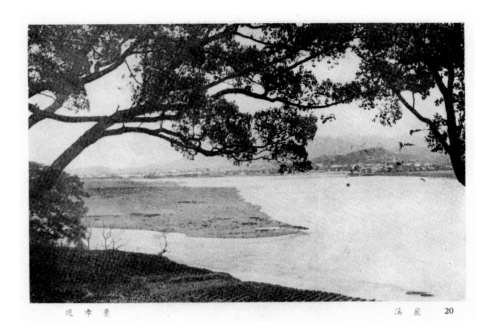

遺孝董 蘭溪 20

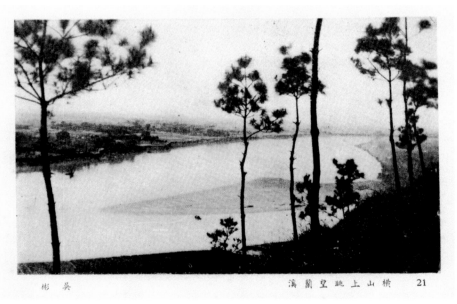

彬吳 橫山上眺望蘭溪 21

Above: Fig. 4.10. Dong Xiaoyi, *Lanxi*, ca. 1934, photograph.
Below: Fig. 4.11. Wu Bin, *View from Mount Heng toward Lanxi*, ca. 1934, photograph.
Both illustrations are reproduced from *In Search of the Southeast* (*Dongnan lansheng*) (1935),
"Along the Hangzhou-Yushan Section . . . ," 17. Photo: Shanghai Library.

北山朝真洞口

任美鍔

15

Fig. 4.12. Ren Mei'e, *The Mouth of Chaozhen Cave on North Mountain*, photograph. Reproduced from *In Search of the Southeast* (*Dongnan lansheng*) (1935), "Along the Hangzhou-Yushan Section . . . ," 12. Photo: Shanghai Library.

In fact, the composition of Yu's "handscroll" series is based on a photographic model on another level. In his illustrations, the river recedes into the distance at the far ends of the "scroll" while running horizontally in the central sections. This bending horizontal course mimics the effect of perspectival distortion in panoramic photographs, such as those taken by Qian Jinghua, who in 1925 invented the Kinhwa Cylinder-Image Camera "to take pictures in accordance with the pictorial norm of traditional Chinese painting"—that is, to take panoramas that resemble handscrolls.[35] This transmedial translation between painting and photography worked in two directions, as Yu Jianhua shows with his integration of panoramic distortion into a medium that does not require linear perspective.

The Three Caves of Jinhua presented Yu Jianhua with another arena in which he could demonstrate the documentary qualities of ink painting (and indirectly address the limitations of photography). Like the Five Cataracts in Zhuji, the

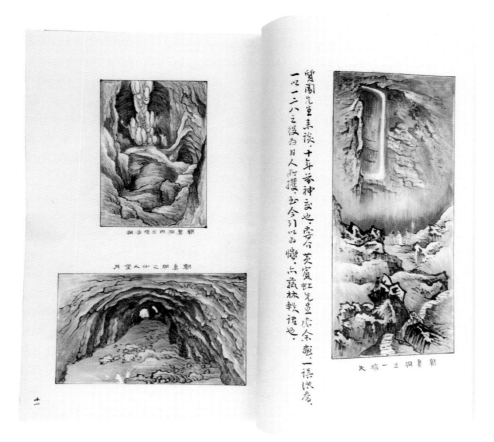

Fig. 4.13. Yu Jianhua, *Further Travels in Eastern Zhejiang* (*Xu you Zhedong ji*), 1935, "Visit to the Three Caves," 10b–11a, with the illustrations *One Thread of Heaven in Chaozhen Cave* (right page), and *Guanyin Cave inside Chaozhen Cave* (top left) and *The Immortal Looking at the Moon of Chaozhen Cave* (bottom left). Two-page spread from an illustrated manuscript, ink and colors on paper. Nanjing University of the Arts Library. Photo by the author.

Three Caves of Jinhua became a default site for travel writing along the Zhejiang-Jiangxi Railway. Owing to the lack of daylight in the caves, contemporary photographs of the sites are basically of two types: they either show the mouth of the cave, with visitors about to descend into the darkness (fig. 4.12), or they are close-up shots of stalactites and stalagmites, lit by flashes and standing out against a black background. Yu Jianhua, by contrast, painted the caves as if they were exposed to daylight. This allowed him to convey every detail of touristic interest. Only in his three images of the interior of Chaozhen Cave did he focus on the effects of the darkness, in order to convey visual phenomena that were named features of the cave and therefore its main touristic sights: One Thread

of Heaven, a line of daylight shining into the cave, and the Immortal Looking at the Moon, a round opening in the cave at the end of a long corridor (fig. 4.13). All images show visitors in the moment of perceiving these phenomena, their torches in hand, thus serving as an exact visual counterpart to the protagonists in the text. The illustration of the Immortal Looking at the Moon echoes Ren Mei'e's photograph *The Mouth of Chaozhen Cave* (see fig. 4.12) and counters the drama of the men's black silhouettes against the sky with a dramatically foreshortened corridor that dwarfs the figures at the cave's entrance.

What Yu Jianhua apparently attempted in his illustrated travelogues was a complete and detailed record of the scenic sites that were so decisively mapped onto touristic itineraries of the period. More important, he attempted to make this record more complete, more detailed, perhaps more personal, and certainly more visible by using the medium of painting instead of photography. *Further Travels* and the subsequent albums can be seen as an effort to prove that painting, and ink painting with colors in particular, was more suited than photography to document the topographies, the geographic and geological characteristics, and the colors of the landscape, as well as the physical and psychological challenges that visitors would encounter there.

Charting New Terrain

On March 29, 1936, almost a year after the journey documented in the *Further Travels* album, Yu Jianhua again set out to travel along the Zhejiang-Jiangxi Railway, this time in the company of two students, Xu Peiji and Yu Xining. They traveled further down the newly extended line into Jiangxi Province, to places not yet covered by the travel literature and imagery produced for the railroad. After the completion of this journey, Yu produced another album in the *shuce* format, *Traces of My Sandals*. This second album differs from *Further Travels in Eastern Zhejiang* in several respects.

The major difference concerns the layout: in *Traces of My Sandals*, the illustrations are not inserted into the text but painted on separate pages dedicated solely to the illustrations and captions. The captions, written by Yu Jianhua, are in the cursive script he used throughout his first album. The main body of text in this album, however, was transcribed by Wu Rongfan, rather than by Yu himself. The text is in a small standard script that imbues it with the character

of an official document and sets it further apart from the images, rendering it more legible, yet less personal. The tension between a travelogue written in an auctorial voice addressing a public readership and the more private character of a unique manuscript that was not intended for reproduction—a tension that had already underlain the *Further Travels in Eastern Zhejiang* album—thus becomes more pronounced. At the same time, the close link Yu established between text and illustrations, and the implicit references to print models such as *The China Traveler* and *In Search of the Southeast* are gone.

Traces of My Sandals* also differs from *Further Travels in Eastern Zhejiang* in its representation of travel. Whereas the earlier album, like other contemporary travelogues, had concentrated on specific sites in the vicinity of train stations, such as the Five Cataracts or the Three Caves, Yu's second *shuce* conveys a stronger sense of his travels through the landscape. This is especially true of his illustrations in the first chapter, which is dedicated to the landscape around Guixi and on the Shangqing River. Yu Jianhua, always very practically minded, blames the weather for the inconveniences that he encountered. In his travelogue, he constantly refers to rain, wind, and fog, and the timetables that required him to move along (after arriving at a destination by train, he traveled locally by bus and boat).[36] The illustrations show vistas that include rivers, mountains, and small towns. The first two images in the album are annotated in the captions as views seen from the train. One of these is the picture of the Immortal's Bridge, a natural stone formation in Fengling (fig. 4.14). The Immortal's Bridge (Xianrenqiao) is set in the background, behind the far bank of a river that crosses the picture plane diagonally, several villages, and an elevation with one of the watchtowers (*diaolou*) that are characteristic of the region. Wolfgang Schivelbusch, in his seminal study *The Railway Journey*, has described how the panoramic view from a train window eliminates the foreground and places the observer outside the space of the perceived objects.[37] Yu Jianhua's image of the Immortal's Bridge, in which he pushes the main motif into the background and depicts it from an elevated viewpoint that is disconnected from the landscape, conveys the impression of a scene glimpsed through the window of a train as described by Schivelbusch. Moreover, the landscape is dominated by diagonal lines that lead toward the rock formation in the upper right corner; they push against the reading direction of right to left, thus adding a sense of movement to the scene: the train has already passed by the Immortal Bridge, which is about to disappear from the viewer's window frame.[38]

楓嶺仙橋

車中偶見楓嶺頗景象時惜未遑遊也 甲戌春 念劬真寫

Fig. 4.14. Yu Jianhua, *The Immortal's Bridge in Fengling*, in *Traces of My Sandals along the Zhejiang-Jiangxi Railway (Zhe-Gan jihen)*, 1936, unpaginated. Ink and colors on paper. Nanjing University of the Arts Library. Photo by the author.

Fig. 4.15. Yu Jianhua, *Qizhen Cliff, Commonly Called Water Cliff*, in *Traces of My Sandals along the Zhejiang-Jiangxi Railway* (*Zhe-Gan jihen*), 1936, "Visit to Guixi," unpaginated. Ink and colors on paper. Nanjing University of the Arts Library. Photo by the author.

Most of the pictures in *Traces of My Sandals* literally center on rivers, their blank surfaces covering large portions in the middle of the illustrations. Several images are in fact based on sketches Yu made while traveling by boat. One sequence illustrates Yu Jianhua's outing on Shangqing River. Here he again depicts one particular motif, the so-called Water Cliff (Shuiyan), across several pictures. This time, however, he does not cite the effect of view-taking from diverging angles; instead, he achieves a notion of temporality. As the boat approaches the cliff, the landing point below the rock face comes into sight (fig. 4.15); it becomes larger as the boat draws nearer (fig. 4.16); it is seen from another angle as the boat leaves again; and finally it recedes into the distance (fig. 4.17 right and left). The sequence of fluvial images thus suggests the movement of travel by boat. The continuity of the movement is sustained by the white band of the river stretching upward to a high horizon line throughout the whole sequence.

Fig. 4.16. Yu Jianhua, *The Temple at the Foot of Qizhen Cliff*, in *Traces of My Sandals along the Zhejiang-Jiangxi Railway (Zhe-Gan jihen)*, 1936, "Visit to Guixi," unpaginated. Ink and colors on paper. Nanjing University of the Arts Library. Photo by the author.

The following day, Yu writes, the weather was much better, and his representation of the landscape changes accordingly. In order not to repeat the haste and regret Yu had experienced the day before at Water Cliff, he and his students spent an additional day around the Thirty-Six Peaks of Yiyang County (also called Tortoise Peaks). They documented the peaks thoroughly in texts, paintings, and photographs. Yu introduces his encounter with the peaks, which he describes as unequaled even by Mount Yandang, by comparing them with a display in an exhibition: "I climbed the [Contemplating Height] Pavilion and looked over the array of peaks vying for strangeness and beauty. They looked as if they were displayed in an exhibition of bizarre peaks. . . . I painted a long handscroll of the surroundings. In front of the pavilion was the Tortoise Peaks bus station, and I started painting from the right side of the station. The peaks that can be named are listed below."[39] This statement is followed by a list of twenty-eight peaks, each supplemented with a brief comment on its position and eponymic features. At the end of his account, Yu lists the same set of names again, albeit in a different order, and adds another ten names of peaks that could be seen only from other locations.[40]

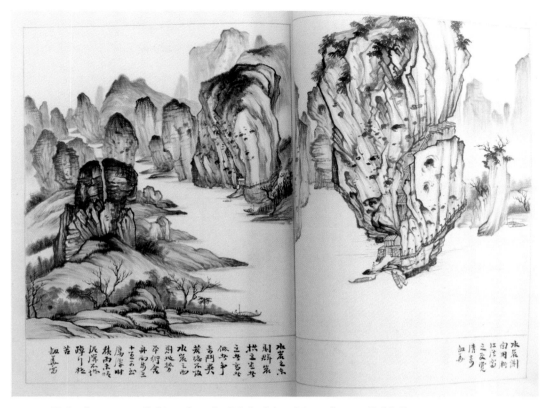

Fig. 4.17. Yu Jianhua, *Water Cliff Seen from the Side* (right) and *East of Water Cliff* (left), in *Traces of My Sandals along the Zhejiang-Jiangxi Railway (Zhe-Gan jihen)*, 1936, "Visit to Guixi," unpaginated. Ink and colors on paper. Nanjing University of the Arts Library. Photo by the author.

The account of the visit to the Thirty-Six Peaks and the lists of names are followed by what Yu referred to as a "long handscroll." Titled *Complete View of the Thirty-Six Peaks* (figs. 4.18a–d), it consists of a continuous band of images that almost seamlessly stretches across fourteen pages and forms a panorama of thirty-six peaks, more or less in the reverse order of Yu's annotated list. Only two peaks from his lists are omitted—the thirty-eighth and farthest, and Jiaye Peak, which, according to Yu's annotation, is located behind another.[41] He even depicts Auspicious Fungus Peak, a smaller rock formation that had collapsed in July 1935, several months prior to Yu's visit (fig. 4.18b, left).[42] The sequence of images thus purports to encompass the peaks in their totality, including those which Yu listed separately because they could not be seen from the central viewing points and the ones that were no longer extant. The peaks are arranged in a row that runs parallel to the picture plane. They are frontally displayed to exhibit their distinctive features and match their descriptions in the text.

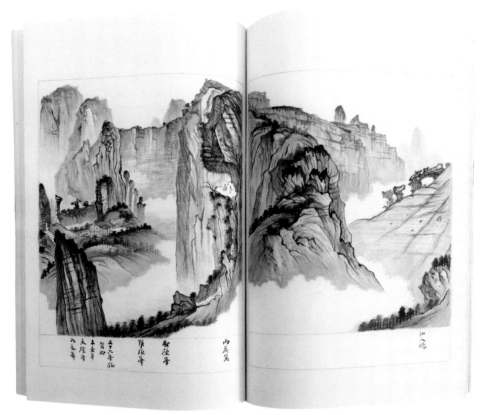

Fig. 4.18d : leaves 12–13

Layered Tortoise Peak, for example, is described as being "located in the center of all the peaks. Two huge rocks of probably several dozens of feet. On the top are three rocks layered over each other like a tortoise, thence the name Tortoise Peak. It is also called Auspicious Omen. Later people changed the name to [the homophone] Ceremonial Jade Peak, thus describing its whole form."[43] The image of the peak (fig. 4.18c, left) precisely delineates a tall, bipartite structure with a pile of three smaller stone slabs on its top. The rendering of the adjacent Double Sword Peak equally matches its description as being split in two parts, and this close concordance can be observed for every peak. Other natural and manmade landmarks are also depicted: a Martyrs' Memorial just outside the mountains (fig. 4.18b, right), the Auspicious Omen Chan Monastery where Yu and his students lodged (fig. 4.18c), the Contemplating Height Pavilion from which Yu set out to sketch the peaks, and the Thirty-Six Peaks Building, an apparently modern, multistory structure. This building and three of the peaks are represented twice, from the front in the central section of the "scroll" (fig. 4.18c, left,

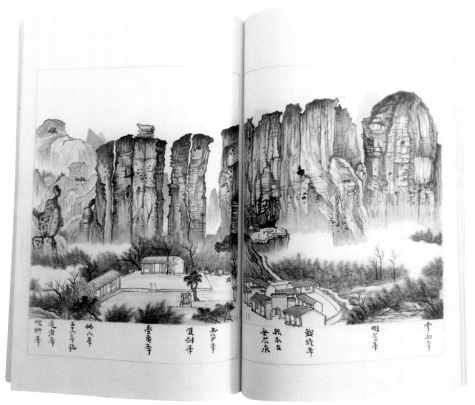

Fig. 4.18c : leaves 4–5

in the background) and from the rear on the penultimate leaf (fig. 4.18d, left). The continuous line of peaks actually describes an S-shaped movement around them. This can be surmised by comparing the "scroll" with a concluding image, *The Tortoise Peaks at One Glance*, which shows the configuration of the peaks as seen from a distance (fig. 4.19).

With the long handscroll format, Yu Jianhua cited the tradition of topographical handscrolls such as the anonymous sixteenth-century scroll of Mount Yandang, now in the collection of the Museum of Fine Arts, Boston.[44] In doing so, he availed himself of the possibility of depicting a large and structurally complex place in a continuous image without privileging elements of the landscape that were closer to the painter's viewpoint over others that were farther away. Instead, the viewpoint moves along an imaginary line that aligns all relevant features in full sight. In his inscription to the *Complete View of the Thirty-Six Peaks*, Yu writes that he "especially sketched a long scroll to record a happy journey" (see fig. 4.18b). The word that he uses for "to record" (*zhi* 志)

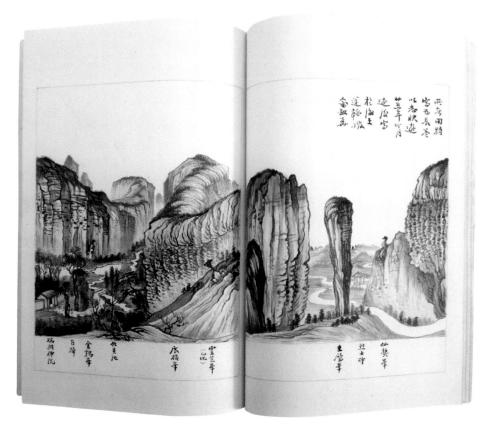

Fig. 4.18b : leaves 2–3

is crucial here. The term also carries a second meaning of "gazetteer," and Yu was probably referring to this second meaning in his choice of word, thereby stressing the moment of documentation. In the first place, the "handscroll" does not document Yu's personal visit to the peaks. Rather, it records the topographical features, geological formations, colors, and names of the peaks and thus provides a plethora of information that is further annotated in the text. The annotated list of peaks in the text cites the conventions followed by local gazetteers, or *difangzhi*. Moreover, the inscriptions of place names and the highlighting of eponymic landscape features are elements frequently found in the woodblock illustrations in local gazetteers. The *Yiyang County Gazetteer* from 1750, for example, includes a picture of the Tortoise Peaks that depicts and names many of the landmarks documented by Yu Jianhua.[45] His reference to illustrations in local gazetteers also works on a more formal level. The stark ink lines on white paper that trace the contours of nearby and distant mountains without relevant tonal gradations imitate the effect of woodblock print illustra-

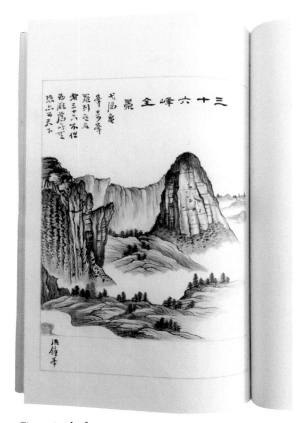

Fig. 4.18 a–d. Yu Jianhua, *Complete View of the Thirty-Six Peaks*, in *Traces of My Sandals along the Zhejiang-Jiangxi Railway (Zhe-Gan jihen)*, 1936, "Visit to Yiyang," unpaginated. Ink and colors on paper. Nanjing University of the Arts Library. Photos by the author. (a) leaf 1; (b) leaves 2–3; (c) leaves 4–5; (d) leaves 12–13 (reading in Chinese order, from here forward to p. 166).

Fig. 4.18a : leaf 1

tions like the one in the *Yiyang County Gazetteer*, or in compendia like the late Ming-dynasty publications *Strange Views within the Four Seas (Hainei qiguan,* 1609) (see fig. 6.3) and *Pictures of Famous Mountains (Mingshan tu,* 1633) (see fig. 6.14).[46]

By referring to topographical handscrolls and woodblock-printed book illustrations in the painted illustrations for a string-bound book, Yu Jianhua evokes the specific medial qualities of those formats. The handscroll mediates the landscape as experienced through continuous movement as the scroll is unrolled, and allows the painter to bring geographically complex topographies into an unfolding sequence. And citing the medium of woodblock prints allows Yu to consciously disregard representational techniques associated with realism and scientific observation, such as linear or aerial perspective. He thereby marks his *Complete View* as a scholarly map that was not scientifically projected but grounded in the tradition of picture-maps for local gazetteers and construed from his individual observations. Since landscape formations such as the

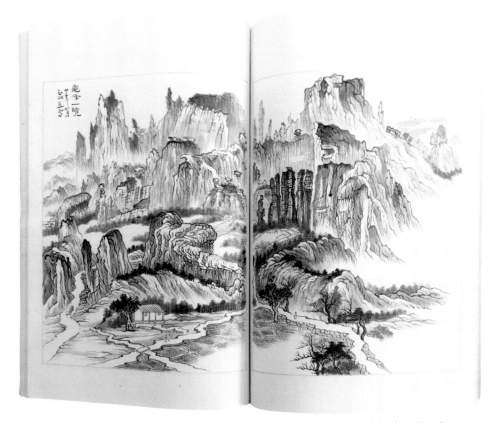

Fig. 4.19. Yu Jianhua, *The Tortoise Peaks at One Glance*, in *Traces of My Sandals along the Zhejiang-Jiangxi Railway (Zhe-Gan jihen)*, 1936, "Visit to Yiyang," unpaginated. Ink on paper. Nanjing University of the Arts Library. Photo by the author.

Thirty-Six Peaks of Yiyang were historically conceived and visually transmitted through topographical paintings and woodblock prints, Yu Jianhua may have seen those media as better suited for documenting them and rendering them visible than, for instance, the medium of photography.

In his painted illustrations, Yu Jianhua was able to reference all these different media and formats—painting, prints, and photography alike. One of the peaks, Daoist Peak (Daozhefeng), is awarded a single image (fig. 4.20). Done in monochrome ink, the illustration is dominated by the bizarre form of the rock and its porous surface. Every hole and fissure is rendered in sharp focus, and the rock is richly shaded, which gives the viewer a strong sense of its volume and physical presence. Below this imposing shape, two wanderers pass along a path between trees; both men and vegetation are depicted in an abbreviated,

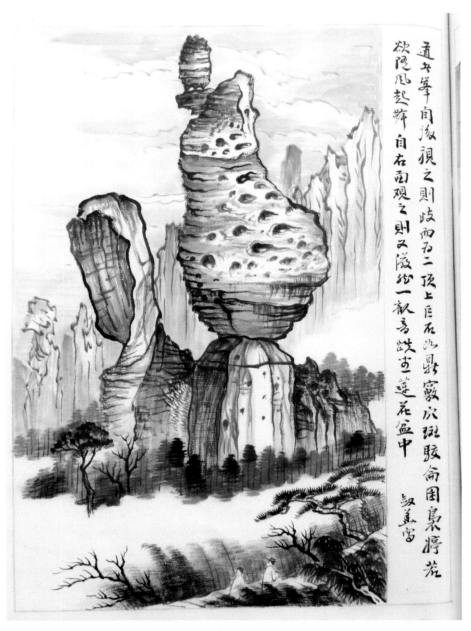

道女峯自後視之則岐而為二頂上巨石叺影竅穴斑駁俞固裊婷荒欲隱風起彝自右面觀之則又微紛一教嶜跌嵳蓮花盆中 敘美寫

Fig. 4.20. Yu Jianhua, *Daoist Peak*, in *Traces of My Sandals along the Zhejiang-Jiangxi Railway* (*Zhe-Gan jihen*), 1936, "Visit to Yiyang," unpaginated. Ink on paper. Nanjing University of the Arts Library. Photo by the author.

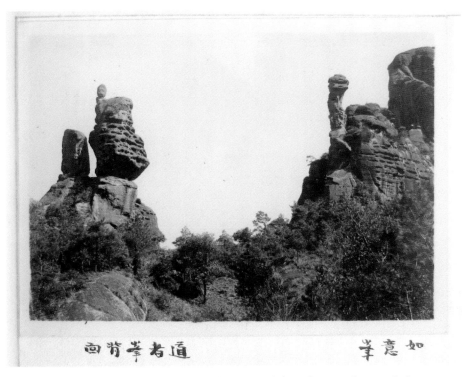

Fig. 4.21. Yu Guiyi (Yu Xining), *Ruyi Peak and Daoist Peak from the Rear*, photograph. In Yu Jianhua, *Traces of My Sandals along the Zhejiang-Jiangxi Railway* (*Zhe-Gan jihen*), 1936, unpaginated. Nanjing University of the Arts Library. Photo by the author.

conventionalized manner derived from the idiom of literati painting. The cliffs in the background, too, are rather summarily treated as crystalline forms. These references around the peak to Chinese painting traditions contrast with the sky, which is filled with clouds in varying shadings that point to Yu's training in watercolors. Moreover, the image's monochromy and its tight frame cite the medium of photography.

Among the photographs by Yu Xining that are pasted onto the last pages of the album, several were taken at the Tortoise Peaks. One of them shows Daoist Peak from the same angle as the illustration painted by Yu Jianhua (fig. 4.21). Actually, the high degree of similarity between the photograph and the painted illustration indicates that Yu may have based his painting not only on the sketches he made in situ but also on his student's photographs. By including the photograph in his album, Yu invites his reader-viewers to compare the capacities of the two pictorial media, thereby confirming the visual veracity of the painting. The photograph is evidence that the painting accurately portrays

the site, but it also proves that Yu's black ink lines are more efficient for tracing the topographical features than the gray tones of the surfaces captured by the photo. The voluminous monumentality and the overly defined clarity of the lines in the painting can therefore be read as a statement about the ability of ink painting to truthfully portray the Chinese landscape—and to do so even more truthfully than photography, a medium associated with scientific modes of vision and representation.

Yu Jianhua occasionally made observations in his travelogue on the structure and the color of the rocks he observed, and he depicted them accordingly.[47] This heightened awareness of geomorphology may be owed to Zhang Qiyun's work published in *In Search of the Southeast*. But despite such scientific observations, geographically accurate representation apparently was not Yu Jianhua's primary goal. He strove to visually describe and accurately document the landscape formations of Jiangxi, but embedding his images in the traditions of Chinese place-related imaging practices was of even greater importance to him. What his images highlight are those features in the landscape that are of aesthetic interest because of their "strange" forms as codified in the peak names, their colors, or his personal viewing experience. Moreover, the discourse on *guohua xiesheng* had, since Hu Peiheng's article in *Journal for Painting Studies*, linked the stylistic idioms of Chinese painting to the geography of China's land. The "national" medium of *guohua*, with its brush modes, techniques of coloration, and conventions of (nonperspectival) spatial representation had come to be regarded as the most adequate medium for representing the national landscape. The illustrations in Yu Jianhua's albums are thus marked by the tension he creates through references to photographic documentation and the canonical forms of Chinese landscape painting.

With the image of Daoist Peak, which translates a photographic visuality into the formal means of ink painting, Yu has made the contemporary perceptions of what constituted "national painting" visible. This is particularly the case in those parts of the image where the painting pulls away from that visuality to conform to conventional formulae that stem from the repertoire of orthodox literati painting. He painstakingly depicts rock formations, strange peaks, and surface structures with ink lines that hark back to conventionalized models whenever possible; at one point in his account of his visit to the Five Cataracts, Yu Jianhua happily states that one mountain looked just as if it had served as a model for Fan Kuan. His image accordingly cites the type of landscape associated with that Northern Song painter—bare, vertical cliffs topped by shrubby vegetation.[48]

But the *Further Travels in Eastern Zhejiang* and *Traces of My Sandals* albums also offer evidence that the visual accuracy in the rendition of famous sites that allowed Yu Jianhua to compete with photographic records was more important to him than adherence to specific historical models. For surrounding details, such as people, trees, grasses, and to some extent buildings, truthful depiction was less relevant. Their rendering in his paintings is largely formulaic, and it is this formulaic attention to premodern conventions that ensures the paintings are still marked as "Chinese."

With his albums, Yu Jianhua claimed that the medium of *guohua* had the capacity to document the Chinese landscape more truly and more comprehensively than photography or drawings deploying linear perspective. As noted earlier, he pinpointed perspective as the main difference between Western- and Chinese-style *xiesheng* in his article, "Sketching from Nature in Chinese Landscape Painting." Yu Jianhua's writings, with their self-conscious evaluation of the advantages and shortcomings of different pictorial media in general, and of the historical methods and techniques of Chinese painting compared with those from Europe and America, in particular, reflect the social Darwinist worldview and the related thinking in terms of competition that informed so many writings on art from the Republican period. In the logic of survival of the fittest and the competition for superiority among different cultural forms, it was necessary for painters working in the medium of *guohua* to constantly prove the relevance of their chosen art form. Yu Jianhua's manuscript travelogues show his keen awareness of the possibilities provided by different media, and of cross-uses and transmedial references. The albums engage in a competitive dialogue with photography, fully deploying the qualities of Chinese ink painting that go beyond the fixed frame of a camera's lens and its dependence on light and are therefore arguably more efficient for the pictorial charting of the landscape.

Documenting Mount Huang

Only a few months after his travels in Jiangxi, in August 1936 Yu Jianhua embarked on another sketching trip, this time to Anhui Province, where he visited Mount Huang, Baiyue, and Mount Jiuhua. He was again accompanied by his two students, Xu Peiji and Yu Xining. After their return, Yu produced a third illustrated travelogue in the *shuce* format, *Yu Jianhua's Illustrated Album of Travels in Southern Anhui.* In this album, the layout is less sophisticated than

in the previous ones, and text and image sections are clearly separated. The travelogue, dated September 2, was again transcribed by Wu Rongfan in small standard script. The following pages are each filled with one illustration, with only minor variations in size. In most cases, the captions provide only the name of the depicted place, peak, or pine tree. Photographs taken by Yu Xining were again pasted onto the last pages.

Like Yu Jianhua's previous travelogues, *Travels in Southern Anhui* is a detailed day-to-day report of his visit to the mountains that allows the reader to trace his exact itinerary, including the departure times of the train he took from Shanghai to Hangzhou and the bus from Hangzhou to Shexian, and the amount of money he spent on individual expenses and in sum. This detailed account is matched by Yu's thorough visual documentation of the sites in the illustrations. This is especially true for the images of Mount Huang: Yu portrayed every single named peak, pine tree, and waterfall that he saw, some of them from more than one angle. Moreover, he painted panoramas of the so-called Front, Back, and Western Seas (Qianhai, Houhai, and Xihai), major scenic districts of Mount Huang, each of which extends over four to six pages. The sites are ordered in the sequence of his itinerary, from the "back road" ascent beginning at Cloud Valley Temple (Yungusi), over Beginning to Believe Peak (Shixinfeng) and Lion Grove (Shizilin), a visit to the Back Sea, a view over the Western Sea (still inaccessible at the time), across Brilliant Radiance Peak (Guangmingding) and Lotus Peak (Lianhuafeng) to Manjuśrī Cloister (Wenshuyuan) and Heavenly Capital Peak (Tiandufeng), and finally to his descent along the "front" route.

Yu Jianhua's visual documentation of Mount Huang is exhaustive but formulaic. Although he renders the topographical layout of the famous sites correctly, he delineates the forms and contours of the rocks in formalized structures designed to unify the composition. In some pictures these structures are reminiscent of woodblock prints, such as those in *Pictures of Mount Huang* (*Huangshan tu*) by Xuezhuang (fl. ca. 1690–after 1718), in which different stylized forms are used to depict the rocks in each image (fig. 4.22).[49] Like Yu's album, Xuezhuang's prints recreate an itinerary across the mountain. Since it was common practice for educated modern travelers to consult historical books on Mount Huang before or even while traveling there, it is likely that Yu Jianhua was familiar with Xuezhuang's images and adapted his sequential arrangement (albeit in reverse order) as well as his formalized mountain forms from these prints.

In some cases Yu also made interpictorial references to photographs. For example, Yu's picture of the Terrace Clear and Cool (Qingliangtai, fig. 4.23)

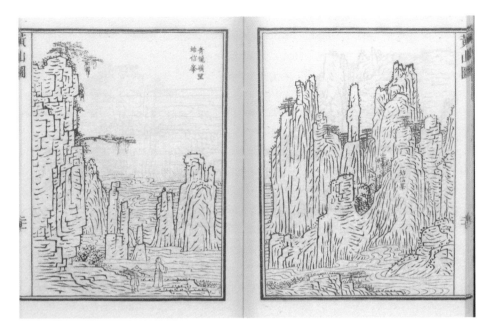

Fig. 4.22. Xuezhuang, *View from Black Dragon Ridge to Beginning to Believe Peak*, from the series *Pictures of Mount Huang (Huangshan tu)*, woodblock print illustration from Wang Shihong, *Gazetteer of Mount Huang: Continued Collection (Huangshan zhi xuji)*, 20b–21a. Qing dynasty, Kangxi period (1662–1722). Facsimile reprint in *Anhui congshu*, vol. 5, ed. Anhui congshu bianshenhui (Shanghai, 1935). National Library of China, General Ancient Books Reading Room. Photo: National Library of China.

shows the terrace as a broad cliff rising over a misty gorge. In the foreground a lower peak topped by a pine tree serves as a *repoussoir*. Two small figures are placed on top of the terrace, one seated and one standing behind the other with a staff in his hands. Here Yu references a photograph (see fig. 5.2) from the album *Painterly Views of Mount Huang (Huangshan huajing)*, which the brothers Zhang Daqian and Zhang Shanzi (1882–1940) had published in 1931.[50] Besides this reference in the image of the terrace, Yu cites leaves from the Zhang brothers' album in two other illustrations.[51] While Yu Jianhua's repeated citing of photographs indicates his personal, complicated interest in that medium, it also shows that by 1936, the iconography of Mount Huang had been significantly reshaped by photography, in a process in which the Zhang brothers' album played an early part.

The extent to which Huangshan imagery was reshaped over the course of the 1930s can be measured with the visual history of two pines, the Tamed Dragon Pine (Raolongsong) and the Guest-Greeting Pine (Yingkesong), both of which

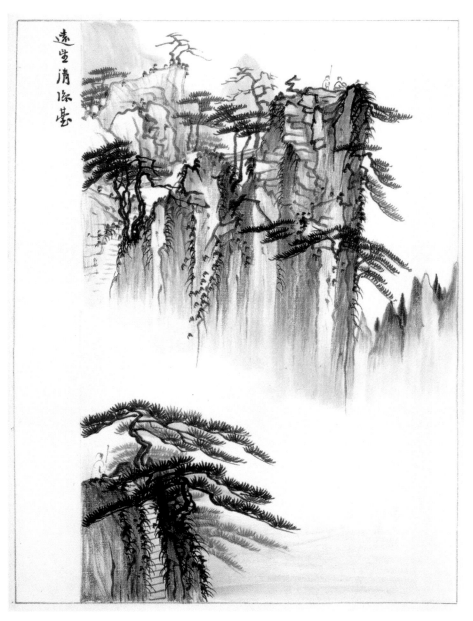

Fig. 4.23. Yu Jianhua, *View from Afar toward the Terrace Clear and Cool*, in *Yu Jianhua's Illustrated Album of Travels in Southern Anhui (Yu Jianhua Wannan jiyou tuce)*, 1936, 7b. Ink and colors on paper. Nanjing University of the Arts Library. Photo by the author.

Yu Jianhua portrayed in his *Travels in Southern Anhui*. Within the span of a few years, the Guest-Greeting Pine became a major stock image in Huangshan iconography and replaced the Tamed Dragon Pine as the most famous tree on the mountain. This change was brought about by the new dominance of photography in the publicity campaign surrounding the Southeastern Infrastructure Tour. The impact of the tour on the environment of Mount Huang and the visual and the literary representations of the mountain is the subject of the next chapter.

The Making of a Standard Mountain
Reshaping the Iconography of Mount Huang

In Yu Jianhua's *Illustrated Album of Travels in Southern Anhui*, as in his earlier travelogues discussed in the previous chapter, he included practical information on train and bus connections and travel costs. In his descriptions of Mount Huang, he also frequently remarked on how the mountain was undergoing changes due to the development of tourism. While in the past it had taken more than ten days to reach the mountain from Shanghai, the journey now took only one day; formerly, Mañjuśrī Cloister had offered humble accommodations, but now construction work on new buildings was underway; a new path with steps had been paved on Heavenly Capital Peak, allowing the ascent of this formerly almost inaccessible summit.[1] Yu concludes his account of his visit to Mount Huang with the following summary:

> Traveling to Mount Huang has long been considered difficult. Since its recent development, one can arrive at the foot of the mountain from Nanjing or Hangzhou within a day. The transport connections are very convenient. The temples on the mountain have all undergone repair. Beds and bedding, food and beverages are clean and sold at fixed prices. If you stay in a temple, every meal is five jiao per person, breakfasts three jiao, accommodation five jiao, porters for sedan chairs and luggage eight jiao per person and day. Furthermore, one should prepare around five jiao per day for other refreshments. There are road signs at every crossroad, so that one does not need a guide and can travel by oneself. Apart from the fact that you have to bring a sweater and padded clothes in the summer, it is not necessary to carry much luggage, making the visit less tiresome.[2]

What Yu Jianhua describes are the effects of the opening of Mount Huang as a major site for tourism, a development that was closely related to the Southeastern Infrastructure Tour and the publicity campaign that led to the publication of *In Search of the Southeast*. Photographers and painters produced a vast number of images of the mountain, making it the most frequently represented scenic site in China and engendering a common mode of representation. This common mode resulted from a productive tension between the different visualities pertaining to photography and (ink) painting; the dominance of photographic images in the print media led to a redefinition of what characterized a Chinese landscape and Chinese painting. These changing modes and perceptions were closely tied to the image of Mount Huang, which in *In Search of the Southeast* was singled out as the "standard mountain of China." This chapter traces how that standardization came about.

The significance of Mount Huang as a touristic site requires a brief review of its history.[3] By the Song dynasty, a topographical book on the mountain, the *Illustrated Classic of Mount Huang* (*Huangshan tujing*), had been written, and the mountain was also the subject of several travel accounts written prior to the early seventeenth century. After the late Ming dynasty, however, travel to Mount Huang increased significantly. Several interrelated factors contributed to the mountain's well-studied rise to prominence as a place of a primarily aesthetic appreciation of the landscape. One factor was the activity of the Buddhist monk Pumen (1546–1625) during the Wanli reign (1573–1620). Pumen received lavish imperial funding and established a sustained monastic presence on the mountain; the trails leading up the mountain were improved, monasteries were built that could serve as lodging for travelers, and monks guided visitors along an increasingly preconfigured itinerary to a prescriptive set of sites. A second, related factor was the rising wealth and influence of merchants from the surrounding Huizhou region in Anhui Province, especially merchants in the salt trade. They established trade networks throughout the empire, and their patronage attracted literati into the region. This patronage is probably responsible for the emergence of a group of Anhui painters in the seventeenth century, commonly classified as the Anhui or Xin'an School.[4] Among the painters associated with the region were Hongren, Shitao, Mei Qing (1623–97), and Dai Benxiao (1621–91), all of whom painted Mount Huang several times. As James Cahill and Stephen McDowall have remarked in their studies on Huangshan painting and travel writing, the increasingly standardized itineraries of visitors to the mountains and their canonization of these

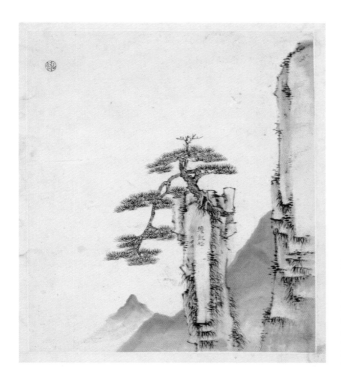

Fig. 5.1. Hongren, *Tamed Dragon Pine*. Leaf from the set of albums *Views of Mount Huang*. Ink and colors on paper, 21.5 × 18.3 cm. The Palace Museum, Beijing. Photo: The Palace Museum.

sites in their literary or pictorial responses mutually reinforced each other. In Cahill's words,

> The creation of such clusters of visual and written information around a sequence of designated places in a site such as Huang Shan reinforced the cultural structure that had come to be superimposed on the physical terrain (a process we can trace . . . in the succession of travel accounts); disseminated and accepted within a social group, these clusters structured in turn the movements and the experience of travelers to the place.[5]

One such cluster of visual and written records centers on a particular pine tree, the Tamed Dragon Pine. With its downward growth around a rock needle, this tree is emblematic of the phrase that has become the standard description of Mount Huang's natural features, "exceptional pines and strange rocks" (*qi song guai shi* 奇松怪石), and it is one of the most well-known motifs in premodern Huangshan iconography.[6] In the 1697 *Register of Pines and Rocks on Mount Huang* (*Huangshan songshi pu*), an unillustrated catalogue of named trees and rocks compiled by Min Linsi (1628–1704), Tamed Dragon Pine is designated "the number one exceptional view among the pine trees" and the "emperor pine."[7] The most iconic painted image of the Tamed Dragon Pine was created by Hongren for his comprehensive album set *Views of Mount Huang*; the painting is now in the collection of the Palace Museum, Beijing (fig. 5.1).[8]

The cultural layers of images and texts and the knowledge about iconic sites were still in the minds of visitors to Mount Huang in the Republican period, but the infrastructure that supported late Ming and early Qing visitors had all but disappeared by the early twentieth century. According to Huang Binhong's contribution to *In Search of the Southeast*, to be discussed in detail later in this chapter, only the four largest temples had survived the devastations of the Taiping Rebellion: the Temple of Radiant Compassion (Ciguangsi), the Mañjuśrī Cloister, and the Lion Grove and Cloud Valley Temple.[9] Like the temples that were renovated during the mid-1930s in the course of touristic development, the landscape, the itineraries, and the visual representation of Mount Huang were reimagined and reconstructed by modern artists and authors.

Painterly Views of Mount Huang: Photography, Painting, and Remediations

One early document of the artistic reconfiguration of Mount Huang is the album of photographs, *Painterly Views of Mount Huang,* by the painters and brothers Zhang Daqian and Zhang Shanzi. The brothers climbed the mountain twice, in 1927 and in the autumn of 1931.[10] On their second visit, they brought a camera and took more than 300 photographs.[11] After their return to Shanghai, they printed a selection of twelve photographs for the album, which consists of single sheets. The album's title is ambiguous and can be translated as either "painterly" or "painted" views of Mount Huang; this ambiguity is in keeping with the Zhang brothers' conceptually ambiguous treatment of their pictures— the album abounds with complex references between painting and photography. The photographs are distinctly amateur in quality, and next to the album's collotype reproductions of the photographs, letterpress captions appear in red; most important, the captions were written in the style of painting inscriptions. Moreover, they treat the photographs as if they were paintings, using technical terms that refer to the conventions of literati painting.

The photograph *Terrace Clear and Cool* by Zhang Daqian (fig. 5.2) is typical of the Zhang brothers' transmedial practice. It cites painting conventions in several respects. It shows the rock face of the Terrace Clear and Cool rising behind the blurred silhouette of a large pine tree, and Zhang Shanzi is portrayed sitting on the terrace, a younger man standing behind him.[12] With this composition the Zhang brothers cite the figure of a scholar contem-

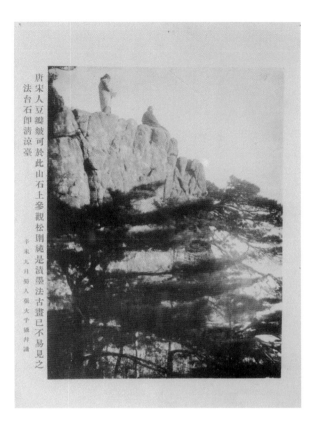

唐宋人豆瓣皴可於此山石上參觀松則純是漬墨法古畫已不易見之

法臺石卽清涼臺

辛未九月蜀人張大千爰并識

Fig. 5.2. Zhang Daqian, *Terrace Clear and Cool*, collotype reproduction of a photograph, from Zhang Daqian and Zhang Shanzi, *Painterly Views of Mount Huang* (*Huangshan huajing*) (Shanghai, 1931). Photo: Zhejiang Provincial Library.

plating a landscape in the company of a boy servant, a conventional motif in pre-twentieth-century landscape painting. Zhang Shanzi, however, does not contemplate the landscape but turns his head toward the camera, looking into the lens. With this turn toward the camera he addresses the medium of photography, and the historical moment in which this image was made is inserted into the picture.

In the photograph's composition, Zhang Daqian was probably citing a specific painting: a leaf from Shitao's *Eight Views of Mount Huang* that combines two spatially distinct landscape features, the Tamed Dragon Pine and the Refining Cinnabar Terrace (fig. 5.3). The terraces in Shitao's leaf and Zhang's photograph dominate the images with their angular profiles, with pine trees set off against the rock faces. Zhang Daqian had copied Shitao's album leaf in hanging scroll format in 1928.[13] His photograph can thus be described as recapturing his copy of Shitao's painting; Yu Jianhua's citation of Zhang's image in painting, discussed in chapter 4 (see fig. 4.23), is then the result of a double remediation.

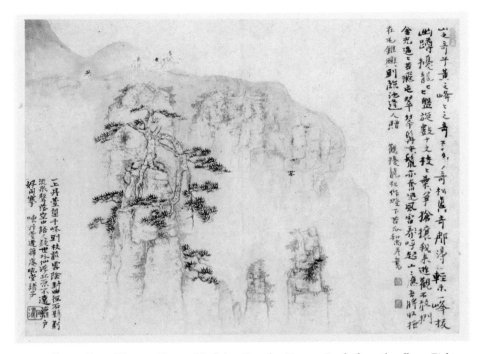

Fig. 5.3. Shitao, *Tamed Dragon Pine and Refining Cinnabar Terrace*. Leaf 7 from the album *Eight Views of Mount Huang*. Ink on paper, 20.4 × 27.1 cm. Sen-Oku Hakukokan Museum, Sumitomo Collection, Kyoto. Photo: Sen-Oku Hakukokan Museum, Sumitomo Collection.

In the accompanying text, which imitates the conventions of painting inscriptions and signatures, Zhang refers not to Shitao but to much earlier sources:

> The bean-petal texture strokes of the masters of the Tang and Song dynasties can be observed in this rock face. The pine tree, by contrast, is done with the method of layered ink. This is a method rarely seen even in ancient paintings. The rock terrace is the Terrace Clear and Cool.
>
> Photographed and recorded in the ninth month of the year *xinwei* [1931] by Zhang Daqian from Sichuan

By thus describing his photograph as a painting, Zhang Daqian invites the viewer to read the blurred silhouette of the pine tree not as out of focus as a function of lens optics, but as achieved through the application of multiple layers of wet ink that run together. Likewise, the structure of the rock is perceived across the conventions of formalized texture strokes (*cunfa*). Since texture strokes also serve as stylistic markers of artistic genealogies, Zhang's statement places the

photograph in the tradition of early landscape painting. That he cites a particularly obscure type of *cunfa* allows him to gloss over the fact that none of the more familiar texture strokes can be discerned in the rock face.

The reference to painting in this album of photographs works on various levels. Describing the mountain itself in terms of painting method implies that the photograph is a transparent window onto the landscape and, furthermore, that painting methods are ultimately descriptive and based on the structures of particular cliffs. Zhang's statement accords with the claims by Hu Peiheng, He Tianjian, and Yu Jianhua, that texture strokes were initially derived from the surfaces of rocks and mountains by the painters of the Tang and Song dynasties. He thereby places his photograph in that tradition and treats it as if it had been painted with brush and ink. In their album, the Zhang brothers disregard not only the medial differences between photography and painting but also the ontological difference between image and motif. Mountain, photographic image, and ink painting become virtually identical.

Painterly Views of Mount Huang is the Zhang brothers' attempt to integrate photography into the pictorial, viewing, and displaying conventions of the medium they were trained in—ink painting. At the same time, it served to link ink painting, with its landscape iconography and representational techniques, to the modern medium of photography. Zhang Daqian and Zhang Shanzi were accomplished as painters but not very experienced as photographers, and their album testifies to the tensions created by their effort to translate one pictorial idiom into another. They were apparently grappling with focal distance, exposure time, and the limitations of the picture frame, while at the same time trying to make the results resemble *shanshuihua* and its conventions of brush and ink technique.

In another photograph by Zhang Daqian from the *Painterly Views* album, *Fantastic Peaks behind Lion Grove* (fig. 5.4), the translation from painting to photography and back is much smoother. He successfully controlled the lighting, exposure, and focal distance to capture one of the clusters of pines and rocks for which Mount Huang is so famous. In his inscription in the album, Zhang names three painters whose names stand for some of the most canonical, yet very different, stylistic modes: "In spirit the scene looks as if Ni Zan had painted in the brush mode of Jing Hao. Although some of the elegance and strength is in Huang Gongwang, he did not grasp it." This eclectic combination of references resembles the idiosyncratic reconfigurations of the artistic canon by He Tianjian and likewise points to the dissolution of artistic lineages and

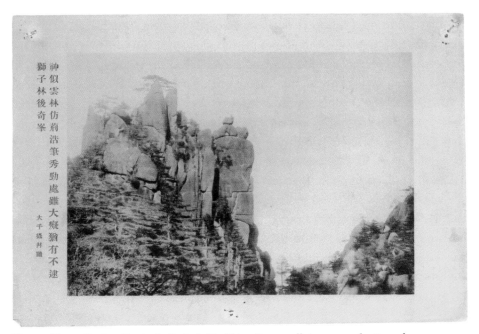

Fig. 5.4. Zhang Daqian, *Fantastic Peaks behind Lion Grove*, collotype reproduction of a photograph, from Zhang Daqian and Zhang Shanzi, *Painterly Views of Mount Huang (Huangshan huajing)* (Shanghai, 1931). Photo: Zhejiang Provincial Library.

regional affiliations as frameworks for understanding painting. Perhaps Zhang's intention was to playfully generate confusion in the minds of his reader-viewers, because when he copied this photograph in a fan painting (fig. 5.5), he chose the painting style that is most closely associated with Mount Huang: he imitated the crisp linear style of Hongren and signed the painting with the earlier master's name.[14]

With their thorough knowledge of historical Chinese paintings in Chinese and Japanese collections, Zhang Daqian and Zhang Shanzi were equipped with a visual matrix that informed how they viewed and depicted Mount Huang. That matrix was formed by the paintings of Hongren, Shitao, and other Anhui School painters. In their inscriptions in the *Painterly Views of Mount Huang*, the Zhang brothers make occasional references to Hongren or Shitao, but more important, they browse through the entire history of Chinese painting and name candidates that have neither a biographical nor a stylistic connection to the place. Besides their intentional reconfiguration of the artistic canon and related modes of representation, another reason for their eclectic references might be the resistance they encountered when they tried to capture the landscape in the medium

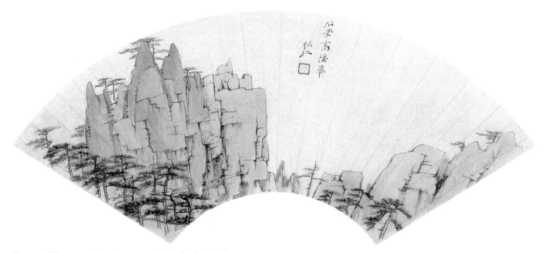

Fig. 5.5. Zhang Daqian, *Fantastic Peaks behind Lion Grove, signed Hongren*, undated. Fan painting mounted as an album leaf, ink and colors on paper, 22.8 × 63.5 cm, former collection of Tien-tsai Hwang. Reproduced from Shen C. Y. Fu, *Challenging the Past: The Paintings of Chang Dai-chien* (Washington, DC, and Seattle, 1991), 105. Photo by the author.

of photography. Their photographs did not easily match the painted record, or what I call the visual matrix. Amateurs such as the Zhang brothers, as well professional photographers taking pictures of Mount Huang, had to reconsider how to view the landscape and how to depict it within the restrictions posed by the camera's viewfinder, exposure time, and linear perspective.

These technical restrictions had a direct effect on the choice of motifs. One apparent result is the absence of the Tamed Dragon Pine from the *Painterly Views of Mount Huang* album, as well as from other contemporary photographs. As evidenced by a depiction of this iconic pine in the Huangshan volume of the important early photobook series, *Scenic China (Zhongguo mingsheng)*, it was simply too inaccessible and too far away from the visitors' paths to be an attractive photographic motif.[15] Within a few years' time it was replaced as the iconic pine of Mount Huang by the more photogenic Guest-Greeting Pine. Unlike the often-painted Tamed Dragon Pine, the Guest-Greeting Pine did not have a significant pictorial history before the twentieth century. It assumed its present incarnation only in 1859, when it, together with the Bidding Farewell Pine (Songkesong), replaced a pair of trees called the Greeting and Parting Pines (Yingsongsong) that had withered in 1799 and 1832, respectively.[16] Following the Southeastern Infrastructure Tour, the Guest-Greeting Pine became a stock item in Huangshan iconography.

The medium of photography not only influenced the choice of motifs but also how those motifs were depicted. Huangshan photography brought forth a new iconography of the mountain, a new formal idiom, and it eventually influenced the way painting history was thought about. These changes in ideas about what characterized an ink landscape painting and, ultimately, a Chinese landscape were intimately connected to the publicity campaign surrounding the Southeastern Infrastructure Tour.

The Southeastern Infrastructure Tour, *In Search of the Southeast*, and Mount Huang as National Landscape

In 1929 Jiang Weiqiao published a travelogue in *The China Traveler* in which he "advised that since southern Anhui was impoverished, travelers should bring everything from canned food and bedding to hot water bottles to keep warm."[17] By the time Yu Jianhua produced his illustrated travelogue of the region in 1936, the situation had changed fundamentally. The Hangzhou-Huizhou Highway had been completed in 1934 in the context of the Southeastern Infrastructure Tour campaign.[18] The new highway enabled cars to drive directly between the provincial capital of Zhejiang and Shexian, the county in Anhui Province closest to the mountain; Hangzhou was the transfer point for travelers coming from Shanghai by train. This improved traffic situation led the Construction Bureau of Anhui Province to found the Huangshan Reconstruction Commission in spring 1934 to promote economic development in the drought-struck region.[19] The chairman of the commission was Xu Shiying, the head of the national Relief Commission. The Huangshan commission cleared and constructed paths leading up and around the mountain; built bridges, sightseeing pavilions, and a bathhouse at the hot springs; and cooperated with China Travel Service to establish a modern hotel at the foot of the mountain.[20] Between 1934 and 1937 infrastructure on the mountain was rapidly developed, turning it into "a modern tourist site for time-bound, security-conscious, middle-class travelers," complete with Western-style hotels and scheduled itineraries.[21] By early 1937, Mount Huang was attracting 500 to 1,000 visitors per month.[22]

The Southeastern Infrastructure Tour, the July 1934 exhibition of works solicited to publicize the tour, and the publication of *In Search of the Southeast* played instrumental roles in an intense public relations campaign encouraging travel to Mount Huang that quickly outgrew the scope of both the tour and the book.

The section of *In Search of the Southeast* titled "Along the Hangzhou-Huizhou Highway," a major part of which is actually about Mount Huang, reflects how the mountain was shaped into a modern travel destination and an emblem of the Chinese nation. It also documents several of the activities organized by the Zhejiang Construction Bureau and the Huangshan Reconstruction Commission that brought the mountain's new identities into being.

The importance accorded to Mount Huang in *In Search of the Southeast* and in the configuration of a modern national identity is mirrored in two "scientific travelogues" in the volume, authored by Huang Binhong and Wu Zhihui (who published his text under his given name, Jingheng). The two authors appropriated the textual traditions of writing about Mount Huang and adjusted them to the intellectual interests of the modern elite traveler.

Huang Binhong was an ideal author for a learned text on Mount Huang. Although he apparently did not participate in the tours organized by the Zhejiang Construction Bureau, his ancestral home was in the village of Tandu, in the vicinity of Mount Huang, and he spent most of his adult life there before he moved to Shanghai in 1909. He strongly identified with Tandu and took the name Binhong, from the Pavilion of the Rainbow at the Water's Edge (Binhongting) in Tandu. He also referred to Mount Huang in several of his painting signatures and seals, and had a substantial collection of paintings by Anhui artists. Huang climbed the mountain nine times between 1883 and 1935, including one visit in 1934 that seems to have been unrelated to the Southeastern Infrastructure Tour, and painted numerous pictures of it.[23] His home region also played an important role in his many publishing activities; he was enlisted in 1934, for example, to contribute to the modern edition of the *Shexian Gazetteer* (*Shexian zhi*), published in 1937 and compiled by his close associate and Shexian compatriot Xu Chengyao (1874–1946).[24]

Perhaps inspired by this editorial involvement, Huang Binhong's contribution to *In Search of the Southeast*, "Analytical Tour of Mount Huang," borrows its structure from local gazetteers.[25] It is divided into sections titled "General Discussion," "Mountains, Rivers, and Pathways," "Temples and Bridges," "Flora and Fauna," "Ancient Relics and Famous Sites," "Epigraphy and Cliff Inscriptions," "Illustrated Books and Painting Albums," and finally, "Literary Works." The work appears, at first sight, to be an abbreviated version of earlier Huangshan gazetteers that documented the geography, botany, and built, written, and visual monuments on and around the mountain. Within the structural template of a gazetteer, however, Huang Binhong adapts his text to the purposes

of *In Search of the Southeast*: in each part, he takes his readers on repeated tours along the routes the traveler would take when climbing the mountain, transforming the gazetteer-style text into a travel guide.

This is most obvious in "Ancient Relics and Famous Sites," which is divided into different subsections according to routes. A similar organization by itinerary underlies other sections as well. In "Mountains, Rivers, and Pathways," Huang takes the reader to the mountain along different routes from the surrounding regions, crossing outlying ridges and following the major streams coming down from Mount Huang. The way up the mountain is treated in more detail, with the names of sites, rocks, ridges, paths, boulders, peaks, and occasionally temples dotting the way. The lists of place names are interspersed with brief landscape descriptions and other information. For example, he describes the view from Refining Cinnabar Terrace as follows:

> Descending through Lotus Gorge, [the path] passes through a stone cleft and ascends to Great Compassion Peak. Turning west, it takes many turns and finally reaches a plateau, this is Refining Cinnabar Terrace. And Xuanyuan, Rongcheng, Cuiwei, Layered Cliff, Hibiscus, Immortal's Palm, Reclining Clouds, and Stone Bed Peaks are towering all around, encircling the plateau from all sides. Heavenly Capital, Lotus, and Brilliant Radiance Peak are called the greatest peaks. The first is Heavenly Capital, the second is Lotus, followed by Brilliant Radiance Peak. Actually, they are all about the same height, and can be regarded as the three legs of a tripod.[26]

The account is highly condensed, synthesizing personal travel experience with inherited knowledge on Mount Huang culled from gazetteers or travelogues. In its sequentiality, proceeding from stream to ridge to cliff to rock to plateau to peak, the text is not primarily an exposition of the geographical make-up of the mountain, as its gazetteer-like title, "Mountains, Rivers, and Pathways," suggests. Rather, it elaborates how to travel on the pathways across the rivers and to the mountain and its various peaks.

The same is true in "Temples and Bridges" and "Ancient Relics and Famous Sites." In these sections Huang explores variants of the same tour, but with a focus on monastic buildings and man-made infrastructure in the former, and with a more detailed discussion of the mountain's history and spectacular sights in the latter. In "Temples and Bridges," Huang's reliance on the written record becomes obvious in a remarkable way: he guides the reader from site to site

without differentiating between extant buildings and those that are no longer there, in exquisitely crafted and learned classical Chinese that does not differentiate between past and present tense. Huang remarks on their absence only as a second step, thus conjuring the glory of the monastic presence of the past, as in his description of Cloud Valley Temple:

> In the beginning, it was the Academy of the Wang Family of Yanzhen; during the Wanli period, it became a sutra repository with a Meditation Hall, Sutra Library, Great Hall, Bell and Drum Towers, Fahua Tower, Upper Realm Hall, Abbot's Quarters, guest rooms, guest assembly hall and guest tower, and kitchen and housekeeping facilities. The old structure was very majestic. Now only pillars are left of the Great Hall, in the rear there are some houses, tiny as boats, and to the east, there are a few hermitages.[27]

The discrepancy between glorious past and humble present is harsh, but with his description Huang Binhong brings the site back onto the itinerary of the historically interested traveler. Since the defunct temples could not provide accommodation for travelers, as he remarks, his text also vividly highlights the necessity to redevelop Mount Huang, legitimizing the undertakings of the Huangshan Reconstruction Commission, to which Huang repeatedly refers.

The section "Flora and Fauna" is also tailored to the interests of the sightseeing tourist. Although a subsection titled "Grasses, Trees, Birds, and Fish," seems to announce a catalogue of local plants and animals, it is mainly devoted to those natural resources for which, according to Huang, Mount Huang is most famed: pine trees and clouds. He indicates the places where the visitor will get the best view of the mountain's famous sea of clouds (Mañjuśrī Cloister, Brilliant Radiance Peak, and Beginning to Believe Peak), and tells readers where to find the most impressive number of pines (Lion Grove). He then gives a long and poetic description of these sights and compares them with painting, simultaneously referring to two rather contrary aesthetic modes: the moist dots associated with works by the Mi family and the blue and green landscapes of Li Sixun. As for the fauna and the strange herbs of Mount Huang, he claims that they are too numerous for an exhaustive discussion. Instead, he transcribes the names of the plants listed in an album of rare herbs, by the monk-painter Xuezhuang.[28]

That same album is mentioned again in the section "Illustrated Books and Painting Albums," in which Huang fully displays his antiquarian and art-historical knowledge. He documents the publication histories of the Song

dynasty's *Illustrated Classic of Mount Huang* and of the various editions of the *Gazetteer of Mount Huang* (*Huangshan zhi*). Then he gives an overview of Anhui School painting, naming the most relevant artists and their representative works. Xuezhuang's album of *Rare Herbs* is mentioned, as is the fact that Huang Binhong's ancestor, Huang Lü (fl. late 17th to early 18th c.), had made a copy of it.[29] (He does not mention that he had acquired the Huang Lü version for his own collection; today it is in the Zhejiang Provincial Museum.)

This subtle insertion of an object to which Huang was personally attached is typical of his account. His sheer breadth of detailed knowledge on routes, sites, mountain formations, streams, and the literary record speaks to his long involvement with the place. But the tours over the mountain that his texts describe are disembodied; Huang largely omits or condenses into conventionalized phrases the individual experience of the landscape's beauty or the dangerous climbs that is so prominent in other Huangshan travelogues. James Cahill has remarked that with the increasing standardization of routes over the mountain, the responses by travelers became more and more similar as well.[30] In Huang's text, aesthetic appreciation or feelings of terror at the sight of the steep cliffs have already become part of the inherited knowledge of Mount Huang; they are as much attached to specific places as names, inscriptions, or temple foundations. His account is innovative, however, in rearranging the geographical and antiquarian knowledge taken from premodern sources along the routes of the modern (and well-educated) traveler, who can use the text on his visit as a cultural guide to Mount Huang.

Wu Zhihui, the author of the second "scientific travelogue" on Mount Huang, was an exact contemporary of Huang Binhong (both were born in 1865) and, like him, a member of the Huangshan Reconstruction Commission. But in their intellectual backgrounds, the two could not be more different. While Huang was a cultural conservative who in the first decades of the twentieth century was active in the National Essence Movement, Wu Zhihui was a prominent anarchist thinker and a proponent of scientism.[31] He was also an influential member of the GMD with personal ties to Jiang Jieshi, and he became a member of the National Construction Commission in 1934.[32] The difference in their backgrounds is also recognizable in the two authors' writing styles: Huang wrote in highly crafted classical Chinese studded with rare vocabulary, which makes his text difficult reading for a less well-educated audience. Wu Zhihui, by contrast, wrote in the vernacular, and his contribution to *In Search of the Southeast* is at once learned, partial, nationalistic, and ironic.

In the first part of his essay, Wu goes to great lengths to argue in a text-critical study that Mount Huang, with its with Heavenly Capital Peak, is actually one of the Three Sons of Heaven Capitals (Santianzidu) mentioned as source of the Zhe River (Zhejiang) in the mytho-geographical *Classic of Mountains and Seas* (*Shanhaijing*), probably written between the fourth and first centuries BCE. Wu's aim, apparently, was to find an even more ancient source on the mountain than *Commentary to the Classic of Waters* (*Shuijing zhu*) by Li Daoyuan (d. 527).[33] He tries to raise Mount Huang's historical pedigree to counter what James Cahill has called "the relative lateness of Huang Shan as a sacred and scenic attraction for travelers."[34]

Wu was well aware that his endeavor was not unproblematic. Concluding his long analysis, he writes: "Some people ask me: You take the almost mythical Sons of Heaven Capital to embellish the identity of Mount Huang. Well, there are the even more ready-made, more sublime, more ancient Yellow Emperor, Fuqiu, and Rongcheng. Why not use them to build a pedestal?"[35] Here he refers to the legend, recorded in the Song-dynasty *Illustrated Classic of Mount Huang*, that the mythical Yellow Emperor (Huangdi) achieved immortality on Mount Huang with the help of his assistants Fuqiu and Rongcheng. According to the same source, an imperial decree was issued in the sixth year of the Tianbao era (747 CE) of the Tang dynasty, changing the name of the mountain from the earlier Mount Yi (Black Mountain) to Mount Huang (Yellow Mountain) in commemoration of the legend. Wu, as a staunch scientist, debunks the myth as a "big ghost story that would make an elementary school student tumble over with laughter."[36] However, he welcomes the idea that Mount Huang should have its name in commemoration of the Yellow Emperor, "who ordered the world," just as one would name a newly built road Zhongshan Road in commemoration of Sun Zhongshan. Moreover, he gives an aestheticizing explanation for the Daoist and Buddhist lore of the mountain: "Because there was no way to describe the wondrous beauty of this mountain, people said it must be because immortals and Buddhas live there. That is why Fuqiu Peak, Rongcheng Stream, Mañjuśrī Terrace, and so on are just metaphors for appreciation, and there is no need to oppose that."[37]

In the second part of his essay, "Mountain Appreciation," Wu Zhihui declares Mount Huang to be, together with Mount Hua in the north, one of "the two standard mountains" (*liangzuo biaozhun shan* 兩座標準山).[38] It suffices to see only those two in one's lifetime, he says, but they are must-sees, even if one has previously climbed many other mountains. Wu also stresses that if he had to choose between Mount Huang and Mount Hua, he would prefer the former. His

essay thus not only pushes Mount Huang's historical record back into the antiquity of the *Classic of Mountains and Seas* but also makes it the most important scenic site of the nation. Finally, he links it to the country's contemporary GMD government by introducing a special "visitor" to the mountain: Jiang Jieshi, who saw Mount Huang from above during a flight from Fujian to Nanjing and said he found the landscape "superb" (*hao ji le* 好極了).[39] However trivial this utterance may appear, it singled out Mount Huang as a mountain of national importance and its development for tourism as a national cause.

The importance accorded to Mount Huang in the Southeastern Infrastructure Tour campaign is also evidenced in the jury decisions on awards for works in the exhibition organized to promote the Southeastern Infrastructure Tour.[40] Prizes in the exhibit mounted in Shanghai and Hangzhou in July 1934 were awarded in four categories: *guohua*, Western painting (oils and watercolors), photography, and literature.[41] Works related to Mount Huang won prizes in every category.

The first prize in the Western-painting category was awarded to *Bird's-Eye View of Lian River* by Zhao Qi (1913–59), which depicts a scene not of Mount Huang, but of the neighboring town of Huizhou (fig. 5.6). It shows the view from a mountaintop over the town, with its characteristic houses with whitewashed walls and black tile roofs in the foreground, and the broad bend of the river coming out of the mountains in the very background. The river is spanned by the long structure of Taiping Bridge, one of the town's landmarks. The houses in the foreground form an abstracted black-and-white pattern, but in its overall composition, the painting is probably based on photographic models. Similar bird's-eye views over the bend of a river and an adjacent town were common in contemporary photography. Rendering the topography, the weather conditions, and the layout of the town from a fixed vantage point, Zhao's painting is representative of those qualities in "Western painting" that were regarded as opposite to the Chinese tradition. The painting was one of the few color reproductions in *In Search of the Southeast*; it also was the only Western-style painting illustrated in the entire book. Considering that the editors thought large, detailed canvases were not apt for reproduction, it was probably the unassuming, watercolor-like flatness of Zhao's painting, in combination with its photographic composition, that made it eligible.

In the *guohua* category, the first prize went to a painting of Mount Yandang by Hu Youge, but both the second and third prizes were awarded to Huangshan paintings by Wang Shuming and Dai Yunqi, respectively.[42] Dai's work was not reproduced in *In Search of the Southeast*, but it is likely the painting in the

Fig. 5.6. Zhao Qi, *Bird's-Eye View of Lian River*, ca. 1934. Oil on canvas (?), dimensions and present whereabouts unknown. Reproduced from *In Search of the Southeast (Dongnan lansheng)* (1935), "Along the Hangzhou-Huizhou Highway," 19. Photo: Shanghai Library.

center, hanging to the right of Wang's, in a press photograph showing the exhibition's *guohua* section (fig. 5.7). Wang Shuming's *Mount Huang* (fig. 5.8) was given a full-page reproduction in *In Search of the Southeast*. It shows a tightly framed view of a mountain peak, a composition that, as noted earlier, in the Republican period marked a painting as having been drawn from nature, or at least as being based on immediate personal observation. Personal vision is represented through the limits of visibility: the path that leads up the mountain is only briefly discernable before it disappears behind rocky boulders; the foot of the main peak is hidden by a row of trees; only the roof of a temple can be glimpsed from behind the summit. In terms of style, the painting is not based on any mode associated with Mount Huang but is executed with dark wet strokes and foliage dots indicative of a moist climate. This is in accordance with the information given in the inscription, where Wang Shuming writes that he climbed Mount Huang in the third month of the *jiaxu* year (1934), stayed overnight at Mañjuśrī Cloister, and painted the picture at a rainy window. The major

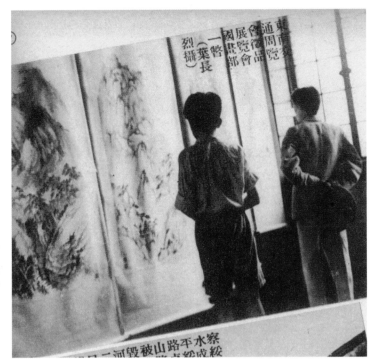

Fig. 5.7. Ye Changlie, "View of the *Guohua* Section of the *Exhibition of Works Solicited for the Southeastern Infrastructure Tour*," *Zhonghua*, no. 29 (1934): 8. Photo: Shanghai Library.

part of the inscription is a variation on Du Fu's poem "Temple of the Dharma Mirror" ("Fajingsi"); in lines 7 to 10, Du's poem describes the sight of the rising sun breaking through the rain clouds and heavy fog of the previous night:

回回山根水，	Waters at the mountain-foot twist and turn,
冉冉松上雨	and rain gradually grows stronger on the pines.
洩雲蒙清晨，	Oozing clouds hide the clear morning,
初日翳復吐	the rising sun is concealed and then breaks through.[43]

These lines come close to the experience of sunrise over the so-called sea of clouds as seen from Mañjuśrī Cloister, described in multiple Huangshan travelogues. Wang had to change only a few characters to adapt Du Fu's poem to the scenery of Mount Huang:

浩浩山外雲，	Clouds outside the mountain are abundant and vast
冉冉松上雨	and rain gradually grows stronger on the pines.
宿霧蒙清晨，	Last night's mists hide the clear morning,
初日翳復吐	the rising sun is concealed and then breaks through.

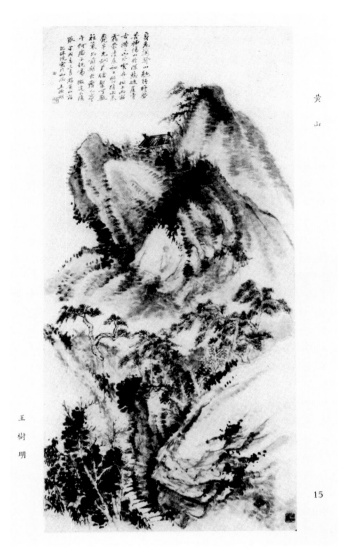

Fig. 5.8. Wang Shuming, *Mount Huang*, 1934. Hanging scroll, ink on paper (?), dimensions and present whereabouts unknown. Reproduced from *In Search of the Southeast (Dongnan lansheng)* (1935), "Along the Hangzhou-Huizhou Highway," 23. Photo: Shanghai Library.

The intimacy of the closely cropped composition is countered by the painting's large size; judging from the photograph showing the work on display in the exhibition (see fig. 5.7), the painting is a large hanging scroll of about 160 centimeters, or 5 *chi*, in height. The painting gains an immersive quality owing to its sheer size: the path leading into the mountain begins just in front of the viewer in the exhibition, inviting him to enter the painting.

In Search of the Southeast features a second Huangshan painting in hanging-scroll format on the facing page, *Splendid Scenery of Mount Huang* by Chen Shou (1905–?) (fig. 5.9), who, like Wang Shuming, was a largely obscure artist. This work represents a contrasting approach to topographical painting in Republican-period *guohua*. Chen's painting combines two stylistic features that refer to painters closely linked to Mount Huang. It blends the linear mode associated with

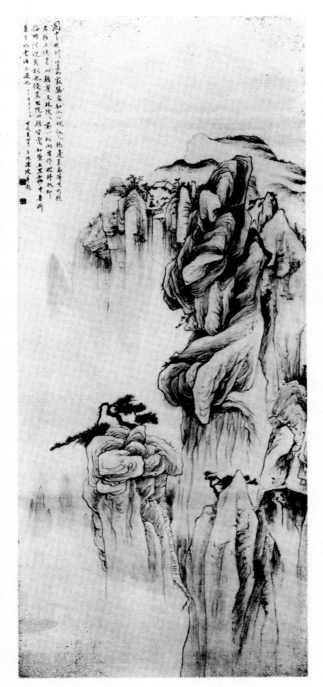

黄山勝景

陳綬

14

Fig. 5.9. Chen Shou, *Splendid Scenery of Mount Huang*, 1934. Ink painting, dimensions and present whereabouts unknown. Reproduced from *In Search of the Southeast* (*Dongnan lansheng*) (1935), "Along the Hangzhou-Huizhou Highway," 22. Photo: Shanghai Library.

Hongren, with the organically bulging rock formations typical of the Huangshan paintings by Mei Qing and Shitao. The result is an almost obscene corporeality of the mountain, especially in the overhanging cliffs in the center part of the painting and in the phallic peak in the foreground. In the inscription, Chen Shou claims that the picture displays the most splendid sites of Mount Huang, such as the Be Careful Slope (Xiaoxinpo), the Immortal's Bridge, and Penglai Island. He also mentions Mañjuśrī Cloister and the Guest-Greeting Pine in front of it. In the painting, he arranged these sites in a collage-like composition that enabled him to bring the famous sights into one picture. The most prominent feature of the painting is the slender peak in the foreground that is topped by a twisted pine with the characteristic shape of the Tamed Dragon Pine. That Chen Shou referred to the Guest-Greeting Pine in his inscription while painting the established iconography of the Tamed Dragon Pine indicates that the process of replacing Tamed Dragon Pine as the most representative Huangshan pine was still ongoing in 1934.

With its collage-like nature, Chen Shou's painting is a "Best of Mount Huang" that construes a "complete view" by combining sites that lie far apart from each other. Chen has translated the characteristics of the painted album—a sequence of pictures that depict a series of distinct stations along a travel itinerary—into a hanging-scroll format. While the album format is suited to a private viewing experience in elite social circles, the hanging scroll, owing to its larger size and single image, lends itself better to public display and print reproduction. *Splendid Scenery of Mount Huang* also serves to highlight the representational possibilities of Chinese painting for synthesizing different viewpoints in one image, in contrast to the perspectival vision with a single viewpoint imported from European painting, which underlies Wang Shuming's work.

Judging from Zhao Qi's and Wang Shuming's prize-winning paintings, it appears that the jurors of the Southeastern Infrastructure Tour exhibition—Xia Jingguan and Huang Binhong for *guohua*, and French-trained sculptor Jiang Xiaojian (1894–1939) and Wang Jiyuan (1893–1975) for Western-style painting—awarded the top prizes in these two categories to paintings that immediately reflect the practice of drawing on site, albeit with medium-specific differences. The case is more complicated for the photography section of the exhibition, juried by the photographers Lang Jingshan and Hu Bozhou (1902–?), the younger brother of the more influential Hu Boxiang (1896–1989). There the first and second prizes both went to photographs that took Mount Huang as their motif but represented it in very different ways. Both images were reproduced in the volume *In Search of the Southeast*.

Photography's Pictorial Aesthetics

In Republican China, Mount Huang came to be regarded as the perfect embodiment of painterly effects in nature. By the late Ming and early Qing periods, visitors to Mount Huang had already compared the scenery favorably with painting.[44] But in the twentieth century, the iconography of the mountain's natural features was reconceived as a perfect motif for photographers who wanted to imbue their images with a Chinese pictorial aesthetic, as well as for painters who strove to reconcile perspectival framing with the encompassing views of pre-twentieth-century landscape paintings.[45] The effect that the photographic appropriation of painting aesthetics had on perceptions of Mount Huang and Chinese painting traditions can be traced in the photographs produced in the larger context of the Southeastern Infrastructure Tour.

In the Southeastern Infrastructure Tour exhibition, the first prize in the photography category was awarded to *Mount Huang in Snow* by Feng Sizhi (1911–84) (fig. 5.10), reproduced in color in *In Search of the Southeast*. The photograph captures a view looking downward from the mountain. A path of neatly cut stone steps leads down the steep slope in a curve; behind it, two tall, snow-clad pines rise up, filling almost the entire picture plane. The trees are majestic, but not particularly "exceptional" (*qi*); nor does the photo feature strange rocks or the sea of clouds commonly associated with Mount Huang. Instead, it captures the experience of descending the mountain over the safe stone-paved paths newly constructed by the Huangshan Reconstruction Commission. The yellow, blue, and green tones of coloration layered over the photograph lend it an ambiguous medial quality: the distinction between photograph and painting becomes blurred. Feng's photograph comes to serve, in this way, as a counterpart to the only other color plate in *Search*'s Huangshan section, the illustration of Zhao Qi's *Bird's-Eye View of Lian River*. Whereas Zhao's work translates a photographic composition into painting, Feng's photograph gains a painterly quality thanks to the warm and softening tones of its coloration.

The winner of the second prize for photography, *Exceptional Sights of Mount Huang: The Sea of Clouds Seen from Brilliant Radiance Peak* by Xu Muru (1904–96), is a prime example of the reinvention of ink-painting aesthetics in Huangshan photography (fig. 5.11). It shows the dark silhouettes of mountain ridges emerging from a layer of clouds that covers the entire foreground. The mountains appear as flat surfaces against the pale clouds, eliminating any effect

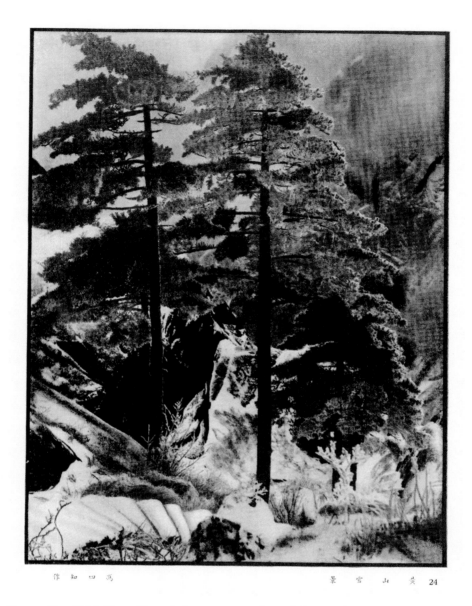

作如四馮　　　　　　　　景雪山黃　24

Fig. 5.10. Feng Sizhi, *Mount Huang in Snow*, ca. 1934, colorized photograph. Reproduced from *In Search of the Southeast (Dongnan lansheng)* (1935), "Along the Hangzhou-Huizhou Highway," 41. Photo: Shanghai Library.

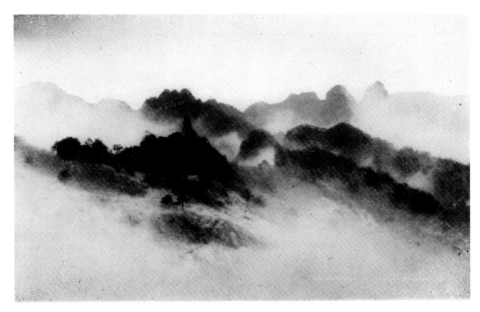

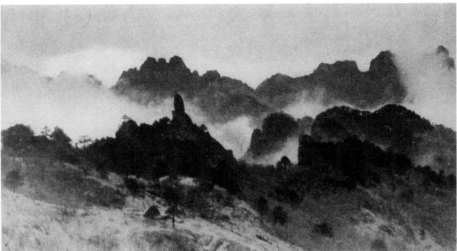

Above: Fig. 5.11. Xu Muru, *Exceptional Sights of Mount Huang: The Sea of Clouds Seen from Brilliant Radiance Peak*, photograph. Reproduced from *In Search of the Southeast* (*Dongnan lansheng*) (1935), "Along the Hangzhou-Huizhou Highway," 33. Photo: Shanghai Library.

Below: Fig. 5.12. Xu Muru, *Sea of Clouds*, photograph. Reproduced from *Feiying*, no. 17 (1937): 9. Photo: Zhejiang Provincial Library.

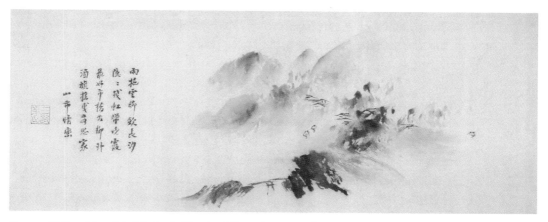

Fig. 5.13. Yujian, *Mountain Market in Clearing Mist*, 13th century. Hanging scroll, ink on paper, 33.5 × 83.5 cm. Idemitsu Museum of Arts, Tokyo. Photo: Idemitsu Museum of Arts.

of spatial foreshortening. The linear vision pertinent to photography is dissimulated in favor of a *kongbai* effect, the ink-painting compositional device in which a blank void suggestive of clouds and mist is used to negotiate the distance between different points in space. The resulting ambiguous spatiality can be seen as countering the gradual foreshortening applied in perspectival modes of picturing. It also enables the painter to leave out irrelevant middle-ground details. In Xu's photograph, the tonal gradations in the mountain silhouettes emulate the effect of ink washes, and the wisps of clouds clinging to the slopes resemble the strokes of a brush that is swiftly wielded over paper. Actually, they probably are the traces of a brush wielded over the photo paper in the darkroom. Another version of the same photograph, titled *Sea of Clouds* and published two years later in the photography journal *Flying Eagle (Feiying)*, shows an unveiled and undramatic mountain slope with scattered trees in the foreground (fig. 5.12). For the version illustrated in *In Search of the Southeast*, Xu not only cropped the composition to gain a more dramatic effect but also eliminated the gray shadings in the foreground, reducing his image to black mountain tops emerging from an artificial sea of clouds.

What Xu Muru recreated in photography was the effect of the so-called splashed-ink technique (*pomo* 潑墨). This technique was first practiced by Tang dynasty painters such as Wang Mo, who created landscapes in bravura performances by splashing ink and spreading it with his brushes, clothes, and hair. During the Southern Song dynasty, it was mainly practiced by monk-painters of the Chan School, such as Yujian (fig. 5.13). With literati painting's increasing dominance over the artistic discourse in China, the technique fell into neglect.

In Japan, however, Chan paintings formed a significant part of the collection of the Ashikaga shoguns, and the style was therefore formative for Japanese perceptions of Chinese painting.[46] It was still regarded as representative of Chinese painting in the twentieth century, and it reentered the attention of Chinese artists such as Fu Baoshi (1904–65), who studied in Japan. As Tamaki Maeda has discussed, Fu's teacher at the Imperial Art School (today Musashino Art University) in Tokyo, the art historian Kinbara Seigo (1888–1958), categorized Chan painting as belonging to the Southern School, that is, literati painting. His book on Tang and Song painting was published in Fu Baoshi's Chinese translation in 1935.[47] Splashed ink thus was rediscovered, via Japan, as representative of Chinese aesthetics. The emphasis on ink rather than brushwork for this painting technique (as opposed to the focus on brushwork in post-Song period literati painting) made its pictorial effects easily adaptable for photography. The effect of mountains materializing out of ink washes and dissolving into the paper seen in Yujian's *Mountain Market in Clearing Mist* (see fig. 5.13) provides a blueprint for "sea of clouds" photographs such as Xu Muru's. The reintroduction of splashed ink as representative of Chinese aesthetics was reinforced and naturalized through the medium of photography, and by means of photographic images this aesthetic was mapped onto the actual site of Mount Huang and connected to a "real mountain."

This reinterpretation of Chinese painting aesthetics on photography's terms is also pervasive in the third long text on Mount Huang in *In Search of the Southeast*, a travelogue by Chen Wanli, one of the most renowned and influential photographers of Republican China.[48] His travelogue "Visit to the Yellow Sea"—Yellow Sea (Huanghai) being a metonym for Mount Huang, or Yellow Mountain—written in the form of a travel diary, presents a vivid first-person account of his visit, the places he saw, his feelings and perceptions, and, to a certain degree, his work as a photographer.[49] Moreover, he compares his own experience with that of earlier travelers and quotes generously from a variety of travelogues by early Qing authors.

Chen traveled with a group of Shanghai photographers who were invited by the Zhejiang Construction Bureau, in the person of its secretary, Wang Yingbin (1897–1971), to join the Southeastern Infrastructure Tour. The group included the editors in chief of the three major Shanghai pictorials, Ye Qianyu (1907–95) of *Modern Miscellany*, Ma Guoliang (1908–2001) of *Liangyou*, and Zhong Shanyin of *Arts & Life*, as well as Lang Jingshan, Xu Tianzhang, Chen Jiazhen

(1912–36), Liu Xucang (1913–66), and Luo Gusun.[50] Judging from Chen's text, the trip was a joyful collective experience. This tone is prevalent in several travelogues published in *In Search of the Southeast*. It not only imparts an air of authenticity to the whole enterprise, but also serves the book's goal of instilling in its readership the desire to travel. By contrast, Ma Guoliang's account of the same journey, published in *The China Traveler*, is much more explicit about the hardships of the climb.[51]

Chen's travel diary covers a period of six days, June 7 to 11, 1934. On the second day, the group visited the office of the Huangshan Reconstruction Commission, which had been set up inside Purple Cloud Retreat (Ziyun'an) near the hot springs at the foot of the mountain.[52] There they were informed about the planning and working situation of the commission. In the course of the essay, Chen repeatedly comments on the modern and smooth roads, informing the reader that many climbs that were described as hair-raisingly dangerous in earlier travel writings were now easy walks.[53] He concludes his account with practical information for future visitors to Mount Huang.

The circumstances of the trip, that the group was invited to Mount Huang to make representative pictures of the mountain, is palpable throughout Chen Wanli's text. When relating how he climbed the mountain or how he experienced the sunrise over the sea of clouds, he discusses issues of representation with professional interest, yet in an entertaining manner. In several instances he compares his perceptions with classical painting, for example when he writes about Penglai Isle: "I find that in this place you can take any angle and any direction, you will always compose a good picture. This is also the reason why Hongren's sparse and splendid landscapes belong to the untrammeled class."[54] Writing about the Heavenly Sea (Tianhai) behind Mañjuśrī Cloister, he writes:

> To the four sides of Heavenly Sea Lodge there are numerous pine trees. In the fog, those further away look blurred and half hidden, making for a very fine picture. Actually it is not only this small part of Mount Huang that could serve as material for painting. The hemp-fiber strokes of Heavenly Capital and Lotus [Peaks] are superb models for *guohua* painters, and the steep cliffs and pine tree silhouettes of Penglai Isle, the winding paths of Lotus Gorge, each taken as a painting motif, are enough to sweep away the limitations of the Four Wangs and to approximate the [masters of the] Song and Yuan. It is a pity that I am neither good at painting nor at poetry, otherwise I would certainly make great progress by looking at this scenery.[55]

Here he reiterates the prevalent prejudice about the painting style of the Four Wangs and its inability to depict real landscapes, as well as the concurrent appraisal of Song and Yuan painting as the appropriate model for modern landscape painting, opinions that were shared by He Tianjian and many other Republican-period painters. In relation to photography, the Song model carries different implications than the *xieshi/xieyi* complex, as becomes evident in another passage of Chen Wanli's text.

> When I leaned against a rock, looking over the landscape, I imagined that what is called the Northern School in *guohua* might achieve its true secrets [*sanmei*, lit. *Samadhi*] here. Stalagmite Peak on the other side was at times occluded by a veil of mist, and although it was hidden, the shadows of some pine trees could be glimpsed. Sometimes only its summit appeared, just like splashed ink. In the distance, three or four peaks suddenly emerged and were covered again. Only Ma Yuan had the ability to grasp this atmosphere and scenery, and to spill nature [*zaohua*] from the tip of his brush. Mei Qing could only grasp bits and pieces of Mount Huang; he was not able to transmit to us a wonderful conception, and after all merely followed other people's precedent.[56]

What Chen discards here is not a general category, such as the Four Wangs style, but one of the painters whose oeuvre and style is closely associated with Mount Huang and formative for the perception and imagination of the mountain. Chen suggests that Mei Qing's delicate, twisted mountain peaks painted with fine outlines and a minimum of ink wash should be supplanted by the bold washes and atmospheric depth of the Ma Yuan style, which he equates with the splashed-ink mode. This proposition that the splashed-ink aesthetic is the ultimate representational mode for Mount Huang resonates with Xu Muru's prize-winning photograph *The Sea of Clouds Viewed from Brilliant Radiance Peak* (see fig. 5.11), which translates the visual effects of that painting mode into photography.

While describing the landscape of Mount Huang in terms of historical painting modes and specific artists' styles, Chen Wanli effectively reinterprets the modes and styles according to the viewing techniques and representational qualities of photography. He describes Hongren's painting as originating from a process of view-finding, as if the seventeenth-century painter were looking through the lens of a camera; as every cadre produced a satisfactory composi-

tion, no matter where the camera was turned, it was no wonder Hongren was a successful artist. He criticizes Mei Qing's painting, on the other hand, because he did not produce those ink effects that photographs of mountain silhouettes emerging from a sea of clouds could emulate so well.

Chen devotes even more space to writing about his work as a photographer who traveled to Mount Huang to take pictures of it. Compared with his excursions on painting aesthetics, his remarks on photography remain remarkably practical, personal, and down-to-earth. He mentions Ye Qianyu taking a picture of a miniature pine shown to the group by a monk; he relates that he and Xu Tianzhang descended from Mañjuśrī Terrace to Be Careful Slope to take photographs of the Sea of Clouds at sunrise, while Lang Jingshan stayed behind, grappling with some pine branches.[57] While he was preparing to take pictures near Lotus Gorge, he witnessed a porter being struck by a falling rock, and he relates how he experienced vertigo when he set up his camera on mountaintops, a feeling that was shared by his travel companions.[58] Most of all, his account is one of professional frustration. He repeatedly writes about not being able to take photographs because of bad weather conditions—standing atop vertiginous Lotus Peak, waiting in vain for the clouds to disperse, finding perfect motifs but being unable to make a picture of them because of the fog, and so on.[59] His literary landscape descriptions and his remarks on pictorial aesthetics thus seem unrelated to his own photographic practice. At one point, he even writes that he regrets not having brought an "old painting master" to paint a spot he thought resembled the work of Wang Meng.

Despite Chen Wanli's complaints about his abortive efforts to take photos during his visit to Mount Huang, the Southeastern Infrastructure Tour group brought back more than 3,000 photographs, according to a *Shenbao* report. The same article relates that an exhibition of the photographs was planned, and that in the forthcoming *Guide to the Five Provinces* (that is, *In Search of the Southeast*), a significant number of Huangshan photographs would be reproduced in fine print quality.[60] However, the number of Huangshan images actually included in *In Search of the Southeast* falls far short of that ambitious prospect. Besides the illustrations discussed in this chapter, a relatively small number of Huangshan photographs accompanied the texts—an especially small number in comparison with other sections in the book that are lavishly illustrated. Of the Shanghai photographers who traveled to Mount Huang together, only Xu Tianzhang and Chen Wanli are represented in *Search*—Xu with two photographs, and Chen himself with only one. His contribution, *Rongxi, on the Way to Mount Huang*,

does not depict classical Huangshan scenery but shows a stream.[61] The other photographic illustrations are by Xu Muru, Feng Sizhi, and Jiang Bingnan (1911–84), who had not been part of the same tour group but submitted their works to the July 1934 preparatory exhibition. The photographs taken during the trip described in Chen's travel diary took on a life of their own, independent of the *In Search of the Southeast* project.

An Exhibition and the Canonization of Mount Huang's Modern Image

Sometime between the photographers' tour of Mount Huang in June and December 1934, members of the tour group, the head of the Huangshan Reconstruction Commission, Xu Shiying, and others founded what they called the Huang Society (Huangshe). In accordance with the wider aim of the Southeastern Infrastructure Tour, the society set out to promote the arts and to propagate and protect the famous sites of Mount Huang.[62] To achieve these goals, the Huang Society organized an exhibition of more than two hundred photographs, mostly by members of the tour group, as well as several paintings by Huang Binhong, Zhang Daqian, Zhang Shanzi, and others.[63] The exhibition was hosted by Wang Yingbin, the secretary of the Zhejiang Construction Bureau and the Shanghai-based representative for the Southeastern Infrastructure Tour. It was shown for three days in Shanghai in mid-December 1934, and then it traveled to Hangzhou and Nanjing in January 1935.[64] In late February Zhang Shanzi, in his capacity as a member of the board of directors of the Huangshan Reconstruction Commission, took the exhibition to Singapore. As the exhibition became an international event, its political profile was also enhanced, and calligraphic works by Cai Yuanpei, Wu Zhihui, Xu Shiying, and Yu Youren (1879–1964) were added to the exhibit.[65] Apparently the exhibition was quite a success; one result was that Singapore entrepreneur Aw Boon Haw (1882–1954) announced he would donate 10,000 yuan to build a hospital on Mount Huang.[66] The various stages of the exhibition and the social events surrounding it were extensively covered by *Shenbao*. It became a venue and a cause around which the political and artistic circles of Shanghai, Nanjing, Zhejiang, Anhui, and even Singapore could meet, gain public visibility, and engage in developmental work as well as charitable activities. The entrance fees for the Shanghai exhibition, for example, were donated to promote the welfare of poor children. The collected

sum of ninety-four yuan seems rather insignificant, however, compared with the "several ten thousand" yuan spent on the production of *In Search of the Southeast*, an amount repeatedly highlighted in advertisements for the book, and even in comparison with the book's list price of eight yuan.[67]

The Huang Society exhibition was also covered by several pictorials that reproduced photographs and paintings on display in the show. One of these was *Liangyou*, which had particularly close ties to the Huangshan project, as its editor in chief, Ma Guoliang, had been part of the photographers' tour group. *Liangyou* featured a double-page spread on the exhibition in its January 1935 issue.[68] The illustrations included photographs by Lang Jingshan, Ye Qianyu, Shao Yuxiang, Luo Gusun, and Chen Wanli (fig. 5.14 right page); two anonymous photographs of structures recently built by the Huangshan Reconstruction Commission, a pavilion and a bridge; ink paintings by Huang Binhong, Huang Yingfen, Zhang Shanzi, and Zhong Shanyin; what appears to be an oil painting or watercolor by Xu Tianzhang; and two pieces of calligraphy, by Xu Shiying (published under his style name Jingren) and Chen Shuren (fig. 5.14 left page). *Liangyou*'s selection represented the various social groups and organizations that made up the core of the Huang Society: the photographers who had traveled to Mount Huang at the invitation of the Zhejiang Construction Bureau in June 1934; the *guohua* painters who had a strong personal attachment to Mount Huang, such as Huang Binhong, his niece and student Huang Yingfen, and the brothers Zhang Shanzi and Zhang Daqian; and the Huangshan Reconstruction Commission in the person of Xu Shiying, who also represented the GMD government together with Chen Shuren. Besides being a painter and one of the founders of the Lingnan School, Chen was also a high GMD official; in the 1930s he served as the chairman of the Overseas Chinese Affairs Commission.[69]

The photographs featured in *Liangyou* (with the exception of those of the bridge and the pavilion) basically follow two compositional schemata. The works by Shao Yuxiang and Luo Gusun are based on the strong contrast between foreground and background. In what would become something of a standard composition for Chinese mountain photographs throughout the twentieth century, the foreground is dominated by the crowns of pine trees, their trunks cut off by the picture frame. Beyond an empty middle ground, the steep cliffs of rocky peaks rise behind the trees. Chen Wanli's photograph is a variant of this pictorial type: a close-up view of pine branches in sharp focus frames a blurred mountain landscape that fills the background. Lang Jingshan's and Ye Qianyu's works, by contrast, adopt the splashed-ink mode in compositions that are similar

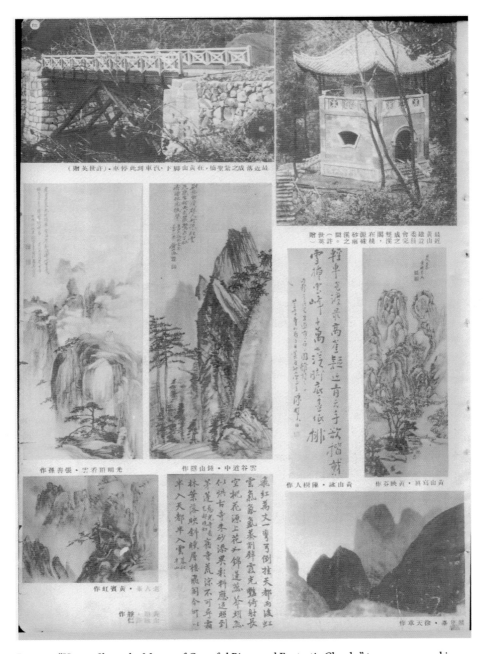

Fig. 5.14. "Huang Shan, the Mount of Graceful Pines and Fantastic Clouds," two-page spread in *Liangyou*, no. 101 (January 1935): 14–15. Photo: Shanghai Library.

Left: Top row, right to left: *Double Stream Pavilion* and *Purple Saint Bridge*, photographs provided by Xu Shiying; middle row, right to left: Huang Yingfen, *True View of Mount Huang*, 1934, ink painting; Chen Shuren, *Song of Mount Huang*, 1934, standard script calligraphy; Zhong Shanyin, *On the Way through Cloud Valley*, ink painting; Zhang Shanzi, *Viewing Clouds on Brilliant*

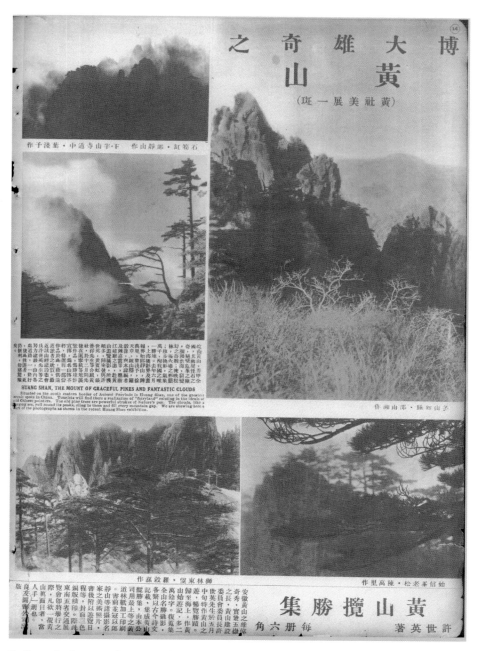

Radiance Peak, 1934, ink painting; bottom row, right to left: Xu Tianzhang, *Tortoise Peak*, oil painting or watercolor?; Xu Jingren (Xu Shiying), *Inscribed Song on Mount Huang*, standard script calligraphy; Huang Binhong, *Old Man Peak*, ink painting.
Above: Top right: Shao Yuxiang, *Winter Mountain in Hibernation*; top left: Lang Jingshan, *Stalagmite Ridge*; middle left: Ye Qianyu, *On the Way to Half Mountain Temple*; bottom right: Chen Wanli, *Old Pine on Beginning to Believe Peak*; bottom left: Luo Gusun, *Eastward View from Lion Grove.*

to Xu Muru's work, discussed earlier in the chapter. Lang's *Stalagmite Ridge*, in particular, is reminiscent of ink-wash landscapes. It is composed solely of black silhouettes and white whiffs of clouds, with the picture's spatial depth largely flattened out by the strong contrasts. Stalagmite Ridge is the place that Chen Wanli compared to landscapes painted in the splashed-ink mode in his Huangshan travelogue; since Chen and Lang visited the site together, Chen's text might actually have been inspired by Lang's image. All of the photographs in the *Liangyou* spread highlight what had been conceptualized as Mount Huang's distinct features since the late Ming dynasty—its numerous steep and rocky peaks, pine trees, and clouds—by deploying contrast: between sharp focus and blurriness, between foreground pines and background rocks, and between dark mountains and white clouds.

The construction of Huangshan imagery through the use of contrasting layers can also be observed in the painting by Xu Tianzhang. Although details cannot be discerned in the reproduction, it seems that the image is composed of more or less flatly applied planes of color that suggest layered silhouettes of mountain ranges receding into the distance. The dominant element of this surprisingly abstract painting is a dark mountainside that seems to emulate the black silhouettes in those photographs that imitate the effect of ink washes.

The ink-wash effect evoked by the photographs by Lang Jingshan and Ye Qianyu, and by Xu Tianzhang's "Western-style" painting, is conspicuously absent in the four *guohua* paintings reproduced on the same spread. None is executed in splashed ink or a similar mode. Whereas many photographers sought to recreate the effects of ink painting, the *guohua* paintings reproduced in *Liangyou* reflect an engagement with a photographic visuality. An exception is Huang Yingfen's painting, which in its inscription claims to show a "true view" of Mount Huang, despite the painting's conventional literati landscape composition with no signifiers of site-specificity. The works by Zhong Shanyin, Huang Binhong, and Zhang Shanzi, on the other hand, exhibit typical characteristics of Republican-period ink painting related to on-site sketching, characteristics that are closely linked to photography.

Zhong Shanyin's *On the Way through Cloud Valley* (see fig. 5.14 left page, center) can be regarded as a painted counterpart to Feng Sizhi's prize-winning photograph, *Mount Huang in Snow* (see fig. 5.10). Like Feng's image, Zhong's ink painting shows the upper portion of a flight of rock-cut steps leading downhill between pine trees; a rocky cliff is blocking the view into the valley. The tightly framed composition, based on a photographic concept of view-taking, is similar

to those in Wang Shuming's *Mount Huang* (see fig. 5.8) and He Tianjian's *Visit to Stone Gate* (see fig. 2.1). As in these two paintings, a view of the landscape that is restricted by a close picture frame and obstructed by natural features standing in the way of perspectival vision serves to indicate that the painting is based on personal on-site observation.

Huang Binhong's painting *Old Man Peak* (see fig. 5.14 left page, bottom left) is based on a similar visual premise. The visibility of details in the painting is greatly reduced in the reproduction, but in its deployment of quasi-photographic pictorial conventions the painting's composition is quite unusual in Huang Binhong's oeuvre. *Old Man Peak* is apparently a small work, either an album leaf or a small hanging scroll. Its horizontal format emphasizes the compositional features the painting shares with the Huangshan photographs printed on the facing page. Like the photographs, it features a strong contrast between foreground and background, which Huang has shifted into a contrast between the right and the left halves of the picture. The right part of the painting is dominated by a shaded mountainside with the white band of a path leading upward and across the ridge. Behind it, the view opens onto a valley filled with pale mists in the left half of the painting. A pine tree grows horizontally out of the foreground cliff, stretching its branches into the void of the *kongbai*. The composition of the left half is tripartite: the mist-filled valley is fenced off below by a row of lower peaks and above by a higher ridge. The painting thus combines several compositional elements observed in the Huangshan photographs. Huang chose a double foreground-background contrast: first, the contrast between the right and left sides of the painting that comes from the darker and lighter tonalities; and second, the contrast in the painting's left side created through its foreground-empty middle ground/*kongbai*-background structure. Moreover, he emphasized the contrast between the darker right side and lighter left side through the device of the pine tree, the ubiquitous motif of Huangshan photography. Although it is not presented in a close-up view, it marks the spatial boundary between the picture planes and, with its fragile black silhouette, highlights the depth of the misty void behind it.

These references to photography suggest that Huang Binhong composed *Old Man Peak* in response to the multitude of photographic images that were shot during the Huangshan tour and that were presented in the same exhibition and in various journals and magazines. In his painting, however, he succeeds in combining the potentially conflicting compositional modes prevalent in Huangshan photography: by positioning his viewpoint in midair, and

by modeling the rocks with the undulating lines of his brushwork, he achieves
an almost organic composition. His modeling of volumes in space and use of
strong shading further serve to create an atmospheric impression. Huang trans-
lated the compositional schemata of Huangshan photography into painting and
simultaneously ignored the limitations of a fixed viewpoint and rigid framing.
Although not much of the brushwork remains visible in the reproduction, based
on his other paintings from the 1930s, we can assume that it effectively unified
the composition, superseding the contrasting effects.

Zhang Shanzi's *Viewing Clouds on Brilliant Radiance Peak* (see fig. 5.14 left
page, middle left) provides another model for integrating a fixed viewpoint
into *guohua*. The so-called bird's-eye view (*niaokan*), frequently employed by
Republican-period *guohua* painters, features an extremely high horizon line and
an elevated viewpoint that allowed artists to represent mountain peaks as seen
from above. This technique enabled painters to base their works on the expe-
rience of outdoor sketching and also create compositions that showed broad
vistas with several peaks, reminiscent of Song and Yuan monumental land-
scape painting. The views from mountaintops provided this opportunity, and
Mount Huang was regarded as the perfect location, owing to the short distances
between its peaks.[70]

In Zhang Shanzi's painting, he depicts Mount Huang from an extremely
high vantage point. The highest peaks reach approximately two-thirds of the
picture plane, disappearing into clouds. The impression is that of a view into
the distance beyond the mountain, with the land remaining invisible under
a layer of clouds. In the foreground, we look down on a plateau dominated
by a large pine spreading its branches across a peak. Behind it, a narrow path
leads up to a massive rock formation filling almost the entire lower half of the
painting—Brilliant Radiance Peak, according to the inscription. On top of that
peak, barely discernible in the reproduction, two men stand close together.
They appear to be looking intently at the puffy clouds billowing around the
peaks in the background.

The pine tree in the foreground stands as a dark silhouette against the rocky
cliffs, in a manner reminiscent of various photographs of Huangshan pines.
By its distinct form it can be identified as the Guest-Greeting Pine. The cliffs
behind it, by contrast, are rendered in a distinctly painterly manner, with crisp
ink outlines and texture strokes modeling the crystalline forms. Zhang based
his rendition not on Anhui School paintings but on the monumental landscapes
of the Five Dynasties and the Northern Song. The painting thus combines

disparate pictorial modes favored by Republican-period landscape painters: the monumental landscapes of the Song dynasty associated with realism and painting from nature, embodied in the main peak; photographic compositions using contrasting elements, in the dark pine tree against sunlit cliffs; the almost photographic portrait character of the pine; and a bird's-eye view that allows these elements to be combined in one picture without too obviously violating the laws of perspective. The moment of personal experience is inserted into the picture through the two figures watching clouds. They can be interpreted as portraits (in Qing dress and hairstyle) of Zhang Shanzi and his brother Zhang Daqian. In its combination of different modes of vision and, accordingly, different representational models, Zhang's painting achieves an eclectic complexity that could only be realized in painting. However, if we regard the relationship between painting and photography in the 1930s as a competitive one, *guohua* paintings were in a much weaker position, at least in the context of print media.

The pictures produced in the wider context of the Huangshan portion of the Southeastern Infrastructure Tour and the Huang Society exhibition exemplify the challenge that photography posed for *guohua*. Huangshan photographs appeared in large numbers and in various publications, from mass-market pictorials, such as *Liangyou* and *Arts & Life*, to journals for professional and amateur photographers, such as *Flying Eagle*, and travel-related publications like *The China Traveler* and *In Search of the Southeast*. Their numbers were reinforced by their potential dual function as reportage and art. The double-page spread in *Liangyou* on the Huang Society exhibition amply demonstrates the practical aspect of photography's visual dominance. While most of the details in the illustrated paintings disappear in the reproductions, owing to size reduction and print quality—the exception being the bold lines and simple composition in Zhong Shanyin's painting—the photographs suffer much less: those parts that appear in sharp focus in the photographs remain in focus in print.

One factor that supported the dominance of photographic mountain representations was the photographers' practice of interpreting their works in terms derived from the Chinese painting tradition and of striving to emulate a painting aesthetic. Their interpretations, however, differed significantly from that tradition and thus exerted a strong influence on how the tradition was perceived. As exemplified by Chen Wanli's travel diary, painting was interpreted in photographic terms, not the other way round. This may be of small wonder when the author is a photographer, but the paintings discussed in this chapter testify to the fact that even more conservative painters like Huang Binhong occasionally

adopted modes of vision or composition linked to photography. *Guohua* artists responded to the visual models provided by travel photography in various ways, and their responses had fundamental implications for a wider understanding of "Chinese" pictorial aesthetics.

Below the spread on the Huang Society exhibition in *Liangyou*, an advertisement appears (see fig. 5.14 right page). It promotes *In Search of Mount Huang* (*Huangshan lansheng ji*), a book edited by Xu Shiying and published in August 1934 (fig. 5.15). The similarity of the title to *In Search of the Southeast* (*Dongnan lansheng*) is not incidental; all of the photographs reproduced on its opening pages were authored by members of the Huangshan tour organized by the Zhejiang Construction Bureau in June 1934, and were probably taken during that tour.[71]

Besides the photographs by members of the tour group—one each by Shao Yuxiang, Lang Jingshan, Luo Gusun, Ye Qianyu, Ma Guoliang, Zhong Shanyin, Chen Wanli, and Chen Jiazhen—*In Search of Mount Huang* contains more than twenty pages of poetry from the seventh to the twentieth century, illustrated by more photographs, mostly by Shao Yuxiang. The poetry section is followed by Xu Shiying's diary of a visit he made to Mount Huang in May 1934. An appendix includes a "Three-Month Plan for the Reconstruction of Mount Huang" drafted by Xu, a travel itinerary, and a list of items visitors should bring with them for their convenience while traveling. As a promotional tool to attract tourists, *In Search of Mount Huang* was much more practical and affordable than *In Search of the Southeast*. It was smaller in size, paperbound, and cost a small fraction of the price of its "mother publication."[72] It also contained more useful hands-on information on how to get to the mountain as well as other helpful details.

What is striking in the comparison between *In Search of the Southeast*'s Huangshan section on the one hand, and *In Search of Mount Huang* and the publications related to the Huang Society exhibition on the other, is the absence in the former of works by prominent painters or by those photographers who went on the tour to Mount Huang to create pictures for the book. Virtually nothing is known today about Chen Shou or Wang Shuming, the painters whose works were reproduced in *In Search of the Southeast*. The photographers Feng Sizhi and Jiang Bingnan founded the Eagle Society (Yingshe) and published the influential photography periodical *Flying Eagle*, but not until 1935; at the time of the Southeastern Infrastructure Tour they were not so prominent as to be

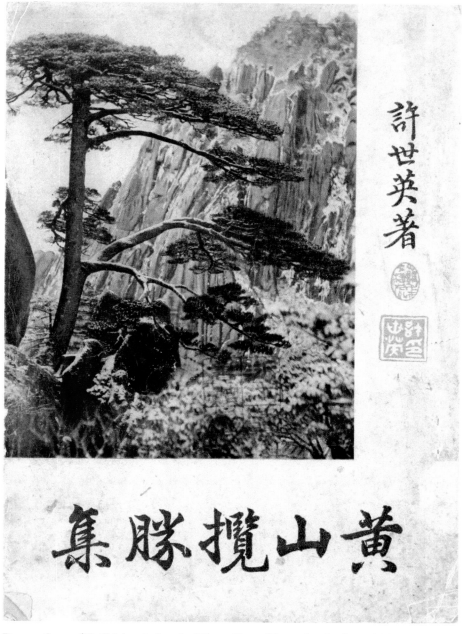

許世英著

黃山攬勝集

Fig. 5.15. Cover of Xu Shiying, *In Search of Mount Huang* (*Huangshan lansheng ji*) (Shanghai, 1934), with colorized photograph of the Guest-Greeting Pine and calligraphy by Xu Shiying. Photo: Zhejiang Provincial Library.

invited on the trip to Mount Huang. The periodicals reporting on the Huang Society exhibition, however, featured paintings by some of the most successful Shanghai artists of the day, such as Huang Binhong, Zhang Daqian, Zhang Shanzi, and Qian Shoutie (1896–1967), alongside photographs by Lang Jingshan, Ye Qianyu, and Shao Yuxiang.[73] In comparison, the illustrations for *In Search of the Southeast*'s Huangshan section almost resemble a collection of works by young talents. This also contrasts with the prominence of the authors of the written contributions.

The reasons for this discrepancy are hard to determine. It seems, though, that the project to promote economic development at Mount Huang outgrew the scope of *In Search of the Southeast*, which focused on the landscapes of Zhejiang Province. Mount Huang, in neighboring Anhui, was only one of many southeastern sites featured in that book. But with its capacity to attract tourists (once it became more accessible by modern transportation), its history as an elite travel destination, and its qualities as a motif for painters and photographers, it outshone any other place along the itineraries of the Southeastern Infrastructure Tour. The high-speed expansion of the region's travel facilities, organized by Xu Shiying, was also unmatched at Zhejiang sites, where road and railway construction primarily followed the needs of trade and military transportation, with tourism as a welcome secondary goal. Since Wang Yingbin participated in both projects, as secretary of the Zhejiang Construction Bureau, as the Shanghai representative for the Southeastern Infrastructure Tour, and as an Anhui native involved in the Huang Society exhibition, the two publications can be considered not as competing enterprises but as coordinated efforts by various members of Shanghai's artistic and publishing sphere.

The public attention that Mount Huang attracted is also indicative of the pivotal role it played in defining a modern Chinese landscape aesthetic, an aesthetic that was largely mediated through photography. The photos on the opening pages of *In Search of Mount Huang*, together with the abundance of Huangshan photographs in other contemporary magazines, served to consolidate the modern iconography of the mountain.

One important aspect of this new iconography was the establishment of the Guest-Greeting Pine as an icon of Mount Huang. The anonymous cover image for *In Search of Mount Huang* is a colorized photograph of the tree in what quickly became a standard composition (see fig. 5.15).[74] It shows the pine next

to a cliff that is cut off by the picture frame. The cliff serves only as a framing device, since the tree stretches two long branches almost horizontally in opposite directions, over the steep slope crossed by the mountain path leading up to Mañjuśrī Cloister. As in many other Huangshan photographs, the pine tree is presented against a backdrop formed by the rocky screen of Heavenly Capital Peak. Several variants of this composition were taken by members of the tour group alone—besides this cover image, Ma Guoliang, Lang Jingshan, and Ye Qianyu published photographs of the pine taken from only slightly different distances and angles.[75] As the tree is shown from the almost obligatory viewpoint that any visitor to Mount Huang would seek out as they pass by the pine on the route leading up the mountain, Guest-Greeting Pine, with its easily recognizable silhouette, became a symbol of the mountain; it still is the most reproduced Huangshan pine today. Another important factor that made this particular tree the perfect motif was the fact that it is located at an ideal distance from the photographers' viewpoint to allow for photographs that are more or less focused throughout. The characteristic depth of field encountered in many photographs forming the new Huangshan iconography, in which either the pine tree in the foreground or the cliffs in the background are out of focus, could be circumvented in the standard photographic view of the Guest-Greeting Pine.

The photographs published in the context of the Huangshan publicity campaign played a decisive role in the formation of this image. While Chen Shou in his painting *Splendid Scenery of Mount Huang* (see fig. 5.9) still painted the Tamed Dragon Pine even when writing about Guest-Greeting Pine, the Guest-Greeting Pine's status as an icon was firmly established by the time *In Search of the Southeast* was available in print. The immediate and profound impact of the new iconography of the Guest-Greeting Pine can be grasped from Yu Jianhua's illustrated Huangshan travelogue, produced around two years after the Southeastern Infrastructure Tour. He describes the Tamed Dragon Pine only briefly, concluding with the words "unfortunately, I could not look at it from a closer distance."[76] He apparently based his illustration on Hongren's composition (see fig. 5.1). By contrast, Yu included three paintings of the Guest-Greeting Pine, which he called "the crown of all Huangshan pines." One of them (fig. 5.16) renders the tree from the same angle as the numerous contemporary photographs, including one by Yu Xining pasted into Yu Jianhua's manuscript.

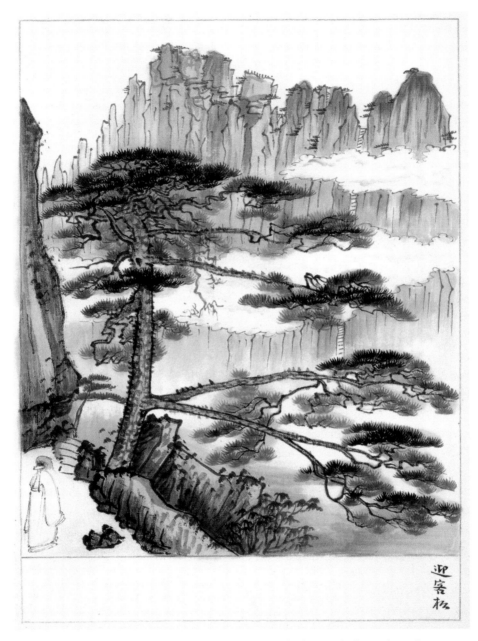

Fig. 5.16. Yu Jianhua, *Guest-Greeting Pine,* from *Yu Jianhua's Illustrated Album of Travels in Southern Anhui (Yu Jianhua Wannan jiyou tuce)*, 1936, 39a. Ink and colors on paper. Nanjing University of the Arts Library. Photo by the author.

Another photograph by Lang Jingshan published in *In Search of Mount Huang* that would take on an important role in the history of Chinese photography was *A Tree on Beginning to Believe Peak* (fig. 5.17). The sole motif of this picture, a rather unspectacular tree hunched on the brink of a cliff, would become an element in Lang's first work produced with his signature technique, which he called *jijin sheying* 集錦攝影, or composite photography: *Majestic Solitude*, created in 1934 (fig. 5.18), and its many variations.[77] By combining two negatives into one image in the darkroom, Lang created a classic example of Huangshan photography: the "tree on Beginning to Believe Peak" becomes the *repoussoir* marking the distance to a monumental peak in the background. By combining two negatives that both show their object in sharp focus, Lang Jingshan avoided the effect that all photographers using the "pine in the foreground, rock face in the background" composition had to grapple with: the fact that either the foreground motif or the background motif would be out of focus. In a later article, "Composite Photography and Chinese Art," Lang wrote:

> With Composite pictures, photographers can now do just the same as Chinese artists: they now have their choice among natural objects: they may now make their own compositions in photography. Neither time nor space need hereafter be an obstacle. All the products of Nature are now their materials, which can be utilized freely, to construct their "Land of Heart's Desire."
>
> . . . Through the lens, front view (subjects in focus) is often clear and sharp, and the distant view (subjects out of focus) dim and obscure. Yet the Chinese painters are painting according to what the human eyes usually see. Therefore, to them, what is within two yards is almost the same as that which is within twenty yards (provided always that there is no defect with one's eyes). Now we are able to make a photograph according to the human visual impression too, and are no longer restricted by the deficiencies of machinery.[78]

That photographs of Mount Huang shot during the Southeastern Infrastructure Tour became the touchstone for Lang Jingshan's photographic reinterpretation of "Chinese art" is certainly not incidental. In the course of the tour, Mount Huang was coded as "the standard mountain of China," in Wu Zhihui's words, and its geographical and climatic characteristics allowed photographers to reinterpret their works in terms of landscape painting. The impact of this double

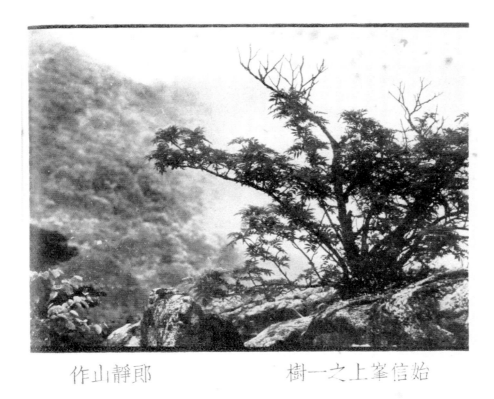

Fig. 5.17. Lang Jingshan, *A Tree on Beginning to Believe Peak*, 1934, photograph. Reproduced from Xu Shiying, *In Search of Mount Huang (Huangshan lansheng ji)* (Shanghai, 1934), unpaginated. Photo: Zhejiang Provincial Library.

standardization of Mount Huang as the national mountain/landscape image of modern China is reflected in the use of one version of Lang Jingshan's *Majestic Solitude* as the cover image for the photographic journal *Flying Eagle*'s special issue for National Day in 1936 (fig. 5.19), only two years after the Southeastern Infrastructure Tour.

As a consequence of the transmedial references in Huangshan imagery, landscape painting and its histories were reinterpreted in ways that connected them with the medial qualities of photography. The collective experience of the Shanghai photographers who visited the mountain together and the sheer number of images that they produced and published through various channels had a strong and formative impact on a large audience. How photography shaped the public imagination about Mount Huang as the typical Chinese landscape and the standard motif of landscape painting can be seen in another two-page

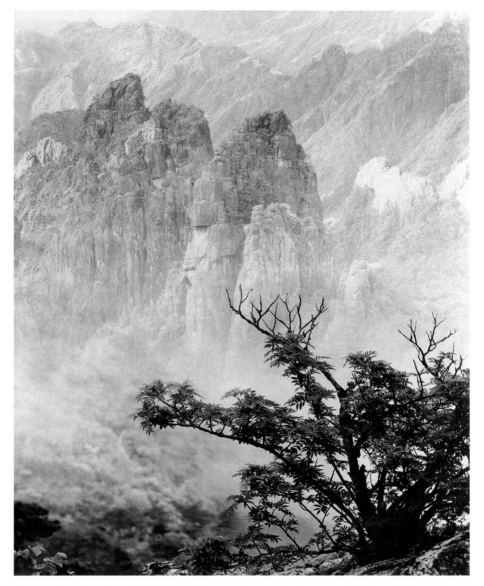

Fig. 5.18. Lang Jingshan, *Majestic Solitude*, 1934, photograph. Courtesy of the Long Chin-san Art and Culture Development Association.

spread from *Liangyou*, published in the June 1936 issue, with the Chinese title "Painterly Conceptions of Mount Huang" ("Huangshan huayi") (fig. 5.20). The publication's English and Chinese texts differ quite markedly. Under the title "Dreamy Sceneries of Huang Shan," the English text is particularly telling in how it introduces the photographs as evidence about Chinese painting: "On

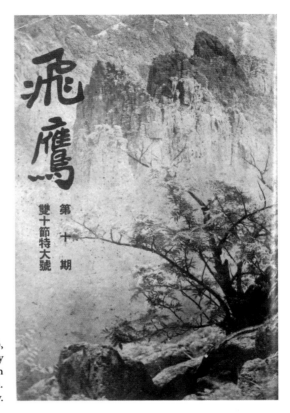

Fig. 5.19. Cover of *Flying Eagle* (*Feiying*),
no. 10, 1936, special issue for National Day
on October 10, featuring a different version
of *Majestic Solitude* by Lang Jingshan.
Photo: Zhejiang Provincial Library.

these two pages, we present six photographic sceneries of Huang Shan (Yellow Hill) to settle the argument that drawings of outdoor scenes by Chinese artists are not merely based on imagination. Seeing is believing—these scenic beauties of a poetic nature actually exist."[79] The editors of *Liangyou* are explaining that Chinese painting is actually based on real landscapes, proving their claim with photographs that imitate ink washes. Judging from the photographs by Feng Sizhi and Ma Yu reproduced on these pages, the editors imagined ink painting as consisting of contrasting and sometimes slightly blurry forms in black and white. Put differently, they did not make reference to painting to explain the aesthetic qualities of the photographs; instead, they imagined Chinese painting as if it were modeled on photography, or more precisely, on Huangshan photography.

To trace the effects of Huangshan photography in actual paintings, it is useful to return to Huang Binhong's *Old Man Peak* (see fig. 5.14 left page). Huang Binhong's paintings are normally not associated with photography, linear perspective, or other techniques introduced from the European artistic tradi-

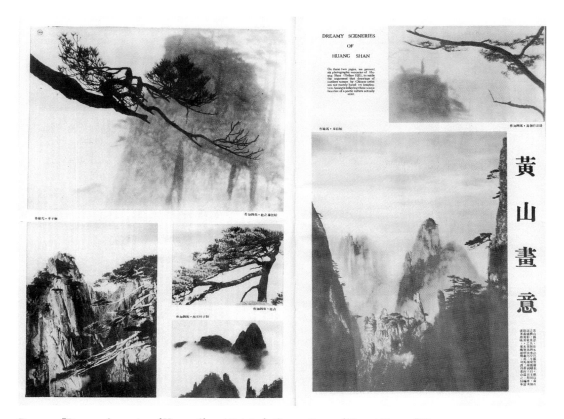

Fig. 5.20. "Dreamy Sceneries of Huang Shan / Painterly Conceptions of Mount Huang." Two-page spread from *Liangyou*, no. 117 (June 1936): 38–39, with photographs by Feng Sizhi and Ma Yu. Photo: Shanghai Library.

tion. *Old Man Peak*, however, is composed of foreground-background contrasts that work on two levels. Its division into clearly distinct grounds resonates with Lang Jingshan's *Majestic Solitude*, which itself interprets a common formula in Huangshan photography with reference to painting. Huang Binhong's rather unspectacular painting evidences his involvement in different modes of representation, different ways of engaging with topographies and the genre of landscape painting, and different pictorial media. I examine this involvement in detail in the following chapter.

Travel and Cultural History in the Paintings of Huang Binhong

Huang Binhong's involvement with both *In Search of the Southeast* and the Huang Society combined two aspects of his life that were of crucial importance to him; their intersection informed many of his works from the period under study. One aspect was his strong attachment to his home region, Shexian and Mount Huang, which was reflected in many of his activities as a scholar, collector, and artist, and in the numerous paintings of Mount Huang that he created throughout his life. The other was travel; between 1928 and 1935 Huang Binhong traveled extensively and produced hundreds of pencil sketches, ink sketches in different degrees of elaboration, and paintings of the landscapes he saw while traveling by boat or visiting particular places.

Some of the places that Huang visited during these years appear with particular frequency in his paintings from the following decades—namely, Mount Huang, Mount Yandang, and various locations in the provinces of Guangxi and Sichuan. His last two visits to Mount Huang took place in 1934 and in 1935, when Huang was at the age of seventy-two *sui*. He visited Mount Yandang in May 1931, and on his return to Shanghai encouraged Yu Jianhua to go on the sketching trip discussed in chapter 4.[1] He spent the summer of 1928 teaching at a summer school at Guangxi University in Guilin, traveling via Hong Kong, Guangdong, and upriver by boat.[2] In 1935 he traveled again to Guangxi via Hong Kong to teach at a summer school in Nanning, and from there he visited such scenic places as Goulou in Beiliu.[3] From September 1932 to September 1933 he traveled along the Yangzi River into Sichuan to teach at the Sichuan Art College (Sichuan yishu zhuanke xuexiao) in Chengdu; his sojourn there was overshadowed by

warfare. However, the landscapes he observed and sketched during his jour-
ney, most notably the landscapes of Mount Emei, Mount Qingcheng, and those
along the rivers of Sichuan, like those seen on his travels in Guilin, Yangshuo,
and Goulou in Guangxi, became recurrent motifs in his paintings.[4]

In contrast, Huang's writings on painting from the same years do not address
travel and studying from nature. In his contributions for *National Painting
Monthly*—most notably, his long essay "The Essentials of Painting Method"
("Huafa yaozhi"), which was serialized in four installments in the journal's
first to fifth issues—Huang's overwhelming concern is with method and canon
formation. He constantly references historical artists and thereby de facto rein-
terprets the history of Chinese painting. Both Claire Roberts and Jason Kuo have
observed that Huang Binhong's depictions of observed landscapes are strongly
informed by his studies of ancient paintings.[5] What remains unexplored is how
his observations of actual landscape topographies informed his interpretations
of ancient methods. In this chapter I examine Huang Binhong's complex prac-
tices in his painting, sketching, reading, and writing, in order to trace the lines
of connection and possible fissures and idiosyncrasies in his engagement with
the landscapes he traveled; with the ancient paintings he studied, emulated, and
criticized; with the activities and artistic productions of his contemporaries;
and with transmedial practices.

Travel and the Mediality of a
Woodblock-Printed Birthday Album

The importance of travel for Huang Binhong, personally as well as in terms of artis-
tic practice, can be understood through a reading of the woodblock-print album
briefly mentioned in the introduction, *Binhong's Travel Album* (*Binhong jiyou
huace*). It was a gift presented to him by thirteen friends and students in 1934 on the
occasion of his seventieth birthday.[6] Its sponsors included, inter alia, the founder of
the Society for the Preservation of National Learning (Guoxue baocun hui) and of
the Cathay Art Union (Shenzhou guoguang she), Deng Shi (1877–1951); Xuan Zhe
(1866–1942), with whom Huang had cofounded the Society for Propriety (Zhenshe)
in 1912; the artist and collector Zhang Hong (*zi* Guchu, 1891–1968); the brothers
Zhang Shanzi and Zhang Daqian; and Huang's niece Huang Yingfen.[7]

This birthday album is unusual in several respects. Earlier examples, such as
the birthday albums from mid-Ming Suzhou studied by Lihong Liu, assembled

paintings and texts produced for the recipient by renowned artists and authors with whom he was associated.[8] In the case of Huang Binhong's album, he produced the images for the album himself, as requested by the presenters, as they write in the preface. Equally unusual is the choice of the woodblock-print medium. In a letter he wrote in 1944 to his student Duan Wuran, Huang stated that the initial idea had been to print the images in light colors and use the printed leaves as stationery. This plan was abandoned because the pigment was too dark and the paper too thick.[9] If it had been realized, the images would have been overlaid with calligraphy, probably in Huang's own handwriting, and then redisseminated as letters among his acquaintances, friends, and students. In the album's present form, it has the character of a *huapu*, a printed painting manual produced by the master for his students, while it also functions as a catalogue of Huang's travel-related works.[10] Woodblock printing was not a very common medium for the production of artist's catalogues in the 1930s. The printing method of choice was collotype, and Huang himself published his works in collotype on other occasions. In producing this birthday album with woodblock printing, Huang or the presenters, or both, deliberately chose an archaizing medium, a choice that had fundamental implications for the interpretation of the pictures.

The complex and reciprocal relationship between the album presenter(s) and the receiver(s) is spelled out in the preface. According to Wang Zhongxiu, it was drafted by Xuan Zhe and collectively signed by the sponsors.[11] With this text, an intimate relationship is outlined between the recipient and the group, which the album reinforces. On the one hand, the album is introduced as a gift to celebrate the longevity of Huang Binhong; on the other, the pictures painted by Huang for the album in turn enable the sponsors to partake in his experience of travel:

> He has been painting in solitude for several decades without getting tired of it. Wherever he travels he must sketch the outstanding landscapes he encounters. In the last decade in particular, when he traveled to Guilin and climbed Mount Yandang, he cared about nothing but travel. Last year he returned from Sichuan, and now the master is already seventy. On the occasion of his birthday on New Year's Eve of the year *guiyou* [which corresponds to February 13, 1934], the group of us made plans for how to congratulate him on his longevity, and we all said: "What the master enjoys most is painting and traveling. We were born in modern times and we don't have the fulfillment of self-attainment. How could we attain longevity? When we read the master's travel poetry, our mind wanders for a long time. Therefore

we should ask the master to recall his former travels and paint a small album to carve in wood, so that his joy may spread endlessly. We are either engaged in mundane business or we do not have the physical condition to travel the famous sites, so we have not been able to follow him. By perusing that album, we could share some of the master's joys, and because of his old age, this would be very generous of him." The master agreed, and after several months, forty pages had been carved [in woodblocks]. Earlier we heard the master discuss Zhao Mengfu's [1254–1322] brush method, saying his rocks were like flying white, the trees like ancient seal script. Viewing this album today, it really conforms to this [method]. What makes us sigh is that last year the master still traveled between Mount Emei and Mount Qingcheng. Only little time has passed since, but we heard that it will not be easy for him to return there [because of warfare in the region]. Yet owing to the strength of the master's back and feet, the breadth of his interests, his productivity and speed when he wields the brush, it will be recognized in ten years or in twenty, thirty years that he has no equal in present days. The travel paintings that the master has painted as gifts for us in recent years could be assembled in a large volume that would constitute an extraordinary monument on a par with the *Travel Diary of Xu Xiake*. This album can serve as a first step.[12]

The preface opens several perspectives that direct the subsequent reading of the album and that are pertinent to the inquiries of this study. One is the generational line that the preface draws between the "group of us" (*wuchai* 吾儕) who present and read the album and the "master" (*xiansheng*) who both produces and receives it. The complex author-audience relationship in the circumstances of the album's production is transposed into the hierarchical relationship between the generations represented by Huang and his friends and students. It emphasizes the bonds between givers and receiver through the interweaving of the reciprocal giving and taking relationships as well as the different experiences and formal representations of life and time. The students describe Huang Binhong's travel and painting activities and also, implicitly, his belonging to another generation as the reasons for his longevity. It is, the preface states, because the presenters were born in modern times that they will not be able to attain the self-fulfillment that is the prerequisite of a long life. It is only through their indirect participation in Huang's travels—through reading his travel poetry and viewing the images in the album that they present to him—that they can try to come closer to this purportedly life-prolonging experience.

The self-positioning of the authors in modernity and, by implication, of Huang Binhong in a generation that belongs to another period points not only to a fundamental difference in their capacity to travel far but also to a significant difference in their approaches to landscape painting in general and travel painting in particular. When Huang moved to Shanghai in 1909 he was already in his forties, and the theoretical and practical foundations of his painting in literati traditions can at least to some degree be explained by the fact that he received his training before the beginning of the twentieth century, and in a provincial context.[13] Compared with his colleagues He Tianjian and Yu Jianhua, who were around thirty years younger, he was less affected by what might be called the "photographic turn" in landscape painting. This does not imply that he did not engage with the visual language of the photographic medium or other modern practices. In fact, he experimented with a variety of formats and media, especially during the 1930s—the woodblock-printed *Binhong's Travel Album* is but one example. But the nature of his engagement differed notably from that of his younger colleagues, and it cannot be detached from his modeling himself as a "scholar painter."

The preface lays out the main coordinates between which Huang established his artistic identity, the first one being the importance of places and the movement between them. In addition to his home region, Mount Huang (illustrated in eight images), the preface lists the most important geographic locales that Huang had visited in the previous years—and that are subsequently illustrated in the pictures: Mount Yandang (four images), Guilin (six images), and Sichuan (twelve images). Second, through the reference to Zhao Mengfu's famous equation of his own painting to calligraphic scripts, the album is brought into the interpretative framework of literati painting with its strong focus on brush method, despite the fact that it was printed from woodblocks.[14] And third, the preface compares Huang Binhong's numerous travel paintings and sketches with the famous travel diary of Xu Xiake and its exhaustive documentation of the topographies he visited. Their meaning is therefore not just purely artistic; they also partake in a learned engagement with and documentation of certain places.

Binhong's Travel Album is composed of single sheets bound with thread binding. It follows the layout and typography of earlier woodblock-printed illustrated books in a modestly produced version, with a soft, dark blue paper cover. In the copy preserved in the Shanghai Library, both the title slip, with Huang Binhong's calligraphy, and the contents of the album are printed in blue ink.

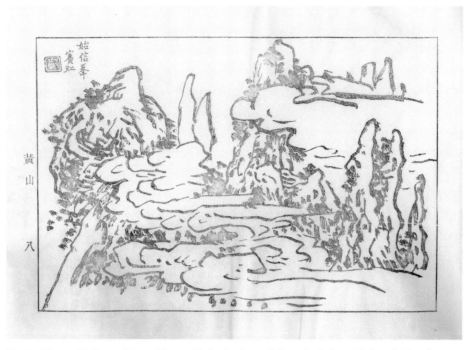

Fig. 6.1. Huang Binhong, *Mount Huang (8): Beginning to Believe Peak*, from *Binhong's Travel Album (Binhong jiyou huace)*, 1934. Woodblock print, 25.4 × 32 cm. Shanghai Library. Photo: Shanghai Library.

The illustrations are organized into geographic units, such as Mount Huang, Mount Yandang, Guilin, and Sichuan, and their sequence follows the chronology of travel. The series of Huangshan pictures, for example, begins with Fuqiu Stream, identified as the "route leading into Mount Huang." The following prints trace the ascent of the mountain, across the major peaks, to the Tamed Dragon Pine and Beginning to Believe Peak (fig. 6.1). The order of the Yandang and Sichuan pictures likewise roughly follows the itinerary of Huang Binhong's visits to those regions, as detailed in the diary of his visit to Mount Yandang and documented in three hand-drawn and annotated maps of his travel route to Sichuan that are now in the collection of the Zhejiang Provincial Museum (see fig. 6.21).[15]

The images are at the same time personal and representative; they are based on Huang Binhong's personal observations during his travels, but the same itineraries were followed by other travelers visiting Mount Huang on the standard route, or taking the steamboat into Sichuan, or to Guilin. Most of the places depicted in the album are well-known landmarks, such as the named peaks

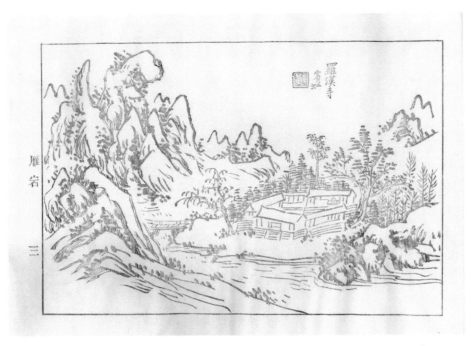

Fig. 6.2. Huang Binhong, *Yandang (3): Luohan Temple*, from *Binhong's Travel Album* (*Binhong jiyou huace*), 1934. Woodblock print, 25.4 × 32 cm. Shanghai Library. Photo: Shanghai Library.

and pines on Mount Huang, or the Spirit Peaks and Luohan Temple on Mount Yandang. Moreover, the print medium itself reinforces the representative character of the illustrated sites. By choosing woodblock printing, the producers of *Binhong's Travel Album* placed it within the genealogy of such illustrated travel compendia as Yang Erzeng's *Strange Views within the Four Seas* and *Pictures of Famous Mountains*, as well as illustrated books dedicated to specific places and created by renowned artists, such as Xuezhuang's *Pictures of Mount Huang* (see fig. 4.22) or Xiao Yuncong's *Landscapes of Taiping County*.[16] *Binhong's Travel Album* references this particular book genre in terms of medium and format and also on a pictorial level. The pages dedicated to Mount Yandang, for example, cite illustrations from *Strange Views within the Four Seas*, as on the leaf showing Luohan Temple (fig. 6.2). In Huang's illustration, the form of the towering peak that leans over the monk-shaped rocks is modeled on the illustration of the same site in *Strange Views within the Four Seas* (fig. 6.3).

The reference to the woodblock medium is complicated by the overt display of Huang's distinctive hand in most of the images in *Binhong's Travel Album*. His brushstrokes pull away from mimetic representation and require a read-

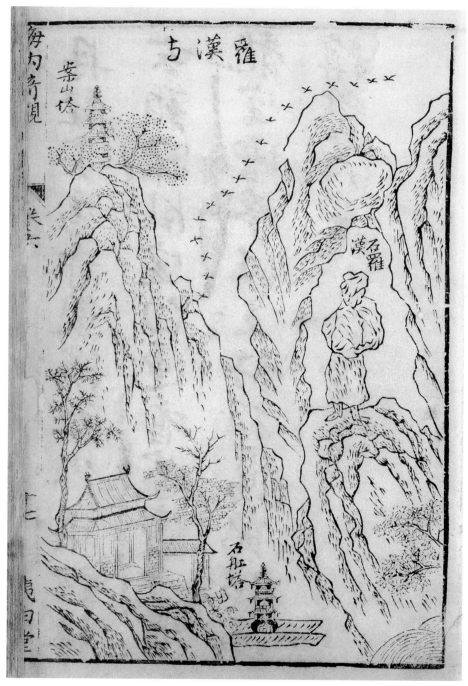

Fig. 6.3. Chen Yiguan, *Luohan Temple*, woodblock print, block carved by Wang Zhongxin. From Yang Erzeng, *Strange Views within the Four Seas (Hainei qiguan)*, 1609, *juan* 6, 17a. National Library of China, Rare Books Reading Room. Photo: National Library of China.

ing in terms of brush method. The depicted places can be identified as sites of Mount Yandang (or other places shown in the album) by virtue of interpictorial references and the names given in the inscriptions; beyond these signifying elements, the generic buildings, mountain formations, and the individual brushwork style all place the images firmly in the literati painting tradition. In this way, *Binhong's Travel Album* draws on two distinct traditions in Chinese scholar culture: the documentation of local topography and cultural history through travel diaries and local gazetteers, and the cultivation and expression of self in painting and calligraphy.

For the prints of Beginning to Believe Peak on Mount Huang and the Spirit Peaks of Mount Yandang, the woodblock carver carefully reproduced the movements of Huang's brush, the undulations of the lines, the thrust in the dots, and the split lines of the so-called flying white effect, which occurs when the brush is moved very swiftly or with little ink. This intermedial reference to painting in woodblock prints also has implications for the medium of ink painting itself. The relationship can be studied in a set of sketches that Claire Roberts has described as "anticipating the translation of his brush and ink lines into those carved in wood."[17] The sketch of Beginning to Believe Peak shows an arrangement of rock needles and swirling clouds that is similar to the images of the same peak in *Binhong's Travel Album* (see fig. 6.1).[18] The stark and slightly stiff black outlines and the dots that appear to have been hatched onto the paper with the brush both anticipate and emulate the work of the carving knife.

Whereas the use of the woodblock medium in *Binhong's Travel Album* is unique in Huang Binhong's oeuvre, album leaves painted in plain ink outlines are not. Their relevance within Huang's work is, however, little studied. In Chinese catalogues of his paintings, they are commonly categorized as "sketches after nature" (*xieshenggao*), and so far, not enough attention has been paid to Huang's different handling of sketching formats and tools, and the question of whether these works are, in fact, sketches after nature. The seemingly anticipatory sketch of Beginning to Believe Peak, like its counterpart in *Binhong's Travel Album*, is signed and sealed. Within a printed album, this indicates that the carved image should be understood either as the reproduction of a painting or, as seems to be the case here, as an original work of art. In the case of the album leaf, the signature and seal designate it as a finished work. Marking a sketch in ink outlines as a signed work in such a manner was highly unusual. Considered from the point of view of the conventional process of painting a landscape, it meant that the later steps of applying texture strokes and color—the painterly

elements of a painting—were deliberately left out, leaving only the "skeleton" of the ink outlines and a minimum of structuring dots. This abandoning of the painterly implies that Huang conferred an artistic value onto drafts that they had not hitherto possessed in China.[19] It also indicates that Huang cited woodblock print illustrations not just on a formal level but with implications for the meaning of the images, as well.

One set of images that can serve to illustrate Huang Binhong's complex use of line drawings is an undated album known as *Twelve Strange Peaks*, now in the Metropolitan Museum of Art. The album depicts mountains in different regions of China in plain outlines, without the overt display of brushwork seen in the Beginning to Believe Peak leaf. The geomantic formations are denoted in holistic compositions, as if the paintings were outline drawings for generic landscapes or for woodblock prints.[20] This formal choice may be linked to the sources of the inscriptions, which were literary travel records. Some of the leaves in *Twelve Strange Peaks* show landscapes that Huang Binhong never actually visited in person, but that are mentioned in the famous Ming dynasty *Travel Diary of Xu Xiake* (*Xu Xiake youji*) by Xu Hongzu, which is referred to in the preface of *Binhong's Travel Album*. Leaf D of the album, for example, shows Tianzhu Peak in Jianchang, present-day Nancheng County in Jiangxi Province (fig. 6.4). The inscription reads: "There are many mountains in the southeast of Jianchang. Tianzhu Peak is the highest. There is a ravine called Flying Legendary Tortoise in the north, and there is a stone terrace which is sandwiched in the ravine. From the terrace, go up to the west and you will see a cleft where the sky looks like a string."[21] This text is actually a heavily abbreviated version of Xu Hongzu's description of the place in his *Travel Diary*.[22] The matching of an account derived from the authoritative source of Xu Xiake's travel diary with an image that in its linearity cites premodern woodblock prints suggests that Huang Binhong aimed at a representative depiction of place. Whereas historical travel paintings such as those by Wang Lü (1322–ca. 1391) in his album of Mount Hua, or those in Shitao's Huangshan albums, record the subjective experience of climbing the mountains and looking at their famous landmarks, woodblock-printed images present a nonindividual, generalized visual record to an anonymous readership.[23] They are more normative and embody the collective knowledge about the places they depict. By citing the formal characteristics of woodblock prints and, in the case of *Binhong's Travel Album*, by actually working in that medium, Huang established a continuum between his own experiences and practices and those of painters such as Xuezhuang or Xiao Yuncong, who designed comprehensive

Fig. 6.4. Huang Binhong, *Tianzhu Peak*. Leaf from the album *Twelve Strange Peaks*, ca. 1940s, ink on paper, 55.9 cm × 41.29 cm. The Metropolitan Museum of Art, New York, Gift of Robert Hatfield Ellsworth, in memory of La Ferne Hatfield Ellsworth, 1986. Photo: bpk / The Metropolitan Museum of Art.

sets of images of Mount Huang and adjacent Taiping County, respectively, for reproduction in woodblock-printed compendia.

As shown in chapter 4, Yu Jianhua also cited woodblock-printed images in some of his illustrations for his *Traces of My Sandals* and *Travels in Southern Anhui*. But ultimately Yu engaged in a dialogue with photography and the exhaustive documentation of the Chinese landscape in *In Search of the Southeast* and *China as She Is*. Accordingly, his citations of the woodblock print medium should be regarded as statements within that dialogue. In contrast, Huang Binhong only rarely engaged with realistic or even photographic modes of representation, and they were not of major concern for him. His overwhelming interest was to preserve Chinese intellectual and artistic practices, practices that extended beyond the realm of painting and that he expressed in his theoretical and art-historical writings, his collection of seals and works by Anhui painters (and others), his work as an editor in diverse journals, his membership in the Society for the Preservation of National Learning, the Society for Propriety, the

Southern Society (Nanshe), and many artistic circles, and his participation in the compilation of the *Collecteana on Anhui Province* (*Anhui congshu*) and the *Shexian Gazetteer* of 1937.[24] His sketches, ink drawings, and paintings that document the various landscapes through which he traveled, or that he saw in other pictures, or that he read about (as apparently was the case with Tianzhu Peak in Jianchang)—which he frequently complemented with geographic notations—must be seen in light of this endeavor as well.

Huang Binhong often transcribed topographical information onto landscape paintings that appear to be generic, or in which place-specificity is not easily recognizable. This combination of a seemingly generic image with specific textual records is, however, not contradictory. Rather, these paintings combine two forms of historicity: Huang cited historical painting modes or the illustrations in place-related literature, such as gazetteers or topographical compendia, and he inscribed historical knowledge about places—geographic information, but also poetry—on many of his paintings. The importance of a place, its history, its topography, and other cultural or religious connotations, is not necessarily conveyed in the painted landscape, but in the text that complements the image.

The importance of the interconnection of cultural and literary history and topography in Huang Binhong's engagement with specific places can also be glimpsed from a set of unmounted sketches of Mount Wuyi in Fujian. They are undated, and nothing is known about the context of their production. Huang Binhong had traveled to Fujian with an uncle at the age of nineteen, and it has been suggested that he painted these sketches from memory.[25] It has also been proposed that they were made after Huang visited Mount Wuyi in 1928 on his homeward journey from Guilin back to Shanghai.[26] A closer examination of the sketches, however, makes both scenarios appear unlikely.

On the first impression, they seem to be swiftly drawn outline sketches that serve to record the most basic mountain contours and landmarks such as temple buildings, caves, and waterfalls, with notations of their names and geographic information. This is especially true for the opening leaf of a series dedicated to the Nine Bends (Jiuqu), titled *Wuyi 1, no. 5*, which is literally crammed with visual and textual information (fig. 6.5). Most of the other leaves, however, are apparently shorthand versions of complex and carefully arranged landscapes, animated with the figures of elite visitors gazing at scenic spots or traveling by boat. The linear but careful rendition of these details can be observed in many of Huang's sketches after paintings by earlier masters. Indeed, the leaf *Wuyi 1, no. 5*

Fig. 6.5. Huang Binhong, *The First Bend*. Leaf from a set of unmounted sketches of Mount Wuyi, undated, ink on paper, 29.5 × 45 cm. Zhejiang Provincial Museum, Hangzhou. Photo: Zhejiang Provincial Museum.

is apparently not based on a painting by an earlier master, but on a woodblock-printed illustration. A likely model for the sketch is the *Complete Map of the Nine Bends* (fig. 6.6) in the Qianlong-period *Gazetteer of Mount Wuyi* (*Wuyishan zhi*, 1751) or a related image.[27] Both the woodblock illustration and Huang's sketch show the same arrangement of a stream flowing diagonally across the picture plane, while the remainder of the composition is clustered with named mountain peaks. The most dominant formations in both the two-page woodblock illustration and Huang's leaf are the squarely towering Great King Peak (Dawangfeng), with several buildings at its foot and a boat that is being rowed to a flight of steps at the water's edge, and the high and slender, tripartite Jade Maiden Peak (Yunüfeng) at the near shore.[28] Moreover, the text that Huang Binhong squeezed into the space along the right margin of his sketch is largely culled from the 1751 gazetteer or a related source, as are the ten poems, *Chants on the Nine Bends*, by the Daoist patriarch Bai Yuchan (1194–1229).[29] Huang Binhong thus added a textual layer of geographic and literary knowledge to the landscape of Mount Wuyi as it was transmitted in mountain gazetteer illustrations, inscribing his complex intellectual and visual interests in the place onto the sketches.

While a thorough engagement with the past and with historical culture certainly was one important factor in Huang's formal and medial choices, his

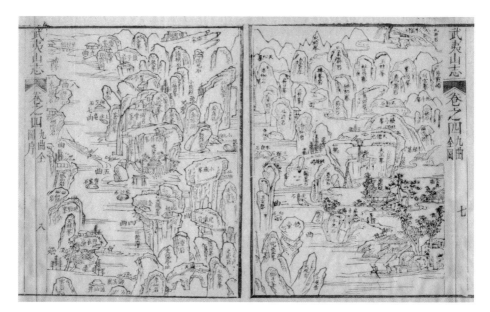

Fig. 6.6. *Complete Map of the Nine Bends*, woodblock print illustration from Dong Tiangong, *Gazetteer of Mount Wuyi* (*Wuyishan zhi*), 1751, *juan* 4, 7b–8a. National Library of China, General Ancient Books Reading Room. Photo: National Library of China.

choices also point to his innovative and experimental handling of those formats. Huang Binhong's cross-referencing of woodblock prints, abbreviated sketches, and paintings, of the carving knife and the brush, is a case of transmedial practice, as are his combinations of paintings with texts taken from nonliterary and non-painting-related sources. In his birthday album and in his outline sketches, he played out the formal properties and the medial qualities of both the brush trace on the paper and the (reproductive) print, blurring the boundaries between the two. This conscious engagement with the aesthetic and material qualities of a specific medium can also be observed in Huang's uses of photomechanical reproduction techniques, such as collotype.

Reproduction and the Production of a Painting Album

As a long-term editor in the Cathay Art Union and other publishing enterprises, Huang Binhong had profound experience in the editing of art reproductions, among other publications, in the *Glories of Cathay* series. Thus, he was well aware of various techniques of photomechanical reproduction and their respective advantages. The Cathay Art Union, together with the Youzheng

Book Company (Youzheng Shuju), was Shanghai's major publisher of fine collotype and halftone reproductions of paintings, calligraphy, and other artifacts.[30] Huang Binhong's strong awareness of different print qualities and the ways in which they impart meanings on reproductions can best be grasped from a small publication from 1934, *Collected Engravings of Epigraphy, Painting, and Calligraphy* (*Jinshi shuhua congke*), which Huang Binhong edited with the noted seal engraver Yi Da'an (1874–1941).[31]

This book has a very personal character. It reproduces items from Yi Da'an's and Huang Binhong's own collections and a few others: an ancient bronze, seal impressions, rubbings from steles, manuscripts, scholar's rocks, and paintings from the late Ming and Qing periods, along with handwritten inscriptions. It also includes several paintings by modern artists, including Huang Binhong and Yi Da'an themselves. Although it refers to the carving (*ke*) of wooden printing blocks in its title, the reproductions in *Collected Engravings* actually include at least three different modern printing techniques: collotype, photolithography, and letterpress. These modes were apparently chosen very deliberately according to the items depicted, to highlight the haptic qualities of each type of object and to place them in different categories.

For illustrations of three-dimensional objects, *Collected Engravings of Epigraphy, Painting, and Calligraphy* fully plays out what Cheng-hua Wang has called the "eyewitness experience" conveyed by collotype.[32] The images of a bronze *zun* and scholar's rocks are set off against a white background, and the subtly scaled shadings in the rocks' perforations and the lights on the bronze give the illustrations a strong sense of plasticity. Another haptic quality is conveyed by the illustration of a rubbing of a Northern Wei–period donors' inscription on a Buddhist stele. It is a photolithographic facsimile printed on thinner and more transparent *xuan* paper and folded because of its vertical format, thereby itself gaining the quality of an actual rubbing. Yi Da'an's inscription appears as if it had been directly written on the paper. Reproductions of Ming- and Qing-period paintings highlight another quality of collotype, its ability to reproduce the tonalities of ink washes.[33] The illustrations emphasize the subtle gradations in the application of ink over a sharp-focused rendering of lines; in some cases, this results in a soft blurriness (fig. 6.7).

But what is most striking about *Collected Engravings* is the sharp discrepancy in print quality between the reproductions of earlier paintings and those of twentieth-century paintings printed using a photolithographic process, a technique that had been in use in China only since 1931.[34] The modern paintings

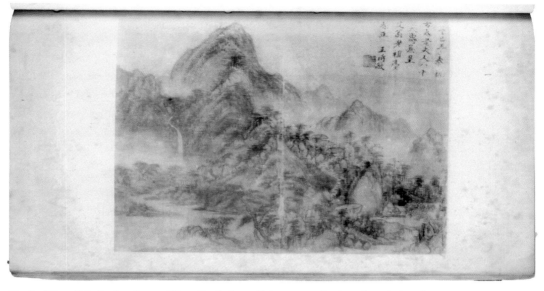

Fig. 6.7. Wang Shimin, *Landscape Album Leaf*, 1677, collotype reproduction of a painting, from Huang Binhong and Yi Da'an, *Collected Engravings of Epigraphy, Painting, and Calligraphy* (*Jinshi shuhua congke*) (Shanghai, 1934). Photo: Zhejiang Provincial Library.

printed with the new facsimile technique have none of the softness and subtlety of collotype. Instead, in what must have been a deliberate editorial decision, the images display stark black-and-white contrasts without any halftones. The ink tones and the brush work in the paintings are almost entirely obscured. The paintings are reduced to their compositions, formed by black lines, dots, and fields on an undifferentiated white background that blends seamlessly with the rest of the page.

This obvious abandonment of the technical possibilities provided by collotype (and of halftone processes applicable to lithography) draws a clear distinction between the earlier paintings, grouped under the heading "Painting and Calligraphy" (*shuhua*), and the contemporary works assembled in book sections titled "Painting Manual" (*huapu*) and "Further Engravings" (*xuke*). While the former are reproduced in a quality that invites appreciation by connoisseurs, the latter are withdrawn from the category of "painting and calligraphy" and turned into something equivalent to woodblock-printed or lithographed painting manuals, as suggested by the section titles. With these manuals, they share the reduction of values to black and white. This editorial strategy also designates the paintings by Huang Binhong, Yi Da'an, and their peers as useful material for practice, but not as enjoying the status of *shuhua*. It is an expression of reverence

for the pre-twentieth-century paintings, and also of the contemporaneity of their own works.[35] Their inclusion in these categories does not mark them out as objects of connoisseurship, but as documents of their personal relationships. Huang Binhong's landscape (fig. 6.8) is dedicated to Yi Da'an; Yi inscribed his own painting of peach blossoms with a poem, and Kuang Zhouyi (1859–1923) and Yu Boyang added poems with matching rhymes; a third painting was collectively created by Yi Da'an, Fu Puchan (1873–1945), and Zou Hui'an. This close network of personal relations and collaborations also extends to the antiques reproduced in *Collected Engravings of Epigraphy, Painting, and Calligraphy*, many of which are annotated by Yi Da'an and other scholars.

The modern paintings thus embody the network that informed the production of the book itself and that the book reinforces. The existence and the illustration of these paintings is what matters most, and not the quality of their brushwork, the subtle tones of their ink washes, or the quality of the reproductions. In an album that he produced two years later, Huang Binhong used collotype in a very different manner to produce another group of his travel paintings.

In 1936, the Cathay Art Union published *Huang Binhong's Album of Travel Paintings* (*Huang Binhong jiyou huace*) in two volumes. Each volume consists of a set of ten single-sheet collotype reproductions of paintings in a paper sleeve. The formats and materials of the originals are not specified, but the paintings appear to be in a small hanging-scroll format. The proportions of the reproductions are not identical, indicating that the originals were not painted as a set. The pictures form a group that is slightly disparate on close inspection in format, style, and textual framing. However, the twenty sheets of identical size leave enough unprinted space around the pictures to compensate for the variations of size in the originals and give them a unified form reminiscent of the mounting in a painting album. The unity of the album is further enhanced by the gray shadings of the monochrome printing that serve to suppress stylistic difference.

The formal characteristics described above are shared by countless art books and periodicals printed in collotype by the Cathay Art Union and other publishers in the first half of the twentieth century. As Yu-jen Liu has noted, the publishers wanted to make reproduced paintings available for the practices of classical Chinese connoisseurship—for mounting, inscribing, and the application of seals. By printing collotype reproductions on *xuan* paper, they dissolved the conceptual boundaries between copy and reproduction.[36] Cheng-hua Wang has remarked that collotype reproductions widened the audience for artworks

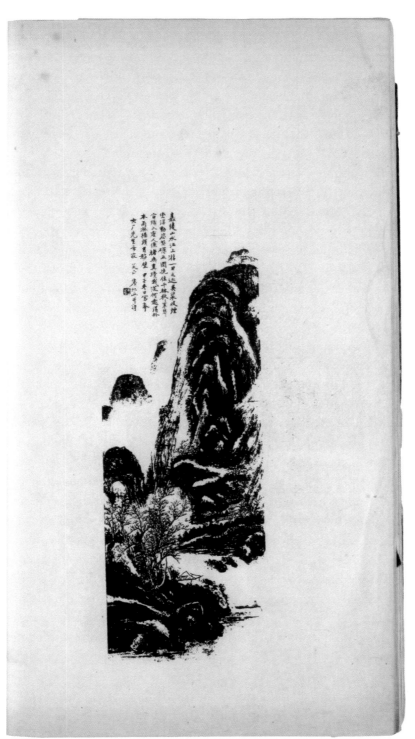

Fig. 6.8. Huang Binhong, *Landscape*, 1924, with dedication to Yi Da'an, photolithographic reproduction of a painting, from Huang Binhong and Yi Da'an, *Collected Engravings of Epigraphy, Painting, and Calligraphy* (*Jinshi shuhua congke*) (Shanghai, 1934). Photo: Zhejiang Provincial Library.

and antiquities to include not only wealthy collectors but also those who could afford the relatively modest price of the books and periodicals devoted to these reproductions.[37] While the *Album of Travel Paintings* shares these characteristics with other contemporary publications, they are here deployed in a conceptually unique and complex way. The two volumes address the mediality of the reproductions, the album's nature as a commercial and collectible item, Huang Binhong's personal travel experience, and cultural geography.

The album's two volumes serve a double function. They reproduce paintings and at the same time transform the medial qualities of the reproduced paintings. The "original" enters an ambiguous relationship with the printed image, since it is through reproduction that the *Album of Travel Paintings* is constituted as a unified corpus. Its leaves thus acquire the status of quasi-originals. This treatment of the *Album of Travel Paintings* as an artwork in its own right is underscored by the design of the sleeve cover, which shows nothing but a printed imitation of a title slip pasted to the cover of a thread-bound book or painting album. The title is written in Huang Binhong's hand, thereby associating the album with long-standing practices of connoisseurship, such as the appreciation of calligraphy and the collecting of books and paintings. In fact, the album was regarded as a collectible, as is shown by the seals of its former and present owners on the copy in the Zhejiang Library.

The reverse side of the paper sleeve, by contrast, testifies to the commercial objective behind the *Album of Travel Paintings*. The main part is covered with a "Complete catalogue of famous paintings in collotype print published by the Cathay Art Union," as well as an introduction on the history of the union and its main publications, its claims to heritage preservation through reproduction, recent changes in address and improvements in technology, and goals for the future.[38] The titles and prices of the catalogue of publications cover about two-thirds of the page, while the title of the album proper, its table of contents, and the imprint are pushed to the lower edge of the sleeve, the titles of the individual leaves printed in a smaller size compared with the items in the catalogue. The juxtaposition of forms borrowed from premodern mounting and connoisseurial practices with the marketing devices of modern publishing companies ascribes distinct yet overlapping functions to the album—the reproduction of individual original paintings also, at the same time, unifies the disparate paintings into one album. The collotype album thus constitutes a new format with a distinct materiality that allows artist and publisher to make the album accessible as a collectible item to a widened audience.

The two volumes are furthermore organized by the logic of a geographic trajectory. Whereas the first volume is almost entirely dedicated to pictures of Mount Huang, the second covers Huang Binhong's major journeys, from the Zhejiang-Anhui region to Sichuan and Guangxi. The table of contents prosaically lists locales depicted in the paintings, thereby emphasizing that the images serve to document travel. The overall geographic framework further serves, together with the photomechanical reproduction, to unify the images and occlude individual differences in size, style, and the handling of motifs. Famous sites and unspectacular valleys, individual perception and cultural history, the Jiangnan region and more remote provinces are drawn together through the personal experience of the painter as well as through the medium of collotype reproduction.

The precision of the locating information is adjusted according to the scope needed for identification; in most cases the county is indicated. One leaf in the first volume, for example, is titled *Gate to the Western Sea, Mount Huang (Shexian, Southern Anhui)*, and the last leaf in the second volume bears the title *Hengcha River (Xun River Fluvial System, Guangxi)*. Despite these precise denominations in the table of contents, an exact identification of the single leaves is not always possible; as is commonly the case with collotype reproductions, the printed pages show only the painting and bear no title or pagination. The degree of geographic detail given in the contents list, however, corresponds to the size and prominence of the represented locales and to the amount of pictorial detail in the paintings, which range from more generalized views of a mountain or river landscape to pictures of single buildings, landmarks, or less well-known sites. These variations in scope are underscored by the corresponding inscriptions.

On one leaf from the first set, probably *Mount Huang* (fig. 6.9), Huang Binhong transcribed the poem "Brilliant Radiance Peak" by Lu Zongdao (996–1029), a native of Shexian and an official at the Song court.

三十六峰凝翠靄	On the Thirty-Six Peaks jade-colored haze congeals
數千餘仞瑣煙嵐	Between thousands of fathoms wisps of mountain vapor
軒皇去後無消息	Since the Yellow Emperor has gone away, no notice
白鹿青牛何處眠	Where the White Deer and the Black Ox sleep

The poem evokes the beauty of the scenery and the Daoist mythology of the mountain without making reference to the specific site named in its title. This

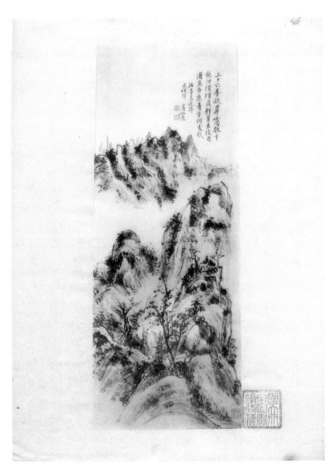

Fig. 6.9. Huang Binhong, *Mount Huang (Shexian, Southern Anhui)*. Leaf from *Huang Binhong's Album of Travel Paintings (Huang Binhong jiyou huace)*, vol. 1 (Shanghai, 1936). National Library of China, General Ancient Books Reading Room. Photo: National Library of China.

invocation of the mythical scenery of Mount Huang as a whole is matched by the painting. The foreground is filled by a steep and massive peak across which cuts a flight of steps. In the upper part of the picture, behind a stretch of clouds, another range of peaks emerges. The elevated viewpoint, the encompassing vista, and the prominence of the foreground peak serve to illustrate the staggering heights described in Lu's poem and to form a picture of the mountain as such.

The following leaves zoom in on different sites across the mountain. A more detailed rendering in the paintings is matched by a more detailed and specific description in the accompanying text. For example, *Gate to the Western Sea, Mount Huang* (fig. 6.10) shows a formation of three peaks towering over a valley. The peaks are twisted and bending backward as if frozen amid vigorous movement. The inscription relates that on Mount Huang there are three rocks "that flew hither" (*feilaishi*) and details their exact locations—one in front of Yinglin

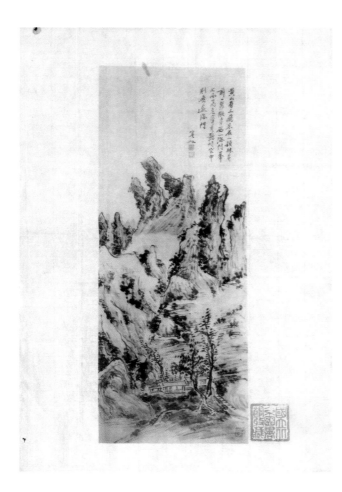

Fig. 6.10. Huang Binhong, *Gate to the Western Sea, Mount Huang (Shexian, Southern Anhui)*. Leaf from *Huang Binhong's Album of Travel Paintings (Huang Binhong jiyou huace)*, vol. 1 (Shanghai, 1936). National Library of China, General Ancient Books Reading Room. Photo: National Library of China.

Retreat, one to the west of Cuiwei Temple and one on West Gate Peak. While the inscription gives precise information on separate locations of the rocks, the number three as well as the notion of rocks "flown hither" are evoked in the painting through the towering structure looming above the valley. The bizarre shape of this peak serves to illustrate a geological phenomenon by association rather than through a depiction that is topographically correct.

Another leaf, *Qian Stream, Mount Huang* (fig. 6.11) shows a decidedly unspectacular landscape. The foreground is dominated by a group of trees in front of a hillock. To the left, a stream recedes toward the background, where a few buildings and two higher peaks can be seen. The most remarkable aspect of the painting is that it shows nothing that catches the viewer's attention. The stream appears to have been pushed to the side to bring the inconspicuous trees within the frame of the painting; the buildings in the back seem to be in the

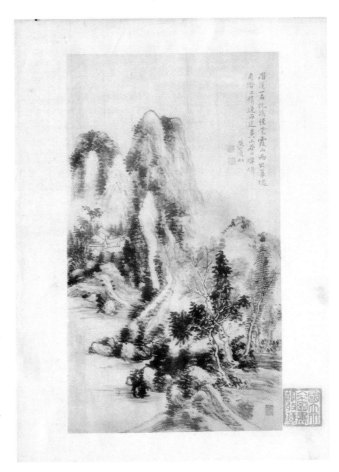

Fig. 6.11. Huang Binhong, *Qian Stream, Mount Huang (Shexian, Southern Anhui)*. Leaf from *Huang Binhong's Album of Travel Paintings* (*Huang Binhong jiyou huace*), vol. 1 (Shanghai, 1936). National Library of China, General Ancient Books Reading Room. Photo: National Library of China.

picture by accident. In short, the tight frame that is laid over the landscape and brings the elements together in a slightly awkward composition is reminiscent of photographic view-taking. Huang Binhong was not an open proponent of the integration of techniques derived from European painting or photography into ink painting, but in several of his paintings from the 1930s, such as *Old Man Peak* discussed in chapter 5, he employed compositions based on a photographic visuality. The deliberate framing of the landscape establishes the presence of the artist as a viewer of the scene. It is the inconspicuous character of the landscape that points to the circumstance that it was visited by the painter, that it was seen and sketched by him, and it was this act of seeing that made it worthy of depiction. This documentation of personal experience is matched by a documentary inscription that again gives geographic information, this time on a stream—presumably the one that appears in the lower left corner of the picture:

"Qian Stream, also known as Ruan Stream. It passes Mount Zixia and emerges at Xinxu. There is [a small town called] Qiankouzhen. To the west of the path the Huangshan Valley Stele was erected." What can be described as the documentary character of the painting and the inscription work in opposite directions. The image conveys a landscape that is brought into the picture through a seemingly deliberate act of framing, and its record of an act of seeing is verified by the frame and also by the lack of visual information and engagement that it provides. By comparison, the short inscription is crammed with place names and topographical features that cannot be found in the painting. In four short phrases, the reader is informed about the names of the stream, its course, the human dwellings nearby, and, perhaps most important, a cultural monument that is near the stream. This highly condensed description of a place is typical of premodern travel accounts or local gazetteers; Huang Binhong frequently employed the idiom of these kinds of texts or even cited them directly. His "Analytical Tour of Mount Huang," written for *In Search of the Southeast* and discussed in chapter 5, is but one example of this practice.[39] His personal experience of traveling, observing, and sketching on Mount Huang and other places is thus linked to historical experiences and topographical knowledge transmitted in travel accounts and gazetteers.

The twenty paintings included in the two volumes of *Huang Binhong's Album of Travel Paintings* are characteristic of Huang's travel paintings in two main aspects. The first is the variety of formats and modes in which the landscapes are represented—his works include holistic renderings of a mountain, depictions of spectacular views, and paintings that are ostensibly based on sketches drawn on site. They are combined with poetic inscriptions, prosaic topographical information, or a combination of both. The second aspect is the distribution of sites within the album. Huang Binhong's lifelong engagement with the scenery of Mount Huang—including less prominent sites on the far side of the mountain and in the valleys, such as Qian Stream—is reflected in the fact that 90 percent of the works in the first volume represent Mount Huang. Other mountains and rivers of Anhui and Zhejiang, as well as places in Sichuan and Guangxi that are assembled in the second volume, are also frequent motifs in Huang's paintings.

The detailed manner in which topographical information is inscribed on the *Qian Stream* leaf and others in the *Album of Travel Paintings* is an important manifestation of how Huang engaged with landscapes. The following section looks more closely at how he addressed the landscapes of specific mountains in his paintings.

Sketching Mountains, Seen and Unseen

To see how Huang Binhong engaged with particular landscapes, how he sketched them and later transferred the sketches into paintings, his pictures of Mount Yandang provide a useful demonstration. Huang visited Mount Yandang only once, in May 1931; there are several documents relating to this visit. He wrote a brief diary that contains notes on his activities, sketches drawn in situ are preserved in the Zhejiang Provincial Museum, and besides the Yandang images in the woodblock-printed birthday album, he painted several hanging scrolls of the mountain, the latest dated 1953. Thus, there is a clearly defined moment when he visited the place, the main destinations on his itinerary are known, and the notations he made on his sketchpad can be related to paintings completed at a later point.

The diary covers twenty-one days, from Huang's departure from Shanghai until his arrival back there. It begins with the notation "May 14, embarked on the Yili Steamboat at 3 o'clock, cabin no. 7. On the boat I looked at Zeng Wei's *Gazetteer of the Wider Mount Yandang* [*Guang Yandangshan zhi*]." The longest entry, from May 19, describes Huang's arrival at the mountain:

> Left Yueqing for Xici, twenty-five *li*. Passed Yao'ao Ridge, gazed at Hibiscus Stream, it was almost like in the midst of Lake Tai, only very few boats. Ascended Forty-Nine Serpentines Ridge, steep road, crossed a stream, all large rocks, climbed the rocks to move on, waterfalls in layers, winding streams. Crossed Saddle Ridge, the rock cliffs were precipitous, like terraces and pavilions soaring into the clouds. The path was very quiet, the stream very narrow, in the middle of its course a large rock with two characters engraved, reading "Lingyan." Entered Lingyan Temple, and stayed there overnight.[40]

After Huang's second day on the mountain, the entries become very short. The entry for May 24 briefly states, in only six characters, "At Lingyan waiting for the rain to stop, made paintings." The following day saw considerably more activities, but these, likewise, were noted with great brevity: "Viewed the Great Dragon Waterfall. Passed the Daoist and Buddhist Monk Cave, Luohan Temple, Shangyang, stayed overnight in Shangmashicun [Upper Horse Rock Village] at the home of a family surnamed Hu."[41] The sites listed in this short entry are among the most famous scenic spots on the mountain; they also appear later in his paintings or in *Binhong's Travel Album*.[42]

Fig. 6.12. Huang Binhong, *Great Dragon Waterfall, Left*, 1931. Leaf from a set of sketches of Mount Yandang. Colored pencil on paper, 12.7 cm × 20.6 cm. Zhejiang Provincial Museum, Hangzhou. Photo: Zhejiang Provincial Museum.

This abbreviated style of verbal notation might in part be owed to the intensity with which Huang made visual notations on his sketch pad on the same day. Among the sketches preserved in the Zhejiang Provincial Museum are some that can be directly linked to the diary entry of May 25, showing the Great Dragon Waterfall, the Luohan Temple, and the village of Shangyang. The sketches are drawn with purple-colored pencil on a smooth paper, now yellowed. Huang used just enough lines to delineate the main geographic structures of the peaks, ridges, and slopes and to note how the landscape is configured. In a leaf inscribed *Great Dragon Waterfall, Left* and numbered two in the lower right corner (fig. 6.12), he outlined the silhouette of the ridge from which the waterfall pours down; the waterfall itself is set apart by long vertical lines and densely drawn short wave lines that can be read as the falling water. Other, less densely applied strokes trace the forms of the cliffs. The sketch provides the minimum of information necessary to understand how the waterfall is situated within the valley. It captures the waterfall from a greater distance than, for instance, Yu Jianhua's close-up view of the same waterfall (see fig. 4.2), which concentrates on the rock face traversed by a band of water. Compared with Yu's tightly framed album-size image, Huang's sketch with its wider vista provides the basis for later reconfigurations in hanging-scroll format.

Fig. 6.13. Huang Binhong, *Great Dragon Waterfall, Mouth*, 1931. Leaf from a set of sketches of Mount Yandang. Colored pencil on paper, 12.7 cm × 20.6 cm. Zhejiang Provincial Museum, Hangzhou. Photo: Zhejiang Provincial Museum.

It seems that immediately after sketching *Great Dragon Waterfall, Left*, Huang Binhong continued sketching the landscape around him. The following numbered leaves in the album are inscribed *Great Dragon Waterfall, Opposite, Outer Right*; *Great Dragon Waterfall, [illegible] Peak*; *Great Dragon Waterfall, Mouth*; and *Outside Dragon Waterfall*. *Great Dragon Waterfall, Mouth*, number five in the series (fig. 6.13), shows a view of a broad valley with what seems to be a stream in the lower left, a low roof, foothills, and a mountain ridge in the background. No particular landmark is highlighted, and were it not for the inscription, it would be impossible to identify the location portrayed here. But with the inscriptions on the related leaves that denote the landscape as adjacent to the Great Dragon Waterfall, the sketches form complementary views of the landscape in which the artist stood in the moment of sketching. The inscribed directions indicate that Huang Binhong was moving through the landscape of Mount Yandang, stopping in several places, and sketching the landscape that surrounded him. In some cases valleys open into the depth of the image space, as in *Great Dragon Waterfall, Mouth*, while on other leaves cliffs dominate the picture plane and make it difficult to discern the spatial configuration. In their sum, the leaves do not represent a series of singular views (although certain views can be singled out) but an ensemble of mountain formations, valleys, and

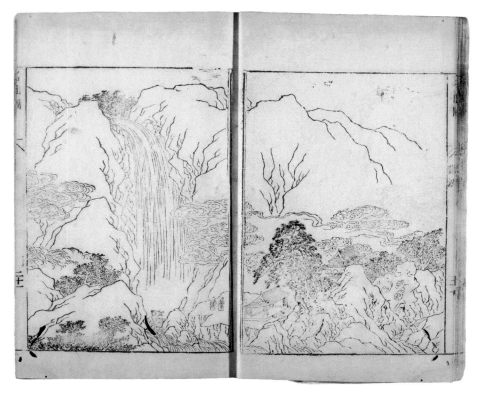

Fig. 6.14. Du Shiliang, *Dragon Waterfall*, woodblock print illustration from Mohuizhai, *Pictures of Famous Mountains* (*Mingshan tu*) (Hangzhou, 1633), 20b–21a. National Library of China, Rare Books Reading Room. Photo: National Library of China.

watercourses that together form the landscape of Mount Yandang. Accordingly (and again, in contrast to Yu Jianhua's Yandang albums), Huang does not use a fixed viewpoint; instead he documents configurations of forms and space encountered in a certain place. These landscape sketches, which in the less spectacular spots note sights that are both particular and general, furnish material for site-specific paintings as well as generic landscapes. Traces of raindrops on the paper that blurred the purple pencil lines highlight the importance of site-specificity and of the corporeal experience of being in the landscape.

These observations do not imply that the sketches were totally spontaneous and unmediated. The sketches of places such as the Great Dragon Waterfall or the Luohan Temple, which qualify as famous sites (*mingsheng*) and already had an established pictorial tradition, clearly reflect Huang Binhong's familiarity with the earlier images. In *Great Dragon Waterfall, Left*, the vertical mountainside that spans the leaf, with the waterfall placed slightly to the left, strongly

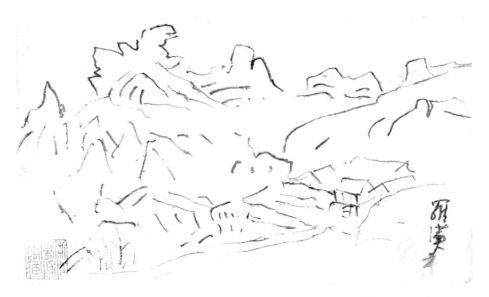

Fig. 6.15. Huang Binhong, *Luohan Temple*, 1931. Leaf from a set of sketches of Mount Yandang. Colored pencil on paper, 12.7 cm × 20.6 cm. Zhejiang Provincial Museum, Hangzhou. Photo: Zhejiang Provincial Museum.

resembles the composition of the double-page illustration of the Great Dragon Waterfall in *Pictures of Famous Mountains* (*Mingshan tu*) from 1633 (fig. 6.14). Both Huang's sketch and the Ming dynasty woodblock print show the indenture in the mountain's contour line through which the waterfall emerges in a curve before cascading downward, and a foothill to the right.

The sketch of Luohan Temple, number nine in the series (fig. 6.15), resonates even more strongly with topographical prints than those of the Great Dragon Waterfall and its environs. Huang Binhong drew the lines more carefully and vigorously, and he traced the outlines of the uniquely shaped "strange peak" in dark and precise lines. The temple itself is also carefully delineated, and the number of buildings and the layout of the compound are recorded. The arrangement of the temple, which is shifted to one side of the composition and faces the strangely formed peak, resonates with similar compositions in the previously cited late-Ming woodblock print compendia, such as the image of the same temple in Yang Erzeng's *Strange Views within the Four Seas* (see fig. 6.3). Three years later, Huang based his image of the Luohan Temple in *Binhong's Travel Album* on this sketch, bringing this composition back into the medium from which it was derived (see fig. 6.2).

Here we can see how one leaf from the series of sketches was transformed into a single view. Huang singled out a particular site from the surrounding environment and depicted it with the standardized iconography that denoted the place as "famous" (in this case, the formation of the peak and the presence of the temple) and worthy of inclusion in a set of "views" (*jing*), the preeminent format through which certain places and their landscape features were canonized in premodern China.[43] In her discussion of late-Ming paintings of Suzhou, Elizabeth Kindall cites Xu Xiake's statement, that a "scene is created when a passer-by chances upon it: once transmitted through his emotions, it is made distinct." Kindall argues that, for painters, "the sympathetic response between viewer and viewed had to be relayed through a visual structuring of the site presented. . . . The painted perspective of the locale reflects the location of the viewer, and the individual components that define the illustrated site echo the interests and experiences of the observer."[44] Typically, the places that became views were not chance findings; they were major landmarks already canonized in literary texts and around which an iconographic tradition had formed that made the views recognizable.

For Huang's paintings of Mount Huang, it is less easy to establish a link between one particular visit to the mountain and certain sketches, albums, or hanging scrolls. As mentioned, Huang Binhong climbed Mount Huang nine times in his life; the last two visits took place in 1934 and 1935.[45] He painted the mountain countless times, but because many of his later Huangshan paintings are undated or were painted several years after his last climb, only a few of them can be linked to specific visits.[46]

One set of works called *Sketches of Mount Huang* (*Huangshan xiesheng*), now in the Zhejiang Provincial Museum, is very likely related to Huang's visits to the mountain in the mid-1930s. Unlike the strongly abbreviated pencil drawings of Mount Yandang, these pictures were not painted in situ; they are tightly organized and carefully composed paintings. However, the intimacy of the views, the brevity of the inscriptions, and the roughness of the brushwork in some of the leaves lend them an informal character that oscillates between aide-mémoire, preparatory sketches, and formal paintings. This ambiguity of function is characteristic of many of Huang Binhong's travel-related paintings: between sketches drawn on mountain paths and aboard boats and paintings on large hanging scrolls, he worked in a variety of more or less informal formats, drafting landscapes with varying degrees of refinement. The unfinished nature

of sketches, such as these of Mount Huang, may be understood as an openness that retains the potential for further reuse and reworking—it marks engagement with the landscape, in painting and beyond, as an ongoing process. In fact Huang Binhong used compositions or formal solutions from the *Sketches of Mount Huang* album in numerous paintings of the mountain.

The sketches include many close-up views of well-known and lesser-known sites on Mount Huang. They do not, however, represent a tour around the mountain to the famous places that usually dominate the itineraries of visitors and the images by painters and photographers. In keeping with Huang's intimate knowledge of the mountain that informed his article "Analytical Tour of Mount Huang" in *In Search of the Southeast*, he depicts lesser and unknown peaks and corners in the vicinity of established landmarks. The album includes several images that refer to the Terrace Clear and Cool. But instead of painting the broad cliff that features so prominently in Zhang Daqian's photograph and Yu Jianhua's illustrated album (see figs. 5.2 and 4.23), Huang's album shows sites "behind" or "to the West below the Terrace Clear and Cool." Some inscriptions record only the name of the place, in others a poem is transcribed, but most of them give brief topographical information that identifies the rendered view and its location. One inscription soberly identifies the painting as showing "Bookcase and Treasure Pagoda Peaks, one is above, the other below Liu Gate."[47]

On another leaf (fig. 6.16), the visual appearance of the Peak That Flew Hither (Feilaifeng) is described in more detail: "The Peak That Flew Hither is towering majestically as if formed out of iron, without texturing [*cun*]. It rises vertically over a thousand feet, dominating the various peaks of the Gate to the [Western] Sea." In the corresponding image, no iron-like, untextured vertical cliff is to be seen. The mountain is composed of rows of narrow peaks of ascending height that rhythmically structure the image, while gathering a momentum that ushers in the highest peak. They are textured with dry scorched ink and clusters of vegetation dots. The uniform movement of the hand conveyed in the brushwork imbues the mountain with an organic character, rather than a metallic one. This organic structure, which serves to unify as well as rhythmize the composition, characterizes many leaves in the album. Consequently it serves to unify the leaves into a coherent whole, while deemphasizing the natural features of Mount Huang; the "strange pines and fantastic peaks" are absorbed into Huang Binhong's brushwork.

The leaf *The Peak That Flew Hither* can be linked to Huang's painting of the same place in the collotype album *Huang Binhong's Album of Travel Paintings*

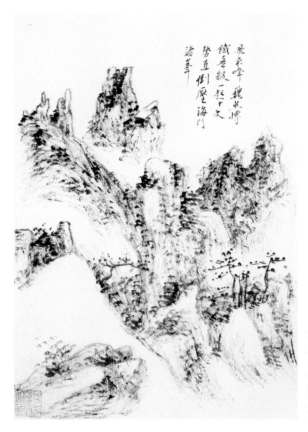

Fig. 6.16. Huang Binhong, *The Peak That Flew Hither*. Leaf from *Sketches of Mount Huang*, ca. 1930s, ink on paper, 28.5 × 19.5 cm. Zhejiang Provincial Museum, Hangzhou. Photo: Zhejiang Provincial Museum.

(see fig. 6.10). The paintings share a similar composition, with a row of smaller peaks stacked vertically across the picture plane and a higher peak rising behind. Whereas the spectacular features of the landscape described in the inscription are subdued and almost absorbed into the brushwork in the sketches, the painting in the collotype album exaggerates the eponymic features in the dynamic and almost fluttering tripartite peak formation suggestive of the Three Rocks That Flew Hither. In the correlation of the two paintings, we can trace how Huang Binhong extrapolated a hanging-scroll format painting from the more informal notation in the sketch: the documentation of mountain shapes that had become part of his personal repertoire of places and formations was transformed into a particularized and representative landscape that addresses a generalized audience.

Two other sets of sketches by Huang Binhong can be linked to the wider context of the Southeastern Infrastructure Tour. One shows views of the Five Cataracts and Fang Cliff, and the other, previously published as *Landscapes*

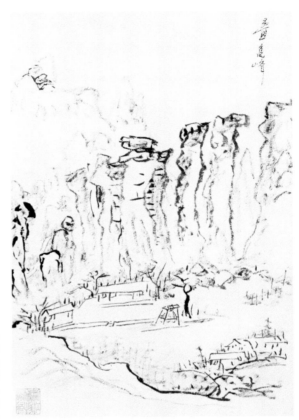

Fig. 6.17. Huang Binhong, *Layered Tortoise Peak*. Leaf from *Landscapes Sketched from Nature*, ca. 1936, ink on paper, 28.8 × 19.5 cm. Zhejiang Provincial Museum, Hangzhou. Photo: Zhejiang Provincial Museum.

Sketched from Nature (*Shanshui xiesheng*), includes views of places in Eastern Zhejiang and Jiangxi that were adjacent to the Zhejiang-Jiangxi Railway. In their stylistic handling and their degree of execution, they are similar to the Huangshan sketches just discussed, and they probably date from roughly the same period, the mid-1930s. Huang Binhong was born and grew up in Jinhua, an important regional center of Eastern Zhejiang, and traveled in the region in his youth. There are no records, however, that show he participated in the Southeastern Infrastructure Tour or otherwise traveled along the route made so convenient by the Zhejiang-Jiangxi Railway in the 1930s. It therefore appears doubtful that these albums are actually based on *xiesheng*, or drawing from nature, and in fact, they are largely based on Yu Jianhua's *Further Travels in Eastern Zhejiang* and *Traces of My Sandals,* for which Huang Binhong wrote a postscript and a preface, respectively.[48] The differences between Yu Jianhua's painstaking documentation of topographies and geological formations through the means of Chinese painting and Huang Binhong's interpretations of the same

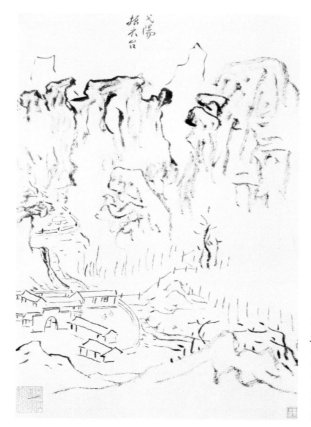

Fig. 6.18. Huang Binhong, *Terrace for Brushing the Dust Off One's Robes*. Leaf from *Landscapes Sketched from Nature*, ca. 1936, ink on paper, 28.8 × 19.5 cm. Zhejiang Provincial Museum, Hangzhou. Photo: Zhejiang Provincial Museum.

views are indicative of the two artists' respective approaches to landscapes and to painting.

Two leaves from Huang's *Landscapes Sketched from Nature* show a particularly strong connection to Yu's comprehensive documentation of the Zhejiang and Jiangxi landscapes. Inscribed *Terrace for Brushing the Dust Off One's Robes* (Zhenyitai, fig. 6.18) and *Layered Tortoise Peak* (Dieguifeng, fig. 6.17), they are apparently copies of two facing pages in Yu Jianhua's *Complete View of the Thirty-Six Peaks*, his panoramic representation of the Tortoise Peaks in Yiyang (see fig. 4.18c). Huang faithfully copied from Yu's view the layout of the buildings, the relative proportions of the cliffs, the adjacent anthropomorphic peaks, and even the detail of a small, dark rock formation on top of a mountain peak in the background. He did not, however, retain the continuity of the panorama, and instead adjusted the foreground and background proportions. Whereas Yu Jianhua arranged the peaks in a row that parallels the picture plane and flattens the space to achieve the continuity of a continuous handscroll composition, Huang Binhong pushed

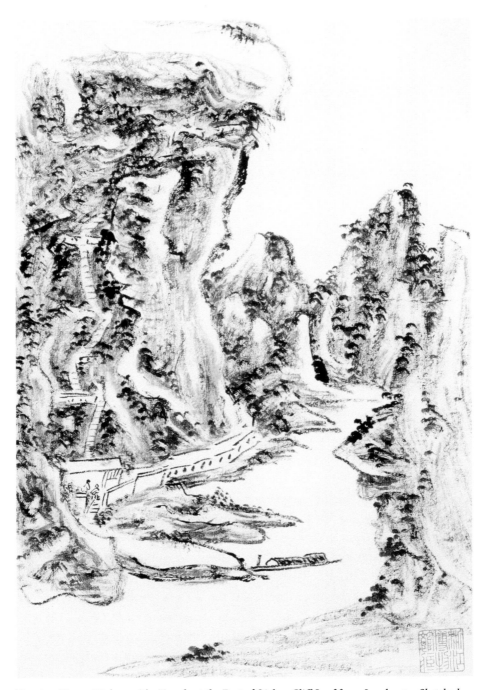

Fig. 6.19. Huang Binhong, *The Temple at the Foot of Qizhen Cliff*. Leaf from *Landscapes Sketched from Nature*, ca. 1936, ink on paper, 28.8 19.5 cm. Zhejiang Provincial Museum, Hangzhou. Photo: Zhejiang Provincial Museum.

the temple in the *Layered Tortoise Peak* leaf further into the middle ground of the pictorial space, pulling a boulder and a group of roughly sketched buildings into the foreground to gain a repoussoir effect. The background peaks, which in Yu's panorama are rendered as more or less the same height, are looming over the main peaks in Huang's version. In a slightly awkward adaptation of Yu's horizontal composition, Huang employs a steeply tilted ground plane to evoke spatial depth within the vertical format of his album leaf.

In most of the other leaves in this album, the resemblance between Yu's original and Huang's interpretation is less obvious. In his copy of Yu Jianhua's illustration *The Temple at the Foot of Qizhen Cliff* (see fig. 4.16), Huang Binhong retains the general layout, with the overhanging cliff dominating the left side of the picture, the wooden structures of the temple, the flights of steps and the walkways, the moored boat, and the river that stretches diagonally across the picture plane (fig. 6.19). But he neither copied Yu Jianhua's careful rendering of the rock surface with its characteristic perforations, nor applied the perspectival rendering of spatial depth. Instead, his mountains are dynamic, almost animated formations that somehow swallow the white band of the river halfway through the pictorial space. Again it is Huang's own brushwork, with the undulating contour lines, the dry textures, and clusters of black vegetation dots, that unifies and dominates the painting. In a manner that prefigures Huang's later paintings, the process and the means of painting—the lines and dots of the texture, the movement of the brush, and the handling of ink—become the main focus of the picture; the geographic structure of the landscape and issues of spatial coherence become secondary by comparison.

Mapping Rivers and the Landscapes of Shu

Perhaps Huang Binhong's most formative experiences with landscapes, at least with regard to his later paintings, were those encountered during his two journeys to Guangxi and his twelve-month sojourn in Sichuan. This can be inferred from the sheer number of sketches that he made during those journeys, which are now preserved in the Zhejiang Provincial Museum; from the number of images dedicated to the two regions in *Binhong's Travel Album* and in the second volume of *Huang Binhong's Album of Travel Paintings*; and from the hanging scrolls reproduced in *Sea of Paintings by Famous Contemporary Artists*, in *Collection of Famous Modern Chinese Paintings*, and as illustrations

for an article titled "On the Future of Chinese Art" ("Lun Zhongguo yishu zhi jianglai").

For inclusion in *Sea of Paintings*, which was published before he traveled to Sichuan, Huang Binhong chose a painting of Pingle (fig. 6.20), a county in Guangxi that is around 220 kilometers (roughly 137 miles) west of Guilin. The painting is a view over the expanse of a river, shown from an elevated position. We can trace its course from a foreground promontory across the water to a hill, around which it winds before it zigzags into the depth of the pictorial space. The vastness of the landscape is invoked through the miniature size of a few fishing boats close to the lower bank, which accentuate the otherwise unpainted surface of the river. Two sketchily rendered rustic houses mark the second bend in the river, and the far end of the composition is punctuated with the multistory building of a temple that stands against a row of varied, slender peaks screening off the background. The location is identified in the inscription: "Zhaoshan in Pingle [County] is located to the west of the town. At the confluence of the Li and Le Rivers, a rocky hill rises steeply in the midst of the current, its name is Zhaoshan. During the Tang dynasty, the prefecture was named Zhao[zhou] after it." This text is a literal quotation from either the Guangxu-period *Gazetteer of Pingle County*, published in 1884, or the Republican-period gazetteer of the same title, which saw its first edition in 1927, the year before Huang Binhong visited the site.[49] Zhaoshan is a small, rocky islet of about hundred square meters that is crowned by a pavilion.[50] None of its distinctive features are seen in the painting, however. Huang Binhong matched a landscape of the rivers and mountains of Pingle with a historical text on one of the county's most famous scenic spots; the visual information conveyed by the painting and the information on historical geography detailed in the inscription complement rather than illuminate each other. The landscape is thus imbued with historicity without being dedicated to a specific site of either historic or scenic interest. Instead, the painting renders a view over the landscape formations at the confluence of two rivers. Although many of the elements are generic—such as the fishing boats, the rustic huts, and the temple compound—the continuous ground plane on which the river ascends toward the horizon, and the heavy shading with black ink on the mountains and boulders in the foreground and middle ground make the painting appear representative of a certain place observed at a certain moment in time. In fact, this painting is one of the rare instances in which Huang Binhong has conveyed both spatial depth and directed lighting, thus convincingly rendering a sense of place—a place, moreover, that he had personally visited.

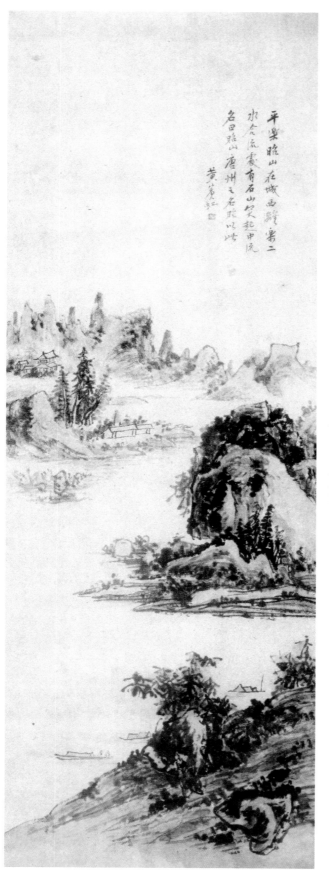

平樂晚山在城西隔書二
水倉流裏青石山突起中流
名曰照山唐州之名照以此

黃賓虹

Fig. 6.20. Huang Binhong, *Zhaoshan*, ca. 1928, dimensions and present whereabouts unknown. Reproduced from *Sea of Paintings by Famous Contemporary Artists* (*Dangdai mingren huahai*, ed. Mifeng huashe) (Shanghai, 1931; 2nd ed. 1936). Photo: Zhejiang Provincial Library.

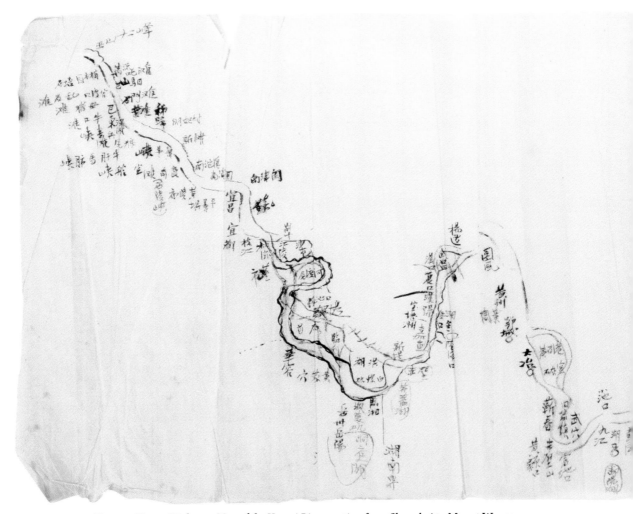

Fig. 6.21. Huang Binhong, *Map of the Yangzi River*, section from Shanghai to Mount Wu, ca. 1932–33. One of three unmounted leaves, ink on paper, 25 × 45 cm. Zhejiang Provincial Museum, Hangzhou. Photo: Zhejiang Provincial Museum.

The *Zhaoshan* painting also exemplifies the importance of rivers as both a means of travel and, accordingly, a painting motif for Huang Binhong. Many of his sketches from Guangxi and Sichuan document that they were sketched while Huang was traveling in a boat: the lower edge of the sketches are left untouched, and the landscapes are rendered above a clear shoreline. In keeping with this structure, several of Huang's landscapes in hanging-scroll format from the 1930s and later are annotated in the inscriptions as "seen from a boat."[51]

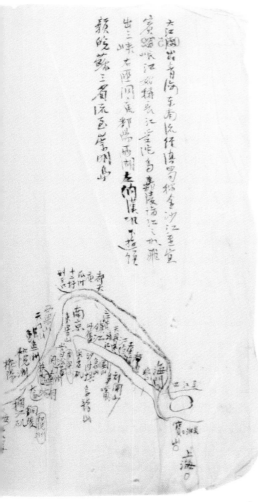

We can see the significance that travel by boat and river itineraries held for Huang Binhong in three leaves that together form a set of maps of his route from Shanghai to Chengdu along the Yangzi River: the first traces the course from Shanghai to Mount Wu (Wushan) in Sichuan (fig. 6.21); the third shows the stretch from Mount Wu to Yibin, and then northward to Chengdu; and the second an intermediary portion from Yichang to Chengdu. Huang sketched the course of the river with calligraphic lines across the blank surface of the paper, and then noted place names, the courses of tributaries, and adjacent lakes vertically along the upper and lower banks of the river. Like many of his sketches from the 1930s, these maps are at once formal and informal. They are formal in the comprehensiveness of the geographic information Huang included, in the geographic designations as well as in the accompanying texts. In the opening section of the first leaf, for example, he describes the entire course of the Yangzi, from its source in Qinghai down to Chongming Island in its delta; the lower part of the third leaf, in which he outlines only the itinerary within Sichuan, is filled with brief notations that contain varied information on diverse places. The maps' informal rendering, with their roughly sketched lines, often barely legible handwriting, and multiple corrections, suggests that Huang drew them for personal use, perhaps as an aide-mémoire or an index to the numerous sketches that he made during his year-long sojourn in the province.

The importance of the Yangzi River in Huang Binhong's engagement with the landscape of Sichuan, or more precisely, the fact that he observed the landscape while traveling by boat, is also clear in his travel sketches drawn in situ, in his birthday album, and in a book-format collotype album, *Album of Paintings by Huang Binhong* (*Huang Binhong huace*), published in 1935.[52]

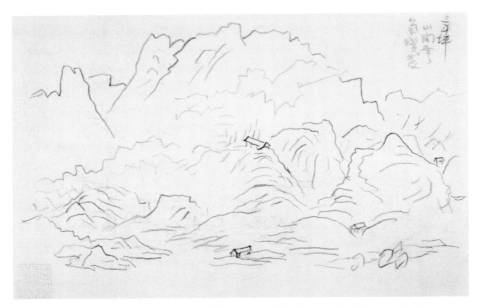

Fig. 6.22. Huang Binhong, *Sandouping*. Leaf from a set of sketches made while traveling in Sichuan, ca. 1932–33, pencil on paper, 16 × 24.7 cm. Zhejiang Provincial Museum, Hangzhou. Photo: Zhejiang Provincial Museum.

Huang Binhong made countless pencil sketches while traveling through Sichuan along the Yangzi; together they form an almost panoramic view of the shoreline. The lower edge of these sketches is occupied by the river (that is, it is unpainted), and the mountains along the river form a band across the middle section (fig. 6.22). In some cases, Huang provides annotations—place names, directions, or, as in the sketch of Sandouping illustrated here, notations about atmospheric conditions. In many cases, however, no annotations are made; those leaves show only a continuous mountain range along the river that fills most of the image space, with occasional settlements or sailboats added. Taken together, they indicate that Huang Binhong kept documenting the configurations of mountains and riverbanks as he traveled on the Yangzi. He also transferred this documentation of his river journey to his birthday album. Five out of the eight images dedicated to the landscapes of Shu (Sichuan) are river scenes, and in three of them he employed the same layout, with the surface of the river as blank paper below the river's edge, and mountainous terrain occupying the center of the picture. In fact, at least one picture from the series, the image of Sandouping, is directly based on the pencil sketch of the place (fig. 6.23). The information in the annotation to the sketch, that the mountains were wrapped

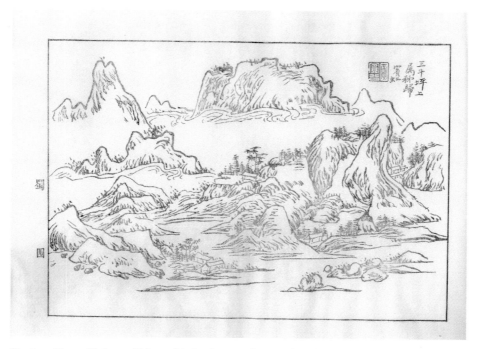

Fig. 6.23. Huang Binhong, *Sichuan (4): Sandouping*, from *Binhong's Travel Album* (*Binhong jiyou huace*), 1934. Woodblock print, 25.4 × 32 cm. Shanghai Library. Photo: Shanghai Library.

in clouds, is also conveyed in the woodblock print, in which whirling clouds serve as screens between the mountain ranges.

The formula of riverbank and mountain range stretching across the central part of the composition is also found in several of the images reproduced in the collotype publication *Album of Paintings by Huang Binhong* of 1935. Different from the single-sheet collection *Huang Binhong's Album of Travel Paintings* that was published a year later, the paintings assembled in this album seem to have been painted as a set. They are variations on the theme of mountain-and-river landscapes; in some, steep slopes descend into the water in a manner that echoes Huang's Sichuan sketches; others show wide bird's-eye views over a mountain range traversed by the course of the river (fig. 6.24), similar to the composition in the *Zhaoshan* hanging scroll reproduced in *Sea of Paintings*. The paintings are inscribed with poems from the *Tongyu Collection* (*Tongyu ji*) by the monk-poet Dexiang (fl. late 14th to early 15th c.). In his poems, Dexiang uses landscape imagery and atmospheric phenomena, such as flowing waters, rain, and falling blossoms, as metaphors in melancholic reflections on the passing of time,

secluded living during troubled times, and the inaccessibility of Peach Blossom Spring, the utopian place described by Tao Yuanming (376–427) in his famous story of the same title.[53] The poem inscribed on the painting illustrated in fig. 6.24 is characteristic:

亂山深處白鷗洲	Deep in the mountains in disorder, there is a White Goose Isle
不見漁朗問隱流	Cannot find the fisherman to ask for the hidden stream
春屋醉聽三天雨	Drunk in the spring chamber, listening to three days of rain
桃花落盡水悠悠	The peach blossoms have all fallen down, the water running on

Inscribed on Huang Binhong's landscape views, Dexiang's descriptions of piled peaks and flowing waters are foregrounded, and the political metaphors of inner exile become less prominent. Their non-site-specific river and water themes imbue Huang's own Republican-period paintings with a seemingly timeless Chinese-landscape aesthetic. The landscapes in the paintings, which are clearly based on his observations of the scenery in Guangxi and Sichuan and on the sketches that he produced during his travels, become generic and timeless. Here we can see how Huang integrated his site-specific sketches into paintings that express a generalized landscape aesthetic, which could become the basis for more formal explorations in brushwork and the application of ink, and for the melancholic representation of political discontent.

The journey to Sichuan was formative for Huang Binhong not only with regard to his river paintings but also, perhaps even more important, with regard to monumental mountainscapes. Again, the woodblock birthday album *Binhong's Travel Album* is indicative in this respect. The sequence of eight illustrations under the caption "Shu" is followed by four pictures dedicated to Heavenly Pond (Tianchi), a lake in Guang'an County north of Chongqing. One of these illustrations shows no signs of water; instead, it is almost filled with mountain slopes (fig. 6.25). Only a little space is left for the inscription (which soberly states that there are more cypresses than pines in Sichuan, except in the mountains around the Heavenly Pond) and one building nestled on the mountainside. Although the intimate, horizontal format of the birthday album is not particularly suited

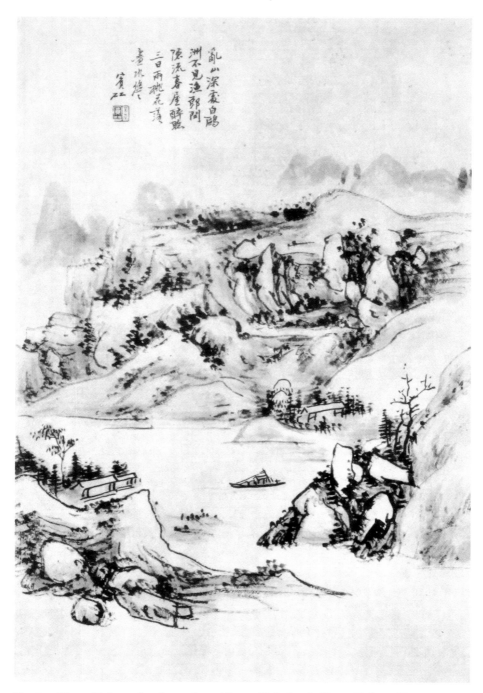

亂山深處白鷗
洲不見漁郎問
陳渡春屋醉臨
三日兩桃花漲
臺水樂
賓虹

Fig. 6.24. Huang Binhong, *Landscape*, from *Album of Paintings by Huang Binhong* (*Huang Binhong huace*), 1935. Photo: Zhejiang Provincial Library.

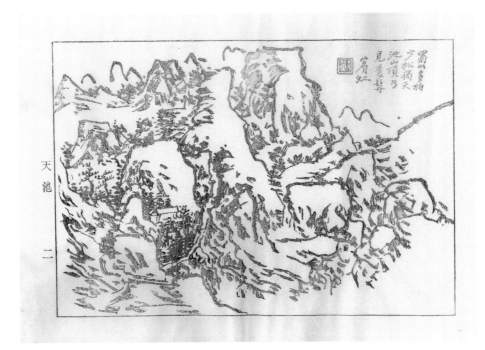

Fig. 6.25. Huang Binhong, *Heavenly Pond (2)*, from *Binhong's Travel Album (Binhong jiyou huace)*, 1934. Woodblock print, 25.4 × 32 cm. Shanghai Library. Photo: Shanghai Library.

to conveying great mountain heights, Huang Binhong repeatedly employed the pictorial formula of mountain slopes filling a major part of the picture plane and consciously working against spatial recession, most notably for Sichuan landscapes.

In the painting he handed in for publication in the Chinese Painting Society's *Collection of Famous Modern Chinese Paintings*, Huang brought this pictorial formula to a vertical hanging scroll (fig. 6.26). The title in the published image caption is *Sutra Chanting in Deep Mountains*; in the inscription on the scroll, the painting is annotated as a "landscape of Shu." About three-fourths of the picture plane is filled by a mountain built up from numerous mounds that loosely cite the Dong-Ju style, with round rock forms set off from each other and against space by means of vegetation dots. Several groups of buildings are set in pockets between the mounds, accentuating the ascent. A white strip runs diagonally across the slope; it might be a watercourse or a mist-filled gorge. This semantic openness is significant: the main function of the strip of unpainted paper is not to represent a waterfall or a layer of clouds but to structure the composition, which happens to depict a mountain slope inspired by a Sichuan

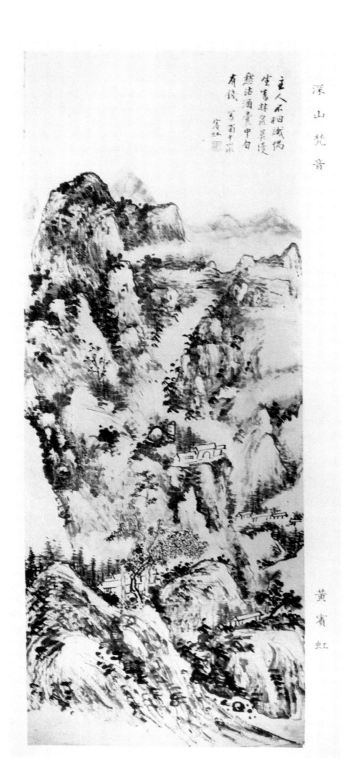

主人不相識偶
坐為林泉故優
慈湖道賈甲申
有餘 寫荊中珍
賓虹

深山梵音

黃賓虹

Fig. 6.26. Huang Binhong,
*Sutra Chanting in Deep
Mountains*, ca. 1935,
dimensions and present
whereabouts unknown.
Reproduced from *Collection
of Famous Modern Chinese
Paintings* (*Zhongguo
xiandai minghua huikan*, ed.
Zhongguo huahui bianyibu)
(Shanghai, 1935), unpaginated.
Shanghai Museum Library.
Photo by the author.

landscape. Besides representing what might be called a Sichuanesque mountain, the picture is a field on which Huang Binhong cites, revises, and rearranges canonical brushwork modes and compositional models; it is a site in which he reinvents literati painting on the basis of his travel sketches. The mountainside is only roughly legible as a feasible geological formation. Instead, it is an assemblage of dots and strokes of varying density, accentuated with the inorganic forms of houses and the organic silhouettes of trees. The dissolution of mountain shapes into the workings of brush and ink on the surface of a sheet of paper is in keeping with the extraordinary amount of attention that Huang Binhong paid to questions of brush-and-ink (*bimo*) in his theoretical writings.

The Essentials of Chinese Painting, Its Future, and Its Past

In the mid-1930s, Huang Binhong published several programmatic texts on the nature of Chinese painting—its techniques, its history, its present state, and its future. The longest and most important of these texts, "The Essentials of Painting Method," was published in four installments in *National Painting Monthly*; it was one of the major contributions to the journal.

In "The Essentials of Painting Method," Huang laid out what defines Chinese painting. He proposed numbered sets of artistic lineages that should be followed (three), and numbered sets of methods for using brush (five) and ink (seven); he described how those methods were used by past masters and how they were to be applied correctly. He also pointed out what should be avoided. In fact, he proposed a new orthodoxy that was in many aspects based on earlier principles of literati painting and that was highly normative. Moreover, he positioned himself indirectly but clearly against any reforms of Chinese painting based on realist techniques. He made this clear in the first lines of the essay:

> There have always been people renowned for their painting. Brush method, ink method, and the method of composition are the three essentials. There has been no one who possessed neither brush method nor ink method, but relied only on the method of composition, and yet was able to establish his own style that was transmitted for a long time. If you do not grasp the methods of brush and ink, but only strive to create something new and fresh on the basis of composition, then you may achieve a high degree of

form-likeness, but it will be difficult to attain a deep and flowing spirit resonance [*qiyun cangrun* 氣韻蒼潤]. Driven by a rope, you will be restricted by standards and norms; the appearance will be there, but the spirit lost. This can be called having neither brush nor ink.[54]

After thus establishing brush and ink methods as the essential markers of quality in painting (the method of composition received no further comment in the remainder of the essay), Huang moved on to point out suitable lineages:

1. Literati painting (writers of poetry and prose; epigraphers)
2. Famous master painting (Southern School; Northern School)
3. Great master painting (the number of masters is not limited; it is not differentiated according to schools)[55]

With his configuration of painting lineages, Huang fundamentally regrouped existing genealogies and criteria for evaluation. For the first group, he reinterpreted the term "literati painting" (*wenrenhua* 文人畫) in a very literal sense, as a form that relied on text-based skills, most importantly on erudition and calligraphy. Accordingly, this group was rather broad. The second group, "famous master painting" (*mingjiahua* 名家畫), was made up of both the Southern and the Northern Schools, the two lineages that had most heavily informed genealogical categories in Chinese art theory since the seventeenth century. According to Huang, both had their shortcomings: the Southern School had an elitist flavor (*shiqi* 士氣) and a tendency to appear weak, while the Northern School had a flavor of craftsmanship (*zuoqi* 作氣) and easily became vulgar.[56] The highest category of the three was that of "great master painting" (*dajiahua* 大家畫):

> They are highly knowledgeable, and their moral attainments are especially accomplished. They elucidate the secrets of brush and ink and create the truth of composition. They combine literati painting and famous master painting and possess the qualities of both. Therefore they can partake in natural creation [*zaohua*]. They weed out the old to establish the new, and they vigorously rectify the current of their times and establish order. They learn from the ancients without imitating the ancients. For a thousand years and within ten thousand miles, there have only been a few of them in each generation.[57]

In a next step, Huang linked "great master painting" to the "untrammeled class" (*yipin* 逸品), a class of painting beyond the qualitative categories of the "competent" (*nengpin* 能品), the "excellent" (*miaopin* 妙品), and the "divine" (*shenpin* 神品).[58] As Claire Roberts has remarked, for Huang Binhong, "*yipin* paintings were those produced by artists who had achieved the rare feat of understanding and synthesizing all of the related traditional Chinese arts and yet transcending them to achieve a feeling of complete naturalness, placing emphasis on the spirit rather than the material nature of what is represented."[59]

Huang proceeded to propose what have become his most frequently cited and widely discussed theoretical concepts: the essential "five methods of the brush" and "seven methods of ink."[60] The five methods of the brush were: "1. the even [*ping* 平], 2. the reserved [*liu* 留], 3. the round [*yuan* 圓], 4. the heavy [*zhong* 重], 5. the transformative [*bian* 變]."[61] In his explanations of the methods, Huang used topical similes from calligraphy theory to describe the visual effects achieved by certain brush techniques: the even method was likened to "drawing a line in sand with an awl"; the reserved method was "like a stain seeping from a leaking roof"; the round was "like a bent hairpin"; the heavy was "like dry wisteria and like a falling rock."[62] He based his five brush methods on some of the most canonical and normative principles in calligraphic theory, on the assumption that the methods of calligraphy and painting were essentially the same; this was a basic tenet of literati painting, as famously expressed, for example, in the poem by Zhao Mengfu that Huang's students cite in their preface to *Binhong's Travel Album*.

However, for the fifth method, the transformative, Huang departed from earlier theorems, though not without continuing to cite canonical models:

> For the so-called transformative method, it cannot be achieved by fabrications or by decorative effects. [When painting with] a centered brush tip or a slanted brush tip, the hidden and the revealed are clearly differentiated. The seal script is round, and the clerical script is rectangular, heart and hand move in accordance; changes are made without obstruction, the movements and countermovements are both deployed. You can see it in the veins of the mountains and in the edges of the rocks; when they are outlined or chopped off, the brushstroke has to transform. Water is sometimes stagnant and sometimes flowing, trees are sometimes withered and sometimes luxuriant; when you render them lush or pale, the brushstroke has to transform. Guo Xi blended monochrome ink and color painting into

one style; Dong Qichang claimed that Dong [Yuan], Ju[ran] and the Two Mis are actually of the same school. In the brushwork of famous masters from antiquity, there is not one that did not transform. What remains unchanged is the method of the ancients; only those who are able to transform are not restricted by the methods. Those who are not restricted by the methods must first deeply penetrate the methods, and only those who are able to transform them can attain the ability to move beyond method. When using the brush you must value transformation, transformation, how could this be neglected?[63]

What seems to begin as a description of brush movements, followed by an excursion on historical masters, was actually a plea for a flexible and idiosyncratic application of the normative methods that Huang spelled out earlier in his essay. How to use the brush depended on what was depicted, and on the depicted objects' visual and material qualities. The methods of the ancient masters could be selectively applied and newly combined, just as Guo Xi and Dong Qichang eclectically combined previously distinct methods. Read together with Huang's description of "great master" painters who partook in natural creation, rectified the current of their times, established order, and learned from the ancients without imitating them, the passage on the transformative method suggests that Huang regarded this method as a prerequisite to becoming a great master.[64]

In Huang Binhong's discussion of ink methods, no single method stood out as superior to the others. Rather, the seven methods for using ink—dark or viscous ink (*nongmo* 濃墨), pale ink (*danmo* 淡墨), broken ink (*pomo* 破墨), accumulated ink (*jimo* 積墨), burned ink (*jiaomo* 焦墨), overnight ink (*sumo* 宿墨), and splashed ink (*pomo* 潑墨)—are more or less idiosyncratic reinterpretations of the techniques and conventions of ink application.[65] Particularly telling in this regard is Huang's explanation of "broken ink":

When you moisten dark ink with pale ink, it becomes gloomy and dull; when you break pale ink with dark ink, it becomes fresh and spirited. Another method of broken ink is to break boundaries and contours and add a few patches of moss and fine grass at the boundary. The Southern Song painters often used this [method], and during the Yuan it was brought to perfection. ["]Dong Yuan painted many fragmented rocks at the feet of slopes to render the mountain formations of Jiankang [i.e., Nanjing]. [He] first added texture strokes beginning from the brushstrokes [of the contour lines], and then used pale ink to break the concavities. The application of

color is not different. He applied dark colors to the rocks, among the mountain rocks and alum heads were clouds and vapors, the texturing is seeping and soft. Below, there are sandy grounds that are rendered with pale [ink] and sweeping and undulating [movements of the brush], and then he again used pale ink to break it.["][66] To moisten color washes with dark ink is another essential of the broken ink method. Whoever is able to blend as well as to differentiate has attained it.[67]

"Broken ink" thus implies the destruction of uniformity and distinction. Fields of pale ink are "broken" with dark ink, and vice versa; color washes are "broken" with ink; contour lines are dissolved with patches of grass and texture strokes; and rocky mountaintops are contrasted with clouds and rendered in soft textures. Huang concluded with another contrast: applying the method of broken ink, that is, combining contrasting tonalities or dissolving clear boundaries, allowed the painter to blend those different tonalities, to blend texture strokes and contour lines, the solid and the void, while at the same time highlighting their contrasts.

The combination of contrasting formal means that Huang described in his definition of broken ink recurs at other points in his essay. In the passage on splashed ink, he wrote that "Mi Fu used the splashed-ink method of Wang Qia [Wang Mo] and combined it with broken ink, accumulated ink, and burned ink; therefore his painting is complex and thick, full of flavor."[68] And at the end of his essay, he wrote a eulogy on Dong Qichang. After arguing that Ming painting was in a state of decline following Shen Zhou and Wen Zhengming, he stated:

> Then came Dong Qichang; his painting was first modeled on Dong Yuan and Juran, and later took its methods from Ni Zan and Huang Gongwang. The excellence of his ink method in particular is unique. He acquired it effortlessly, [his paintings convey] spirit resonance and life-movement, the fresh colors of his ink are full of clear brilliance, radiant and pleasing. . . . The ink method of Dong Qichang consists of applying mostly texture strokes and washes simultaneously [*jian cun dai ran* 兼皴帶染], this is not one of the old methods of the famous masters of the Song and Yuan.[69]

With this idiosyncratic characterization of Dong Qichang's method, Huang again highlighted the combination of two distinct formal means in landscape

painting—the (basically linear) application of texture strokes and the addition of (planar) ink or color washes.

What Huang Binhong proposed throughout his essay was not one single normative method but a constant appropriation of ancient methods and their re-creation, combination, and transformation, even by means of "breaking" them. The potential of these methods to render representations of landscape played only a minor role in this text, as well as in his other theoretical writings. His "essential methods of painting" were first and foremost formal in nature: Huang concentrated on the correct ways to make a brushstroke or to achieve a certain effect in the application of ink. That he relied on theoretical tropes from canonical texts on calligraphy points to the fact that his overwhelming interest lay in *how* something is painted, rather than in *what* is painted. The whole text of "The Essentials of Painting Method" speaks of a deep concern with defining the methods of Chinese painting and preserving them in a way that is based on the methods and theoretical assumptions of literati painting. At the same time, however, Huang stressed the need for constant transformation and innovation.

The importance of transformation was even more prominent in a short text titled "The Development of Chinese Landscape Painting in the Present and the Past" ("Zhongguo shanshuihua jinxi zhi bianqian"), which Huang Binhong published between the third and fourth installments of "Essentials," as his contribution to *National Painting Monthly*'s "Special Issue on the Ideas of Landscape Painting in China and the West." He began by writing: "The history of Chinese landscape painting has been recorded for thousands of years and is clearly documented. Many famous works have been transmitted, with various methods and from many schools, the moderns have learned from the ancients, and every generation underwent transformations."[70] What followed was a very condensed history of Chinese painting as a history of constant learning from the ancients and changing their methods. As such, it is a consequent rewriting of Chinese history as evolutionary. Huang translated this evolutionism into his characteristic writing style in archaizing classical Chinese, which emulated the language of historical texts on paintings. Although Huang avoids the use of neologisms, his essay, like He Tianjian's contributions to the special issue discussed in chapters 1 and 2, is an example of translingual practice as defined by Lydia Liu. He brings the history of Chinese painting into a framework formed by modern concepts of developmental history. Moreover, the focus on transformation and change throughout Huang Binhong's text can be fully understood

only when it is considered within the context of the special issue. It is a statement directed at the topic of the special issue: a comparison of Chinese and European landscape painting and their respective histories. Huang Binhong entered into a dialogue with the developmental model of art historiography imported from "the West." To cite Lydia Liu's conceptualization of translingual practice again, Huang created a "trope of equivalence" between the two painting traditions by writing the history of Chinese painting as a history of constant change.[71]

While Huang addressed the influx of Western notions of art and art historiography only indirectly in his contribution to the special issue, he discussed it explicitly and critically in his article "On the Future of Chinese Art" ("Lun Zhongguo yishu zhi jianglai"), published in the journal *Meishu* in 1934. This text begins with a gloomy assessment of the negative effects of modern materialism, industrialized mass production, and economic greed on people's minds and world peace. Since World War I, Huang claimed, Europeans had increasingly turned to spiritual civilization and Eastern culture. The main part of the essay is a historical excursion on the spiritual, normative, educating, and politically stabilizing function of art in China ever since antiquity. The historical account ends with the increasing exportation of Chinese art and antiquities to North America and Europe. Huang does not write about the future of Chinese art throughout the text, and he may not have chosen the article's title himself. But in the last sentences of the essay he writes about the timeless formal qualities of Chinese painting and their relevance in modern times:

> Ever since the carving knife was exchanged for the soft brush, since bamboo slips were replaced by silk, whether painted in color, in gold-and-green, or in monochrome ink, Chinese painting has always changed with the times; the art [of every period] had its special characteristics and works of excellence. With regard to coloration, whether with oil or lacquer, there are records from before the Han and Jin dynasties. The methods of rulers and charcoal were all there and were transmitted, this can be checked in old books, it is needless to dwell longer on this. In Western painting, the discussion has also turned from impressionism to abstraction, from the accumulation of dots to the drawing of lines. Its artistic vigor has reached its culmination, and it will gradually integrate with the East. The former is based on [the principles of] mechanical photography, stresses the rules, and is mainly indebted to material civilization. The latter proceeds from poetry, prose, and calligraphy, emphasizes brush-and-ink, and has benefited more from

spiritual civilization. That is the difference between science and philosophy, and the distinction between the literatus and the craftsman. When technique approaches the Dao, humans will be close to nature.[72]

In this paragraph, Huang Binhong made two statements: First, he proposed that many forms of artistic expression have always existed in Chinese painting, including the use of oil painting, and of ruled line drawing (*jiehua* 界畫), the latter being the technique that Kang Youwei in 1917 had singled out as the Chinese version of realism.[73] This implies that any formal innovation, be it the appropriation of oil painting techniques or of realist modes of representation, can be subsumed under "Chinese painting" and does not necessarily point to an appropriation of foreign forms and techniques. Second, and consequently, he claimed that there were similarities between Chinese painting and certain modes of "Western" painting, and that there was even a future possibility that the Eastern and Western painting traditions would merge—on the basis of Chinese painting. What he discarded outright was a "mechanical" realism based on photographic veracity. In keeping with the tenets he proposed in "The Essentials of Painting Method," brush and ink—and, one may conclude, the personal expression of the painter through their application—were, for Huang, the prerequisites of good painting.

How do these propositions relate to his own paintings from this time? "On the Future of Chinese Art" is illustrated with two paintings, both simply titled *Landscape* in the captions. One is now in the collection of the Metropolitan Museum of Art, New York, and known under the title *Ten Thousand Valleys in Deep Shade* (fig. 6.27); the whereabouts of the other (fig. 6.28) are unknown. The two paintings may originally have formed a set. They have similar proportions; moreover, they are inscribed with related poems from a collection of poetry that Huang anthologized after his return from Sichuan, *Miscellaneous Chants from Travels in Sichuan* (*Shuyou zayong*) and presented to his friends in a facsimile print of the manuscript.[74]

Although the landscapes on the hanging scrolls cannot be linked to the topography of a specific place, the inscribed poems tie them to the landscapes of Sichuan. Within the scrolls' extremely tall and narrow format, Huang arranged high and elongated mountain forms. The steepness and height of the almost vertically rising mountains dominate the visual impression of the paintings, while depth is reduced and the space seems to be compressed as the mountains pile on top of each other. The method of representing monumentality and the

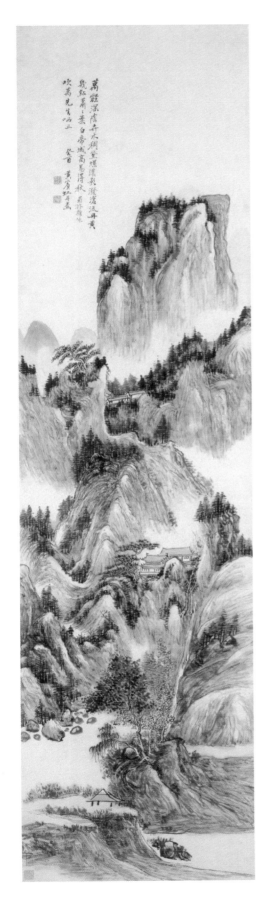

Fig. 6.27. Huang Binhong, *Ten Thousand Valleys in Deep Shade*, 1933. Hanging scroll, ink and colors on paper, 171.5 × 46 cm. The Metropolitan Museum of Art, New York, Gift of Robert Hatfield Ellsworth, in memory of La Ferne Hatfield Ellsworth, 1986. Photo: bpk / The Metropolitan Museum of Art.

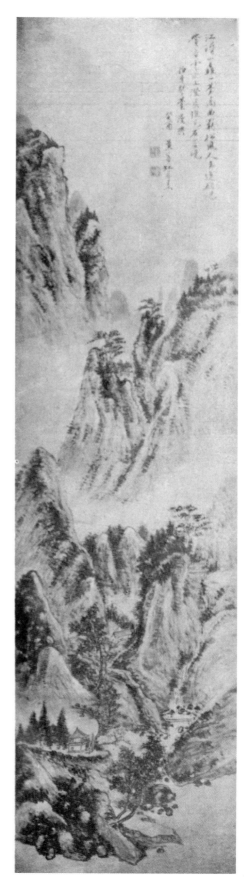

Fig. 6.28. Huang Binhong, *Landscape*, 1933, dimensions
and present whereabouts unknown. Reproduced from
Meishu 1, no. 1 (1934), 48. Photo: Shanghai Library.

filling of the picture plane with mountain structures that rise almost parallel to the picture surface are two major outcomes of Huang's travels to Sichuan. This type of composition apparently resulted from his visits to Mounts Emei and Qingcheng; he repeatedly refers to those two mountains in his writings, stressing the importance of the visits for his painting.

In *Sutra Chanting in Deep Mountains* (see fig. 6.26) the pictorial formula of a mountain slope that fills large parts of the picture is realized more radically. This slightly later painting is also more radical in its brushwork than the pair of scrolls illustrated in "On the Future of Chinese Art." Outlines are broken by moist dots, pale ink is broken by darker ink, and dark ink with pale washes. The whole mountainside is built with loosely applied and constantly transforming strokes and dots, and varying tonalities of ink. The solid forms of the landscape are virtually dissolved by multiple, vibrant layers of brushwork. *Ten Thousand Valleys in Deep Shade* is much more conservative by comparison; texture strokes and vegetation dots are painted in a much more careful and constrained manner. But Huang uses them similarly, to build a very densely structured and therefore rather dark landscape, thus evoking the monumental mountains of Sichuan. Moreover, the form of the highest peak in this painting cites the mode of the Northern Song painter Fan Kuan, who is considered the epitome of monumentality in Chinese painting history.

The grandeur and richly textured darkness of Northern Song painting, as represented by the Fan Kuan mode, was repeatedly characterized by Huang Binhong as "lush and resplendent" (*hunhou huazi* 渾厚華滋).[75] Huang's combination of such "lush and resplendent" landscapes with his idiosyncratic transformation of brush modes expressed in Dong Qichang's purported technique of "texturing and applying washes simultaneously" was apparently inspired by his experience of the mountains of Sichuan. Many of the paintings that he published in the mid-1930s showed Sichuan landscapes, including the paintings published in the popular pictorials *Liangyou* and *Arts & Life*.[76]

The close connections, for Huang, among Sichuan landscapes, Northern Song painting, Dong Qichang, the epithet "lush and resplendent," and the technique of "texturing and applying washed simultaneously" becomes more evident in painting inscriptions Huang Binhong wrote several years later.[77] During the 1940s, he increasingly inscribed his theoretical reflections and memories of former travels on his paintings. The inscription on a painting from 1948 titled *Landscape of Sichuan* is characteristic. It reads in part:

> The paintings by the masters of the Song and Yuan were completed over the course of many months and years. They are lush and resplendent, and there is nothing shallow and weak about them. When I traveled through Sichuan, I passed from Guan County through Yudie Pass into Mount Qingcheng. What I saw by day and night, the forests and foothills in mist and rain, as they emerged and disappeared, there was nothing that I did not sketch.[78]

Likewise, Huang Binhong stated in numerous painting inscriptions that Dong Qichang's method was characterized by a simultaneous application of texture strokes and washes. The sheer repetition of these two phrases suggests that the effect of *hunhou huazi* was what Huang Binhong strove to achieve in his own painting, and that the combination of texture strokes and washes was the method he adopted for doing that.

Huang's late paintings are often characterized by mountain slopes that are scarcely defined in terms of spatiality but form the ground for the application of loose and scratchy brush strokes covered by dense clusters of black ink dots, which are in turn "broken" with ink and ochre washes of varying tonalities. The landscape seems to serve only as the setting for the display of thick layers of ink and almost abstract brushwork. It is this type of painting that has been the focus of much of the later reception of Huang Binhong's work, and that seems to be in tune with modernist sensibilities in its apparent similarities to abstract expressionism. But his quasi-abstract painting is actually largely rooted in Huang's readings of calligraphy theory and interpretations of literati painting, as well as in the impressions that the landscape of Sichuan made on him.

A Pine Tree on Mount Huang

Chinese literati painting and calligraphy theory were not the sole sources for Huang Binhong's innovative brushwork, however. In 1943, the French-trained art critic, translator, and intellectual interlocutor for Huang Binhong, Fu Lei (1908–66), wrote to him about his observation that Huang's most recent works showed similarities to European impressionism.[79] Huang Binhong apparently never directly responded to this, but from the essays discussed in this chapter, we can discern his strong awareness of European painting as well as a moderate openness toward integrating certain aspects of it.[80] Huang explicitly mentioned

impressionism when discussing the possibility that Eastern and Western painting might merge one day. As he suggested in the same paragraph, the fact that the Chinese supposedly were already practicing oil painting before the Han dynasty (206 BCE–220 CE) would facilitate the process.

More important, some of Huang Binhong's paintings offer evidence that he did in fact study modes of representation that are derived from oil painting. One work in which his engagement with these modes is particularly apparent is a small and little-studied hanging scroll showing a pine tree on Mount Huang (fig. 6.29). Briefly inscribed "Wind in the Pines of the Yellow Sea" and undated, it shows an inconspicuous pine tree growing next to an equally small rock needle. This close-up study of a single tree, done on a small scale and within a reduced scene, has the immediacy of a view sketched in situ. That impression is transposed into the scroll format by means of the close framing and the white patch of unpainted paper in the painting's lower right corner that suggests a path—and thus a viewer-painter on that path.

The painted lines dissolve into fields of ink and color in a technique that may be described as the "simultaneous application of texture strokes and washes." Within the washes of malachite, ochre, and ink that form the tree and the rock, each brushstroke remains visible; the texturing, on the other hand, is applied with an extremely dry brush drawn loosely over the paper. These dry strokes are "broken" with applications of highly diluted ink and green pigment that spread into the paper at several points, creating an impression of cool moistness.

A strong sense of plasticity is achieved through modeling and shading: dark and moist patches placed at the left side of the rock and the pine tree clearly function as shadows and, by consequence, mark the position of the sun that brightens the right side at an angle suggestive of evening light. This is a clear reference to European painting conventions and indeed, most likely, impressionism. The same can be proposed for Huang's application of ink and color. The layering of pigments and ink in differing degrees of dilution, or, in Huang Binhong's own terminology, the use of the "broken ink method," was very likely inspired by the application of color in multiple layers in oil painting, as was the dissolution of the difference between outline and texture stroke. The rendering of the pine tree and the rock gains a greater density and weight, in an effect that can be described with the words *hunhou huazi* (although it is only insufficiently captured in the translation "lush and resplendent").

Although no specific method from the repertoire of named texture strokes (*cun*) can be discerned, the tools of Chinese painting remain visible throughout;

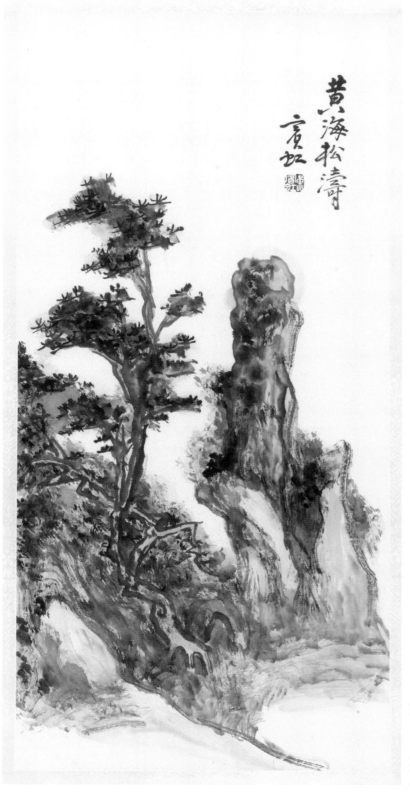

黄海松濤
賓虹

Fig. 6.29. Huang Binhong, *Wind in the Pines of the Yellow Sea*, undated. Hanging scroll, ink and colors on paper, 67 × 32 cm. National Art Museum of China, Beijing. Photo: National Art Museum of China.

every brushstroke can be traced, and the application of scorched or diluted ink can be described with the terminology derived from premodern Chinese texts on painting. Huang Binhong, in another act of transmedial practice, was able to translate his borrowings from oil painting into the idiom of Chinese painting. He is now commonly viewed as the major modern representative of literati painting modes, although his paintings look more modernist than those of his more openly progressive contemporaries. His theoretical reflections and his travels to Guangxi and Sichuan in the first half of the 1930s formed the basis of Huang Binhong's later oeuvre, although he only developed his mature painting style during the 1940s, when he was living in Beiping and unable to undertake further travels because of the Sino-Japanese War.

The Second Sino-Japanese War (1937–45) marked a rupture in the lives of Chinese artists, and many of them relocated to different places across the country. While neither Huang Binhong nor He Tianjian nor Yu Jianhua reacted to the war with openly political paintings, the changed political circumstances after 1937 had a profound impact on their lives and works. The war also brought an end to the flurry of activity that marked the Shanghai artworld of the Nanjing decade. There is not the enough space here for a history of ink painting during the war period, but the epilogue will briefly sketch how this fundamental change of situation was reflected in the works of the artists discussed in this book.[81]

Epilogue

Landscape Painting in Times of War

In the spring of 1937, He Tianjian made a painting that uncannily prefigured the traumatizing events that followed the Japanese invasion of China in July of the same year (fig. E.1). In the poem inscribed on the painting, He evokes the sandstorms in the borderlands beyond the Great Wall, contrasting them with the scents of southern China:

塞外黃沙十丈飛	Beyond the borders, the yellow sands fly ten feet high
江南時節總芳菲	In Jiangnan, the spring season is always full of fragrance
畫材爲取關山意	For painting motifs, I choose the conception of mountain passes
著簡明駝歸萬里	And create a strong camel to return across ten thousand miles

The center of the painting is dominated by a sharp and pointed mountain form that rises precipitously from a bank of clouds, textured by long strokes in ochre and dark blue (*huaqing*) that condense into black at the peak. Beneath the peak and the agitated woods below, a path emerges on which a man in rustic dress is leading a heavily laden camel. Read together with the poem, the billowing clouds blown through the trees are suggestive of the sandstorms that sweep over North China in the winter and spring months. Camel caravans were stock

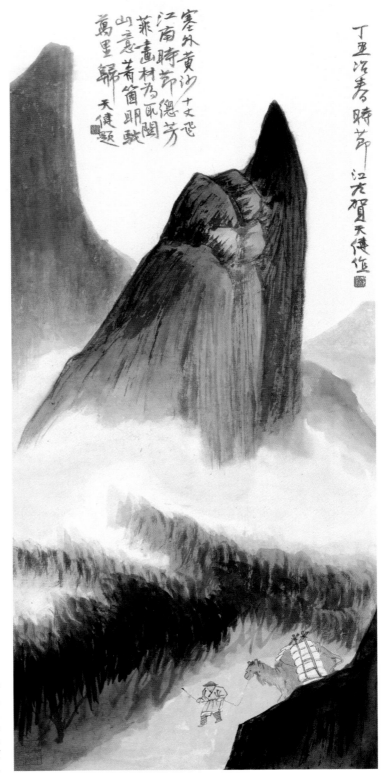

塞外黃沙十丈飛
江南時節總芳菲
菜畫材為瓦陶
山意菁蒼即戟
萬里歸
天健題

丁丑泛春時節
江左賀天健作

Fig. E.1. He Tianjian, *Long Journey*, 1937. Hanging scroll, ink and colors on paper, 105 × 37 cm. Shanghai Institute of Chinese Painting. Photo: Shanghai Institute of Chinese Painting.

motifs in twentieth-century photographs of Beijing and its environs. The paint-ing can therefore be interpreted primarily as a southerner's chilly and exoti-cizing springtime fantasy based on popular imagery of North China, probably derived from the print media. But with regard to the events that shook China only a few months later, that had been gathering momentum north of the Great Wall in Manchuria since 1931, the blade-shaped peak appears as a metaphor for the menacing presence of Japanese imperialism. The face of the man leading the camel is left blank, and the eyes of the camel seem to be closed—together they form a picture of blindly laboring people who shut their eyes to the imminent danger looming above them.

The beginning of the war in 1937 put an end to the cosmopolitanism, cultural pluralism, and hedonism of prewar Shanghai. Instead, Chinese artists were subjected to very diverse conditions, depending on which side of the front they found themselves on—in the unoccupied parts of Shanghai, in occupied Beiping, or in Chongqing, the wartime capital of the Nationalist government. After the Battle of Shanghai, which lasted from August to October 1937 and devastated the Chinese-controlled parts of the city, the International Settlement and the French Concession formed a "lone island" (*gudao*) that was not occu-pied by the Japanese. This situation lasted until the outbreak of the Pacific War in 1941. The unoccupied parts of the city experienced an economic boost, and their inhabitants were able to continue a life that was less affected by war than life in other regions of the country.[1] But it also meant that painters living in Shanghai's foreign concessions had to discontinue the extensive travel that had been such an important activity for many of them in the years preceding the war. He Tianjian, who stayed in Shanghai throughout the war period, wrote about the dilemma of not being able to travel in his autobiography. He worked out a plan to substitute for actual travel in his search for an individual style. His plan consisted of "(1) not looking at ancient paintings frequently; (2) striving for new concepts before starting to paint; (3) recalling from memory the places previ-ously visited; (4) reading historical travelogues; (5) lying down on the ground in parks and public squares and watching the clouds in the sky."[2] While He is very detailed about the reasons behind these five points, he does not relate them to his paintings of this period. But there is a set of four narrow hanging scrolls that can serve as a basis for studying how He Tianjian went about "recalling from memory the places previously visited."[3] The four scrolls (fig. E.2) were painted for a Mr. Peiyu, who, according to He's inscriptions, had visited Mount Huang in 1935 and Mount Yandang in 1937. Two scrolls show scenic sites on Mount

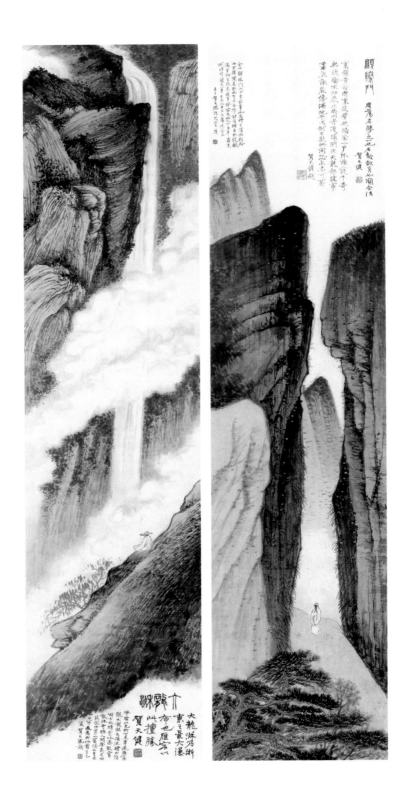

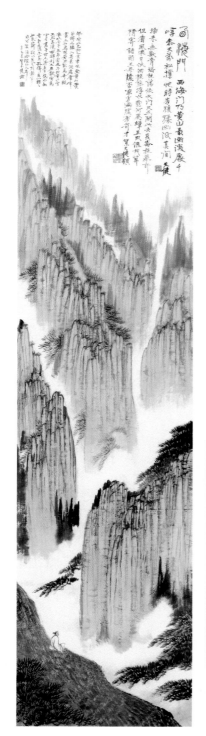

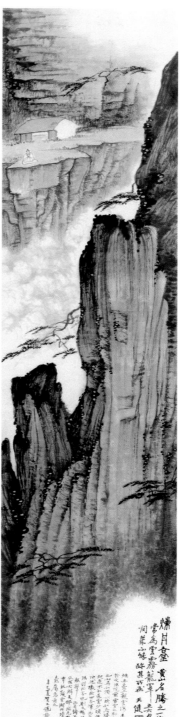

Fig. E.2. He Tianjian, *Scenic Views of Mount Huang and Mount Yandang*, 1941. Set of four hanging scrolls, ink and colors on paper, each 128.5 cm × 30.5 cm. Present whereabouts unknown. Photos: Chengxuan Auctions.

From right to left the four panels are: *Refining Cinnabar Terrace*; *Gate to the Western Sea*; *Xiansheng Gate*; and *Great Dragon Waterfall*.

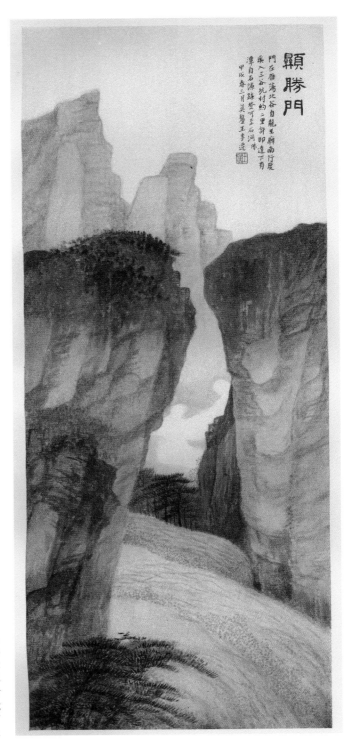

顯勝門

門在雁蕩北谷自龍王廟南行歷
乘入三谷坑村約二里許即達下有
潭自石瀑跡登可至石洞佛
甲戌春三月吳縣王季遷

Fig. E.3. Wang Jiqian (C. C. Wang),
Xiansheng Gate, 1934. Ink and colors
on paper, dimensions and present
whereabouts unknown. Reproduced
from *In Search of the Southeast*
(*Dongnan lansheng*) (1935), "Along
the Hangzhou-Fuzhou Highway . . . ,"
45. Photo: Shanghai Library.

Huang—the Gate to the Western Sea and Refining Cinnabar Terrace—and two show sites on Mount Yandang—Great Dragon Waterfall and Xiansheng Gate. The scrolls *Refining Cinnabar Terrace* and *Great Dragon Waterfall* show dramatic close-ups of the sites, which fill the elongated scrolls almost entirely, giving them an otherworldly character and highlighting the exceptionality of the views. *Gate to the Western Sea* is more conventional by comparison, showing a view over multitudinous peaks. With *Xiansheng Gate*, He turned to *In Search of the Southeast* as a source of information on the place: his composition, with two vertically rising cliffs that face each other across a narrow cleft, is clearly based on a painting by Wang Jiqian (C. C. Wang, 1907–2003) of the same place that was reproduced in color in *In Search of the Southeast* (fig. E.3). The similarities extend beyond the layout of the painting proper to the placement of the inscription and the title in seal script. The main difference is that He Tianjian mistook the stream rushing through the cleft in Wang's painting for a path, on which he placed a wanderer gazing upward. This citation testifies to the normative power that *In Search of the Southeast* and the other travel-related publications of the Nanjing decade had in the imagining of the Chinese landscape, even beyond the historical circumstances that had led to its production.

Yu Jianhua, who had been affiliated with Jinan University as an administrator since 1938, relocated with the university to Jianyang in northern Fujian after the beginning of the Pacific War on December 8, 1941, and the occupation of Shanghai's International Settlement.[4] This gave Yu the opportunity to travel to Mount Wuyi in April 1942. After his visit, he created his fourth and final painted travelogue. *Travel Pictures of Wuyi and the Nine Bends* is yet another variant of Yu's *shuce* travelogues. In terms of text, the most significant difference from the earlier albums is that besides his own travel account (again transcribed by Yu himself), he also copied into the album historical poems on the depicted sites. While imitating the layout of premodern poetry collections such as those found in local gazetteers, Yu chose a different calligraphic style for every page of poetry, employing different variants of running script, clerical script, and seal script. His other references to printed media include the album's painted cover, complete with title and cover image (fig. E.4), and a precisely drawn map of his itinerary across the mountain and the Nine Bends. The actual illustrations are rather uniform; they show representative stages along the journey (the scenic sites), with the place names written on the respective structures and a comment added in the form of a painting inscription. Like Yu's earlier albums, *Travel Pictures of Wuyi and the Nine Bends* is a thorough and systematic record of the place, albeit structured according to an

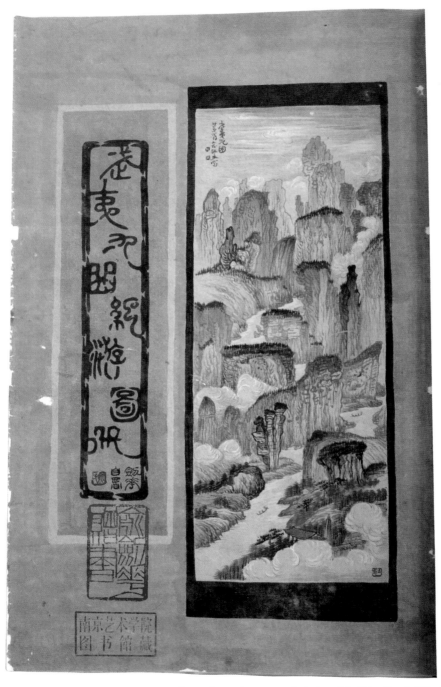

Fig. E.4. Yu Jianhua, Title page from *Album of Travel Pictures of Wuyi and the Nine Bends* (*Wuyi Jiuqu jiyou tuce*), 1942. Ink and colors on paper, 36.2 × 24.1 cm. Nanjing University of the Arts Library. Photo by the author.

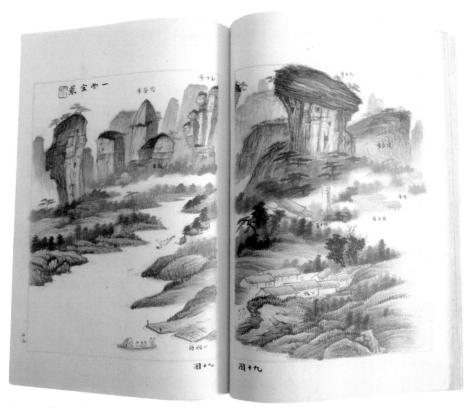

Fig. E.5. Yu Jianhua, *Complete View of the First Bend*, from *Album of Travel Pictures of Wuyi and the Nine Bends (Wuyi Jiuqu jiyou tuce)*, 1942, fig. 19. Ink and colors on paper. Nanjing University of the Arts Library. Photo by the author.

individual itinerary. Visual documentation of particular local landscape features; historical, canonized experiences of the place; and the individual instantiation of this experience thus become one. With this album, Yu reinforced historical and cultural continuity in a time of severe national crisis.

It is likely that Yu relied on historical images of Mount Wuyi and the Nine Bends for his illustrations. This appears to be the case with his *Complete View of the First Bend* (fig. E.5), which shows the same basic composition as relevant illustrations in the *Gazetteer of Mount Wuyi* (see fig. 6.6), and, by consequence, Huang Binhong's sketch of the site (see fig. 6.5). A boat with visitors is about to moor by a jetty, and clusters of buildings (partly modern and functional) are grouped beneath the major Great King Peak, the name of which is inscribed next to it. It is possible that Yu Jianhua based his illustration on Huang's sketch or that Huang based his leaf on Yu's painting. Because Huang's sketches are undated, this remains an open question.

The uncertainty about the exact date of Huang Binhong's Wuyi sketches reveals the difficulties posed by his numerous undated works, including his countless travel sketches, which make it almost impossible to establish a definitive chronology of his oeuvre. It is possible that he made these sketches years after the actual journey, while living in Beiping during the war. In an autobiographical essay written for an exhibition organized in Shanghai in 1943 to celebrate his eightieth birthday, Huang wrote: "Many people demand to see my paintings, and I show them my daily exercises in recording my travels [*jiyou huagao*]."[5] This phrase could be referring to his paintings, but Huang's use of the term *huagao* (literally, painting sketch) makes it more likely that he was writing about his sketches.[6]

Huang Binhong resided in Beiping throughout the war years, returning to South China only in 1948 when he accepted a position as professor at the Hangzhou National Art Academy (Hangzhou guoli yishu zhuanke xuexiao). He had moved to the former capital in April 1937 when he was appointed to the Beiping National Art College (Beiping guoli yishu zhuanke xuexiao). It seems that he had deemed it safer to stay in Beiping after the outbreak of the war than to move southward with parts of the faculty of the college. He continued teaching at the college and other schools in Beiping, under Japanese administration.[7] Diana Lary, describing occupied Beiping and Tianjin, wrote that the "Japanese rulers went out of their way not to disturb the cities and were rewarded with a gloomy acceptance of their presence."[8] This attitude seems to have been shared by Huang Binhong; he continued to teach, exhibit, and publish during the Japanese occupation, while maintaining contact with his network of friends, colleagues, and collectors in Shanghai, Hong Kong, and Singapore. He also engaged with the paintings and biographies of Ming loyalists of the early Qing dynasty, a fact that points to an identification with their stance.[9] Several dated paintings from his Beiping years depict places that Huang had previously visited. For example, he painted albums with views of Mount Huang in 1938 and 1940. In the album of 1938, now in the collection of the Hong Kong Museum of Art, he carried the guiding principle of his undated Huangshan sketch *The Peak That Flew Hither*, discussed in the chapter 6, one step further (see fig. 6.16). He combined topographical details of minor side peaks (and in some cases, cultural-historical background information) with close-up views of the peaks (fig. E.6).[10] The zooming-in effect is so strong that the peaks and slopes fill almost the entire picture plane and become a stage for the display of brushwork, whereas the peaks become particular beyond recognition, identi-

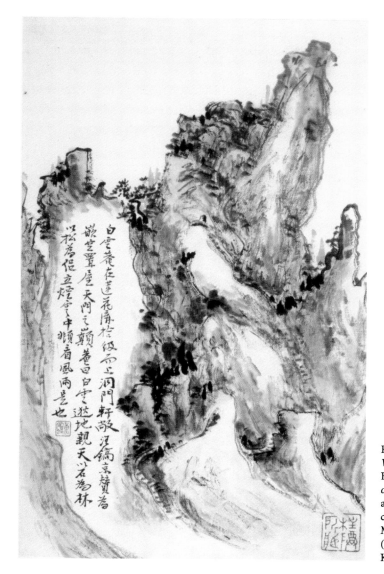

Fig. E.6. Huang Binhong, *White Cloud Retreat*. Leaf B from the album *Scenes of Mount Huang*, 1938, ink and colors on paper, 31.9 cm × 19.6 cm. Hong Kong Museum of Art, Hong Kong (FA1992.0001). Photo: Hong Kong Museum of Art.

fiable only through the inscription. Using a compositional device that further emphasizes the visual effect of the tightly framed close-up view, the inscriptions on several leaves are placed in blank areas within the outline of the peaks. This pictorial element draws attention to the formal means of the painting—the brushwork, the composition, and text-image relations. As in the Sichuan landscape *Sutra Chanting in Deep Mountains* (see fig. 6.26), the painting is still tied to a specific place by means of the inscription, but the site becomes the foil for the performance of painting.

One significant shift in Huang's paintings from the Beiping period is that his inscriptions more frequently include references to historical painters and their modes or theoretical statements on brushwork and ink. This development might be a consequence of his not being able to travel anymore, owing to the war and his advanced age. It may also result from his intense involvement with the collection of the Palace Museum in the years immediately prior to the war. He had been assigned to appraise paintings and calligraphy from the museum's collection for their authenticity, in the context of a (trumped-up) court case against the former director of the Palace Museum, Yi Peiji (1880–1937), and others, who had been accused of having replaced artworks from the museum with fakes. Over the course of twelve months, spread over a period between December 1935 and January 1937, Huang had authenticated nearly 5,000 artworks at locations in Shanghai, Beiping, and Nanjing.[11] He had also made countless sketches based on the paintings he viewed.[12] This unprecedented opportunity to engage with the most canonical works of Chinese painting (albeit under great time pressure) may have prompted Huang's intensified reflections on issues of painting method in the following years.

Another circumstance that had a decisive impact on Huang's later paintings was his gradual loss of eyesight owing to cataracts. This is most clearly reflected in his paintings from 1953, when he was almost blind, before he finally regained his vision after surgery. The deterioration of his vision, which had begun in the late 1930s, can also be discerned in his paintings from that period.[13] In the inscription to an undated painting probably done in the 1940s (fig. E.7), Huang Binhong continued his reflections on the commonalities between painting and calligraphy methods, which he had elaborated on in his 1934 essay, "The Essentials of Painting Method." He wrote, "Those discussing calligraphy value maturity, majesty, depth and refinement; painting should be lush and resplendent [hunhou huazi]. These two highest principles are interlinked, as in clerical-style painting." As in many of his paintings, it is difficult to establish a direct link between the text of the inscription and the painting itself. Clerical-style calligraphy is characterized by a horizontal orientation and strongly flaring diagonal strokes. No comparable strokes were applied by Huang in this painting, which he executed in his typical mode—the outlines were drawn with a centered brush tip, and he built the undulating mountain slopes and vegetation with a variety of loosely applied strokes and dots of ink that are sometimes light, sometimes dark, sometimes scorched, sometimes wet and overflowing. This application of broken ink in the sense described by Huang in his "Essentials of Painting

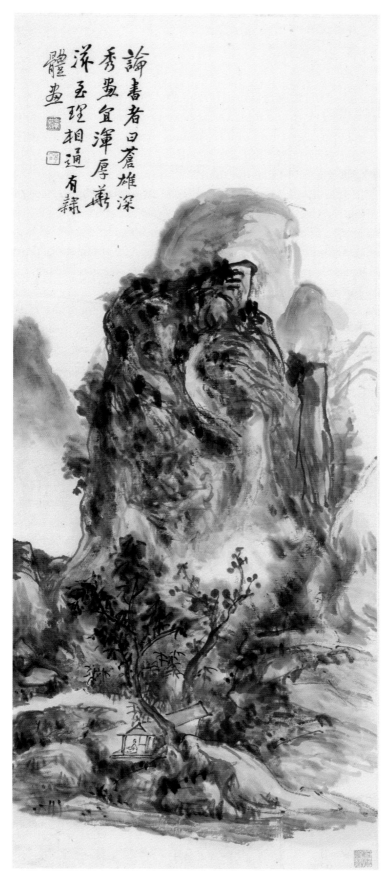

論書者曰蒼雄深
秀蜀宜渾厚蕪
滋玉理相通有隸
體畫

Fig. E.7. Huang Binhong, *A Painting Evoking Clerical Script*, 1940s. Hanging scroll, ink and colors on paper, 96.5 × 39.5 cm. Zhejiang Provincial Museum, Hangzhou. Photo: Zhejiang Provincial Museum.

Method" causes an effect of blurriness in several parts of the painting, for example in the foliage of the tree in the foreground or in the slope to its right. This gray halo of light ink appears in numerous paintings from the 1940s onward. It is comparable to the gray veil that impairs the vision of people suffering from cataracts, and as such it is an indication that Huang was literally transferring what he saw into his paintings. His growing interest in nighttime landscapes, "the dark side of the mountain," and Northern Song painting can likewise be linked to the progression of his eye disease.[14] With his interest in dense and lush brushwork on massive mountains, and by basing the physical application of his brushstrokes on the abstract principles of calligraphy, he could compensate for his loss of visual acuity.

The landscape of Sichuan gave Huang an important basis for accommodating within one painting the issues of place, brushwork, and ink technique, and a growing sense of abstraction that conveys the blurring of vision and the distance of memory. Huang's painting *Mount Qingcheng in Rain*, datable to the 1940s, serves as an example (fig. E.8). The upper half of the painting is dominated by a monumental mountain that rises vertically above a group of rustic houses wrapped in clouds. With its breadth and height and its contours drawn in scratchy lines of burned ink, it could be a typical mountain in the Fan Kuan mode. That mode is, however, literally dissolved in layers of light wet ink that form the cliffs of the mountain and spill across the contour lines. The same wetness also marks the foothills in the lower part of the picture, whereas the side of the mountain slips away into a blur. The subtle gradations of the watery ink, together with the white patches of untouched paper suggestive of clouds, give the painting a luminosity that is unusual in Huang's oeuvre. In the inscription, the wetness is explained by the weather conditions: "Sitting in the rain on Mount Qingcheng, the tree-covered mountain range, so remote, so misty. I conceived this image and then returned home."[15] With this inscription, Huang recalls an experience he had in 1933 while traveling in Sichuan. But it was not until the 1940s, after his vision began to deteriorate, that he translated the experience of rainy weather into the consciously applied blur of wet ink.

The landscape of Sichuan, which played such a formative role in Huang Binhong's painting, shifted into the center of artistic attention and the popular imagination on a broader scale when the Nationalist government resettled in Chongqing in 1938, after the fall of Nanjing and the interim capital of Wuhan. Numerous art schools relocated from the metropolises to Sichuan as a consequence of the Japanese occupation. Here again photography would become a

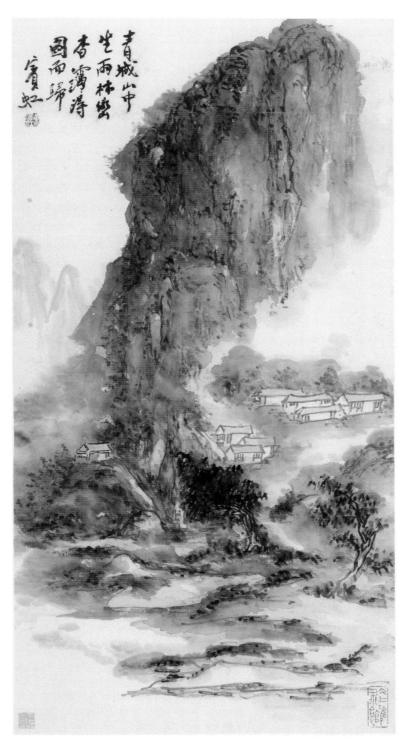

青城山中
坐雨林密
香霭浮
图雨归
宾虹

Fig. E.8. Huang Binhong, *Mount Qingcheng in Rain*, 1940s. Hanging scroll, ink and colors on paper, 86.5 × 44.5 cm. Zhejiang Provincial Museum, Hangzhou. Photo: Zhejiang Provincial Museum.

decisive element in shaping perceptions of the landscape. In 1939 the China Travel Service published a photobook titled *Scenic Beauties in Southwest China*, which mapped out the landscape of the heretofore remote southwest as a series of representative scenic sites on a par with those of the southeast, which were no longer safely accessible. The book's Chinese title, *Xinan lansheng*, clearly refers to *In Search of the Southeast* (*Dongnan lansheng*), but apart from that the two books do not have much in common. In its purpose and layout, the later book resembles the 1934 *Liangyou* publication *China As She Is: A Comprehensive Album*, although it is much smaller in size. Like *Liangyou*'s album, *Scenic Beauties in Southwest China* is bilingual. Besides the brief captions for the photographs, the book's only texts are the preface and brief introductions to each province. In the English version of the preface, the general manager of China Travel Service, Pan Enlin, set out the thematic and ideological scope of the publication:

> The history of the Chinese people is turning an important page with the stupendous westward march which has been taking place since the beginning of the Sino-Japanese hostilities. For two years, as never before, the population of coastal China have been migrating in large numbers to the vast plateau hinterland lying between the upper Yangtze and the valley of le Fleuve Rouge (the Red River). In those mountainous regions where life was comparatively undisturbed and conditions were very much the same as they had been centuries ago, there is now much hustle and bustle, and activities and prosperity are forcing themselves upon the untraveled highlands. Factories are springing up; universities and schools formerly situated in the coastal cities are transplanting themselves in the long-deserted seats of ancient learning and culture; new government offices, newspapers, broadcasting stations, banking and commercial institutions, travel facilities, modern homes and recreation houses are coming into existence. The land that for thousands of years was destined solely for political exiles is today the goal of a gigantic rush, where new cities are being born and old communities reassembled en bloc.[16]

The photographs in *Scenic Beauties* presented little-known territories that were representative of a timeless culture untouched by modernization, but which were also, at the same time, undergoing a fundamental and rapid development thanks to the efforts of the GMD government. Despite the hostilities that caused the westward migration of Nationalist China, the ensuing enterprise was to be

conveyed in a positive way that would render the hinterland attractive to both inner-Chinese migrants and tourists from abroad.

Lang Jingshan, who took all the photographs in the Sichuan chapter of *Scenic Beauties*, set about that task by relying on the aesthetics of pictorialism, with occasional tints of modernism when it came to portraying modern structures. But even the wartime capital of Chongqing, to which the first pages are devoted, is shown in sweeping views, from above and in one case from behind trees, that highlight the city's location by the river. Between the city views is one photograph of a fishing boat on a misty river, framed by reeds. Other motifs in the Sichuan chapter include temples, salt wells, noodle factories, the Three Gorges, ancient bridges, terraced fields, a panda bear, and a portrait of the president of the Republic, Lin Sen (1868–1943), in front of a hot spring. As Mia Liu has noted, many of Lang's images were initially made for purposes of reportage and were shown in exhibitions in Hong Kong and Shanghai before they were published in *Scenic Beauties in Southwest China*. A *Shenbao* report on the Shanghai exhibition shows that the photographs were reviewed as representations of an idealized, almost utopian counterpart to the wartime realities in "lone island" Shanghai—a reading at which *Scenic Beauties in Southwest China* aimed as well.[17] Beyond photojournalism and political propaganda, Lang Jingshan used these photographs to achieve his personal artistic agenda. After the end of the war, in 1948, he published a collection of his composite photographs under the title

Symphony in Black and White (*Jingshan jijin*).[18] Among the photos first published in *Scenic Beauties in Southwest China* and then reprinted in *Symphony in Black and White* were Lang's portrait of a panda (already freed in the darkroom from what was probably a zoo background and transferred into fluffy clouds for the 1939 *Scenic Beauties* version), and a tranquil image of the front of a temple (fig. E.9), which Lang placed facing the

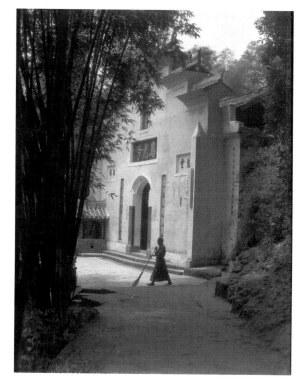

Fig. E.9. Lang Jingshan, *Ancient Temple of Wuyou*. Reproduced from Lang Jingshan, *Symphony in Black and White (Jingshan jijin)* (1948), 12. Courtesy of the Long Chin-san Art and Culture Development Association.

Fig. E.10. Lang Jingshan,
*The Co-operative Treasury
in Beibei*. Reproduced from
*Scenic Beauties in Southwest
China (Xinan lansheng*, ed.
China Travel Service), rev. ed.
(Shanghai, 1940), 33. Photo:
Staatsbibliothek zu Berlin–
Preußischer Kulturbesitz.

Guest-Greeting Pine. In a third photograph, the Co-operative Treasury building
in the town of Beibei, praised as "one of the new enterprises" in *Scenic Beauties
in Southwest China* (fig. E.10), was removed from its environment by the Yangzi
River, mirrored, and set floating on mist between a tree and a cliff (fig. E.11). By
editing his photographs to resemble ink painting, Lang Jingshan also defined
the Chinese aesthetic as timeless rather than realistic in its representations.
Prefaces to *Symphony in Black and White* were written by Zhang Daqian, Zheng
Wuchang, and Chen Wanli; Lang's composite photography and its new Chinese
landscape aesthetics were thus publicly endorsed by a prominent photographer
and two influential *guohua* painters.

The practice of sketching from nature that had been so central to *guohua*
practice since the early 1920s did not lead to a widespread depiction of war land-
scapes or explicit reflections on the situation in the circles of *guohua* artists, who
primarily identified themselves as landscape painters continuing and renewing
the classical traditions. A painting such as the 1939 *Chongqing after Bombing*
by Huang Junbi (1898–1991), which shows dark clouds of smoke rising from

Fig. E.11. Lang Jingshan, *Lofty Pavilion and Running Stream*. Reproduced from Lang Jingshan, *Symphony in Black and White (Jingshan jijin)* (1948), 19. Courtesy of the Long Chin-san Art and Culture Development Association.

burning houses, appears to be a rare exception.[19] It seems that while representatives of "reformed" *guohua*, such as the Lingnan School painter Gao Jianfu (1878–1951) and his student Guan Shanyue (1912–2000), addressed the horrors of war, as did caricaturists, woodcut artists, and oil painters, the painters studied in these chapters strove for continuity and, maybe in the same vein as in their prewar debates on the future of Chinese painting, the cultural survival of their medium.

After the founding of the People's Republic of China and the ensuing Communist Party control over artistic production, sketching from nature and portraying "real mountains and real waters" once again became legitimations for continuing the practice of landscape painting in ink. The new government also sponsored the project of national reconstruction and economic development through large-scale infrastructure projects such as railroad construction and the building of bridges and dams. The aesthetic strategies of landscape representation, however, changed significantly. Now the massive transformations that industrial development inflicted on the mountains, rivers, and

Fig. E.12. Unidentified photographer, *Lotus Peak Enshrouded in Clouds*. Reproduced from *Mount Huang* (*Huangshan*, ed. Anhui huabao she) (Hefei, 1959), 33. Guangzhou Academy of Arts Library. Photo by the author.

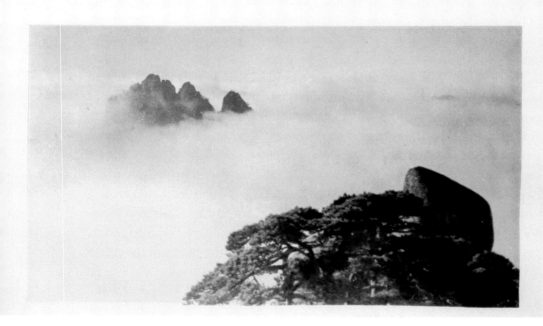

atmosphere were foregrounded as the achievements of socialism. Traditional modes and techniques of landscape painting often stood in an uneasy tension with the pictorial signifiers of the modernizing state.[20] A notable exception to the industrial aesthetics of the socialist landscape is Mount Huang, one of a few motifs that could be painted or photographed without explicit references to production and development, and it was by far the most frequently pictured. The pictorial formula of clouds, rocks, and pines in black and white that evoked the aesthetics of splashed ink developed during the 1930s continued to be explored after 1949, along with the compositional schema of a pine tree in the foreground against rocky cliffs. And like Lang Jingshan's image *Majestic Solitude*, which appeared on the cover of *Flying Eagle* for National Day in 1936 (see fig. 5.19), Huangshan photographs were used to celebrate the tenth anniversary of the People's Republic in 1959, in a finely printed photobook plainly titled *Mount Huang (Huangshan)*. A series of four photographs that show Lotus Peak rising out of the Sea of Clouds (fig. E.12) employs the aesthetic of dark rock formations and white whiffs of clouds in a manner that echoes Xu Muru's and Lang Jingshan's explorations of 1934 (see figs. 5.11 and 5.14 right). The accompanying caption comments on the series in a very technical fashion, while evoking the established trope of Mount Huang as an "exceptional view": "These four photographs were taken as a sequence within a few minutes, from the summit of Heavenly Capital Peak. They show the myriad transformations of the Sea of Clouds of Mount Huang within the glimpse of a moment."[21] The photographers depicting Mount Huang to celebrate the birth of the socialist nation employed the same visual strategies the Republican artists and politicians did in their endeavor to create a national landscape for nationalist China. That the camera captured the series of four images within a very short time span again serves to ground the pictorialist strategies in a technically defined reality. And as the range of motifs for landscape imagery narrowed down to sites of socialist production or national representation, Mount Huang was literally, and finally, singled out as the standard mountain of China.

NOTES

Introduction

1 Huang Binhong, *Binhong jiyou huace*, unpaginated.

2 The writings discussed in this book use the term *guohua* as an abbreviation of *Zhongguo-hua* ("Chinese painting"); another possible origin of the term is *guocuihua* ("national essence painting"); see Kao, "Foreword," in *Twentieth-Century Chinese Painting*, xxi; Andrews, *Painters and Politics*, 50.

3 Cheng-hua Wang, "Rediscovering Song Painting for the Nation"; David Der-wei Wang, "In the Name of the Real," 29–47; Wong, *The Other Kang Youwei*, 85–87; Lawrence Wu, "Kang Youwei and the Westernisation."

4 Kao, "Reforms in Education," 147–52. According to Jane Zheng, the Shanghai Art School was the first art school to "formulate a curriculum especially for the teaching of literati painting" (in 1924), while the older Chinese painting department at the Beijing Art School had "a curriculum for *guohua* that had a high proportion of European academic training courses." Jane Zheng, *Modernization of Chinese Art*, 180. Zheng also states that *guohua* was not taught in primary and secondary schools before 1935; ibid., 175.

5 An important early piece that deconstructs the boundaries between traditionalism, modernism, and "reformed" *guohua* is Eugene Wang, "Sketch Conceptualism as Modernist Contingency." The relationship between Chinese artists and art historians and their Japanese counterparts, and its implications for modern *guohua*, were first explored in Wong, *Parting the Mists*. See also Maeda, "Rediscovering China in Japan"; Andrews and Shen, "Japanese Impact on the Chinese Art World," 25–28; and the essays assembled in Fogel, *Role of Japan*. Zhang Daqian's (1899–1983) engagement with Tibetan painting and its techniques has been discussed in Fraser, "Sha bo tshe ring, Zhang Daqian and Sino-Tibetan Cultural Exchange." On engagement with Western painting in the seemingly conservative *guohua* circles in early Republican-period Beijing, see Hang, "Wenhe de jianjin zhi lu." See also Clunas, *Chinese Painting and Its Audiences* 175–85.

6 Gu, *Chinese Ways of Seeing*; Shih, "Mingshan qisheng zhi lü."

7 For detailed discussions of the special issue, which was published as two issues of the monthly (numbers 4 and 5), see also Li Weiming, "Jindai yujing zhong de 'shanshui' yu

'fengjing'"; for a more general discussion of the journal, see Chan, *Making of a Modern Art World*, 120–39.

8 On travel-related paintings in Ming and Qing China, see Cahill, "Huang Shan Paintings"; Li-tsui Flora Fu, *Framing Famous Mountains*; Ganza, "The Artist as Traveler"; Kindall, *Geo-Narratives of a Filial Son*; Kindall, "Visual Experience in Late Ming Suzhou"; Liscomb, *Learning from Mount Hua*.

9 Dongnan jiaotong zhoulanhui xuanchuanzu, *Dongnan lansheng*.

10 On the political background of the Southeastern Infrastructure Tour and its influence on the development of tourism, see Chan, "In Search of the Southeast."

11 For a translation of two such reports, see Chan, *Making of a Modern Art World*, 7–8. On *Shenbao*, see Tsai, *Reading* Shenbao.

12 Roberts, "Dark Side of the Mountain," 142–53; Wang Zhongxiu, *Huang Binhong nianpu*, 194–201 and 361.

13 For a study of early inscriptions on rock faces (*moya*), see Harrist, *Landscape of Words*.

14 Kindall, *Geo-Narratives of a Filial Son*, 4.

15 Strassberg, *Inscribed Landscapes*, 6.

16 Mitchell, "Introduction," in *Landscape and Power*, 2.

17 See, for example, Cahill, "Huang Shan Paintings," 250–53, for an outline of how a layer of place-naming and textual records became attached to the landscape of Mount Huang and gradually superseded the "firsthand observation of untouched nature" (252). For a detailed critical discussion of different theories of place and space and their applicability to Chinese conceptions of landscape and place, see Stuer, "Dimensions of Place," 18–35 and 59–73.

18 For related studies, see Eugene Wang, "Perceptions of Change"; Noth, "Mountains and a Lot of Water."

19 DeLue, "Elusive Landscapes and Shifting Grounds"; Mitchell, *Landscape and Power*, x.

20 On *Liangyou*, see Pickowicz, Shen, and Zhang, "Introduction," in *Liangyou*; on *Arts & Life*, see Waara, "Arts and Life."

21 *Xiesheng* is a "return graphic loan," i.e., a word adapted in Japanese from classical Chinese and reintroduced to China with a modern meaning. Lydia Liu, citing Gao Mingkai and Liu Zhengtan, states that these kinds of loanwords are deceptively transparent (Liu's words), because they are "easily mistaken as direct derivatives from classical Chinese." (Lydia Liu, *Translingual Practice*, 33.) In Song dynasty usage, e.g., in the *Xuanhe huapu*, the term *xiesheng* denoted depictions of flowers, birds, and insects; thus it denominated a genre rather than a particular practice of representation. It acquired the meaning "sketching from life" in Japanese art discourse during the nineteenth century; Gu, *Chinese Ways of Seeing*, 2–3. On the Japanese discourse, see Satō, *Modern Japanese Art*, 231–54. On the formation of the term *sheying*, see Gu, "What's in a Name?" 120.

22 Bachmann-Medick, *Cultural Turns*, 246.

23 Lydia Liu, *Translingual Practice*, 26.

24 Kristeva, "Bakhtin, le mot, le dialogue et le roman."

25 Rajewski, *Intermedialität*, 15–17.

26 Ibid., 62.

27 Meyer et al., "Vorwort," *In Transmedialität*, 10.

28 Ibid., 8.

29 Bolter and Grusin, *Remediation*, 45.

30 Ibid., 55.

31 Rajewski, *Intermedialität*, 70–71.

32 Mersmann, "Global Routes," 409.

33 Ortiz, *Contrapunteo cubano*; Rama, *Transculturación narrativa*; Pratt, *Imperial Eyes*.

34 Pratt, *Imperial Eyes*, 7.

35 Bachmann et al., "Introduction," in *Art/Histories in Transcultural Dynamics*, 15.

36 Mitter, "Decentering Modernism," 542.

37 Hobsbawm, "Introduction: Inventing Traditions," 4–5.

38 Besides the works already mentioned, the study of modern Chinese art has been most profoundly shaped by the work of Julia F. Andrews and Kuiyi Shen. Representative studies include Andrews and Shen, *A Century in Crisis*, and their articles, "Traditionalism as a Modern Stance" and "The Traditionalist Response to Modernity." On the close connections between ink painters, oil painters, and photographers and their collaborations in associations, exhibitions, and publications, see Andrews, "Heavenly Horse Society."

39 Kirby, "Engineering China," 137. On the work of the state institutions, see Strauss, *Strong Institutions in Weak Polities*.

40 Musgrove, *Contested Capital*.

41 Sun Yat-sen, *International Development of China*, cited in Kirby, "Engineering China," 138; see also Köll, *Railroads*, 3.

42 Dirlik, "Ideological Foundations"; Eastman, *Abortive Revolution*, 66–70. Examples of recent work on the movement include Ferlanti, "New Life Movement in Jiangxi"; Wennan Liu, "Redefining the Moral and Legal Roles."

43 Chan, "In Search of the Southeast," 209–10.

44 Ferlanti, "New Life Movement in Jiangxi," 967.

45 Ibid., 994–99.

46 For an introduction on the Nanjing decade, see Zarrow, *China in War and Revolution*, 248–70; for a stronger focus on military aspects, see van de Ven, *War and Nationalism in China*, 131–69.

47 Mackerras, *China in Transformation*, 48.

48 William Schaefer makes a similar observation about 1934 regarding the modernist literature and image culture he studies, in Schaefer, *Shadow Modernism*, 17.

49 Yu-jen Liu, "Second Only to the Original"; Yu-jen Liu, "Publishing Chinese Art"; Chenghua Wang, "New Printing Technology"; Johnson, "'(Un)richtige Aufnahme.'" See also Wue, *Art Worlds*, for a related study on painters' engagement with different pictorial formats and their involvement with the mediasphere in an earlier period.

50 For a chronology of He Tianjian's life, see Shanghai meishuguan, *Diancang mingjia jingpinxilie: He Tianjian*, unpaginated.

51 He Tianjian, *Xue hua shanshui guocheng zishu*, 3.

52 Gu, *Chinese Ways of Seeing*, 104–12; Chan, *Making of a Modern Art World*.

53 Chan, *Making of a Modern Art World*; Gu, *Chinese Ways of Seeing*, 85–94.

54 Yu Jianhua, *Zhongguo gudai hualun leibian*; Yu Jianhua, *Zhongguo meishujia renming cidian*.

55 On Yu's career and personal networks before 1937, see Zhou Jiyin and Wang Zongying, *Yu Jianhua*, 16–44.

56 Xie Haiyan, "Qianyan," unpaginated.

57 For the dissertations on Huang, see Roberts, "Dark Side of the Mountain"; Kotewall, "Huang Binhong"; and Hertel, "Inner Workings of Brush-and-Ink." The two monographs are Roberts, *Friendship in Art*; and Kuo, *Transforming Traditions*. Among the many articles and essays on Huang's work, the studies by Hong Zaixin in English and Chinese deserve particular attention; see, e.g., his "'Excellent Painter of the Chinese People.'"

58 Roberts, "Dark Side of the Mountain," 66.

Chapter 1

1 Li Weiming, "Jindai yujing zhong de 'shanshui' yu 'fengjing,'" 107–8. Numbers 9/10 and 11/12 of *National Painting Monthly* appeared as double issues.

2 Bianzhe, "Fakanyu."

3 "Zhongguo huahui kai chengli dahui." Julia F. Andrews and Kuiyi Shen give 1931 as the year when the association was established; Andrews and Shen, "Traditionalist Response to Modernity," 80. This follows the information given in Wang Yichang, *Meishu nianjian*, 8, and subsequently in Xu Zhihao, *Zhongguo meishu shetuan manlu*, 118–19. I follow Pedith Chan in taking 1932 as the year it was established, based on the fact that the inaugural meeting took place in June 1932; Chan, *Making of a Modern Art World*, 55–56.

4 On the Bee Society, see Chan, *Making of a Modern Art World*, 42–49; Wang Yichang, *Meishu nianjian*, 10–11. On the activities and organizational structure of the Chinese Painting Society, see Andrews and Shen, *Art of Modern China*, 98–103; Chan, *Making of a Modern Art World*, 49–64.

5 Lu, "Guohuajia jiying lianhe." For a full translation into English, see Andrews and Shen, "Traditionalist Response to Modernity," 83–85. For a detailed discussion of the mission statement, see Chan, *Making of a Modern Art World*, 50–51.

6 Lu, "Guohuajia jiying lianhe"; translation from Andrews and Shen, "Traditionalist Response to Modernity," 85.

7 "Zhongguo huahui xianren weiyuan."

8 In an article in the last issue, in which he summarized his work for *National Painting Monthly*, He Tianjian claimed that Xie Haiyan had been hired for copyediting and was given the title of editor in chief as a favor. He Tianjian, "Guowang zhi banban," 238. See also Li Weiming, "Jindai yujing zhong de 'shanshui' yu 'fengjing,'" 107. Xie announced his resignation to the readers in "Xie Haiyan jinyao qishi." Zheng Wuchang later suggested that Xie Haiyan resigned because of a disagreement with He Tianjian; Zheng Wuchang, "Guohua yuekan yu Guohua."

9 He Tianjian, "Zhongguo huahui lilun."

10 Similar goals stated in the association's revised bylaws of 1947 also included establishing an art museum and building member dormitories; Wang Yichang, *Meishu nianjian*, 9. It appears, however, that none of these goals was realized.

11 On Yan Fu's *Tianyan lun*, see Schwartz, *In Search of Wealth and Power*, 90–112; Dikötter, *Discourse of Race*, 105–6. For a later, critical discussion of Yan Fu's translation and the use of the terms *chuneng* and *xiaoshi* by the renowned scientist Ren Hongjuan (1886–1961), see Ren, "Kexue fanyi wenti," 178.

12 For a discussion of evolutionist thinking in the late Qing period, see Dikötter, *Discourse of Race*, 98–107. For early twentieth-century evolutionist thought, see, Xu Jilin, "Social Darwinism in Modern China."

13 Zhengfeng, "Jinri huafeng zhi yaomo."

14 Kang, "Wanmu caotang"; see also Cheng-hua Wang, "Rediscovering Song Painting for the Nation," 227–28; Lawrence Wu, "Kang Youwei and Westernisation," 47–48; Dal Lago, "Realism as a Tool."

15 Cheng-hua Wang, "Rediscovering Song Painting for the Nation," 225. The lectures that Wang refers to were published in *Beijing Daxue rikan* and *Huixue zazhi*; see "Huafa yanjiuhui jishi di shiwu"; "Huafa yanjiuhui jishi di shijiu."

16 Chen Duxiu, "Meishu geming." See Cheng-hua Wang, "Rediscovering Song Painting for the Nation," 228; David Wang, "In the Name of the Real," 40.

17 Hu Peiheng, "Zhongguo shanshuihua xiesheng de wenti."

18 Cheng-hua Wang, "Rediscovering Song Painting for the Nation," 229–39.

19 Zheng Wuchang, "Xiandai Zhongguo huajia." For his work as an art historian, see Zheng Wuchang, *Zhongguo huaxue quanshi*; Zheng Wuchang, *Zhongguo meishushi*; cf. Andrews and Shen, "Japanese Impact," 25–28; Guo, "Writing Chinese Art History," 3.

20 Cheng-hua Wang, "Rediscovering Song Painting for the Nation," 239. On the reception of Ōmura Seigai's work in China, see Andrews and Shen, "Japanese Impact," 12–15; Krischer, "Ōmura Seigai's Conception," 282–85.

21 He Tianjian, "Zhongguo shanshuihua zai huake zhong."

22 He fully reproduces Zong Bing's (374–443) *Preface on Landscape Painting* (*Hua shanshui xu*) (He Tianjian, "Zhongguo shanshuihua zai huake zhong," 53) and Shitao's chapter "Brush and Ink" from his *Discourses on Painting by the Monk Bittermelon* (*Kugua heshang huayulu*) (He, 55). A long quotation from Guo Ruoxu's *Record of My Experiences in Painting* (*Tuhua jianwen zhi*, 1074) is also included (He, 53).

23 The translation of the First Law cited here is from Acker, *Some T'ang and Pre-T'ang Texts*, 1:4. For a summary of the various interpretations of the Six Laws in historical texts on painting and by modern scholars, see Bush and Shih, *Early Chinese Texts on Painting*, 10–16.

24 He Tianjian, "Zhongguo shanshuihua zai huake zhong," 54. For the original quotation from the *Yijing*, see *Zhou Yi*, 77. My translation is based on Wilhelm, *I Ching*, 1:347.

25 He Tianjian, "Zhongguo shanshuihua zai huake zhong," 54.

26 See Bush, *Chinese Literati on Painting*, 32.

27 He Tianjian, "Zhongguo shanshuihua zai huake zhong," 54.

28 Ibid., 55–56. He actually inserts the term "natural object" into Dong Qichang's famous dictum, "With regard to the exceptionality of scenery, painting cannot compare with landscape (the natural object), but with regard to the marvels of brush and ink, landscape cannot compare with painting." See Dong Qichang, "Huachanshi lun hua," 724. To make his point about the transformative qualities of brushwork, He quotes in full Shitao's chapter on brush and ink from his *Discourses on Painting*.

29 He Tianjian, "Zhongguo shanshuihua zai huake zhong," 52–53.

30 Zheng Wuchang, "Zhongxi shanshuihua sixiang zhuankan zhanwang"; [Xie] Haiyan, "Zhongxi shanshuihua sixiang zhuanhao kanqian tan."

31 Li Weiming, "Jindai yujing zhong de 'shanshui' yu 'fengjing,'" 116.

32 Sun Fuxi, "Xiyanghua zhong de fengjing," 87. Li Weiming has also remarked on Japan's omission from the special issue; Li Weiming, "Jindai yujing zhong de 'shanshui' yu 'fengjing,'" 113 and 115.

33 Xie Haiyan, "Zhongguo shanshuihua sixiang de yuanyuan."

34 The initial plan was to publish every fourth issue on a special topic. See [Xie] Haiyan, "Zhongxi shanshuihua sixiang zhuanhao kanqian tan."

35 Ibid.

36 Zheng Wuchang, "Zhongxi shanshuihua sixiang zhuankan zhanwang."

37 Wang Xinming et al., "Zhongguo benwei de wenhua." On the manifesto, see Q. Edward Wang, *Inventing China through History*, 152–56; Wang translates the title as "Declaration of the Construction of a China-Based Culture." He Bingsong's name was the second on the list of signers, but according to Edward Wang, he was the key author and was perceived as such by the public (ibid., 153). This corresponds to Zheng Wuchang's reference to him as the main author of the manifesto.

38 Wang Xinming et al., "Zhongguo benwei de wenhua," 81.

39 Ibid., 83.

40 Zheng Wuchang, "Zhongxi shanshuihua sixiang zhuankan zhanwang."

41 Chan, *Making of a Modern Art World*, 49.

42 Mifeng huashe, *Mifeng huashe sheyoulu*, unpaginated; the translation is from Chan, *Making of a Modern Art World*, 44.

43 Zheng Wuchang, "Zhongxi shanshuihua sixiang zhuankan zhanwang."

44 Li Baoquan, "Zhongxi shanshuihua de gudianzhuyi yu ziranzhuyi."

45 For a discussion of this terminological question, see Li Weiming "Jindai yujing zhong de 'shanshui' yu 'fengjing,'" 116–17.

46 Li Baoquan, "Zhongxi shanshuihua de gudianzhuyi yu ziranzhuyi," 57.

47 On Dong Qichang's theory of the Southern and Northern Schools, see Wai-kam Ho, "Tung Ch'i-ch'ang's New Orthodoxy"; Cahill, "Tung Ch'i-ch'ang's 'Southern and Northern Schools'"; Fong, "Tung Ch'i-ch'ang and Artistic Renewal."

48 Li Baoquan, "Zhongxi shanshuihua de gudianzhuyi yu ziranzhuyi," 58.

49 Wong, *Parting the Mists*, 54–76, esp. 63–68 on Chen Shizeng. Chen Shizeng, "Wenrenhua de jiazhi" (in vernacular Chinese); Chen Shizeng, *Zhongguo wenrenhua zhi yanjiu* (in classical Chinese). For a discussion of this text and Chen's cooperation with the Japanese art historian Ōmura Seigai, see Andrews and Shen, "Japanese Impact," 9–13.

50 Lydia Liu, *Translingual Practice*, 40.

51 Ibid.

52 This perceived equivalence between literati painting modes and modern(ist) painting can also be found in more recent writings on Chinese painting, for example in Wen C. Fong's reading of *Twin Pines, Level Distance* (early 1300s) by Zhao Mengfu (1254–1322) along the lines of Clement Greenberg's definition of modernist painting as "art calling attention to art"; Fong, *Between Two Cultures*, 18. On comparisons of Yuan painting with modernist painting in American post–World War II art historiography, see also Vinograd, "De-Centering Yuan Painting," 198–99.

53 Ni Yide, "Xiyang shanshuihua jifa jiantao."

54 Ibid., 76.

55 Wilde's opening line, "The artist is the creator of beautiful things," comes closest to Ni Yide's statement; Wilde, *Picture of Dorian Gray*, 165. A Chinese translation of the Preface by Yu Dafu appeared in 1922 in the journal of the Creation Society (Chuangzao she); Wei'erte [Oscar Wilde], "Dulian Gelai de xuwen." On the reception of Oscar Wilde in China, see McDougall, *Fictional Authors, Imaginary Audiences*, 75–92.

56 Ni Yide, "Xiyang shanshuihua jifa jiantao," 76.

57 Ibid., 120.

58 Wong, *Parting the Mists*, see, e.g., 63.

59 Bianzhe, "Zhongxi shanshuihua sixiang zhuankan chatu."

60 The painting attributed to Guo Xi appears to be a Ming copy; on the *Preliminary Exhibition* in Shanghai from April 8 to May 5, 1935, see Guo, "New Categories, New History."

61 *Tō Sō Gen Min meigaten gō*; the editors of *Guohua yuekan* erroneously cite the title as *Tang Song Yuan Ming minghua ji*.

62 Bianzhe, "Zhongxi shanshuihua sixiang zhuankan chatu," 164.

63 *Tō Sō Gen Min meigaten gō*, 7.

64 *Tō Sō Gen Min meiga taikan*, vol. 1, no. 20.

65 Shimada Shūjirō identified an almost effaced Li Tang signature near the pine branches in the center of the painting; Shimada, "Kōtō-in shozō no sansuiga," 137. However, this signature is most likely a later addition and the attribution is a matter of debate; see, for example, Barnhart, "Li T'ang and the Kōtō-In Landscapes"; Cahill, "Imperial Painting Academy," 194.

66 Bianzhe, "Zhongxi shanshuihua sixiang zhuankan chatu," 163–64.

67 Guo, *Writing Chinese Art History*, esp. 29–31; Andrews and Shen, "Japanese Impact," 21–30.

68 Cf. Chan, *Making of a Modern Art World*, 93–95.

69 In her discussion of a reproduction of Gu Kaizhi's *Admonitions* scroll in *Guocui Xuebao* (*Journal of National Essence Studies*), Lisa Claypool sees the poor print quality as conferring "a symbolic power reinforcing the traditional elite," since it "requires the written testimony of the editors to establish its value and a scholarly education for its connoisseurial appreciation." Claypool, "Ways of Seeing the Nation," 73. While I do not agree with Claypool's specific reading that seems to suggest a deliberate occlusion of the image by the editors, I share her view on the importance of printing techniques of different qualities and the correspondence of the visual with the written discourse. For a study of the role of (high-quality) collotype reproductions in the discourse on national heritage preservation in the late Qing and early Republican periods, see Cheng-hua Wang, "New Printing Technology." For a comparison of the different printing techniques employed for (high-quality) art reproductions in early-twentieth-century publications, see Yu-jen Liu, "Second Only to the Original," 77–81.

70 A similar observation has been made by Huaiyin Li for modern Chinese historiography: "The historians who wrote about modern China, ranging from the first generation that enthused about the making of 'New History' under the influence of social Darwinism in the 1920s to the latest generation[,] . . . all linked their studies of China's recent past with the stated purpose of national salvation and strengthening[,] or the explicit political agendas of specific groups. . . . As active participants in a revolutionary or reform movement, they used their interpretations of the past to give the movement a teleological meaning, to shape its guideline and direction, and to inspire future actions of its participants." Huaiyin Li, *Reinventing Modern China*, 6.

71 Huang Binhong, Yu Jianhua, Zheng Wuchang, Ding Nianxian, and He Tianjian served as editors and (with the exception of Ding) regular contributors; Xia Jingguan, Wang Yachen, Shi Chongpeng, and Hu Zhongying had authored articles; Xie Gongzhan, Chen Xiaocui, Dai Yunqi, and Sun Xueni had contributed poetry.

72 Zhongguo huahui bianyibu, *Zhongguo xiandai minghua huikan*.

73 He Tianjian, "Xieyan," unpaginated.

74 Ibid.

75 On the Chinese Women's Calligraphy and Painting Society and for brief biographical accounts of these artists, see Andrews and Shen, "Traditionalism as a Modern Stance."

76 Tang Jihui, "Jiushi yuese."

77 Hu Zhongying, "Zhongguo shanshuihua jianshangjia"; Hu Zhongying, "Xin yu jiu."

78 The painting was sold by Duo Yun Xuan Auctions, in its Modern Chinese Paintings auction on December 14, 2011, lot no. 37. Artron.net, accessed January 20, 2016, http://auction.artron.net/paimai-art5012830037.

79 Brigitta Ann Lee, "Imitation, Remembrance and the Formation of the Poetic Past," 119, n. 212.

80 For a collection of poems on the theme of gathering water caltrops, see the entry on the water caltrop in the plant section of *Gujin tushu jicheng*: "Caomu dian: Ling bu: Yiwen," *juan* 99.

81 See, for example, Luo Ping (1733–99), "After Zhao Mengfu's *Gathering Water Caltrops*," a leaf from the album *Landscapes in the Manner of Old Masters*, Princeton University Art Museum, Princeton, NJ, which in composition is similar to He's painting.

82 According to the Song dynasty painter Han Zhuo (fl. ca. 1095–ca. 1125), gathering water caltrops was one of the subjects suitable for autumn scenes; Han Zhuo, *Shanshui chunquan ji*, cited in Bush and Shih, *Early Chinese Texts*, 155.

83 Mifeng huashe, *Mifeng huaji*; Mifeng huashe, *Dangdai mingren huahai*.

84 On Zhonghua Books, see Reed, *Gutenberg in Shanghai*, 225–40. Zheng Wuchang first joined the art division as an editor in 1922; Shen, "Xian jun yi dong sheng hua bi," 7.

85 The National Library of China holds editions from 1931 and 1936; worldcat.org lists a 1933 edition as the third edition, and the 1936 edition as the fifth edition of the book. https://www.worldcat.org/search?qt=worldcat_org_all&q=當代名人畫海, accessed September 17, 2017.

86 Yu-jen Liu, "Second Only to the Original," 78; Cheng-hua Wang, "New Printing Technology," 273 and 282–83. For the history and a detailed description of the collotype printing process, see "Collotype" in Stulik and Kaplan, *Atlas*, 4–7, http://hdl.handle.net/10020/gci_pubs/atlas_analytical, accessed January 18, 2016.

87 Kapr, *Buchgestaltung*, 181.

88 Of those six women, four are also represented in *Collection of Famous Modern Chinese Paintings*: Li Qiujun, Wu Qingxia (1910–2008), Yang Xuejiu, and Zhang Hongwei (1878 or 1879–1970).

89 He Tianjian, "Daobie yu zengyan."

90 He Tianjian, "Huajia yingshou zhi xintiao."

91 Zheng Wuchang, "*Guohua yuekan* yu *Guohua*."

Chapter 2

1 [Xie] Haiyan, "Zhongxi shanshuihua sixiang zhuanhao kanqian tan."

2 He Tianjian, "Zhongguo shanshuihua jinri zhi bingtai."

3 Ibid., 100–101.

4 Ibid., 102.

5 Ibid.

6 Gu, *Chinese Ways of Seeing*, 21–28.

7 He Tianjian, *Xue hua shanshui guocheng zishu*. The preface is dated March 31, 1960.

8 Shitao employed this phrase in *Discourses on Painting by the Monk Bittermelon* (Daoji [Shitao], *Kugua heshang huayulu*, 153), as the title of a painting now in the collection of the Palace Museum Beijing and in a seal. It was frequently cited by twentieth-century artists as a historical expression for sketching from nature.

9 He Tianjian, *Xue hua shanshui guocheng zishu*, 5–7.

10 Ibid., 9–10. On this episode see also Gu, *Chinese Ways of Seeing*, 104–5.

11 Gu, *Chinese Ways of Seeing*, 108–9.

12 He Tianjian, *Xue hua shanshui guocheng zishu*, 50–72.

13 Ibid., 50.

14 Literally, "to take Creation as one's master." This phrase derives from Zhang Yanyuan, *Lidai minghua ji (Record of Famous Paintings of All Times)*, 857, who quotes the painter Zhang Zao as stating, in the translation by William Acker: "Without, I have taken Creation as my master; Within, I have found the well-spring of the mind" (*wai shi zaohua, zhong de xinyuan*); Acker, *Some T'ang and Pre-T'ang Texts*, 2.1:283 (English translation) and 2.2:121 (Chinese text).

15 He Tianjian, "Zhedong shanshui." I discuss this essay later in the chapter.

16 He Tianjian, *Xue hua shanshui guocheng zishu*, 77–78.

17 Ibid., 16.

18 It is unclear whether this painting of the Stone Gate is actually the painting He wrote about in his autobiography; he mentions it in the subchapter "From Age Seventeen to Age Twenty-Seven," which corresponds to 1907–17. The painting of 1929 discussed here, however, corresponds to the painting method ("Wang Hui's interpretation of Li Tang") proclaimed in *Learning to Paint Landscapes*.

19 See also Gu, *Chinese Ways of Seeing*, 108–12.

20 He Tianjian, "Shimen tansheng ji," 3.

21 According to his essay "Exploring the Scenery of Stone Gate," He visited the place on his own but met an old man accompanied by a young boy. The old man told him the ancient myth whence the place gained its name (He Tianjian, "Shimen tansheng ji," 4). If we assume that the painting and essay refer to the same visit, the man standing in the center of the group can be identified as the old man talking to He, who is standing to the left.

22 On the impact of photographic view-taking and outdoor sketching on Republican landscape painting, see Gu, *Chinese Ways of Seeing*, 43–47; Shih, "Mingshan qisheng zhi lü," 25–37.

23 Daoji [Shitao], "Kugua heshang huayulu," 149; translation in Hay, *Shitao*, 229.

24 Wai-kam Ho, *Century of Tung Ch'i-ch'ang*, 2:184. On Zhou Xiangyun's collection and how it was successively purchased by the Shanghai Museum, see Zheng Zhong, "Hongdingfang laoban."

25 For a reproduction of the possible source painting attributed to Dong Yuan, see Wai-kam Ho, *Century of Tung Ch'i-ch'ang*, 1:100, fig. 46.

26 He Tianjian, *Xue hua shanshui guocheng zishu*, 16.

27 Ibid., 20–21.

28 Ibid., 30.

29 This nationalization of historical painting styles is comparable to the conception of *nihonga* in late nineteenth-century Japan; see Foxwell, *Making Modern Japanese-Style Painting*, 2–3; Weston, *Japanese Painting and National Identity*, 3.

30 Daoji [Shitao], "Kugua heshang huayulu," 147; translation, with minor revisions, in Hay, *Shitao*, 274.

31 Daoji [Shitao], "Kugua heshang huayulu," 148; translation in Strassberg, *Enlightening Remarks*, 64. Other sources for He's inscriptions are the second and seventeenth chapters, Daoji [Shitao], "Kugua heshang huayulu," 148 and 158; see Strassberg, *Enlightening Remarks*, 63: "Ink tonalities are inspired by Nature. . . . Brushstrokes are from the hand of man. . . . The ancient masters always employed such methods, for to have lacked them would have deprived the world of guidelines. But the [One Brushstroke] does not guide by rejecting guidelines, nor does it guide by constituting a particular stylistic method. True method is without inhibition just as inhibition destroys true method. . . . When method can be separated from inhibition, then the activity of the Creative and the Receptive forces can be grasped. The Dao of painting will shine forth." And "Heaven can provide man with methods, but it cannot teach him artistic achievement. It can provide him with the elements of painting, but it cannot teach him how to transform them. . . . Heaven provides these things to man because man is capable of receiving them. . . . Thus, through the ages, painting and calligraphy have been rooted in Heaven while attaining completion in man" (ibid., 86–87). In my translation of He Tianjian's inscription I have rendered *tian*, given as "Heaven" by Strassberg, as "nature."

32 *Tō Sō Gen Min meigaten gō*, 62.

33 He Tianjian, "Zhongguo shanshuihua zai huake zhong," 55.

34 For a study of the iconography of the donkey rider, see Sturman, "Donkey Rider as Icon." In He's painting, the donkey riders can be understood as references to Song painting in general. Besides this reference, they are generic figures that guide the viewer through the landscape, or they serve as personifications of the artist himself.

35 Daoji [Shitao], "Kugua heshang huayulu," 147; translation in Hay, *Shitao*, 274.

36 Hay, *Shitao*, 274.

37 Daoji [Shitao], "Kugua heshang huayulu," 152–53; translation in Hay, *Shitao*, 276.

38 Burkus-Chasson, "Clouds and Mists," 184.

39 He Tianjian, "Zhongguo shanshuihua zai huake zhong," 54.

40 Ni Yide, "Xiyang shanshuihua jifa jiantao," 76.

41 He Tianjian uses the term "genius" (*tiancai*) once in his essay on landscape painting in the *National Painting Monthly* special issue, when he glosses Wang Wei's term "wonderful realization" (*miaowu*) as depending on genius; He Tianjian, "Zhongguo shanshuihua zai huake zhong," 54.

42 For a study of painters' advertising in nineteenth-century Shanghai, see Wue, *Art Worlds*, 71–107.

43 *He Tianjian huaji*, pl. 13. The painting was sold at auction in 2004; Jinghua Art Auctions, Shanghai, Spring Auction: Shanghai School Painting and Calligraphy, April 15, 2004, lot no. 60; Artron.net, http://auction.artron.net/paimai-art25760060, accessed February 17, 2016.

44 The forgery, which bears a date corresponding to 1942, was auctioned twice, in 2001 and 2003; Zhonghongxin International Auctions, 2001 Autumn Auction: Chinese Painting and Calligraphy, December 7, 2001, lot no. 162, http://auction.artron.net/paimai-art06820162/, accessed February 17, 2016; Beijing Huachen Auctions, 2003 Spring Auction: Modern Chinese Painting and Calligraphy, July 11, 2003, lot no. 443, http://auction.artron.net/paimai-art21020183/, accessed February 17, 2016.

45 On the poetic theme of "contemplating the past at Jinling (Nanjing)" (*Jinling huaigu*), see Owen, "Place." On the poetic genre of the autumn lament (*beiqiu*), see Kubin, *Der durchsichtige Berg*, 100–102.

46 He Tianjian, "Zhedong shanshui."

47 See, for example, Claire Roberts's discussion of Huang Yanpei's photograph of the terrace taken in 1914; Roberts, *Photography and China*, 62–63.

48 Dongnan jiaotong zhoulanhui xuanchuanzu, *Dongnan lansheng*, "Zhe-Gan tielu Hang-Yu duan," 31.

49 He Tianjian, "Zhedong shanshui," 5.

50 Ibid., 3–4. For a discussion of He's essay, see also Gu, *Chinese Ways of Seeing*, 105–7.

51 "Zeng Shirong," www.huaxia.com, accessed October 7, 2015, http://search.huaxia.com /s.jsp?iDocId=501088.

52 Shih, "Mingshan qisheng zhi lü," 25–37.

53 Gu, "Scientizing Vision in China," 124.

54 Dongnan jiaotong zhoulanhui xuanchuanzu, *Dongnan lansheng*, "Zhe-Gan tielu Hang-Yu duan," 5.

55 Hangzhou tieluju, *Zhedong jingwu ji. Scenic Sites in Eastern Zhejiang* will be discussed in more detail in chapter 3.

56 Chen and Xu, *Zhongguo sheying yishushi*, 152–92; Kent, "Fine Art Photography in Republican-Period Shanghai," 854–66; Kent, "Early Twentieth-Century Art Photography in China"; Roberts, *Photography and China*, 82–84 and 89–90.

Chapter 3

1 On the political background of the NEC, see Zanasi, *Saving the Nation*, 93–99; on road construction under the auspices of the NEC, see Kirby, "Engineering China," 145–46; Osterhammel, "'Technical Co-operation,'" 674–75; on road construction in Zhejiang Province, see Miner, "Chekiang," 233–43.

2 "Jiang Weiyuanzhang ling choubei."

3 Kirby, "Engineering China," 145.

4 "Jiang Weiyuanzhang ling choubei"; "Jiaotong anquan yundong." Lu Danlin, in an article published in April 1934, included detailed tour routes that were basically identical to those published in *Dongnan lansheng* the following year; Lu, "Dongnan jiaotong zhoulanhui."

5 "Jiang ling Zeng Yangfu zhuban"; "Zhe Jianting choubei."

6 Cheng Yuqing, "Dongnan jiaotong zhoulanhui."

7 "Dongnan jiaotong zhoulanhui zanhuan juxing."

8 "Dongnan jiaotong zhoulanhui chou yin."

9 "Wu Zhihui deng you Tianmushan."

10 "Dongnan jiaotong zhoulanhui xingcheng." According to Wang Shuliang et al., *Zhongguo xiandai lüyou shi*, 120, the tours were organized by China Travel Service.

11 "Dongnan jiaotong zhoulanhui Huangshan sheying."

12 "Dongnan jiaotong zhoulanhui zuori zhanlan." Pedith Chan assumes *In Search of the Southeast* to be the catalogue for this exhibition; Chan, "In Search of the Southeast," 213. In my view, this does not give due credit to the book's importance as one of the activities initiated for the Southeastern Infrastructure Tour.

13 "Dongnan jiaotong zhoulanhui chou yin."

14 Zeng Yangfu, "Xu," unpaginated; Yih, "In Search of the Southeast," unpaginated.

15 Miner, "Chekiang," 243–53; on the implications of the railway for the rural areas of Eastern Zhejiang, see Ding, "Firedrake."

16 Ding, "Firedrake," 33; Miner, "Chekiang," 254–55. The bridge survived for only three months after its opening in September 1937; it was destroyed to prevent Japanese troops from crossing the Qiantang River in December and was not reopened until 1947. See also Xiao Hui, "Zeng Yangfu yu Qiantangjiang daqiao," 73.

17 Zeng Yangfu, "Jiansheting zhi zeren"; Zeng Yangfu, "Zhejiang jianshe shiye." Cf. Ding, "Firedrake," 33.

18 Zeng Yangfu, "Xu"; cf. Yih, "In Search of the Southeast."

19 On *The China Traveler*, see Dong, "Shanghai's *China Traveler*"; Wang Shuliang et al., *Zhongguo xiandai lüyou shi*, 127–39; Gross, "Flights of Fancy," 129–34.

20 Shen, "Scholar, Official, and Artist Ye Gongchuo."

21 The editors of *Modern Miscellany* on the editorial board of *In Search of the Southeast* were Ye Qianyu, Zhang Guangyu, Zhang Zhenyu, Shao Xunmei, and Lin Yutang; see Shen, "A Modern Showcase."

22 In their introduction to the book, the editors explain the relatively small number of paintings as resulting from the difficulty of reproducing paintings, especially large canvases and long handscrolls; "Liyan," in Dongnan jiaotong zhoulanhui xuanchuanzu, *Dongnan lansheng*, unpaginated.

23 [Jiang] Jiamei, "Kexue de youji."

24 Kirby, "Engineering China," 138; Miner, "Chekiang," 230–31; Dabringhaus, *Territorialer Nationalismus*, 195–96.

25 One important precursor publication was *Scenic Sites in Eastern Zhejiang*, published by the Hangzhou Railway Bureau (Hangzhou tieluju) in 1933; another text indicative of *In Search of the Southeast*'s close links to *The China Traveler* is a travel diary written on one of the tour routes (not included in the *Search*) by Zhao Shuyong, "Di yi xian youlan riji."

26 Yih, "In Search of the Southeast," unpaginated.

27 Zhang Qiyun, "Zhejiang sheng fengjing zongshuo."

28 Han Guanghui, "Zhang Qiyun"; Hausherr, *Entwicklung der chinesischen Geographie*, 29.

29 Zhang Qiyun, *Zhejiang sheng shidi jiyao*. A slightly longer version of his contribution to *In Search of the Southeast* had appeared a year earlier under a different title; Zhang Qiyun, "Zhe you jisheng."

30 See also Hausherr, *Entwicklung der chinesischen Geographie*, 45.

31 Hausherr, *Entwicklung der chinesischen Geographie*, 20–21. On Xu's writings see Ward, *Xu Xiake*.

32 Yu Dafu, "Tianmushan youji," 9 and 13. On Yu's travel writing, see Zhu Defa, *Zhongguo xiandai jiyou wenxue shi*, 165–80.

33 Yu Dafu, "Tianmushan youji," 10.

34 For a comprehensive discussion of the *youji* genre, see Eggert, *Vom Sinn des Reisens*.

35 Miner, "Chekiang," 244–49.

36 Ding, "Firedrake," 33 and 52 n. 11; Miner, "Chekiang," 248.

37 Ding, "Firedrake," 32.

38 Dongnan jiaotong zhoulanhui xuanchuanzu, *Dongnan lansheng*, "Zhe-Gan tielu Hang-Yu duan," 7.

39 Zhang Qiyun, "Zhejiang sheng fengjing zongshuo," 20; Zhang cites the second couplet of Tang's poem.

40 Strassberg, *Inscribed Landscapes*, 6.

41 Dongnan jiaotong zhoulanhui xuanchuanzu, *Dongnan lansheng*, "Zhe-Gan tielu Hang-Yu duan," 19 and 20–21.

42 He Tianjian, "Du Xianxialing."

43 Yu Dafu, "Xianxia jixian," in *Dongnan lansheng*, "Zhe-Gan tielu Hang-Yu duan."

44 Yu Dafu, "Zhedong jingwu jilüe," in Hangzhou tielu ju, *Zhedong jingwu ji*, 31–49.

45 Yu Dafu, "Xianxia jixian," *Shenbao*, December 13, 1933, 15, and December 14, 1933, 17. This version has been anthologized in collections of Yu's travel writings, beginning with *Scattered Traces of My Wooden Sandals* (*Jihen chuchu*) of 1934. See Yu, *Yu Dafu youji ji*, 49.

46 Yu Dafu, "Xianxia jixian," *Shenbao*, December 13, 1933, 15.

47 Yu Dafu, "Xianxia jixian (xu)," *Shenbao*, December 14, 1933, 17.

48 Wu Liande, *Zhonghua jingxiang*, 9.

49 Ibid., 105.

50 On the Fujian Rebellion, see Eastman, *Abortive Revolution*, 85–139.

51 Ibid., 132.

52 Yu Dafu, "Hang-Jiang xiaoli jicheng."

53 "Minfei gongxian Pucheng."

54 Yu Dafu, "Xianxia jixian," in *Dongnan lansheng*, "Zhe-Gan tielu Hang-Yu duan," 23.

55 Bianzhe, "Bianyan," unpaginated.

56 Yu Dafu, "Hang-Jiang xiaoli jicheng," in *Zhedong jingwu ji*, 1. This assessment agrees with similar statements by the editors; see Bianzhe, "Bianyan," unpaginated. The word "Baedeker" is romanized in the original.

57 Yu Dafu, "Hang-Jiang xiaoli jicheng," in *Yu Dafu zuopin jingdian*, 3:236–37.

58 Yu Dafu, "Zhedong jingwu jilüe," in *Yu Dafu zuopin jingdian*, 3:265.

59 *Dongnan lansheng*, "Zhe-Gan tielu Hang-Yu duan," 21, fig. 26.

60 Ji Guanghua, "Hang-Jiang tielu yanxian tansheng ji."

61 Zheng Suyan, "1949 nian qian Zhang Qiyun," 109.

62 Zhang Qiyun, "Zhe you jisheng," 153 and 154.

63 Hang-Jiang tielu gongchengju gongwuke, *Hang-Jiang tielu gongcheng jilüe*.

64 See Schivelbusch, *Railway Journey*, 54–59, on the difficulties encountered by railroad travelers "who were still accustomed to pre-industrial travel and thus not able to develop new modes of perception appropriate to the new form of transportation" (ibid., 58).

65 Lang and Chen were active in several photographic societies of the time. In 1919 Chen Wanli became one of the founders of the earliest, the Guangshe (Light Society) in Beijing; Chen and Xu, *Zhongguo sheying yishushi*, 204. Both Chen and Lang Jingshan were among the founders of the Zhonghua sheying xueshe (China Photographic Study Society), or Huashe, established 1928 in Shanghai (ibid., 217). On Chen Wanli, see ibid., 171–80. On Lang Jingshan, see ibid., 284–96; Xiao Yongsheng, *Huayi—Jijin—Lang Jingshan*; Chen Baozhen, "Wenrenhua de yanshen"; Mia Liu, "Allegorical Landscape"; and numerous catalogues of his work. See also Roberts, *Photography and China*, 80–84; Kent, "Early Twentieth-Century Art Photography in China," and Kent, "Fine Art Photography in Republican-Period Shanghai," 854–57.

66 Hausherr, *Entwicklung der chinesischen Geographie*, 30.

67 Yu Dafu, "Bingchuan jixiu," in *Dongnan lansheng*, "Zhe-Gan tielu Hang-Yu duan."

68 Like "The Steepness of Xianxia," "The Beauty of Bingchuan" was independently published in another venue, namely, *Liangyou*, together with photographs by Chen Wanli, Lang

Jingshan, and Chen Jizhi: Yu Dafu, "Bingchuan jixiu," *Liangyou* no. 84 (January 1934): 16–17.

69 *"Dongnan lansheng* feishi banzai."

70 The low-cost edition of *Scenic Sites in Eastern Zhejiang* was printed on newsprint; an edition printed on nonabsorbent Dowling paper (*Daolin zhi*) cost 0.6 silver dollars.

71 Xu Shiying, *Huangshan lansheng ji.*

72 Shao Yuanchong, *Xibei lansheng.*

73 Wu Liande et al., *Zhongguo daguan.*

74 China Travel Service, *Xinan lansheng.* Lang Jingshan contributed all the photographs in the Sichuan chapter; Pan, "Xuyan." On Lang's involvement with this publication, see also Mia Liu, "Allegorical Landscape," 5–8.

75 For a selection of paintings by Tao Lengyue (1895–1985), Hu Peiheng, and Zhang Daqian with the motif of Mount Yandang, see Shih, "Mingshan qisheng zhi lü," figs. 1.7, 1.19, 1.20, and 1.28. On Mount Yandang in the context of the Southeastern Infrastructure Tour, see also Chan, "In Search of the Southeast," 219–22.

76 Because they had been to Mount Yandang previously, Yu Jianhua and Xu Peiji traveled only to Mount Tiantai with the group; Zhou and Wang, *Yu Jianhua,* 151.

Chapter 4

1 Yu Jianhua, "Zhongguo shanshuihua zhi xiesheng." On this article and Yu's practice of outdoor sketching, see Gu, *Chinese Ways of Seeing,* 87–94.

2 The Ni Zan quotation is from a colophon dated 1368; translation in Bush and Shih, *Early Chinese Texts on Painting,* 280.

3 Yu Jianhua, "Zhongguo shanshuihua zhi xiesheng," 72.

4 Ibid., 73.

5 Ibid.

6 [Xie] Haiyan, "Zhongxi shanshuihua sixiang zhuanhao kanqian tan.".

7 Gu, *Chinese Ways of Seeing,* chap. 1.

8 Yu Jianhua, "Zai jingda Wu Yinghe xiansheng."

9 Cf. Gu, *Chinese Ways of Seeing,* 82–85.

10 Hu Peiheng, "Zhongguo shanshuihua xiesheng de wenti," 4.

11 Ibid., 6.

12 The institute was founded in 1918 as Society for the Research of Painting Methods (Beijing daxue huafa yanjiuhui) by Cai Yuanpei, president of Peking University. Cheng-hua Wang, "Rediscovering Song Painting for the Nation," 221.

13 Cheng-hua Wang, "Rediscovering Song Painting for the Nation," 233–34; on Cai Yuanpei's views on aesthetics see also Ban Wang, *The Sublime Figure of History,* 22–24.

14 Cai Yuanpei, "Meixue de jinhua," 5.

15 Cai Yuanpei, "Meishu de jinhua," 4.

16 Chen Shizeng, "Zhongguohua shi jinbude."

17 According to Yu Jianhua, the second part of Chen's article is not extant; Yu Jianhua, *Chen Shizeng,* 38.

18 Hu Peiheng, "Zhongguo shanshuihua xiesheng de wenti," 4.

19 Yu Jianhua, "Zhongguo shanshuihua zhi xiesheng," 73.

20 Ibid., 74–75.

21 The accounts of sketching trips he undertook in the 1920s were published under his given name, Yu Kun, in the supplement to *Chenbao*; see, e.g., Yu Kun, "Qufu Tai'an xiesheng lüxing ji."

22 The text was first published in 1931 in the journal *Minli* in several installments, of which I was able to access only the second, third, and fifth. In the following I cite the *China Traveler* version.

23 Here Yu Jianhua paraphrases the often-quoted statement by the Tang dynasty painter Zhang Zao (fl. eighth century), "Without, I have taken Creation as my master; Within, I have found the well-spring of the mind." Zhang Yanyuan, *Lidai minghua ji* (847), translation in Acker, *Some T'ang and Pre-T'ang Texts*, 2.1:283 (English translation) and 2.2:121 (Chinese text).

24 Yu Jianhua, "Yandang xiesheng ji," part 1, 18–19.

25 Ibid., part 4, 33.

26 Yu uses the lunar calendar in his account. He begins by giving the cyclical date of the year, *xinwei*, and he mentions the Duanwu Festival, thus setting the beginning of his journey in the fifth month. Yu Jianhua, "Yandang xiesheng ji," part 1, 15.

27 Ibid., part 3, 33.

28 Ibid., part 4, 32.

29 Yu Jianhua, *Yu Jianhua xiesheng jiyou*.

30 "Wu Zhihui deng you Tianmushan"; "Dongnan jiaotong zhoulanhui xingcheng."

31 Yu Jianhua, "Zhongguo shanshuihua zhi xiesheng," 73.

32 Xu Peiji's version of this view even includes a train pulled by a steaming locomotive; see Xu Peiji, *Wan'er muqian*, 73.

33 The term "picture-map" is from Cahill, "Huang Shan Paintings," 253. For a critical discussion of Cahill's application of the term, see Orell, "Picturing the Yangzi River," 9.

34 Gu, "What's in a Name?" 121.

35 Gu, "Photography and Its Chinese Origins," 165.

36 Yu Jianhua, "Zhe-Gan jihen," in Yu, *Yu Jianhua xiesheng jiyou*, 158–59.

37 Schivelbusch, *Railway Journey*, 63.

38 See also ibid., 64: "Panoramic perception . . . no longer belonged to the same space as the perceived objects: the traveler saw the objects, landscapes, etc., *through* the apparatus which moved him through the world. That machine and the motion it created became integrated into his visual perception: thus he could only see things in motion."

39 Yu Jianhua, "Zhe-Gan jihen," in Yu, *Yu Jianhua xiesheng jiyou*, 180.

40 Ibid., 186–87.

41 Ibid., 181.

42 Ibid., 182.

43 Ibid., 181.

44 Li-tsui Fu, *Framing Famous Mountains*, 100.

45 Chen Yuanlin and Liu Zhao, *Yiyang xianzhi*, 8:56–57.

46 Yang Erzeng, *Hainei qiguan*; Mohuizhai, *Mingshan tu*.

47 Yu Jianhua, "Xu you Zhedong ji," in Yu, *Yu Jianhua xiesheng jiyou*, 115; Yu Jianhua, "Zhe-Gan jihen," in ibid., 148.

48 Yu Jianhua, "Xu you Zhedong ji," in Yu, *Yu Jianhua xiesheng jiyou*, 101.

49 Xuezhuang, *Huangshan tu*, in Min Linsi, *Huangshan zhi dingben*, 1–24.

50 Zhang Daqian and Zhang Shanzi, *Huangshan huajing*.

51 Yu Jianhua refers to photographs in the Zhang brothers' album in his picture of the withered Rock Breaking and Rock Lining Pines, and in his close copy of the composition of Zhang Daqian's photograph of Flying Dragon Pine at Lotus Peak, identified by Yu as the Hanging Dragon Pine; Yu Jianhua, "Yu Jianhua Wannan jiyou tuce," in Yu, *Yu Jianhua xiesheng jiyou*, 341 and 345.

Chapter 5

1 Yu Jianhua, "Yu Jianhua Wannan jiyou tuce," in Yu, *Yu Jianhua xiesheng jiyou*, 227 and 235.

2 Ibid., 237.

3 This historical review is based on McDermott, "Making of a Chinese Mountain"; Cahill, "Huang Shan Paintings"; McDowall, *Qian Qianyi's Reflections on Yellow Mountain*.

4 Cahill, *Shadows of Mount Huang*.

5 Cahill, "Huang Shan Paintings," 280. See also McDowall, *Qian Qianyi's Reflections on Yellow Mountain*, 61.

6 On the origins of this phrase, "exceptional pines and strange rocks," see McDowall, *Qian Qianyi's Reflections on Yellow Mountain*, 45–46.

7 Min Linsi, *Huangshan songshi pu*, 52.

8 On woodblock-print copies of Hongren's image by Jiang Zhu (b. 1623?) in the *Huangshan zhi* (1674) and by Xiao Chen (1658–?) in the *Huangshan zhi dingben* (1686), see Zhang Guobiao, *Huipai banhua yishu*, 23; Xu Qifeng, "Ming Qing Huizhou fangzhi zhong," 21–22.

9 Huang Binhong, "Huangshan xilan," 27.

10 Li Yongqiao, *Zhang Daqian nianpu*, 46.

11 Ibid., 61. See also Shen Fu, *Challenging the Past*, 42.

12 This young man might be one of the three students who traveled with the Zhang brothers, Zhang Xuming (?–1936), Wu Zijing (?–1940), or Mu Lingfei (1913–97); Li Yongqiao, *Zhang Daqian nianpu*, 61.

13 Zhang Daqian's painting is now in the collection of the Nanjing Museum.

14 On the fan painting, see Shen Fu, *Challenging the Past*, 104.

15 Huang Yanpei and Lü Yishou, *Zhongguo mingsheng*, vol. 1, plate 29.

16 Xinhua News Agency, "Huangshan Songkesong tishen lumian." The Greeting and Parting Pines are the seventh and eighth of ten pine trees listed in the *Register of Pines and Rocks on Mount Huang* (Min Linsi, *Huangshan songshi pu*, 52). A woodblock illustration from Xuezhuang's *Pictures of Mount Huang* shows two pines leaning toward each other as if they were embracing; Min Linsi, *Huangshan zhi dingben*, 4–5. The Tamed Dragon Pine withered in the early 1980s; it was first replaced with a plastic copy in 1984, and with a new tree in 2004. He Cong, "Huangshan Mengbi sheng xin hua."

17 Gross, "Flights of Fancy," 135.

18 Xu Shiying, *Huangshan lansheng ji*, 43.

19 "Wan sheng jiji kaifa Huangshan"; "Huangshan jiji jianshe." The aspect of relief aid is highlighted in "Xu Shiying fan Hu tan Huangshan jianshe."

20 "Xu Shiying fabiao Huangshan chubu jianshe."

21 Gross, "Flights of Fancy," 136.

22 "Wan Jianshetingzhang Liu Yiyan."

23 For in-depth discussions of Huang's attachment to his home region, see Roberts, "Metal and Stone, Brush and Ink," 4–11; Roberts, "Dark Side of the Mountain," 43–61.

24 Shi Guozhu, *Shexian zhi*, 8. Huang Binhong is listed in the book as one of the compilers; it does not say which parts he contributed. See also Wang Zhongxiu, *Huang Binhong nianpu*, 326–27.

25 Huang Binhong, "Huangshan xilan."

26 Ibid., 26.

27 Ibid., 28.

28 Ibid., 30.

29 Ibid., 39.

30 Cahill, "Huang Shan Paintings," 253.

31 Roberts, "Dark Side of the Mountain," 65–69.

32 On Wu's scientism, see Kwok, *Scientism in Chinese Thought*, 33–58; on Wu's role in early anarchism, see Dirlik, *Anarchism and the Chinese Revolution*, 81–100. On his role in the GMD, ibid., 248–85; Xu Youchun, *Minguo renwu da cidian*, 367–68.

33 Wu Jingheng (Wu Zhihui), "Huangshan shanshi ji shanping," 43.

34 Cahill, "Huang Shan Paintings," 275.

35 Wu Jingheng, "Huangshan shanshi ji shanping," 46.

36 Ibid.

37 Ibid.

38 Ibid., 47.

39 Ibid., 49.

40 "Dongnan jiaotong zhoulanhui zuori zhanlan."

41 The following information on the prizes awarded during the exhibition and on the jury are based on the *Shenbao* report, "Dongnan jiaotong zhoulanhui yingzheng wenyi zuopin zhanlan."

42 Hu Youge's painting of Mount Yandang is reproduced in *Dongnan lansheng*, "Hang-Fu gonglu . . . ," 35.

43 Du Fu, *Poetry of Du Fu*, 2: 240–43.

44 Cahill, "Huang Shan Paintings," 277.

45 Gu, *Chinese Ways of Seeing*, 60–71.

46 For a recent study on the practice of splashed ink painting in Japan and a review of its early history in China, see Lippit, "Of Modes and Manners," 54–60.

47 Maeda, "Rediscovering China in Japan," 73–74.

48 See chap. 3, note 65.

49 Chen Wanli, "Huanghai zhi you."

50 "Dongnan jiaotong zhoulanhui Huangshan sheying." *Shenbao*'s article does not mention that Ye Qianyu, Ma Guoliang, and Zhong Shanyin were editors of the newspaper's competitor publications in the Shanghai print market. This information is given by Ye Qianyu in his autobiography; Ye Qianyu, *Xixu cangsang ji liunian*, 69. Ye erroneously dates the trip to 1931 and states that the group consisted only of six people.

51 Ma Guoliang, "Huangshan jiyou."

52 Chen Wanli, "Huanghai zhi you," 50.

53 Ibid., 55.

54 Ibid., 51.

55 Ibid., 56.

56 Ibid., 57.

57 Ibid., 51 and 52.

58 The incident of the porter being struck is also related in Ma Guoliang, "Huangshan jiyou," 55. On his feelings of vertigo, see Chen Wanli, "Huanghai zhi you," 55.

59 Chen Wanli, "Huanghai zhi you," 55, 57.

60 "Dongnan jiaotong zhoulanhui Huangshan sheying."

61 *Dongnan lansheng*, "Hang-Hui gonglu yanxian zhi bu," 25.

62 "Huangshe jiang kai zhanlanhui."

63 Ibid.; "Huangshan sheyingzhan jinri kaimu."

64 "Huangshe Huangshan yingzhan."

65 "Huangshan sheying mingzuo."

66 "Hu Wenhu juanzi jianzhu Huangshan yiyuan."

67 On the donated sum, see "Qingnianhui ku'er dahui jinxun"; on the book's cost and price, see "*Dongnan lansheng* feishi banzai."

68 "Boda xiongqi de Huangshan."

69 Croizier, *Art and Revolution in Modern China*, 127.

70 See also Gu, *Chinese Ways of Seeing*, 65–71.

71 Xu Shiying, *Huangshan lansheng ji*.

72 The price of *Dongnan lansheng* was 8 yuan, with a 50 percent discount for subscribers. *Huangshan lansheng ji* cost only 6 jiao (0.6 yuan).

73 "Huangshan xinying"; "Huangshan shengjing."

74 No author is indicated for the cover image; the same photograph was reprinted without author credit in a Huangshan travel guide titled *Essentials for a Visit to Mount Huang*, also published in 1934; Jiang Zhenhua, *Huangshan youlan bixie quanshu*, 194. A black-and-white print of the photograph with seal and signature by Lang Jingshan was auctioned in 2018 by Huachen Auctions; Artron.net, https://auction.artron.net/paimai-art0079110749/, accessed August 12, 2021. This attribution remains open to doubt; although some of the photographs in *Essentials for a Visit to Mount Huang* are credited to Lang Jingshan, this one is not.

75 Ma Guoliang's photo was included in *Huangshan lansheng ji* and in a *Liangyou* feature on Huangshan pines; Ma, "Huangshan songjing." Lang Jingshan's version was reproduced in *Libai liu*, no. 566 (1934): 22; Ye Qianyu's image was published in *Xin Xiwang*, no. 5 (1949): 8.

76 Yu Jianhua, "Yu Jianhua Wannan jiyou tuce," in Yu, *Yu Jianhua xiesheng jiyou*, 230.

77 Mia Liu, "Allegorical Landscape," 9; Xiao Yongsheng, *Huayi—Jijin—Lang Jingshan*, 138–39.

78 Lang Jingshan, "Composite Pictures and Chinese Art," unpaginated. For a critical discussion of this text and Lang's composite picture making, see Schaefer, *Shadow Modernism*, 170–76.

79 "Huangshan huayi." Perhaps not incidentally, the Chinese title closely resembles the title of Zhang Daqian and Zhang Shanzi's album of Mount Huang photography, *Huangshan huajing*; only the last of the four characters differs.

Chapter 6

1 Wang Zhongxiu, *Huang Binhong nianpu*, 266–67; Yu Jianhua, "Yandang xiesheng ji," part 1, 15.

2 Roberts, "Dark Side of the Mountain," 142–49; Wang Zhongxiu, *Huang Binhong nianpu*, 194–201.

3 Roberts, "Dark Side of the Mountain," 150–53; Wang Zhongxiu, *Huang Binhong nianpu*, 361.

4 Roberts, "Dark Side of the Mountain," 155–62; Wang Zhongxiu, *Huang Binhong nianpu*, 284–305.

5 Roberts, "Dark Side of the Mountain," 139; Kuo, *Transforming Traditions*, 79.

6 According to his own age count, his seventieth birthday would have been on Chinese New Year's Eve, 1933. See Kuo, *Transforming Traditions*, 16, n. 1.

7 On the intellectual relationship between Huang Binhong and Deng Shi, see Hong Zaixin, "Cong minzuzhuyi dao xiandaizhuyi." On Deng Shi as editor of *Shenzhou guoguang ji*, see Cheng-hua Wang, "New Printing Technology," 283–90; Yu-jen Liu, "Second Only to the Original," 72. On the relationship between Huang Binhong and Xuan Zhe, see Wang Zhongxiu, *Huang Binhong nianpu*, 91–94; and between Huang and Zhang Hong, see Hong Zaixin, "Xueshu yu shichang."

8 Lihong Liu, "Collecting the Here and Now."

9 Huang Binhong, *Huang Binhong quanji*, 10:211. The Shanghai Library holds a second version of the birthday album, catalogued under the title *Huang Binhong Painting Album* (*Huang Binhong huace*), with a slightly different selection of images and smaller in number, printed in red, green, and light blue. This version may have been part of the experiment with using the prints as stationery.

10 For a discussion of the term *huapu*, or "painting manual," see Park, *Art by the Book*, 30. With this dual function, the album resembles a lithographic artist book by Chen Yusheng, published 1876, that is discussed by Wue, *Art Worlds*, 112–26.

11 Wang Zhongxiu, *Huang Binhong nianpu*, 313; according to Wang, a manuscript version of the preface was previously in the collection of Fu Lei. This version is reproduced in Roberts, "Dark Side of the Mountain," fig. 5.39.

12 Huang Binhong, *Binhong jiyou huace*, unpaginated. The preface is transcribed, with punctuation marks added and several misspellings, in Wang Zhongxiu, *Huang Binhong nianpu*, 313.

13 As Claire Roberts has remarked, Huang's activities before his move to Shanghai are not very well documented. On the first decades of his life and his early paintings, see Roberts, "Dark Side of the Mountain," 13–61; Wang Zhongxiu, "Huang Binhong huazhuan (1)."

14 Zhao Mengfu originally inscribed his poem, "Rocks like flying white [script], trees as in seal script / When painting bamboo, one applies the spreading-eight [late clerical] method. / Those who understand this thoroughly / Will realize that calligraphy and painting have always been the same," as a colophon on his painting *Elegant Rocks and Sparse Forest*, ca. 1314, Palace Museum, Beijing; translation in Fong, *Beyond Representation*, 440.

15 Huang Binhong, "You Yandang riji."

16 Xiao Yuncong, *Taiping shanshui tuhua*.

17 Roberts, "Dark Side of the Mountain," 165–66.

18 For an illustration of this sketch see ibid., fig. 5.40a.

19 For a pre-twentieth-century instance in which travel sketches were transferred into a more formal format in East Asia, see *Diary of the Journey to the Three Peaks* (*Sangaku kikō*, 1760, Kyoto National Museum) by Ike no Taiga (1723–76), now pasted on an eight-panel folding

screen. Taiga's sketches share striking similarities with those by Huang Binhong. See Takeuchi, *Taiga's True Views*, 37–40.

20 Wen C. Fong has previously compared this album with the woodblock-print illustrations in the *Huangshan Gazetteer*, but he has erroneously described the drawings as "life sketches from visual impressions." Fong, *Between Two Cultures*, 168.

21 Translation in Ellsworth, *Later Chinese Painting and Calligraphy*, 1:152. Romanization has been adapted to Hanyu Pinyin.

22 Xu Hongzu, *Xu Xiake youji*, 78.

23 For a study of Wang Lü's album, see Liscomb, *Learning from Mount Hua*.

24 Anhui congshu bianshenhui, *Anhui congshu* (*Collecteana on Anhui Province*) is a compilation of premodern books by authors hailing from Anhui Province; Huang Binhong contributed books from his personal collection for reprinting in the series. Cf. Wang Zhongxiu, *Huang Binhong nianpu*, 264–65.

25 Zhejiang Provincial Museum, exhibition text on "Travel Paintings of Eastern Zhejiang, Sketches from Nature of Wuyishan," seen on-site in the gallery in 2014.

26 Huang Binhong, *Huang Binhong quanji*, 10:182.

27 Dong Tiangong, *Wuyishan zhi*, 78–79. Huang's sketch includes more topographical information, such as place names, and buildings, than *Complete Map of the Nine Bends*. Moreover, several of the other leaves cannot be directly linked to the gazetteer's illustrations. It is therefore likely that his sketch is actually based on another, unidentified source that is similar to the illustrations from the 1751 gazetteer, or on several different sources.

28 In Huang's sketch, the name Dawangfeng is inscribed on a narrow cliff beneath a pagoda, but it refers to the entire formation.

29 Dong Tiangong, *Wuyishan zhi*, 75, 94, and 89.

30 Cheng-hua Wang, "New Printing Technology"; Yu-jen Liu, "Second Only to the Original"; on Huang Binhong's role at the Cathay Art Union, see Roberts, "Dark Side of the Mountain," 69–72; on the publications by the Youzheng Book Company, see Vinograd, "Patrimonies in Press," 258–64.

31 Huang and Yi, *Jinshi shuhua congke*. On Yi Da'an, see Chu-tsing Li, *Trends in Modern Chinese Painting*, 40–44; Zhu Jingsheng, "Yi kong yi bang."

32 Cheng-hua Wang, "New Printing Technology," 301.

33 Yu-jen Liu, "Second Only to the Original," 81.

34 He Shengnai, "Sanshiwu nian lai zhi yinshuashu," 190.

35 Yu-jen Liu, "Second Only to the Original," 79, also argues that the "items chosen to be reproduced in collotype were those which were more culturally valued."

36 Yu-jen Liu, "Second Only to the Original," 84–86.

37 Cheng-hua Wang, "New Printing Technology," 284–85 and 289–90.

38 These claims are discussed in ibid. See also Cheng-hua Wang, "The Qing Imperial Collection."

39 For another discussion of this practice, see Noth, "Seen from a Boat," 180–83.

40 May 14 and May 19 entries cited from Huang Binhong, "You Yandang riji," 596.

41 May 24 and 25 entries cited from ibid., 597.

42 For example, Huang commemorated his visit to Shangyang village in a painting made in 1953, now in the collection of the Zhejiang Provincial Museum. For a reproduction, see Xiaoneng Yang, *Tracing the Past*, 293.

43 Most commonly, these sets consist of eight or ten pictures, each representing one view; cf. Kindall, "Visual Experience"; Murck, *Poetry and Painting in Song China*, 210–27.

44 Kindall, "Visual Experience," 139; the translation of the Xu Xiake quotation is from Ward, *Xu Xiake*, 119.

45 Huang Binhong, *Huang Binhong quanji*, 10:210, 212; Wang Zhongxiu, *Huang Binhong nianpu*, 365–66.

46 One example is a leaf in an album dated 1909 that shows the Tamed Dragon Pine; Chu and Wang, *Homage to Tradition*, cat. 2; Roberts, "Dark Side of the Mountain," 76–78.

47 Huang Binhong, *Huang Binhong quanji*, 6:171.

48 Yu Jianhua, *Yu Jianhua xiesheng jiyou*, 142 and 146.

49 Quan et al., *Guangxu Pingle xianzhi*, 15; Jiang Gengfan et al., *Minguo Pingle xianzhi*, 294.

50 Pingle xian difangzhi bianzuan weiyuanhui, *Pingle xianzhi*, 644.

51 Noth, "Seen from a Boat," 181.

52 Huang Binhong, *Huang Binhong huace*.

53 According to a biographical note in the *Siku quanshu*, Dexiang was indicted during the Hongwu reign (1368–98) because he purportedly criticized the emperor in his poem "Summer in the Western Garden"; see *Siku quanshu zongmu tiyao*, juan 175. The poems inscribed on the paintings in *Huang Binhong's Painting Album* are also anthologized under "Inscribed on a Landscape Album in the Year Yihai" (*Yihai ti shanshui ce*) in the poetry section of *Huang Binhong's Collected Writings*, without Huang's citation of his source; Huang Binhong, *Huang Binhong wenji: Shici bian*, 196–97.

54 Huang Binhong, "Huafa yaozhi" (1934–35), part 1, 8.

55 Ibid.

56 For an English translation of some passages on literati painting and famous master painting, see Kuo, *Transforming Traditions*, 45–46.

57 Huang Binhong, "Huafei yaozhi" (1934–35), part 1, 8.

58 Cf. Roberts, "Dark Side of the Mountain," 116–17. On the category of *yipin*, see Nelson, "*I-p'in* in Later Painting Criticism."

59 Roberts, "The Dark Side of the Mountain," 117.

60 For a discussion of the "five methods of the brush" and "seven methods of ink," cf. Kuo, *Transforming Traditions*, 58–62.

61 The "five methods of the brush" have been translated in various versions. Roberts renders them as "evenness or control, presence, roundness, substance and variety"; Roberts, "Dark Side of the Mountain," 117. Wen C. Fong renders them as "the level, the round, the reserved, the heavy, and the changing"; Fong, *Between Two Cultures*, 170.

62 On the origins of these topoi see Debon, *Grundbegriffe der chinesischen Schrifttheorie*, 2–6 ("like drawing lines in the sand with an awl"), 8 ("like a withered wisteria, like a falling rock"), 11–12 ("like a bent hairpin"), and 12–15 ("like a stain seeping under a leaking roof").

63 Huang Binhong, "Huafa yaozhi" (1934–35), part 1, 10; part 2, 22.

64 In a later version of his five methods of the brush in the article "Conversations on Painting" ("Hua tan"), the phrase "to weed out the old to establish the new" (*tui chen chu xin*) appears in the paragraph on the transformative method; Huang Binhong, "Hua tan," 160. This essay was first published under the pseudonym Yuxiang in 1940 in the magazine *Zhonghe*. For a discussion of Huang Binhong's conception of transformation (*bian*) with special regard to his calligraphy, see Hertel, "Inner Workings of Brush-and-Ink," 72–85; Hertel, "Copy and Culmination," especially 44–53.

65 The *National Painting Monthly* edition of "The Essentials of Painting" listed only six methods (omitting splashed ink) but discussed seven, giving splashed ink more weight than burned and overnight ink, which were treated together. Roberts concludes that this was an oversight (Roberts, "Dark Side of the Mountain," 118, n. 39). In the version published in *Xueyi zazhi*, the section on ink methods is restructured and the list, which still includes six methods, is introduced as consisting of seven (Huang Binhong, "Huafa yaozhi" [1935], 50). This was the version reprinted in *Huang Binhong wenji: Shuhua bian (1)*, 495. The later version of Huang's theoretical proposition, published in "Conversations on Painting," lists all seven methods (Huang, "Hua tan," 162–63).

66 Here Huang Binhong cites Huang Gongwang's *Secrets of Describing Landscape*, with minor revisions and omissions; Huang Gongwang, "Xie shanshui jue," 700.

67 Huang Binhong, "Huafa yaozhi" (1934–35), part 4 (no. 5), 122.

68 Ibid., 122–23.

69 Ibid., 124.

70 Huang Binhong, "Zhongguo shanshuihua jinxi zhi bianqian," 59.

71 Lydia Liu, *Translingual Practice*, 40.

72 Huang Binhong, "Lun Zhongguo yishu zhi jianglai," 49.

73 Kang, "Wanmu caotang," 441.

74 The poems are titled "Boya's Zither Terrace" and "Baidicheng." They appear almost next to each other in the anthology, with only one poem inserted between them; Huang Binhong, *Huang Binhong wenji: Shici bian*, 92. On Huang's compilation of the anthology, see Wang Zhongxiu, *Huang Binhong nianpu*, 322.

75 The translation is by Wen C. Fong, *Between Two Cultures*, 170.

76 In *Liangyou* no. 85 (February 1934), 19, Huang Binhong was introduced in the magazine's feature "The Young Companion's Series of Contemporary Paintings by Chinese Artists," with color reproductions of two album leaves titled *Landscape (Szechuan Province)*; a landscape inscribed with the same poem as the scroll in fig. 6.28 was given a full-page reproduction in *Meishu shenghuo* no. 2 (1934).

77 Many of the (mostly undated) painting inscriptions anthologized in the relevant section of *Huang Binhong wenji* include the phrase *hunhou huazi*; Huang Binhong, *Huang Binhong wenji: Tiba bian*, e.g., 22, 23, 27, 28, 37, 38, 39, 42, 43.

78 Cited in Xu Hongquan, *Zhongguo yishu dashi Huang Binhong*, 87.

79 Fu Lei, letter to Huang Binhong, June 9, 1943, in *Fu Lei wenji: Shuxin juan* 1 (Hefei: Anhui Wenyi Chubanshe, 1998), 52, cited in Li Weiming, "Dashi zhi xue yu shengxian zhi xue," 11. On the friendship between Huang and Fu, see the study by Roberts, *Friendship in Art*.

80 Li Weiming, "Dashi zhi xue yu shengxian zhi xue," 12.

81 For a recent study of the wartime paintings by Guan Shanyue (1912–2000), see Gu, *Chinese Ways of Seeing*, chap. 4. In general, *guohua* has not played a major role in studies of the art of wartime China; cf. Huang Zongxian, *Kangri zhanzheng meishu tushi*; Cai Tao, *1938 nian*; Hung, *War and Popular Culture*.

Epilogue

1 Yeh, *Wartime Shanghai*, 2–5; Henriot and Yeh, *In the Shadow of the Rising Sun*, 6.

2 He Tianjian, *Xue hua shanshui guocheng zishu*, 33.

3 The hanging scrolls appeared separately on the auction market; all of them were at one

point sold at a Beijing Chengxuan auction. *Great Dragon Waterfall* and *Gate to the Western Sea* were both auctioned on November 23, 2009; the latter reappeared on the auction market twice in 2012, at Zhejiang Changle (July 15, 2012) and Shanghai Tianheng (December 27, 2012). *Refining Cinnabar Terrace* was first sold through Duoyunxuan (June 30, 2006) and again by Chengxuan (May 17, 2010). *Xiansheng Gate* was sold by Chengxuan on November 21, 2010, and resold by Beijing Yingchang on January 22, 2015. Artron.com, accessed December 16, 2015.

4 Yu Jianhua, "Wuyi Jiuqu jiyou tuce," in *Yu Jianhua xiesheng jiyou*, 6. On the different situations in the regions of China during the war, see Lary, "Introduction: Context of the War."

5 Huang Binhong, "Zixu," 4, translation in Roberts, "Dark Side of the Mountain," 203.

6 That Huang made sketches of sites he had visited earlier while living in Beiping has also been suggested by the curator at the Zhejiang Provincial Museum, Luo Jianqun, in a personal conversation in October 2012.

7 Roberts, "Dark Side of the Mountain," 179–81.

8 Lary, "Introduction: Context of the War," 8.

9 Roberts, "Dark Side of the Mountain," 182–214.

10 I discuss the inscription on this leaf and its historical connotations in Noth, "Seen from a Boat," 187–89.

11 Roberts, "Questions of Authenticity."

12 Huang Binhong, *Huang Binhong quanji*, 6: part 1.

13 Wang Zhongxiu, *Huang Binhong nianpu*, 414.

14 See also Roberts, "Dark Side of the Mountain," 214–20.

15 Translation revised after Xiaoneng Yang, *Tracing the Past*, 253.

16 Pan Enlin, "Introduction / Xuyan," unpaginated.

17 Mia Liu, "Allegorical Landscape," 5–8.

18 Lang Jingshan, *Jingshan jijin*.

19 Lee, *Den Himmel in der Pinselspitze*, cat. 22.

20 On outdoor sketching and landscape painting in socialist China, see Gu, *Chinese Ways of Seeing*, chap. 5; Christine Ho, *Drawing from Life*, esp. chap. 4.

21 Anhui huabao she, *Huangshan*, 34–35

BIBLIOGRAPHY

Acker, William R. B. *Some T'ang and Pre-T'ang Texts on Chinese Painting.* 2 vols. Leiden: Brill, 1954 and 1974.

Andrews, Julia F. "The Heavenly Horse Society (Tianmahui) and Chinese Landscape Painting." In *Ershi shiji shanshuihua yanjiu wenji* 二十世紀山水畫研究文集, edited by Shanghai Shuhua Chubanshe 上海書畫出版社, 556–91. Shanghai: Shanghai Shuhua Chubanshe, 2006.

———. *Painters and Politics in the People's Republic of China, 1949–1979.* Berkeley: University of California Press, 1994.

Andrews, Julia F., and Kuiyi Shen. *The Art of Modern China.* Berkeley: University of California Press, 2012.

———, eds. *A Century in Crisis: Modernity and Tradition in the Art of Twentieth-Century China.* Exhibition catalogue. New York: Guggenheim Museum, 1998. Distributed by Harry N. Abrams.

———. "The Japanese Impact on the Chinese Art World: The Construction of Chinese Art History as a Modern Field." *Twentieth-Century China* 32, no. 1 (2006): 4–35.

———. "Traditionalism as a Modern Stance: The Chinese Women's Calligraphy and Painting Society." *Modern Chinese Literature and Culture* 11, no. 1 (Spring 1999): 1–29.

———. "The Traditionalist Response to Modernity: The Chinese Painting Society of Shanghai." In *Visual Culture in Shanghai, 1850s to 1930s*, edited by Jason Kuo, 79–93. Washington, DC: New Academia Publishing, 2007.

Anhui congshu bianshenhui 安徽叢書編審會, ed. *Anhui congshu* 安徽叢書. Shanghai: Anhui congshu bianyinchu, 1932–36.

Anhui huabao she 安徽畫報社, ed. *Huangshan* 黄山. With photographs by Lu Shifu 盧施福, Huang Xiang 黄翔, Qi Guanshan 齊觀山, Wang Junhua 王君華, Wu Baoji 吳寶基, and Ding Jun 丁峻. Hefei: Anhui renmin chubanshe, 1959.

Bachmann, Pauline, Melanie Klein, Tomoko Mamine, and Georg Vasold, eds. *Art/Histories in Transcultural Dynamics: Narratives, Concepts, and Practices at Work, 20th and 21st Centuries.* Paderborn: Wilhelm Fink Verlag, 2017.

Bachmann-Medick, Doris. *Cultural Turns: Neuorientierungen in den Kulturwissenschaften.* Reinbek bei Hamburg: Rowohlt, 2009.

Barnhart, Richard. "Li T'ang (c. 1050–c. 1130) and the Kōtō-in Landscapes." *Burlington Magazine* 114, no. 830 (May 1972): 304–11, 313–14.

Bianzhe 編者 [The editors]. "Bianyan" 弁言. In *Zhedong jingwu ji: Hang-Jiang tielu daoyou congshu zhi yi*, unpaginated. Edited by Hangzhou tieluju. Hangzhou: Hangzhou tieluju, 1933.

———. "Fakanyu" 發刊語. *Guohua yuekan* 1, no. 1 (1934): 2.

———. "Zhongxi shanshuihua sixiang zhuankan chatu zhi jiandian" 中西山水畫思想專刊插圖之檢點. *Guohua yuekan* 1, no. 7 (1935): 163–66.

"Boda xiongqi zhi Huangshan (Huangshe meizhan yiban)" 博大雄奇之黃山 （黃社美展一斑） ("Huang Shan, the Mount of Graceful Pines and Fantastic Clouds"). *Liangyou*, no. 101 (January 1935): 14–15.

Bolter, Jay David, and Richard Grusin. *Remediation: Understanding New Media*. Cambridge, MA: MIT Press, 1999. Paperback edition, 2000.

Burkus-Chasson, Anne. "'Clouds and Mists That Emanate and Sink Away': Shitao's *Waterfall on Mount Lu* and Practices of Observation in the Seventeenth Century." *Art History* 19, no. 2 (June 1996): 168–90.

Bush, Susan. *The Chinese Literati on Painting: Su Shih (1037–1101) to Tung Ch'i-ch'ang (1555–1636)*. Hong Kong: Hong Kong University Press, 2012. First published in 1971, Harvard University Press.

Bush, Susan, and Hsio-yen Shih, eds. *Early Chinese Texts on Painting*, 2nd edition. Hong Kong: Hong Kong University Press, 2012.

Cahill, James. "Huang Shan Paintings as Pilgrimage Pictures." In *Pilgrims and Sacred Sites in China*, edited by Susan Naquin and Chün-fang Yü, 246–92. Berkeley: University of California Press, 1992.

———, "The Imperial Painting Academy." In *Possessing the Past: Treasures from the National Palace Museum Taipei*, edited by Wen C. Fong and James C. Y. Watt, 159–99. New York: Metropolitan Museum of Art, 1996.

———, ed. *Shadows of Mount Huang: Chinese Painting and Printing of the Anhui School*. Exhibition catalogue. Berkeley, CA: University Art Museum, 1981.

———. "Tung Ch'i-ch'ang's 'Southern and Northern Schools' in the History and Theory of Painting: A Reconsideration." In *Sudden and Gradual: Approaches to Enlightenment in Chinese Thought*, edited by Peter N. Gregory, 429–46. Honolulu: University of Hawai'i Press, 1987.

Cai Tao 蔡濤. *1938 nian: Guojia yu yishujia—Huanghelou da bihua yu kangzhan chuqi Zhongguo xiandai meishu de zhuanxing* 1938 年：國家與藝術家—黃鶴樓大壁畫與抗戰初期中國現代美術的轉型. PhD diss., China Academy of Arts, 2014.

Cai Yuanpei 蔡元培. "Meishu de jinhua" 美術的進化. *Huixue zazhi*, no. 3 (1921), "Tonglun": 1–5.

———. "Meixue de jinhua" 美學的進化. *Huixue zazhi*, no. 3 (1921), "Tonglun": 5–10.

Chan, Pedith Pui. "In Search of the Southeast: Tourism, Nationalism, and Scenic Landscape in Republican China," *Twentieth-Century China* 43, no. 3 (2018): 207–31.

———. *The Making of a Modern Art World: The Institutionalisation and Legitimisation of Guohua in Republican Shanghai*. Leiden: Brill, 2017.

Chen Baozhen 陳葆真. "Wenrenhua de yanshen: Lang Jingshan de sheying yishu" 文人畫的延伸—郎靜山的攝影藝術. *Gugong wenwu yuekan* 20, no. 10 (2003): 42–57.

Chen Duxiu 陳獨秀. "Meishu geming: Da Lü Cheng" 美術革命—答呂澂. *Xin Qingnian* 6, no. 1 (January 1919): 85–86.

Chen Shen 陳申 and Xu Xijing 徐希景. *Zhongguo sheying yishushi* 中國攝影藝術史. Beijing: Sanlian Shudian, 2011.

Chen Shizeng 陳師曾. "Wenrenhua de jiazhi" 文人畫的價值. *Huixue zazhi*, no. 2 (January 1921): "Zhuanlun": 1–6.

———. "Zhongguohua shi jinbude" 中國畫是進步的. *Huixue zazhi*, no. 3 (1921), "Zhuanlun": 1–3.

———. *Zhongguo wenrenhua zhi yanjiu* 中國文人畫之研究. Shanghai: Zhonghua Shuju, 1922.

Chen Wanli 陳萬里. "Huanghai zhi you" 黃海之遊. In *Dongnan lansheng* 東南攬勝, "Hang-Hui gonglu yanxian zhi bu" 杭徽公路沿線支部, 50–58.

Chen Yuanlin 陳元麟 and Liu Zhao 劉照, comps. *Yiyang xianzhi* 弋陽縣志. Facsimile reprint of 1750 edition. In *Shanghai Cishu Chubanshe Tushuguan cang xijian fangzhi chubian* 上海辭書出版社圖書館藏稀見方志初編, vols. 8–9. Shanghai: Shanghai Cishu Chubanshe, 2013.

Cheng Yuqing 程與青. "Dongnan jiaotong zhoulanhui: Sheying juehao ziliao" 東南交通周覽會：攝影絕好資料. *Sheying huabao* 10, no. 24 (1934): 20–21.

China Travel Service, ed. *Xinan lansheng* 西南攬勝 (*Scenic Beauties in Southwest China*). Revised edition. Shanghai: China Travel Service, 1940.

Chu, Christina, and Wang Bomin, eds. *Homage to Tradition: Huang Binhong, 1865–1955*. Exhibition catalogue. Hong Kong: Hong Kong Museum of Art, 1995.

Claypool, Lisa. "Ways of Seeing the Nation: Chinese Painting in the *National Essence Journal* (1905–1911) and Exhibition Culture." *Positions: East Asian Cultures Critique* 19, no. 1 (Spring 2011): 55–82.

Clunas, Craig. *Chinese Painting and Its Audiences*. Princeton, NJ: Princeton University Press, 2017.

Croizier, Ralph. *Art and Revolution in Modern China: The Lingnan (Cantonese) School of Painting, 1906–1951*. Berkeley: University of California Press, 1988.

Dabringhaus, Sabine. *Territorialer Nationalismus in China: Historisch-geographisches Denken, 1900–1949*. Cologne: Böhlau Verlag, 2006.

Dal Lago, Francesca. "Realism as a Tool of National Modernisation in the Reformist Discourse of Late Nineteenth- and Early Twentieth-Century China." In *Crossing Cultures: Conflict, Migration and Convergence: The Proceedings of the 32nd International Congress in the History of Art*, edited by Jaynie Anderson, 852–56. Melbourne: Miegunyah Press, 2009.

Daoji 道濟 [Shitao]. "*Kugua heshang huayulu*" 苦瓜和尚畫語錄. In *Zhongguo gudai hualun leibian* 中國古代畫論類編, edited by Yu Jianhua 俞劍華. 2nd edition. Vol. 1, 147–60. Beijing: Renmin Meishu Chubanshe, 1998.

Debon, Günther. *Grundbegriffe der chinesischen Schrifttheorie und ihre Verbindung zu Dichtung und Malerei*. Wiesbaden: Franz Steiner Verlag, 1978.

DeLue, Rachael Ziady. "Elusive Landscapes and Shifting Grounds." In *Landscape Theory*, edited by Rachael Ziady DeLue and James Elkins, 3–14. New York: Routledge, 2008.

Dikötter, Frank. *The Discourse of Race in Modern China*. London: Hurst & Co., 1992.

Ding Xianyong. "Firedrake: Local Society and Train Transport in Zhejiang Province in the 1930s." *Transfers* 3, no. 3 (2013): 27–55.

Dirlik, Arif. *Anarchism and the Chinese Revolution*. Berkeley: University of California Press, 1991.

———. "The Ideological Foundations of the New Life Movement: A Study in Counterrevolution." *Journal of Asian Studies* 34, no. 4 (August 1975): 945–80.

Dong, Madeleine Yue. "Shanghai's *China Traveler*." In *Everyday Modernity in China*, edited by Madeleine Yue Dong and Joshua L. Goldstein, 195–226. Seattle and London: Washington University Press, 2006.

Dong Qichang 董其昌. "Huachanshi lun hua" 畫禪室論畫. In *Zhongguo gudai hualun leibian* 中國古代畫論類編, edited by Yu Jianhua 俞劍華. 2nd edition. Vol. 2, 724–34. Beijing: Renmin Meishu Chubanshe, 1998.

Dong Tiangong 董天工, comp. *Wuyishan zhi* 武夷山志. Facsimile reprint of 1751 edition in *Guojia tushuguan cang Zhongguo shanshuizhi congkan* 國家圖書館藏中國山水志叢刊: *Shanzhi juan* 山志卷 34. Beijing: Xianzhuang Shuju, 2004.

"Dongnan jiaotong zhoulanhui chou yin *Dongnan lansheng*" 東南交通周覽會籌印《東南攬勝》. *Shenbao*, August 23, 1934, 12.

"Dongnan jiaotong zhoulanhui Huangshan sheying jiang kai zhanlanhui" 東南交通周覽會黃山攝影將開展覽會. *Shenbao*, June 27, 1934, 13.

"Dongnan jiaotong zhoulanhui xingcheng" 東南交通周覽會行程. *Shenbao*, April 6, 1934, 7.

Dongnan jiaotong zhoulanhui xuanchuanzu 東南交通周覽會宣傳組, ed. *Dongnan lansheng* 東南攬勝 (*In Search of the Southeast*). N.p.: Quanguo jingji weiyuanhui Dongnan jiaotong zhoulanhui 全國經濟委員會東南交通周覽會, 1935.

"Dongnan jiaotong zhoulanhui yingzheng wenyi zuopin zhanlan" 東南交通周覽會應徵文藝作品展覽. *Shenbao*, July 21, 1934, 12.

"Dongnan jiaotong zhoulanhui zanhuan juxing" 東南交通周覽會暫緩舉行. *Shenbao*, September 2, 1934, 12.

"Dongnan jiaotong zhoulanhui zuori zhanlan chengji zai Baxianqiao Qingnianhui jiu lou" 東南交通周覽會昨日展覽成績在八仙橋青年會九樓. *Shenbao*, July 20, 1934, 11.

Dongnan lansheng. See above under Dongnanjiaotong zhoulanhui xuanchuanzu, ed.

"*Dongnan lansheng* feishi banzai feijin shuwan jingzhuang juce" 東南攬勝費時半載費金數萬精裝巨冊. Advertisement by China Travel Service Shanghai Branch. *Shenbao*, December 3, 1934, 4.

Du Fu. *The Poetry of Du Fu*. Translated by Stephen Owen. Edited by Ding Xiang Warner and Paul Kroll. 6 vols. Berlin: De Gruyter, 2016. Accessed March 12, 2016. http://www.degruyter.com/view/product/246946.

Eastman, Lloyd. *The Abortive Revolution: China under Nationalist Rule, 1927–1937*. 3rd edition. Cambridge, MA: Harvard University Press, 1990.

Eggert, Marion. *Vom Sinn des Reisens: Chinesische Reiseschriften vom 16. bis zum frühen 19. Jahrhundert*. Sinologica Coloniensia 23. Wiesbaden: Harrassowitz, 2004.

Ellsworth, Robert Hatfield. *Later Chinese Painting and Calligraphy, 1800–1950*. 3 vols. New York: Random House, 1986–87.

Ferlanti, Federica. "The New Life Movement in Jiangxi Province, 1934–1938." *Modern Asian Studies* 44, no. 5 (2010): 961–1000.

Fogel, Joshua A., ed. *The Role of Japan in Modern Chinese Art*. Berkeley: University of California Press, 2012.

Fong, Wen C. *Between Two Cultures: Late Nineteenth- and Twentieth-Century Chinese Paintings from the Robert H. Ellsworth Collection*. New York: Metropolitan Museum of Art, 2001.

———. *Beyond Representation: Chinese Painting and Calligraphy 8th–14th Century*. New York: Metropolitan Museum of Art, 1992.

———. "Tung Ch'i-ch'ang and Artistic Renewal." In *The Century of Tung Ch'i-ch'ang (1555–1636)*, edited by Wai-kam Ho. Vol. 1, 43–54. Kansas City, MO: Nelson-Atkins Museum of Art, 1992.

Foxwell, Chelsea. *Making Modern Japanese-Style Painting: Kano Hōgai and the Search for Images*. Chicago: Chicago University Press, 2015.

Fraser, Sarah E. "Sha bo tshe ring, Zhang Daqian and Sino-Tibetan Cultural Exchange, 1941–1943: Defining Research Methods for Amdo Regional Painting Workshops in the Medieval and Modern Periods." In *Art in Tibet: Issues in Traditional Tibetan Art from the Seventh to the Twentieth Century*, edited by Erberto F. Lo Bue, 115–36. Leiden: Brill, 2011.

Fu, Li-tsui Flora. *Framing Famous Mountains: Grand Tour and Mingshan Paintings in Sixteenth-Century China*. Hong Kong: Chinese University Press, 2009.

Fu, Shen C. Y. *Challenging the Past: The Paintings of Chang Dai-chien*. Exhibition catalogue. Washington, DC: Arthur M. Sackler Gallery, Smithsonian Institution, in association with University of Washington Press, Seattle, 1991.

Ganza, Kenneth. "The Artist as Traveler: The Origin and Development of Travel as a Theme in Chinese Landscape Painting from the Fourteenth to Seventeenth Centuries." PhD diss., Indiana University, 1990.

Gross, Miriam. "Flights of Fancy from a Sedan Chair: Marketing Tourism in Republican China, 1927–1937." *Twentieth-Century China* 36, no. 2 (July 2011): 99–147.

Gu, Yi. *Chinese Ways of Seeing and Open-Air Painting*. Cambridge, MA: Harvard University Asia Center, 2020.

———. "Photography and Its Chinese Origins." In *Photography and Its Origins*, edited by Tanya Sheehan and Andrés Mario Zervigón, 157–70. New York: Routledge, 2015.

———. "What's in a Name? Photography and the Reinvention of Visual Truth in China, 1840–1911." *Art Bulletin* 95, no. 1 (March 2013): 120–38.

Gujin tushu jicheng 古今圖書集成. 88 vols. Chengdu: Zhonghua Shuju Bashu Shushe, 1985.

Guo, Hui. "New Categories, New History: 'The Preliminary Exhibition of Chinese Art' in Shanghai, 1935." In *Crossing Cultures: Conflict, Migration and Convergence: The Proceedings of the 32nd International Congress in the History of Art*, edited by Jaynie Anderson, 857–60. Melbourne: Miegunyah Press, 2009.

———. "Writing Chinese Art History in Early Twentieth-Century China." PhD diss., Universiteit Leiden, 2010.

Han Guanghui 韓光輝. "Zhang Qiyun ji qi lishi dilixue gongxian" 張其昀及其歷史地理學貢獻. *Zhongguo keji shiliao* 18, no. 1 (1997): 38–48.

Hang Chunxiao 杭春曉. "Wenhe de jianjin zhi lu: Yi Minchu Beijing diqu Zhongguohua chuantongpai huajia wei zhongxin de kaocha" 溫和的漸進之路——以民初北京地區中國畫傳統派畫家爲中心的考察. PhD diss., Zhongguo Yishu Yanjiuyuan, 2006.

Hang-Jiang tielu gongchengju gongwuke 杭江鐵路工程局工務課, ed. *Hang-Jiang tielu gongcheng jilüe* 杭江鐵路工程紀略. Hangzhou: Hang-Jiang tielu gongchengju, 1933. 2nd edition 1934.

Hangzhou tieluju 杭州鐵路局, ed. *Zhedong jingwu ji: Hang-Jiang tielu daoyou congshu zhi yi* 浙東景物紀—杭江鐵路導遊叢書之一 (*Scenic Sites in Eastern Zhejiang: An Anthology of Travel Guides to the Hangzhou-Jiangshan Railway*). Hangzhou: Hangzhou tieluju, 1933.

Harrist, Robert E., Jr. *Landscape of Words: Stone Inscriptions from Early and Medieval China.* Seattle: University of Washington Press, 2008.

Hausherr, Inka Bianca. *Die Entwicklung der chinesischen Geographie im 20. Jahrhundert: Ein disziplingeschichtlicher Überblick.* Bremer Beiträge zur Geographie und Raumplanung, 40: Beiträge zur Chinaforschung. Bremen: Universität Bremen, Institut für Geographie, 2003.

Hay, Jonathan. *Shitao: Painting and Modernity in Early Qing China.* Cambridge: Cambridge University Press, 2001.

He Cong 何聰. "Huangshan Mengbi sheng xin hua fangling yi yisui" 黄山夢筆生新花芳齡已一歲. *Renmin ribao*, April 1, 2004.

He Shengnai 賀聖鼐. "Sanshiwu nian lai zhi yinshuashu" 三十五年來之印刷术. In *Zuijin sanshiwu nian zhi Zhongguo jiaoyu* 最近三十五年來之中國教育, edited by Zhuang Yu 莊俞 and He Shengnai. Vol. 2, 173–202. Shanghai: Shangwu Yinshuguan, 1931.

He Tianjian 賀天健. "Daobie yu zengyan" 道別與贈言. *Guohua yuekan* 1, no. 11/12 (1935): 234–36.

——. "Du Xianxialing" 度仙霞嶺. In *Dongnan lansheng*, edited by Dongnan jiaotong zhoulanhui xuanchuanzu, "Zhe-Gan tielu Hang-Yu duan yu Hang-Guang gonglu yanxian ji Fuchunjiang zhi bu," 20–21. N.p.: Quanguo Jingji Weiyuanhui Dongnan Jiaotong Zhoulanhui, 1935.

——. "Guowang zhi banban" 過往之般般. *Guohua yuekan* 1, no. 11/12 (1935): 238.

——. "Huajia yingshou zhi xintiao" 畫家應守之信條. *Guohua yuekan* 1, no. 8 (1935): 168; no. 9/10 (1935): 184 and 202; no. 11/12 (1935): 225 and 234.

——. "Shimen tansheng ji" 石門探勝記. *Ziluolan* 4, no. 12 (1929): 1–5.

——. "Xieyan" 楔言. In *Zhongguo xiandai minghua huikan* 中國現代名畫彙刊, edited by Zhongguo huahui bianyibu 中國畫會編譯部, unpaginated. Shanghai: Zhongguo Huahui, 1935.

——. *Xue hua shanshui guocheng zishu* 學畫山水過程自述. Beijing: Renmin Meishu Chubanshe, 1962.

——. "Zhedong shanshui zai huaxue shang zhi zhengyan ji" 淛東山水在畫學上之證驗記. In *Dongnan lansheng*, edited by Dongnan jiaotong zhoulanhui xuanchuanzu, "Zazu bu," 3–5. N.p.: Quanguo Jingji Weiyuanhui Dongnan Jiaotong Zhoulanhui, 1935.

——. "Zhongguo huahui lilun shang zhi yanshu" 中國畫會理論上之演述. *Guohua yuekan* 1, no. 1 (1934): 3–6.

——. "Zhongguo shanshuihua jinri zhi bingtai ji qi jiuji fangfa" 中國山水畫今日之病態及其救濟方法. *Guohua yuekan* 1, no. 5 (1935): 100–103.

——. "Zhongguo shanshuihua zai huake zhong datou zhi lunzheng" 中國山水畫在畫科中打頭之論證. *Guohua yuekan* 1, no. 4 (1935): 51–56.

He Tianjian huaji 賀天健畫集. Shanghai: Renmin Meishu Chubanshe, 1982.

Henriot, Christian, and Wen-hsin Yeh, eds. *In the Shadow of the Rising Sun: Shanghai under Japanese Occupation.* Cambridge: Cambridge University Press, 2004.

Hertel, Shao-Lan. "Copy and Culmination: Attempting to Assess the Significance of Huang Binhong's Calligraphy in the Context of His 'Late Bloom.'" In *Huang Binhong yu xiandai yishu sixiangshi guoji xueshu yantaohui wenji 2012 Hangzhou* 黃賓虹與現代藝術思想史國際學術研討會2012杭州 (*Huang Binhong and the Evolution of Modern Ideas in Art: An International Forum, Hangzhou, China*), edited by Kong Lingwei 孔令偉 and Juliane Noth, 40–63. Hangzhou: Zhongguo Meishu Xueyuan Chubanshe, 2014.

——. "The Inner Workings of Brush-and-Ink: A Study on Huang Binhong (1865–1955) as Calligrapher, with Special Respect to the Concept of Interior Beauty (*Neimei*)." PhD diss.,

Freie Universität Berlin, 2016. Accessed July 19, 2017. http://www.diss.fu-berlin.de/diss/receive/FUDISS_thesis_000000105034.

Ho, Christine I. *Drawing from Life: Sketching and Socialist Realism in the People's Republic of China*. Oakland: University of California Press, 2020.

Ho, Wai-kam, ed. *The Century of Tung Ch'i-ch'ang (1555–1636)*, 2 vols. Exhibition catalogue. Kansas City, MO: Nelson-Atkins Museum of Art, 1992.

——. "Tung Ch'i-ch'ang's New Orthodoxy and the Southern School Theory." In *Artists and Traditions: Uses of the Past in Chinese Culture*, edited by Christian F. Murck, 113–29. Princeton, NJ: The Art Museum, Princeton University, 1976.

Hobsbawm, Eric. "Introduction: Inventing Traditions." In *The Invention of Tradition*, edited by Eric Hobsbawm and Terence Ranger, 1–14. Cambridge: Cambridge University Press, 1983.

Hong Zaixin 洪再新. "Cong minzuzhuyi dao xiandaizhuyi: Deng Shi, Huang Binhong xueshu sixiang guanxi kaolüe" 從民族主義到現代主義：鄧實、黃賓虹學術思想關係考略. In *Huang Binhong yu xiandai yishu sixiangshi guoji xueshu yantaohui wenji 2012 Hangzhou*, edited by Kong Lingwei and Juliane Noth, 136–87. Hangzhou: Zhongguo Meishu Xueyuan Chubanshe, 2014.

——. "'The Excellent Painter of the Chinese People': Huang Binhong and Contemporary Art Movements." In *Tracing the Past, Drawing the Future: Master Ink Painters in Twentieth-Century China*, edited by Xiaoneng Yang, 230–41. Exhibition catalogue. Milan: 5 Continents Editions, 2010. Distributed by Harry N. Abrams.

——. "Xueshu yu shichang: Cong Huang Binhong yu Zhang Hong de jiaowang kan Guangdongren de yishu shiyan" 學術與市場：從黃賓虹與張虹的交往看廣東人的藝術實驗. *Rongbaozhai*, no. 3 (May 2004): 60–75; no. 4 (July 2004): 62–71; no. 5 (September 2004): 68–81.

Hu Peiheng 胡佩衡. "Zhongguo shanshuihua xiesheng de wenti" 中國山水畫寫生的問題. *Huixue zazhi*, no. 3 (1921), "Zhuanlun": 3–7.

"Hu Wenhu juanzi jianzhu Huangshan yiyuan" 胡文虎捐貲建築黃山醫院. *Shenbao*, June 12, 1935, 10.

Hu Zhongying 胡鍾英. "Xin yu jiu" 新與舊. *Guohua yuekan* 1, no. 5 (1935): 122.

——. "Zhongguo shanshuihua jianshangjia linmojia chuangzuojia zhi kaohe" 中國山水畫鑑賞家臨摹家創作家之考核. *Guohua yuekan* 1, no. 4 (1935): 91.

"Huafa yanjiuhui jishi di shijiu" 畫法研究會紀事第十九. *Beijing Daxue rikan*, May 23, 1918, 2–3; May 24, 1918, 2–3; and May 25, 1918, 2–3. Reprinted as Xu Beihong 徐悲鴻, "Zhongguohua gailiang lun" 中國畫改良論. *Huixue zazhi* 1 (June 1920): 12–14.

"Huafa yanjiuhui jishi di shiwu" 畫法研究會紀事第十五. *Beijing Daxue rikan*, May 10, 1918, 2–3, and May 11, 1918, 2–3. Reprinted as Xu Beihong, "Wenhuadian canguanji" 文華殿參觀記. *Huixue zazhi* 1 (June 1920): 1–6.

Huang Binhong 黃賓虹. *Binhong jiyou huace* 賓虹紀游畫冊. Woodblock-print album. N.p.: privately published, 1934.

——. "Huafa yaozhi" 畫法要恉. *Guohua yuekan* 1, no. 1 (November 1934): 8–10; no. 2 (December 1934): 22–24; no. 3 (January 1935): 39–40; no. 5 (March 1935): 122–24.

——. "Huafa yaozhi." *Xueyi zazhi* 14, no. 1 (1935): 45–52. Reprinted in *Huang Binhong wenji: Shuhua bian (1)* 書畫編（上）, 489–98. Shanghai: Shanghai Shuhua Chubanshe, 1999.

——. *Huang Binhong huace* 黃賓虹畫冊. N.p., 1935.

——. *Huang Binhong jiyou huace* 黃賓虹紀游畫冊, 2 vols. Shanghai: Shenzhou Guoguang She, 1936.

——. *Huang Binhong quanji* 黃賓虹全集. 10 vols. Edited by *Huang Binhong quanji* bianji

weiyuanhui. Jinan: Shandong Meishu Chubanshe; Hangzhou: Zhejiang Renmin Meishu Chubanshe, 2006.

———. *Huang Binhong wenji* 黃賓虹文集. 6 vols. Edited by Shanghai Shuhua Chubanshe 上海書畫出版社 and Zhejiang Sheng Bowuguan 浙江省博物館. Shanghai: Shanghai Shuhua Chubanshe, 1999.

———. "Huangshan xilan" 黃山析覽. In *Dongnan lansheng*, edited by Dongnan jiaotong zhoulanhui xuanchuanzu, "Hang-Hui gonglu yanxian zhi bu," 24–40. N.p.: Quanguo Jingji Weiyuanhui Dongnan Jiaotong Zhoulanhui, 1935. Reprinted in *Huang Binhong wenji: Zazhu bian* 雜著編, 507–25. Shanghai: Shanghai Shuhua Chubanshe, 1999.

———. "Hua tan" 畫談. In *Huang Binhong wenji: Shuhua bian (2)*, 158–67. Shanghai: Shanghai Shuhua Chubanshe, 1999.

———. "Lun Zhongguo yishu zhi jianglai" 論中國藝術之將來. *Meishu zazhi* 1, no. 1 (1934): 48–49.

———. "You Yandang riji" 遊雁蕩日記. In *Huang Binhong wenji: Zazhu bian* 黃賓虹文集·雜著編, edited by Shanghai Shuhua Chubanshe 上海書畫出版社 and Zhejiang Sheng Bowuguan 浙江省博物館, 596–97. Shanghai: Shanghai Shuhua Chubanshe, 1999.

———. "Zhongguo shanshuihua jinxi zhi bianqian" 中國山水畫今昔之變遷. *Guohua yuekan* 1, no. 4 (1935): 59–60.

———. "Zixu." In *Huang Binhong shuhuazhan tekan* 黃賓虹書畫展特刊, edited by Huang Binhong shuhua zhanlanhui choubeichu 黃賓虹書畫展覽會籌備處, 1–4. Shanghai: Huang Binhong shuhua zhanlanhui choubeichu, 1943.

Huang Binhong 黃賓虹 and Yi Da'an 易大厂. *Jinshi shuhua congke* 金石書畫叢刻. Shanghai: Jinshi shuhua she, 1934.

Huang Gongwang 黃公望. "Xie shanshui jue" 寫山水訣. In *Zhongguo gudai hualun leibian* 中國古代畫論類編, edited by Yu Jianhua 俞劍華, 2nd ed. Vol. 2, 700–703. Beijing: Renmin Meishu Chubanshe, 1998.

Huang Yanpei 黃炎培, ed., Lü Yishou 呂頤壽, photogr. *Zhongguo mingsheng (1): Huangshan* 中國名勝 第一種 黃山 (*Scenic China Series*, vol. 1: *Huang Shan, Anhui*). Shanghai: Commercial Press, 1914.

Huang Zongxian 黃宗賢. *Kangri zhanzheng meishu tushi* 抗日戰爭美術圖史. Changsha: Hunan Meishu Chubanshe, 2005.

"Huangshan huayi" 黃山畫意 ("Dreamy Sceneries of Huang Shan"). *Liangyou*, no. 117 (June 1936): 38–39.

"Huangshan jiji jianshe: Xu Shiying ren jianweihui changwei, Jiaoting jiang zai shan choushe xuexiao" 黃山積極建設：許世英任建委會常委，教廳將在山籌設學校. *Shenbao*, May 22, 1934, 8.

"Huangshan shengjing" 黃山勝景. *Shishi xunbao*, no. 19 (1935): 18–19.

"Huangshan sheying mingzuo shijiu ri yun Xingjiapo zhanlan" 黃山攝影名作十九日運星加坡展覽. *Shenbao*, February 12, 1935, 12.

"Huangshan sheyingzhan jinri kaimu" 黃山攝影展今日開幕. *Shenbao*, December 15, 1934, 14.

"Huangshan xinying" 黃山心影. *Wei Mei*, no. 2 (1935): 7–8.

"Huangshe Huangshan yingzhan jiang you Hang yi Jing" 黃社黃山影展將由杭移京. *Shenbao*, January 1, 1935, 29.

"Huangshe jiang kai zhanlanhui" 黃社將開展覽會. *Shenbao*, December 7, 1934, 14.

Hung, Chang-tai. *War and Popular Culture: Resistance in Modern China, 1937–1945*. Berkeley: University of California Press, 1994.

Ji Guanghua 嵇光華. "Hang-Jiang tielu yanxian tansheng ji" 杭江鐵路沿綫探勝記. *Lüxing zazhi* 7, no. 2 (1933): 11–23; no. 3 (1933): 33–45.

Jiang Gengfan 蔣庚蕃, Guo Chuntian 郭春田, and Zhang Zhilin 張智林, comps. *Minguo Pingle xianzhi* 民國平樂縣志. Reprinted in *Zhongguo difangzhi jicheng: Guangxi fuxianzhi ji* 中國地方志集成:廣西府縣志輯 39. Nanjing: Fenghuang Chubanshe, 2014.

[Jiang] Jiamei [江]家瑂. "Kexue de youji" 科學的遊記. In *Dongnan lansheng*, edited by Dongnan jiaotong zhoulanhui xuanchuanzu, "Zazu," 5. N.p.: Quanguo Jingji Weiyuanhui Dongnan Jiaotong Zhoulanhui, 1935.

"Jiang ling Zeng Yangfu zhuban Dongnan jiaotong zhoulanhui" 蔣令曾養甫主辦東南交通周覽會. *Shenbao*, April 26, 1934, 9.

"Jiang Weiyuanzhang ling choubei Dongnan jiaotong zhoulanhui" 蔣委員長令籌備東南交通周覽會. *Shenbao*, February 18, 1934, 13.

Jiang Zhenhua 江振華. *Huangshan youlan bixie quanshu* 黃山游覽必攜全書. Shanghai: Daode shuju, 1934. Reprinted in *Minguo shiqi lüyou wenxian huibian* 民國時期旅游文獻彙編, edited by Jia Hongyan 賈鴻雁, vol. 6, 175–343. Beijing: Guojia tushuguan chubanshe, 2019.

"Jiaotong anquan yundong: Dongnan jiaotong zhoulanhui bennian liuyue zhong juxing" 交通安全運動:東南交通周覽會本年六月中舉行. *Shenbao*, February 22, 1934, 12.

Johnson, Geraldine A. "'(Un)richtige Aufnahme': Renaissance Sculpture and the Visual Historiography of Art History." *Art History* 36, no.1 (February 2013): 12–51.

Kang Youwei 康有爲. "Wanmu caotang suocang Zhongguohua mu" 萬木草堂所藏中國畫目. In *Kang Youwei quanji*, edited by Jiang Yihua 姜義華 and Zhang Ronghua 張榮華, vol. 10, 441–55. Beijing: Zhongguo Renmin Daxue Chubanshe, 2006.

Kao, Mayching. "Reforms in Education and the Beginning of the Western-Style Painting Movement in China." In *A Century in Crisis: Modernity and Tradition in the Art of Twentieth-Century China*, edited by Julia F. Andrews and Kuiyi Shen, 146–61. Exhibition catalogue. New York: Guggenheim Museum, 1998. Distributed by Harry N. Abrams.

———, ed. *Twentieth-Century Chinese Painting*. Oxford: Oxford University Press, 1988.

Kapr, Albert. *Buchgestaltung*. Dresden: VEB Verlag der Kunst, ca. 1963.

Kent, Richard K. "Early Twentieth-Century Art Photography in China: Adopting, Domesticating, and Embracing the Foreign." *TransAsia Photography Review* 3, no. 2 (2013). Accessed September 8, 2015. http://hdl.handle.net/2027/spo.7977573.0003.204.

———. "Fine Art Photography in Republican-Period Shanghai: From Pictorialism to Modernism." In *Bridges to Heaven: Essays in East Asian Art in Honor of Professor Wen C. Fong*, edited by Jerome Silbergeld, Dora C. Y. Ching, Judith G. Smith. and Alfreda Murck. Vol. 2, 849–74. Princeton, NJ: P. Y. and Kinmay W. Tang Center for East Asian Art, Department of Art and Archaeology, Princeton University, in association with Princeton University Press, 2011.

Kindall, Elizabeth. *Geo-Narratives of a Filial Son*. Cambridge, MA: Harvard University Asia Center, distributed by Harvard University Press, 2016.

———. "Visual Experience in Late Ming Suzhou 'Honorific' and 'Famous Sites' Paintings." *Ars Orientalis* 36 (2009): 137–77.

Kirby, William C. "Engineering China: Birth of the Developmental State, 1928–1937." In *Becoming Chinese: Passages to Modernity and Beyond*, edited by Wen-hsin Yeh, 137–60. Berkeley: University of California Press, 2000.

Köll, Elisabeth. *Railroads and the Transformation of China*. Cambridge, MA: Harvard University Press, 2019.

Kotewall, Pikyee. "Huang Binhong (1865–1955) and His Redefinition of the Chinese Painting Tradition in the Twentieth Century." PhD diss., Hong Kong University, 1998.

Krischer, Olivier. "Ōmura Seigai's Conception of Oriental Art History and China." In *Questioning Oriental Aesthetics and Thinking: Conflicting Visions of "Asia" under the Colonial Empires*, edited by Inaga Shigemi, 265–87. Kyoto: International Research Center for Japanese Studies, 2010.

Kristeva, Julia. "Bakhtin, le mot, le dialogue et le roman." *Critique* 23 (1967): 438–65.

Kubin, Wolfgang. *Der durchsichtige Berg: Die Entwicklung der Naturanschauung in der chinesischen Lyrik*. Stuttgart: Steiner-Verlag Wiesbaden, 1985.

Kuo, Jason C. *Transforming Traditions in Modern Chinese Painting: Huang Pin-hung's Late Work*. New York: Peter Lang, 2004.

Kwok, D. W. Y. *Scientism in Chinese Thought, 1900–1950*. New Haven: Yale University Press, 1965.

Lang Jingshan 郎靜山 (Chin-San Long). "Composite Pictures and Chinese Art." In *Techniques in Composite Picture Making* 靜山集錦作法, revised edition. Taipei: China Series Publishing Committee, 1958.

———. *Jingshan jijin* 靜山集錦 (*Symphony in Black and White*). Shanghai: Tongyun Shuwu, 1948.

Lary, Diana. "Introduction: The Context of the War." In *China at War: Regions of China, 1937–1945*, edited by Stephen R. MacKinnon, Diana Lary, and Ezra F. Vogel, 1–14. Stanford, CA: Stanford University Press, 2007.

Lee, Brigitta Ann. "Imitation, Remembrance, and the Formation of the Poetic Past in Early Medieval China." PhD diss., Princeton University, 2007.

Lee, Joohyun. *Den Himmel in der Pinselspitze: Chinesische Malerei des 20. Jahrhunderts im Museum für Ostasiatische Kunst Köln*. Exhibition catalogue. Heidelberg: Kehrer, 2005.

Li Baoquan 李寶泉. "Zhongxi shanshuihua de gudianzhuyi yu ziranzhuyi" 中西山水畫的古典主義與自然主義. *Guohua yuekan* 1, no. 4 (1935): 57–59.

Li, Chu-tsing. *Trends in Modern Chinese Painting Painting: The C. A. Drenowatz Collection*. Ascona, Switzerland: Artibus Asiae, 1979.

Li, Huaiyin. *Reinventing Modern China: Imagination and Authenticity in Chinese Historical Writing*. Honolulu: University of Hawai'i Press, 2013.

Li Weiming 李偉銘. "Dashi zhi xue yu shengxian zhi xue: Guanyu Huang Binhong ji qi dangdai xiaoying de sikao zhaji" 大師之學與聖賢之學——關於黃賓虹及其當代效應的思考札記. In *Huang Binhong yu xiandai yishu sixiangshi guoji xueshu yantaohui wenji 2012 Hangzhou*, edited by Kong Lingwei and Juliane Noth, 8–17. Hangzhou: Zhongguo Meishu Xueyuan Chubanshe: 2014.

———. "Jindai yujing zhong de 'shanshui' yu 'fengjing': Yi *Guohua yuekan* 'Zhongxi shanshuihua sixiang zhuanhao' wei zhongxin" 近代語境中的'山水'與'風景': 以《國畫月刊》'中西山水畫思想專號'爲中心. *Wenyi yanjiu*, no. 1 (2006): 107–20.

Li Yongqiao 李永翹. *Zhang Daqian nianpu* 張大千年譜. Chengdu: Sichuan sheng Shehuikexueyuan chubanshe, 1987.

Lippit, Yukio. "Of Modes and Manners in Japanese Ink Painting: Sesshū's *Splashed Ink Landscape* of 1495." *Art Bulletin* 94, no. 1 (March 2012): 50–77.

Liscomb, Kathlyn Maurean. *Learning from Mount Hua: A Chinese Physician's Illustrated Travel Record and Painting Theory*. Cambridge: Cambridge University Press, 1993.

Liu, Lihong. "Collecting the Here and Now: Birthday Albums and the Aesthetics of Association in Mid-Ming China." *Journal of Chinese Literature and Culture* 2, no. 1 (April 2015): 43–91.

Liu, Lydia H. *Translingual Practice: Literature, National Culture, and Translated Modernity— China, 1900–1937.* Stanford, CA: Stanford University Press, 1995.

Liu, Mia Yinxing. "The Allegorical Landscape: Lang Jingshan's Photography in Context." *Archives of Asian Art* 65, nos. 1–2 (2015): 1–24.

Liu, Wennan. "Redefining the Moral and Legal Roles of the State in Everyday Life: The New Life Movement in China in the Mid-1930s." *Cross-Currents: East Asian History and Culture Review* 2, no. 2 (November 2013): 335–65.

Liu, Yu-jen. "Publishing Chinese Art: Issues of Reproduction in Chinese Art, 1905–1918." DPhil thesis, Oxford University, 2010.

———. "Second Only to the Original: Rhetoric and Practice in the Photographic Reproduction of Art in Early Twentieth Century China." *Art History* 37, no. 1 (February 2014): 68–95.

"Liyan" 例言. In *Dongnan lansheng*, edited by Dongnan jiaotong zhoulanhui xuanchuanzu, unpaginated. N.p.: Quanguo Jingji Weiyuanhui Dongnan Jiaotong Zhoulanhui, 1935.

Lu Danlin 陸丹林. "Dongnan jiaotong zhoulanhui de yiyi" 東南交通周覽會的意義. *Daolu yuekan* 43, no. 2 (1934): 1–3.

———. "Guohuajia jiying lianhe" 國畫家亟應聯合. *Mifeng huabao* 蜜蜂畫報 (1930). Republished as "Minguo shijiu nian Zhongguo huahui yuanqi" 民國十九年中國畫會緣起 in *Zhonghua minguo sanshiliu nian Zhongguo meishu nianjian* 中華民國三十六年中國美術年鑒, edited by Wang Yichang 王宸昌, 8. Shanghai: Shanghai shi wenhua yundong weiyuanhui, 1948. Reprint, Shanghai: Shanghai Shehui Kexueyuan Chubanshe, 2008. References are to the reprint edition.

Ma Guoliang 馬國亮. "Huangshan jiyou" 黃山紀游. *Lüxing zazhi* 8, no. 11 (1934): 47–52, and no. 12 (1934): 55–58.

———, photogr. "Huangshan songjing" 黃山松景 ("Graceful Old Pines: Another Scenic Wonder of Huang Shan"). *Liangyou*, no. 91 (August 1, 1934): 12–13.

Mackerras, Colin. *China in Transformation, 1900–1949.* London and New York: Longman, 1998.

Maeda, Tamaki. "Rediscovering China in Japan: Fu Baoshi's Ink Painting." In *Writing Modern Chinese Art: Historiographic Explorations*, edited by Josh Yiu, 70–81. Seattle: Seattle Art Museum, 2009.

McDermott, Joseph P. "The Making of a Chinese Mountain: Huangshan, Wealth and Politics in Chinese Art." *Ajia Bunka Kenkyū (Asian Cultural Studies)* 17 (March 1989): 145–76.

McDougall, Bonnie S. *Fictional Authors, Imaginary Audiences: Modern Chinese Literature in the Twentieth Century.* Hong Kong: Chinese University Press, 2003.

McDowall, Stephen. *Qian Qianyi's Reflections on Yellow Mountain: Traces of a Late Ming Hatchet and Chisel.* Hong Kong: Hong Kong University Press, 2009.

Mersmann, Birgit. "Global Routes: Transmediation and Transculturation as Key Concepts of Translation Studies." In *Transmediality and Transculturality*, edited by Nadja Gernalzick and Gabriele Pisarz-Ramirez, 405–23. Heidelberg: Universitätsverlag Winter, 2013.

Meyer, Urs, Robert Simanowski, and Christoph Zeller. "Vorwort." In *Transmedialität: Zur Ästhetik paraliterarischer Verfahren*, edited by Urs Meyer, Robert Simanowski, and Christoph Zeller, 7–17. Göttingen: Wallstein Verlag, 2006.

Mifeng huashe 蜜蜂畫社, ed. *Dangdai mingren huahai* 當代名人畫海. Shanghai: Zhonghua Shuju, 1931.

———, ed. *Mifeng huaji* 蜜蜂畫集. Shanghai, 1930.

———, ed. *Mifeng huashe sheyoulu* 蜜蜂畫社社友錄. Shanghai: n.p., 1930.

Min Linsi 閔麟嗣. *Huangshan songshi pu* 黃山松石譜 (1697). In *Zhaodai congshu* 昭代叢書, compiled by Zhang Chao 張潮 et al., vol. 1, 52–54. Reprinted by Shanghai: Shanghai Guji Chubanshe, 1990.

———, comp. *Huangshan zhi dingben*. Edited by Gugong Bowuyuan 故宮博物院. *Gugong zhenben congkan*. Haikou: Hainan Chubanshe, 2001.

Miner, Noel R. "Chekiang: The Nationalists' Effort in Agrarian Reform and Construction, 1927–1937." PhD diss., Stanford University, 1973.

"Minfei gongxian Pucheng, Zhe sheng bianfang gaoji" 閩匪攻陷浦城浙省邊防告急. *Shenbao*, September 26, 1932, 4.

Mitchell, W. J. T., ed. *Landscape and Power*. 2nd edition. Chicago: University of Chicago Press, 2002.

Mitter, Partha. "Decentering Modernism: Art History and Avant-Garde Art from the Periphery." *Art Bulletin* 90, no. 4 (December 2008): 531–48.

Mohuizhai 墨繪齋. *Mingshan tu* 名山圖 (1633). Reprinted in *Zhongguo gudai banhua congkan er bian* 中國古代版畫叢刊二編, vol. 8. Shanghai: Shanghai Guji Chubanshe, 1994.

Murck, Alfreda. *Poetry and Painting in Song China: The Subtle Art of Dissent*. Cambridge, MA: Harvard University Asia Center, 2000.

Musgrove, Charles D. *The Contested Capital: Architecture, Ritual, and Response in Nanjing*. Honolulu: University of Hawai'i Press; Hong Kong: Hong Kong University Press, 2013.

Nelson, Susan E. "*I-p'in* in Later Painting Criticism." In *Theories of the Arts in China*, edited by Susan Bush and Christian Murck, 397–424. Princeton, NJ: Princeton University Press, 1983.

Ni Yide 倪貽德. "Xiyang shanshuihua jifa jiantao" 西洋山水畫技法檢討. *Guohua yuekan* 1, no. 4 (1935): 76–78, and no. 5 (1935): 119–20.

Noth, Juliane. "Mountains and a Lot of Water: How Photography Reshaped Imaginations of the Chinese Landscape." In *Einfluss, Strömung, Quelle: Aquatische Metaphern in der Kunstgeschichte*, edited by Ulrich Pfisterer and Christine Tauber, 123–38. Bielefeld: Transcript, 2019.

———. "Seen from a Boat: Travel and Cultural History in Huang Binhong's Landscape Paintings." In *The Itineraries of Art: Topographies of Artistic Mobility in Europe and Asia*, edited by Karin Gludovatz, Juliane Noth, and Joachim Rees, 175–99. Paderborn: Wilhelm Fink Verlag, 2015.

Orell, Julia. "Picturing the Yangzi River in Southern Song China (1127–1279)." PhD diss., University of Chicago, 2011.

Ortiz, Fernando. *Contrapunteo cubano del tabaco y el azúcar* (1940). Madrid: Catédra, 2002.

Osterhammel, Jürgen. "'Technical Co-operation' between the League of Nations and China." *Modern Asian Studies* 13, no. 4 (1979): 661–80.

Owen, Stephen. "Place: Meditation on the Past at Chin-ling," *Harvard Journal of Asiatic Studies* 50, no. 2 (December 1990): 417–57.

Pan Enlin 潘恩霖. "Xuyan / Introduction" 序言. In *Xinan lansheng* 西南攬勝 (*Scenic Beauties in Southwest China*), edited by China Travel Service. Revised edition, unpaginated. Shanghai: China Travel Service, 1940.

Park, J. P. *Art by the Book: Painting Manuals and the Leisure Life in Late Ming China*. Seattle: University of Washington Press, 2012.

Pickowicz, Paul R., Kuiyi Shen, and Yingjin Zhang, eds. *Liangyou: Kaleidoscopic Modernity and the Shanghai Global Metropolis, 1926–1945*. Leiden: Brill, 2013.

Pingle xian difangzhi bianzuan weiyuanhui 平樂縣地方誌編纂委員會. *Pingle xianzhi* 平樂縣誌. Beijing: Fangzhi Chubanshe, 1996.

Pratt, Mary Louise. *Imperial Eyes: Travel Writing and Transculturation* (1992). Updated and expanded second edition. London and New York: Routledge, 2007.

"Qingnianhui ku'er dahui jinxun" 青年會苦兒大會近訊. *Shenbao*, December 20, 1934, 13.

Quan Wenbing 全文炳 et al., comps. *Guangxu Pingle xianzhi* 光緒平樂縣誌. Reprinted in *Zhongguo difangzhi jicheng: Guangxi fuxianzhi ji* 中國地方誌集成:廣西府縣誌輯, vol. 39. Nanjing: Fenghuang Chubanshe et al., 2014.

Rajewski, Irina O. *Intermedialität*. Tübingen: A. Francke, 2002.

Rama, Ángel. *Transculturación narrativa en América Latina*. Mexico City: Siglo XXI, 1982.

Reed, Christopher. *Gutenberg in Shanghai: Chinese Print Capitalism, 1876–1937*. Vancouver: University of British Columbia Press, 2004.

Ren Hongjuan 任鴻雋. "Kexue fanyi wenti: Cong Yan yi Tianyan lun shuoqi" 科學翻譯問題: 從嚴譯天演論說起. *Kexue* 3 (1959): 178–80.

Roberts, Claire. "The Dark Side of the Mountain: Huang Binhong (1865–1955) and Artistic Continuity in Twentieth Century China." PhD diss., Australian National University, 2005.

———. *Friendship in Art: Fou Lei and Huang Binhong*. Hong Kong: Hong Kong University Press, 2010.

———. "Metal and Stone, Brush and Ink: Word as Source in the Art of Huang Binhong." In "Politics and Aesthetics in China," edited by Maurizio Marinelli. Special issue, *Portal: Journal of Multidisciplinary International Studies* 9, no. 3 (November 2012): 1–25. Accessed March 16, 2016. http://epress.lib.uts.edu.au/ojs/index.php/portal.

———. *Photography and China*. London: Reaktion Books, 2013.

———. "Questions of Authenticity: Huang Binhong and the Palace Museum." *China Heritage Quarterly* no. 10 (June 2007). Accessed October 3, 2017. http://www.chinaheritagequarterly.org/scholarship.php?searchterm=010_HBH-Palace.inc&issue=010.

Satō, Dōshin. *Modern Japanese Art and the Meiji State: The Politics of Beauty*. Translated by Hiroshi Nara. Los Angeles: Getty Research Institute, 2011.

Schaefer, William. *Shadow Modernism: Photography, Writing, and Space in Shanghai, 1925–1937*. Durham, NC: Duke University Press, 2017.

Schivelbusch, Wolfgang. *The Railway Journey: The Industrialization of Time and Space in the 19th Century*. Berkeley: University of California Press, 1986.

Schwartz, Benjamin. *In Search of Wealth and Power: Yen Fu and the West*. Cambridge, MA: Belknap Press of Harvard University Press, 1964.

Shanghai meishuguan 上海美術館, ed. *Diancang mingjia jingpin xilie: He Tianjian* 典藏名家精品系列:賀天健. Shanghai: Shanghai Renmin Meishu Chubanshe, 2012.

Shao Yuanchong 邵元沖, ed. *Xibei lansheng* 西北攬勝 (*China's Northwest: A Pictorial Survey*). Nanjing: Zhengzhong Shuju, 1936.

Shen, Kuiyi. "A Modern Showcase: *Shidai* (Modern Miscellany) in 1930s Shanghai." *Yishuxue yanjiu* 12 (2013): 129–70.

———. "Scholar, Official, and Artist Ye Gongchuo." In *Elegant Gathering: The Yeh Family Collection*, 21–33. Exhibition catalogue. San Francisco: Asian Art Museum of San Francisco, 2006.

———. "Xian jun yi dong sheng hua bi, wan shui qian shan lie huatang: Zheng Wuchang de huihua yishu" 羨君一動生花筆，萬水千山列畫堂：鄭午昌的繪畫藝術. In *Zheng Wuchang* 鄭午昌, 5–19. *Ershi shiji Zhongguo huajia congji* 二十世紀中國畫家叢集. Shanghai: Shanghai Shuhua Chubanshe, 2000.

Shi Guozhu 石國柱, ed. *Shexian zhi: Anhui sheng Shexian zhi* 歙縣志. 安徽省歙縣志, compiled by Xu Chengyao 許承堯. *Zhongguo fangzhi congshu, Huazhong difang* 中國方志叢書, 華中地方, no. 246, 9 vols. Taipei: Chengwen Chubanshe, 1975.

Shih Shou-chi'en 石守謙. "Mingshan qisheng zhi lü yu ershi shiji qianqi Zhongguo shanshuihua de xiandai zhuanhua" 名山奇勝之旅與二十世紀前期中國山水畫的現代轉化. In *Travelling with Gaze: The Tourist Culture in Modern China and Taiwan* 旅行之視線：近代中國與臺灣的觀光文化, edited by Su Shuobin 蘇碩斌, 13–67. Taipei: Guoli Yangming Daxue Renwen Shehui Kexueyuan, 2012.

Shimada Shūjirō 島田二郎. "Kōtō-in shozō no sansuiga ni tsuite" 高桐院所藏の山水畫について ("On the Landscape Paintings in the Kōtō-in Temple"). *Bijutsu Kenkyū* 美術研究 165 (1951): 136–49.

Siku quanshu zongmu tiyao 四庫全書總目提要, *juan* 175. Wikisource. Accessed July 12, 2017. https://zh.wikisource.org/w/index.php?title=四庫全書總目提要&/卷175&oldid=85606.

Strassberg, Richard E., trans. *Enlightening Remarks on Painting by Shih-t'ao*. Pacific Asia Museum Monographs. Pasadena, CA: Castle Press, 1989.

———. *Inscribed Landscapes: Travel Writing from Imperial China*. Berkeley: University of California Press, 1994.

Strauss, Julia C. *Strong Institutions in Weak Polities: State Building in Republican China*. Oxford: Clarendon Press, 1998.

Stuer, Catherine. "Dimensions of Place: Map, Itinerary, and Trace in Images of Nanjing." PhD diss., University of Chicago, 2012.

Stulik, Dusan, and Art Kaplan. *The Atlas of Analytical Signatures of Photographic Processes*. Los Angeles: Getty Conservation Institute, 2013. Accessed January 18, 2016. http://hdl.handle.net/10020/gci_pubs/atlas_analytical.

Sturman, Peter. "The Donkey Rider as Icon: Li Cheng and Early Chinese Landscape Painting." *Artibus Asiae* 55, no. 1/2 (1995): 43–97.

Sun Fuxi 孫福熙. "Xiyanghua zhong de fengjing" 西洋畫中的風景. *Guohua yuekan* 1, no. 4 (1935): 86–87.

Takeuchi, Melinda. *Taiga's True Views: The Language of Landscape Painting in Eighteenth-Century Japan*. Stanford, CA: Stanford University Press, 1992.

Tang, Jihui 唐吉慧. "Jiushi yuese" 舊時月色. *Meishubao*, May 14, 2011, 72. Accessed January 14, 2015. http://msb.zjol.com.cn/html/2011-05/14/content_836072.htm?div=-1.

Tō Sō Gen Min meiga taikan 唐宋元明名画大観. 4 vols. Tokyo: Ōtsuka Kōgeisha, 1929.

Tō Sō Gen Min meigaten gō 唐宋元明名画展号. Tokyo: Tōkyō Asahi Shinbun Hakkōjo, 1928.

Tsai, Weipin. *Reading* Shenbao: *Nationalism, Consumerism and Individuality in China, 1919–1937*. Basingstoke: Palgrave Macmillan, 2010.

van de Ven, Hans J. *War and Nationalism in China, 1925–1945*. London: RoutledgeCurzon, 2003.

Vinograd, Richard. "De-Centering Yuan Painting." *Ars Orientalis* 37 (2009): 195–212.

———. "Patrimonies in Press: Art Publishing, Cultural Politics, and Canon Construction in the Career of Di Baoxian." In *The Role of Japan in Modern Chinese Art*, edited by Joshua Fogel, 245–72. Berkeley: University of California Press, 2012.

Waara, Carol Lynne. "Arts and Life: Public and Private Culture in Chinese Art Periodicals, 1912–1937." PhD diss., University of Michigan, 1994.

"Wan Jianshetingzhang Liu Yiyan zuo di Hu fenwu gefang jieqia Huangshan jianshe shiyi" 皖建設廳長劉貽燕昨抵滬分晤各方接洽黃山建設事宜. *Shenbao*, February 20, 1937, 16.

"Wan sheng jiji kaifa Huangshan: Xiujian wenquan yushi, zhengli paifang tingtai" 皖省積極開發黃山——修建溫泉浴室，整理牌坊亭臺. *Shenbao*, April 2, 1934, 9.

Wang, Ban. *The Sublime Figure of History: Aesthetics and Politics in Twentieth-Century China*. Stanford, CA: Stanford University Press, 1997.

Wang, Cheng-hua. "New Printing Technology and Heritage Preservation: Collotype Reproduction of Antiquities in Modern China, circa 1908–1917." In *The Role of Japan in Modern Chinese Art*, edited by Joshua Fogel, 273–308. Berkeley: University of California Press, 2012.

———. "The Qing Imperial Collection circa 1905–25: National Humiliation, Heritage Preservation and Exhibition Culture." In *Reinventing the Past: Archaism and Antiquarianism in Chinese Art and Visual Culture*, edited by Wu Hung, 320–41. Chicago: University of Chicago Press, 2010.

———. "Rediscovering Song Painting for the Nation: Artistic Discursive Practice in Early Twentieth Century China." *Artibus Asiae* 71, no. 2 (2011): 221–46.

Wang, David Der-wei. "In the Name of the Real." In *Chinese Art: Modern Expressions*, edited by Maxwell K. Hearn and Judith G. Smith, 28–59. New York: Metropolitan Museum of Art, 2001.

Wang, Eugene Y. "Perceptions of Change, Changes of Perception: West Lake as Contested Site/Sight in the Wake of the 1911 Revolution." *Modern Chinese Literature and Culture* 12, no. 2 (2000): 73–122.

———. "Sketch Conceptualism as Modernist Contingency." In *Chinese Art: Modern Expressions*, edited by Maxwell K. Hearn and Judith G. Smith, 102–61. New York: Metropolitan Museum of Art, 2001.

Wang, Q. Edward. *Inventing China through History: The May Fourth Approach to Historiography*. Albany: State University of New York Press, 2001.

Wang Shuliang 王淑良, Jia Hongyan 賈鴻雁, Wang Jinchi 王金池, and Ma Minhua 馬民華. *Zhongguo xiandai lüyou shi* 中國現代旅遊史. Nanjing: Dongnan Daxue Chubanshe, 2005.

Wang Xinming 王新明, He Bingsong 何炳松, Wu Yugan 武堉干, Sun Hanbing 孫寒冰, Huang Wenshan 黃文山, Tao Xisheng 陶希聖, Zhang Yi 章益, Chen Gaoyong 陳高傭, Fan Zhongyun 樊仲雲, and Sa Mengwu 薩孟武. "Zhongguo benwei de wenhua jianshe xuanyan" 中國本位的文化建設宣言. *Wenhua jianshe* 1, no. 4 (January 1935). Reprinted in *Dongfang zazhi* 32, no. 4 (1935): 81–83.

Wang Yichang 王宸昌, ed. *Zhonghua minguo sanshiliu nian Zhongguo meishu nianjian* 中華民國三十六年中國美術年鑒. Shanghai: Shanghai shi wenhua yundong weiyuanhui, 1948.

Reprint, Shanghai: Shanghai Shehui Kexueyuan Chubanshe, 2008. References are to the reprint edition.

Wang Zhongxiu 王中秀. "Huang Binhong huazhuan" 黃賓虹畫傳. *Rongbaozhai*, no. 1 (2007): 278–94; no. 2 (2007): 268–77; no. 3 (2007): 266–73; no. 4 (2007): 264–73; no. 5 (2007): 256–67; no. 6 (2007): 258–67; no. 1 (2008): 260–69.

———. *Huang Binhong nianpu* 黃賓虹年譜. Shanghai: Shanghai Shuhua Chubanshe, 2005.

Ward, Julian. *Xu Xiake (1587–1641): The Art of Travel Writing*. Richmond, Surrey: Curzon, 2001.

Wei'erte 維爾特 [Oscar Wilde]. "Dulian Gelai de xuwen" 杜蓮格來的序文. Translated by Yu Dafu 郁達夫. *Chuangzao jikan* 1, no. 1 (1922): 145–46.

Weston, Victoria. *Japanese Painting and National Identity: Okakura Tenshin and His Circle*. Ann Arbor: Center for Japanese Studies, University of Michigan, 2004.

Wilde, Oscar. *The Picture of Dorian Gray: The 1890 and 1891 Texts*. Vol. 3 of *The Complete Works of Oscar Wilde*, edited by Joseph Bristow. Oxford: Oxford University Press, 2005.

Wilhelm, Richard, trans. *The I Ching, or Book of Changes*. Rendered into English by Cary F. Baynes. Bollingen Series 19, vol. 1. New York: Pantheon Books, 1950.

Wong, Aida Yuen. *The Other Kang Youwei: Calligrapher, Art Activist, and Aesthetic Reformer in Modern China*. Leiden: Brill, 2016.

———. *Parting the Mists: Discovering Japan and the Rise of National-Style Painting in Modern China*. Honolulu: University of Hawai'i Press, 2006.

Wu Jingheng 吳敬恆. "Huangshan shanshi ji shanping" 黃山山史及山評. In *Dongnan lansheng*, edited by Dongnan jiaotong zhoulanhui xuanchuanzu, "Hang-Hui gonglu yanxian zhi bu," 43–49. N.p.: Quanguo Jingji Weiyuanhui Dongnan Jiaotong Zhoulanhui, 1935.

Wu, Lawrence. "Kang Youwei and the Westernisation of Modern Chinese Art." *Orientations*, March 1990, 46–53.

Wu Liande 伍聯德, ed. *Zhonghua jingxiang: Quanguo sheying zongji* 中華景象：全國攝影總集 (*China As She Is: A Comprehensive Album*). Shanghai: Liang You Printing & Publishing Co., 1934.

Wu Liande 伍聯德, Liang Desuo 梁得所, Ming Yaowu 明耀五, and Chen Binghong 陳炳洪, eds. *Zhongguo daguan: Tuhua nianjian 1930* 中國大觀：圖畫年鑒 1930 (*The Living China: A Pictorial Record 1930*). Shanghai: Liang You Printing & Publishing Co., 1930.

"Wu Zhihui deng you Tianmushan" 吳稚暉等游天目山. *Shenbao*, April 1, 1934, 11.

Wue, Roberta. *Art Worlds: Artists, Images, and Audiences in Late Nineteenth-Century Shanghai*. Hong Kong: Hong Kong University Press; Honolulu: University of Hawai'i Press, 2014.

Xiao Hui 曉輝. "Zeng Yangfu yu Qiantangjiang daqiao" 曾養甫與錢塘江大橋. *Wenshi chunqiu*, no. 3 (1999): 71–73.

Xiao Yongsheng 蕭永盛. *Huayi—Jijin—Lang Jingshan* 畫意—集錦—郎靜山. Taipei: Xiongshi, 2004.

Xiao Yuncong 蕭云從. *Taiping shanshui tuhua* 太平山水圖畫, engraved by Liu Rong 劉鎔, Tang Yi 湯義, and Tang Shang 湯尚. Published in 1648 by Huaigutang 懷古堂. Reprinted in *Zhongguo gudai banhua congkan er bian* 中國古代版畫叢刊二編, vol. 8. Shanghai: Shanghai Guji Chubanshe, 1994.

Xie Haiyan 謝海燕. "Qianyan" 前言. In *Yu Jianhua huaji* 俞劍華畫集, unpaginated. Jinan: Shandong Renmin Chubanshe, 1981.

———. "Xie Haiyan jinyao qishi" 謝海燕緊要啓事. *Guohua yuekan* 1, no. 7 (1935): 166.

———. "Zhongguo shanshuihua sixiang de yuanyuan" 中國山水畫思想的淵源. *Guohua yuekan* 1, no. 4 (1935): 61–66 and no. 5 (1935): 121.

[Xie] Haiyan [謝] 海燕. "Zhongxi shanshuihua sixiang zhuanhao kanqian tan" 中西山水畫思想專號發刊前談. *Guohua yuekan* 1, no. 3 (1935): 48.

Xinhua News Agency. "Huangshan Songkesong tishen lumian, shi da mingsong jin an zai" 黃山送客松替身露面 十大名松今安在. Sina.com.cn, January 12, 2006. Accessed March 24, 2016. http://tech.sina.com.cn/d/2006-01-12/0811817899.shtml.

Xu Hongquan 許宏泉. *Zhongguo yishu dashi Huang Binhong* 中國藝術大師黃賓虹. Shijiazhuang: Hebei Meishu Chubanshe, 2009.

Xu Hongzu 徐弘祖. *Xu Xiake youji* 徐霞客遊記. Facsimile reprint of 1933 edition. Zhengzhou: Zhongzhou Guji Chubanshe, 1992.

Xu Jilin. "Social Darwinism in Modern China." *Journal of Modern Chinese History* 6, no. 2 (December 2012): 182–97.

Xu Peiji 徐培基. *Wan'er muqian: Xu Peiji sanshi niandai jiyou huagao* 宛爾目前: 徐培基三十年代紀遊畫稿. Edited by Li Xun 黎洵. Jinan: Shandong Meishu Chubanshe, 2009.

Xu Qifeng 徐祈丰. "Ming Qing Huizhou fangzhi zhong de banhua chatu" 明清徽州方志中的版畫插圖. MA thesis, Nanjing Arts University, 2012.

Xu Shiying 許世英. *Huangshan lansheng ji* 黃山攬勝集. Shanghai: Liangyou Tushu Yinshua Gongsi, 1934.

"Xu Shiying fabiao Huangshan chubu jianshe sange yue jihua" 許世英發表黃山初步建設三個月計劃. *Shenbao*, June 28, 1936, 14.

"Xu Shiying fan Hu tan Huangshan jianshe yi wancheng, dingqi fu Jing ye Jiang baogao" 許世英返滬談黃山建設已完成‧定期赴京謁蔣報告. *Shenbao*, November 23, 1934, 9.

Xu Youchun 徐友春, ed. *Minguo renwu da cidian* 民國人物大辞典. Shijiazhuang: Hebei Renmin Chubanshe, 1991.

Xu Zhihao 許志浩. *Zhongguo meishu shetuan manlu* 中國美術社團漫錄. Shanghai: Shanghai Shuhua Chubanshe, 1994.

Yang Erzeng 楊爾曾. *Hainei qiguan* 海內奇觀 (1609). Reprinted in *Zhongguo gudai banhua congkan er bian* 中國古代版畫叢刊二編, vol. 8. Shanghai: Shanghai Guji Chubanshe, 1994.

Yang, Xiaoneng. *Tracing the Past, Drawing the Future: Master Ink Painters in Twentieth-Century China*. Exhibition catalogue. Milan: 5 Continents Editions, 2010. Distributed by Harry N. Abrams.

Ye Qianyu 葉淺予. *Xixu cangsang ji liunian* 細敘滄桑記流年. Beijing: Qunyan Chubanshe, 1992.

Yeh, Wen-hsin, ed. *Wartime Shanghai*. London: Routledge, 1998.

Yih, Y. Weitan [Ye Qiuyuan 葉秋原]. "In Search of the Southeast." In *Dongnan lansheng*, edited by Dongnan jiaotong zhoulanhui xuanchuanzu, unpaginated. N.p.: Quanguo Jingji Weiyuanhui Dongnan Jiaotong Zhoulanhui, 1935.

Yu Dafu 郁達夫. "Bingchuan jixiu" 冰川紀秀. In *Dongnan lansheng*, edited by Dongnan jiaotong zhoulanhui xuanchuanzu, "Zhe-Gan tielu Hang-Yu duan yu Hang-Guang gonglu yanxian ji Fuchunjiang zhi bu," 25. N.p.: Quanguo Jingji Weiyuanhui Dongnan Jiaotong Zhoulanhui, 1935.

———. "Bingchuan jixiu ("Scenic Beauty of the Ping Stream, Kiangsi")." *Liangyou* no. 84 (January 1934): 16–17.

———. "Hang-Jiang xiaoli jicheng" 杭江小歷紀程. In *Zhedong jingwu ji: Hang-Jiang tielu daoyou congshu zhi yi*, edited by Hangzhou tieluju, 1–30. Hangzhou: Hangzhou tieluju,

1933. Reprinted in *Yu Dafu zuopin jingdian* 郁達夫作品經典, edited by Yang Zhansheng 楊占升, vol. 3, 236–54. Beijing: Zhongguo huaqiao chubanshe, 1998.

———. "Tianmushan youji" 天目山遊記. In *Dongnan lansheng*, edited by Dongnan jiaotong zhoulanhui xuanchuanzu, "Hang-Hui gonglu yanxian zhi bu," 9–15. N.p.: Quanguo Jingji Weiyuanhui Dongnan Jiaotong Zhoulanhui, 1935.

———. "Xianxia jixian" 仙霞紀險. In *Dongnan lansheng*, edited by Dongnan jiaotong zhoulanhui xuanchuanzu, "Zhe-Gan tielu Hang-Yu duan yu Hang-Guang gonglu yanxian ji Fuchunjiang zhi bu," 21–23. N.p.: Quanguo Jingji Weiyuanhui Dongnan Jiaotong Zhoulanhui, 1935.

———. "Xianxia jixian." *Shenbao*, December 13, 1933, 15; December 14, 1933, 17.

———. *Yu Dafu youji ji* 郁達夫游記集. Hangzhou: Zhejiang Renmin Chubanshe, 1982.

———. "Zhedong jingwu jilüe" 浙東景物紀略. In *Zhedong jingwu ji: Hang-Jiang tielu daoyou congshu zhi yi*, 31–49. Hangzhou: Hangzhou tieluju, 1933. Reprinted in *Yu Dafu zuopin jingdian* 郁達夫作品經典, edited by Yang Zhansheng 楊占升, vol. 3, 255–68. Beijing: Zhongguo huaqiao chubanshe, 1998.

Yu Jianhua 俞劍華. *Chen Shizeng* 陳師曾. Shanghai: Shanghai Renmin Meishu Chubanshe, 1981.

———. "Yandang xiesheng ji" 雁蕩寫生記. 4 parts. *Lüxing zazhi* (*The China Traveler*) 6, no. 2 (1932): 15–24; no. 3 (1932): 33–44; no. 5 (1932): 29–36; no. 6 (1932): 31–34.

———. *Yu Jianhua xiesheng jiyou* 俞劍華寫生紀游. Nanjing: Dongnan Daxue Chubanshe, 2009.

———. "Zai jingda Wu Yinghe xiansheng" 再敬答吳英鶴先生. *Guohua yuekan* 1, no. 11–12: 228–29.

———, ed. *Zhongguo gudai hualun leibian* 中國古代畫論類編. Reprint edition. 2 vols. Beijing: Renmin Meishu Chubanshe, 1998.

———, ed. *Zhongguo meishujia renming cidian* 中國美術家人名辭典. Reprint edition. Shanghai: Shanghai Renmin Meishu Chubanshe, 1981.

———. "Zhongguo shanshuihua zhi xiesheng" 中國山水畫之寫生. *Guohua yuekan* 1, no. 4 (1935): 71–75.

Yu Kun 俞錕 [Yu Jianhua]. "Qufu Tai'an xiesheng lüxing ji" 曲阜泰安寫生旅行記. *Chenbao fukan*, October 8, 13–17, 19, 21–25, 27, and 29–31, 1922.

Zanasi, Margherita. *Saving the Nation: Economic Modernity in Republican China*. Chicago: University of Chicago Press, 2006.

Zarrow, Peter. *China in War and Revolution, 1895–1949*. London: Routledge, 2005.

"Zeng Shirong." www.huaxia.com. Accessed October 7, 2015. http://search.huaxia.com/s.jsp?iDocId=501088.

Zeng Yangfu 曾養甫. "Jiansheting zhi zeren" 建設廳之責任. *Zhejiang sheng jianshe yuekan* 5, no. 8 (1932): 3–4.

———. "Xu" 序. In *Dongnan lansheng*, edited by Dongnan jiaotong zhoulanhui xuanchuanzu, unpaginated. N.p.: Quanguo Jingji Weiyuanhui Dongnan Jiaotong Zhoulanhui, 1935.

———. "Zhejiang jianshe shiye zhi huigu jiqi zhanwang" 浙江建設事業之回顧及其展望. *Shishi yuebao* 12, no. 1 (1935): 90–98.

Zhang Daqian 張大千 and Zhang Shanzi 張善孖. *Huangshan huajing* 黃山畫景. Shanghai: Tanshe, 1931.

Zhang Guobiao 張國標, ed. *Huipai banhua yishu* 徽派版畫藝術 (*Art of Woodcut of the Huizhou School*). Hefei: Anhui Meishu Chubanshe, 1996.

Zhang Qiyun 張其昀. "Zhejiang sheng fengjing zongshuo" 浙江省風景總説. In *Dongnan lansheng*, edited by Dongnan jiaotong zhoulanhui xuanchuanzu, "Gaishuo," 3–29. N.p.: Quanguo Jingji Weiyuanhui Dongnan Jiaotong Zhoulanhui, 1935.

———. *Zhejiang sheng shidi jiyao* 浙江省史地紀要. 2nd edition. Shanghai: Shangwu yinshuguan, 1928.

———. "Zhe you jisheng" 浙遊紀勝. *Dili xuebao*, no. 1 (1934): 107–56 and 210–11.

Zhao Shuyong 趙叔雍. "Di yi xian youlan riji" 第一線遊覽日記. *Lüxing zazhi (The China Traveler)* 8, no. 7 (1934): 5–23 and no. 8 (1934): 23–39.

"Zhe Jianting choubei Dongnan jiaotong zhoulanhui" 浙建廳籌備東南交通周覽會. *Shenbao*, May 8, 1934, 7.

Zheng, Jane. *The Modernization of Chinese Art: The Shanghai Art College, 1913–1937*. Leuven: Leuven University Press, 2016.

Zheng Suyan 鄭素燕. "1949 nian qian Zhang Qiyun de renji wangluo" 1949年前張其昀的人際網絡. *Changchun Gongye Daxue xuebao* 22, no. 5 (2010): 107–9.

Zheng Wuchang 鄭午昌. "Guohua yuekan yu *Guohua*" 《國畫月刊》與《國畫》. *Guohua*, no. 1 (1936): 2.

———. "Xiandai Zhongguo huajia ying fu zhi zeren" 現代中國畫家應負之責任. *Guohua yuekan* 1, no. 2 (1934): 17.

———. *Zhongguo huaxue quanshi* 中國畫學全史. Shanghai: Zhonghua Shuju, 1929.

———. *Zhongguo meishushi* 中國美術史. Shanghai: Zhonghua Shuju, 1935.

———. "Zhongxi shanshuihua sixiang zhuankan zhanwang" 中西山水畫思想專刊展望. *Guohua yuekan* 1, no. 4 (1935): opening page.

Zheng Zhong 鄭重. "Hongdingfang laoban: Zhou Xiangyun he ta de shoucang" 紅頂房老板：周湘雲和他的收藏. *Da Meishu* no. 10 (2007): 87–89.

Zhengfeng 正風. "Jinri huafeng zhi yaomo" 今日畫風之妖魔. *Guohua yuekan* 1, no. 1 (1934): 6.

Zhongguo huahui bianyibu 中國畫會編譯部 ed. *Zhongguo xiandai minghua huikan* 中國現代名畫彙刊. Shanghai: Zhongguo Huahui, 1935.

"Zhongguo huahui kai chengli dahui" 中國畫會開成立大會. *Shenbao*, June 27, 1932, 11.

"Zhongguo huahui xianren weiyuan" 中國畫會現任委員. *Guohua yuekan* 1, no. 1 (1934): 16.

Zhou Jiyin 周積寅 and Wang Zongying 王宗英. *Yu Jianhua* 俞劍華. Nanjing: Dongnan Daxue Chubanshe, 2012.

Zhou Yi 周易, annotated by Zhu Xi 朱熹. In *Zhongguo wenhua jingdian* 中國文化經典, part 1, vol. 5. Hangzhou: Xiling Yinshe Chubanshe, 2007.

Zhu Defa 朱德發. *Zhongguo xiandai jiyou wenxue shi* 中國現代紀遊文學史. Jinan: Shandong Youyi Chubanshe, 1990.

Zhu Jingsheng 朱京生. "Yi kong yi bang, bianhua cong xin: Tan jindai yinjia Yi Da'an" 一空依傍 變化從心：談近代印家易大厂. *Zhongguo Shuhua*, no. 12 (2004): 104–6.

GLOSSARY-INDEX

Harvard East Asian Monographs
(most recent titles)